Jeff Wall

Jeff Wall

Selected Essays and Interviews

THE MUSEUM OF MODERN ART, NEW YORK

Contents

PART II: INTERVIEWS

Preface

Virtually all of Jeff Wall's essays and interviews were occasioned by invitations from editors, critics, curators, and other colleagues and friends of the artist. Otherwise the two types of text are very different from each other: the essays are mostly about the work of other artists; the interviews, mostly about Wall's own work.

The purpose of this book is to make conveniently available a selection of the best essays and interviews. Within each of the two parts, the texts are presented in chronological order. At the foot of the first page of each text is a note that records the date of composition, the first instance of publication, and (if it is different) the first instance of publication in English. In the case of nearly all of the texts, no one version is strictly definitive. For this book Wall has made new changes to some texts.

Both the essays and the interviews habitually refer to artists, philosophers, critics, and other figures by their last names. This and other efficiencies of expression have been preserved. An index of proper names is provided but otherwise no new scholarly apparatus has been introduced. The author has kindly permitted the substitution of American for British spellings, but the book preserves his use of "which" (as opposed to "that") to designate a defining subordinate clause.

Béatrice Gross in the Department of Photography has done the lion's share of the work of preparing this book—from assembling the texts and illustrations to checking countless details. David Frankel and Marc Sapir in the Department of Publications have ably handled the editorial and production tasks respectively. Katy Homans created the elegant design. Jeff Wall joins me in thanking them and in thanking Carol and David Appel for their generous and indispensable support.

PETER GALASSI

Chief Curator of Photography
The Museum of Modern Art

This publication is made possible by Carol and David Appel.

Bibliographical Note

The essential reference for Jeff Wall's work (including his texts of all kinds) is Theodora Vischer and Heidi Naef, eds., *Jeff Wall: Catalogue Raisonné 1978–2004* (Basel: Laurenz Foundation, Schaulager Basel, in association with Steidl, Göttingen, 2005). It includes a comprehensive bibliography through 2004, including chronological lists of Wall's essays and interviews (pp. 457–60). It also includes a number of shorter texts devoted to individual works by Wall—texts that are essential to the study of his art but too narrowly focused for a general anthology.

Anthologies of Wall's texts exist in German and French translations:

Jeff Wall, *Szenarien im Bildraum der Wirklichkeit: Essays und Interviews*, ed. Gregor Stemmrich (Amsterdam and Dresden: Verlag der Kunst, Fundus Books, 1997).

Jeff Wall, *Essais et entretiens 1984–2001*, ed. Jean-François Chevrier (Paris: École nationale supérieure des beaux-arts, 2001).

A Note on the Illustrations

Unless otherwise noted, works by Jeff Wall are silver dye bleach transparencies in light boxes. The dimensions provided are those of the image, not of the light box or frame.

Part I: Essays

A Draft for "Dan Graham's Kammerspiel"

PREFACE

This essay was written in 1981. It was the first draft of the first part of my essay "Dan Graham's Kammerspiel," which was published in the catalogue of the exhibition *Dan Graham* at the Art Gallery of Western Australia, in Perth, in September 1985, and then in *Real Life* magazine (numbers 14 and 15, Summer 1985 and Winter 1985–86). The final and published version of the Kammerspiel essay was written in 1982.

This draft was rejected as part of the final version. It may have contributed to a critical discussion about the interpretation of Graham's work in the writings of Benjamin Buchloh, but it did not position Graham's work adequately in the context of the whole idea. It was therefore put aside as a false start, although it seemed that the discussion it outlined might be resumed on another, more appropriate, occasion.

Graham has continued to think that this draft discusses matters of importance to his work. The publication of the Kammerspiel essay has provided a context for the consideration of this one, and so I have agreed to its translation and publication.

It will be clear in the text that my critique of Buchloh's writing was developed in an atmosphere of respect and admiration for his work. It was conceived as a contribution to a dialectic in which Buchloh had set exemplary standards.

JEFF WALL, August 1986

Interest in Dan Graham's work has been strongest among antiformalists involved in the development of a sociology of illusion in relation to art. This critical direction has been developed in large part by Benjamin Buchloh. Buchloh has constructed an important argument about current art in which a canonical status has been given to Graham, along with Daniel Buren and Michael Asher, as "functionalists."

Buchloh's argument, formed in a synthesis of aesthetic structural analysis and *Ideologiekritik* in the tradition of the Frankfurt School, has been little analyzed in English, although it has been part of European artistic discourse for some time.

Buchloh's ideas are indebted to the radicalism associated with Frankfurt School critical theory, and particularly with Theodor W. Adorno and Max Horkheimer. This

Written in 1981. First published in French as "Project pour 'Kammerspiel de Dan Graham,' 1981, Ière partie (1981)," in Wall, *Kammerspiel de Dan Graham* (Brussels: Daled-Goldschmidt, 1988), pp. 121–65. First published in English as "A Draft for 'Dan Graham's Kammerspiel'," in Wall, *Dan Graham's Kammerspiel* (Toronto: Art Metropole, 1991), pp. 85–115. The Art Metropole edition incorporates editorial changes not approved by the author.

In 1979 or early 1980, Thomas Lawson, editor of *Real Life* magazine, invited Wall and Dan Graham to write in tandem, each artist choosing for discussion a single work by the other. Graham's essay was published as "The Destroyed Room of Jeff Wall," *Real Life* (New York) no. 3 (March 1980): 4–6. This is Wall's first (incomplete) draft; the finished essay appears on pp. 31–75.

is a radicalism of negation in the face of the totalized alienation of technological soci- ety or neocapitalism. This type of critical theory emerged when the possibility of a social or political alternative to this domination of society by "barbaric" authoritarian forces appeared to have completely disintegrated. The historical roots of this disinte- gration are to be found in the collapse of the anti-Nazi forces in Weimar Germany. The cause of this collapse, in turn, is traced back to the failures of the revolutionary upsurge of 1919–23 in Germany and Hungary, and the subsequent deformation of revolutionary subjectivity and potential in the working-class movement.

In Buchloh's work, however, the negativity of the Adorno-Horkheimer position is uncomfortably combined with the activism of Walter Benjamin's Brechtian writ- ings. This, of course, is a combination characteristic of the European New Left, and it has always been recognized as problematic. But it is exactly the problematic and unstable character of this combination which gives it its legitimacy, for it expresses with great concentration the central dialectic of the crisis period of modernism, the period begun with the decline of the revolutionary wave around 1920. The dialectic in question is that constituted by the conflict between the trend toward the restriction of art to technological entertainment and decor, and that which asserts art as a cri- tique of subjectivity, as subjectivity is constructed in the production and consumption of imagery and artistic commodities. The extension of this critique of subjectivity toward the functionalization of art as an element of social planning for a liberated order is always implied in Buchloh's perspective. It is the basis of his establishment of a pantheon consisting of two wings: productivism (including the political aspects of Dada and Surrealism) and the readymade.

Buchloh's insistence upon the evocation of this perspective in consideration of contemporary art is aimed at holding open the question of the historical memory (or loss of memory) of the art movement most closely aligned with the student radical- ism of the New Left—conceptualism. Conceptual art is Buchloh's starting point and essential frame of reference. It is seen as the connection between the presence in the history of modernism of authentic critical discourse and the problems of the present, in which that discourse seems threatened with extinction. In pressing the question of these connections, Buchloh develops new and significant contradictions, around which his demand for a functionalist post-conceptualism turns.

Buchloh identifies this functionalism with the continuation of critical theory's attempt to expose the process of bureaucratic totalization of social life in "monopoly," or "late," or "neo" capitalism, and to delineate the resulting atomization, estrange- ment, and psychic regression of the individual subject. This monumentalized repres- sion, which corresponds to the interests of a nihilistic and destructive ruling class obliged to replace its own democratic traditions with authoritarian forms of rule, is both effected and reflected in the cultural sphere through the "excessive aestheticiza- tion of the world."[1]

The proposal of an excessive aestheticization of social life as the cultural symptom of authoritarianism depends explicitly upon Benjamin's valiant thesis, written in 1936:

> "*Fiat ars—pereat mundus*" says Fascism, and, as Marinetti admits, expects war to supply the artistic gratification of a sense perception that has been changed by technology. This is evidently the consummation of "*l'art pour l'art*." Mankind, which in Homer's time was an object of contemplation for the Olympian gods, now is one for itself. Its self-alienation has reached such a degree that it can experience its own destruction as an aesthetic pleasure of the first order. This is the situation of politics which Fascism is rendering aesthetic. Communism responds by politicizing art.[2]

The final sentence of this paragraph has been understood—correctly—as expressing Benjamin's desire to overcome his oppressors, fascism and the Stalinism of the Popular Front and the Moscow Trials, and to participate as a writer in the development of a revolutionary movement. But it must be recognized that Benjamin's conclusion also reflects the enormous shock of the defeats suffered by the German working-class movement in the previous decade. The final sentence is stirring but schematic, decisive but vague. What sort of alternative does this indefinite "politicization of art" indicate in 1936? The preceding paragraph makes it clear that fascism politicized art, too, and that this process was essential in its development of the futuristic primitivism characteristic of Nazi publicity-art. Benjamin struggles to put at the disposal of his readers a set of concepts useful in the fight against the Nazi propaganda machine. This machine is entirely based upon modern technology, which may indeed destroy the atavistic "aura" of old works of art, but which, in the same process, creates the "aura" of the Führer and his vision. It is this aura, the one induced by reproducibility, not the one cancelled by it, which is the decisive mystery of the period. From the point of view of critical theory, it is this aura which is the key to the success of fascism in mobilizing popular support.[3] Benjamin, however, was aware that the Nazis were not victorious simply through their own mastery of society. He was conscious—as was his friend Bertolt Brecht—of the role of the Stalinist bureaucracy in the victory of Hitler through its disastrous misleading of the German working-class movement; and he was conscious, too, that these disasters and betrayals were continuing, in Spain and in the Moscow Trials. The insights of this essay must be understood historically as emerging in a desperate situation of defeat, disorientation, and the shocking consciousness of betrayal. Benjamin's struggle to overcome the political and theoretical confusion produced by these defeats makes the essay a precious contribution to the development of revolutionary thought about art. However, the first lesson to be taken from it is that of its own limits.

Benjamin, who sets out to develop concepts "completely useless for the purposes of Fascism" but "useful for the formulation of revolutionary demands in the politics

of art,"[4] concludes with a distressing revelation readable in the emptiness of his final sentence. "Communism responds by politicizing art" says nothing. That is, it veils the fact that communism in 1936 does not respond; it has given away the materials of response to its enemy in taking the weapons of theory and organization, formed in the history of the revolutionary movement, from the hands of the German workers. It took these away with its false policies—primarily those of "social fascism" and then of the Popular Front. In doing so, all the techniques of propaganda and agitation developed in the period by the workers' organizations in conflict with mass publicity not only became ineffective, but actually passed with increased volatility and strength into the hands of the fascist enemy.

In expressing only the gap between what was demanded by the historical situation and what the response of communism was, it is almost as if Benjamin's excessively inadequate final sentence is itself a literary device. Its vacant generality, following the explicitness of the fascist solution, is a warning sign, an insignia that draws attention to itself, that incriminates itself. In becoming aware of the Nazi victory's consequences for theoretical thought, Benjamin becomes aware of its impact on himself, on his own capacities. The emptiness of the final sentence becomes a symptom of Benjamin's own inability to speak clearly about the response of communism, to speak about what the Popular Front's debacle makes clear as the "silence of communism."

The consequences of the silent response of communism to the aestheticization of politics through the mass media, and of the difficulties experienced by the anti-fascist writers most closely identified with Benjamin, emerge in the pessimistic anti-positivism of Adorno and Horkheimer, whose *Dialectic of Enlightenment* (1944) establishes the broad outlines of a theory of the "culture industry" which is, with the ideas of Marcuse and Reich, among the dominant influences upon the New Left critique of culture and art after 1968.

Adorno's and Horkheimer's analysis of mass culture and the forms of domination identified with it was elaborated, like Benjamin's, under the impact of the triumph of Nazism and of wartime America; this indicates that their conceptual totalization of the repressive and estranging effects of the culture industry is itself in large part a response to the collapse of the communist alternative. The new silence of communism and the apparent inexplicability of this silence become the basis for a new type of critique of society which, in the years after 1939, breaks decisively with revolutionary Marxism, a Marxism which is seen as having disappeared into this silence. This new critical theory is a central factor in the development of the idea of the totalized domination of society, both capitalist and socialist, by unshakable bureaucratic corporate-state forms which transcend and cancel the contradictions of the "old-fashioned" capitalism spoken of by Marx. These state forms naturally integrate into themselves the new communications technology, thereby outflanking the positions of politicized cultural critique identified with the avant-garde. These ideas

were developed in the 1930s in reference to the rise of the integrated fascist state, the political degeneration of the Soviet Union, and the emergence of a highly developed corporatism in the United States. These phenomena were seen as part of a single historical process.

The Frankfurt School thinkers generally held a centrist position in the argument about the interpretation of this process, an argument which raged throughout the working-class movement in the 1930s. They were unable to swallow the fraudulent Russian claims of the achievement of "Socialism in One Country," and they refused to apologize for the buildup of a political dictatorship in the Soviet Union. At the same time, they rejected what they saw as the "extremist" position of the Left Opposition identified with Trotsky, which called for a political revolution in the USSR and a return to Bolshevik internationalism. Through the 1930s this centrist position remained in a state of crisis. The Stalin-Hitler Pact of 1939 and the outbreak of the war dissolved the culture of the Popular Front and exposed its duplicity. The perspective of socialism was severely damaged, and the connections of radical theorists to the organizations of the working-class movement were largely destroyed.

Critical theory's mature social and cultural outlook was formed in this era, in the process of melancholy adjustment to the new historical necessity, that of living within the silence of communism, within the perspective bounded by the disappearance of the possibility of the revolutionary transformation of a self-destructive society. Within the Frankfurt School's bitter and accurate exposures of the forms of stunted and damaged consciousness generated within this society, which so influenced the artistic New Left, there persists an opening, a gap. This gap is identifiable with the silence of communism, and it gives onto a social and philosophical outlook which, for all the hatred for capitalism which it expresses, and for all its affection for certain Marxist concepts, is profoundly and classically pessimistic. The insights of Marxist social theory, separated from their roots in the working-class movement, become a language of hurtful evidence. They provide witness that social life is reified and unintelligible and that the bureaucratic-corporate manipulators (Godard's "Paramount-Mosfilm") have succeeded, or are in the final stages of succeeding, in transmuting all rational ideals of freedom and truth into irrational slogans of ever more invisible and complete repression—into what later, in Foucault, for example, becomes the demonic "power-knowledge." With the specter of the passing away into history of the Marxist concept of the unity of theory and practice in social revolution, this newer critique sees the circle of domination and even extinction closing about it. Critical theory broods forlornly over all that it has been divested of and, unable to transform its position within the order of domination which it comprehends so well, it gestures constantly toward the outrage of its own eradication. This eradication is the spectacle it awaits and whose shadow it glimpses and denounces behind all the other irrational spectacles concocted by instrumental reason and power. In critically characterizing

and exposing these developments it carries out its defensive task, that of demarcating the shrinking circle of freedom. This freedom is that of pure negativity, of absolute, static refusal; it is the freedom to lament. Thereby, critical theory becomes the avant-garde of postwar bourgeois pessimism, the philosophical laboratory in which the incessant waves of revolt against capitalism are transmuted into apocalyptic obsessions.

These obsessions are strengthened and deepened by the selective inclusion within them of the powerful Marxist concepts of reification, alienation, false consciousness, and fetishization, which, following the lead of Lukács, critical theory salvages from its earlier period. The process of separating these concepts from the whole structure of Marxist theory permits the enthronement of unchallenged ideas of total domination in *Dialectic of Enlightenment*. In this emblematic book, a synthesis of the whole outlook of mature critical theory, Adorno and Horkheimer introduced their studies by writing, "In the enigmatic readiness of the technologically educated masses to fall under the sway of any despotism, in its self-destructive affinity to popular paranoia, and in all uncomprehended absurdity, the weakness of the modern theoretical faculty is apparent."[5] So much has the "modern theoretical faculty" been weakened by the events of the 1930s that even the conceptual expression of revolutionary solidarity has become impossible: "It is [the] unity of the collectivity and domination, and not direct social universality, solidarity, which is expressed in thought forms."[6]

Within this perspective, the work of art, with its roots in beauty and pleasure, ugliness and unpleasure, as the concrete form of its development as critical cognition, becomes completely subjected to the repressive falsifications of the culture industry. Mechanized cultural production, according to Adorno, functions through the perverse transformation of pleasure into a repetitious structure of servile gratification, which is imperceptible as such. Within this structure, oppressive norms of debased and debasing "beauty" are both instrumental in the production process and its product, in that they form the primal occasions made available for commodity fetishism. On this basis, Adorno elaborates his ideas about the process of regression of reception toward the infantilized gratification characteristic of authoritarian personalities. All popular art in the modern era generally falls under this characterization; it is "garbage." Under these conditions of utter falsification of culture, the work of art as aesthetic object and the aesthetic itself as a mode of critical cognition become, strictly speaking, unthinkable. The highest artistic achievement, therefore, is to bring forward this wretched unthinkability of the aesthetic in all its accusatory palpability. Out of its conditions of impossibility, however, the work of art is nevertheless idealized as a great form of defeatism:

> Today . . . the alienation present in the consistency of artistic technique forms the very substance of the work of art. The shocks of incomprehension, emitted by artistic technique in the age of its meaninglessness, undergo a sudden

change. They illuminate the meaningless world. Modern music sacrifices itself to this effort. It has taken upon itself all the darkness and guilt of the world. Its fortune lies in the perception of misfortune; all of its beauty is in denying itself the illusion of beauty. No one wishes to become involved with art— individuals as little as collectives. It dies away unheard, without even an echo. If time crystallizes around that music which has been heard, revealing its radiant quintessence, music which has not been heard falls into empty time like an impotent bullet. Modern music spontaneously aims towards this last experience, evidenced hourly in mechanical music. Modern music sees absolute oblivion as its goal. It is the surviving message of despair from the shipwrecked.[7]

Adorno's critique remains eternally delayed at the point of receiving the shock of absolutely disintegrating possibilities for changing reality. Its task is thus to turn this historic defeat into the most modern (and negative) form of transcendence, to dramatize it in his writing as a continuously evolving moment of absolute defeat, the consciousness of which forms the outline of whatever self-knowledge remains possible in this period.

A critical perspective like Buchloh's, which is interested in the potential of the work of art in affecting society, must have difficulty remaining faithful to whatever roots it has in Adorno's defeatism.

Writing about Michael Asher's *Installation at Münster* (1977), Buchloh says:

As far as the historically significant preoccupation with architectural dimension is concerned, the present-day artist is in a position that bears no comparison with the circumstances that had surrounded the Russian Productivists or El Lissitzky who could optimistically discuss his Prouns in terms of a 'change-over from painting to architecture.' The political situation no longer justifies that sort of utopian impetus and what is more, the aesthetic producer, even if he were at all willing and able to analyze the world that surrounds him, has no way of becoming effective outside the narrow domain of art allotted to him. Any thought of creating a functional relationship with reality is instantly ruined by that reality. Moreover, it seems that the aesthetic producer, having interiorized the morals of culture-industry according to which he is to go in such circles as will fit in the narrow art domain, has himself eventually become incapable of reflecting upon this dimension of his practice. Whereas the art discussion from the beginning of this century had increasingly revolved around functionalism—culminating both theoretically and practically in the twenties—after the Second World War this problem in art has become more of an anathema than anything else: faced with this reality any artistic or even architectural (and thus political) attempt on the part of

aesthetic practice to deal with reality is condemned to turn into either a farce or a decorative transfiguration of the existing situation.[8]

For Buchloh as for Adorno, art is now completely encircled within the repressive falsification of its very resources by a complex institutional mechanism of control which has the effect, among others, of inhibiting the artist's own subjective consciousness of his or her own state. Moreover, this falsification is renewed with each aesthetic gesture or "production." The work of art is thus at best a "concretion of this dilemma."[9] The best works, in Buchloh's terms, both struggle toward a "functional relationship with reality" in the sense of New Left activism and a desire for a resolution of the dilemma, a break, and at the same time concretize the dilemma of the immobilization and ruination of art by reflecting that ruination in their own structure.

The functionalistic aspect of such work attempts to break the closed circle of falsification in a radical inversion, one which has its precedents in the reductivism of '60s art. This reductivism, "emphasizing the reference to reality,"[10] is in turn seen as the direct precondition for the dematerialization of the work of art into critical language.

This dematerialization of art into a more direct form of critical cognition is for Buchloh the essential achievement of conceptualism. The inner relation of this dematerialized art form to the production of Asher or Graham is constituted in the fact that conceptualism speaks the discourse of academicism, of publicity, and of architecture, architecture here understood as the discourse of the siting of the effects of power generated by publicity, information, and bureaucracy in the city. The critical operation of Conceptual art is located in its appropriation of language as against the image or object. But language is conceived not as a theoretical, almost mathematical object, but in terms of its physicality, its modes of production and enforcement in the city and its institutions. Thus Conceptual art participated in the development of the critique of the interdependence of academicism and publicity. That is, it made explicit in many works the insight that both the university system and the media monopolies, having been purged of Marxism during the cold war, have become primary support-systems for new art in the same process in which they were inscribed in a complex of corporate structures of authority and knowledge, whose essential cognitive structure—almost their epistemology—is publicity. The best appreciated of this Conceptual art—Kosuth's, for example—presents the vestiges of the instrumentalized, "value-free" academic disciplines characteristic of the new American-type universities (empiricist sociology, information theory, positivist language philosophy) in the fashionable forms of 1960s advertising.

Conceptualism's exhibition strategy self-consciously presents the museum-gallery system as the crucial social arena of this new synthesis. This is inseparable from appropriation of existing media forms such as magazines, TV, or billboards. In

both these aspects, the kinship with Pop art is evident. Unlike Pop, however, conceptualism attempts to incriminate the art business as the mechanism by means of which a corporatization of aesthetic thought is being carried out. Conceptualism sees this as a social and political crisis in art, and senses that in this crisis crucial elements of the critical traditions of modern art are being liquidated.

This sense of crisis, which is essentially a response of younger artists to the political events of the 1963–75 period, links the discourse of conceptualism as it emerges from a reflection on the institutionalization of radical but still puristic Minimal art, to the concurrent revival of critical theory in the New Left. It is this linkage which provides the basis for Buchloh's assessment of conceptualism as the artistic movement which effects the decisive reopening of the historical memory of American art after the long interlude of the domination of politically neutralized formalism. The route from the earlier, acutely circumscribed academic linguistic work of the Art & Language type toward the "postconceptual" positions of Buren, Asher, or Graham is opened by the combination of New Left critical theory with a historicist critique of urbanism. Academically, this took the form of linked studies in the development of state and scientific institutions as mechanisms of power, and of the methods of siting these institutions within the modern city, or, more accurately, their strategic positioning at the center of its structure. For the purposes of the consideration of Graham's work, these areas of thought are most directly linked with the writings of Barthes, Foucault, and Tafuri. The influence of the Frankfurt School is evident in the connections these authors make between their specific objects of study and the psychological or psychosocial effects of these objects, in which mechanisms of power and domination are internalized by the urban masses and reproduced involuntarily as profound estrangement and impotence.

Artistically, these issues are raised in the rapid turn toward techniques and skills identified with the communications monopolies and state information agencies. Through the appropriation of these techniques at the expense of the traditional art media, Conceptual art attempts to construct a critique of formalist or "purely aesthetic" art and thereby to turn directly toward "reality" (identified with the city) "with a view to changing it."[11]

Conceptual art moves toward reality by means of a strategy of active intervention into the existing complex of social forces constituted by urban communication and representation systems. Its intervention is inseparable from its attacks on other art, particularly the art out of which it most directly emerges—Minimalism and Pop. Conceptualism recognizes Minimal art as neither simply formalism nor the negation of formalism, but as a transitional style dominated by a Romantic concept of negativity. This negativity is seen to be the antithesis to Pop art's seemingly chronic affirmativeness, and so there is considerable disappointment, particularly among the *Fox* group, that the Minimalist "heroes" never make a decisive break from the

dominant positivism within American formalism. In consequence, Minimalism appears to be no more than the "negativist" version of formalism. This inadequacy within Minimalism in a sense provided the opening for the domination in the 1970s of social concepts of art engendered primarily by Pop, and essentially by Warhol. In this light, conceptualism in the 1970s represents a resistance to Pop on its own ground—the media—by artists desiring to remain faithful to certain ideas of the artistic New Left, primarily ideas about the necessity of negativity. It is in these terms that we understand the claims of critics like Buchloh that conceptualism be considered antiformalist.

However, Conceptual art itself is far from free of the negative formalism which has disappointed it. Although its dependence on social language implies a decisive rejection of the whole idea of abstract art, and its rootedness in mass-communication techniques moves it in the direction of a new kind of social imagery—a sort of antithesis to Warhol imagery—its sources in the politically neutralized character of Minimalist purism and reductivism do not really permit these elements to develop in the direction of a revival of an openly socially critical modernist art.

Conceptual art, however, begins to make a penetrating critique of reductivism, denouncing it for its armored inwardness and its ultimate indifference toward the social discourse which it incited and upon which it depended for its status as controversial modernist art. Nevertheless, reductivism formed a primal fascination in the '60s because it resulted in an austere mechanistic object whose aggressive passivity and stylish indifference evoked feelings of alienation and dehumanization reminiscent of those experienced in everyday life. So the response of the Conceptualist critique was twofold and contradictory. On the one hand, it was clearly seen that Minimalism's exhibitionistic "objecthood" accomplished only the reproduction of alienation and anxiety. Anxiety was not really constituted as a subject of the work (which, of course, could not admit of having a subject at all), but was concocted as a theatrical effect to which the gallery spectator was subjected, as he was subjected to publicity and commands in relation to objects in normal social existence. On the other hand, this theatrical effect itself created at least an up-to-date physical form which implied, however involuntarily and indifferently, concepts about the relationship between the experience of art and the experience of social domination. These concepts were rapidly turned against the Minimal art which helped stimulate them. In this process, narcissism and fetishistic regression were identified with the theatricalized status of art objects in general. Conceptual art as "anti-object" is the result.

Elimination of the object is identified with elimination of the commodity. The market was recognized as the foundation of all forms of domination in culture, but most Conceptual artists did not develop their ideas toward a political economy of art production until the mid-1970s, when the phenomenon of enormous inflation-driven prices for works of Minimal and Pop art became too obviously identifiable with the

opening of the crisis of world inflation generally. Even then, this aspect of the auto-critique of art remained exceptionally muted. This limit of the conceptualist critique indicates that the movement remains dominated by the ideas it is criticizing. Its paradoxical reification of critical language as instrumental and static "information" takes place in the same process in which a critique based on the concept of reification dematerializes the object and appears to transcend the commodity form.

Consequently, in Conceptual art the accepted forms of "pure" (that is, institutionally purified) knowledge are packaged as announcements for commodities rather than as commodities themselves. All forms of commercialized or bureaucratized information are appropriated as artistic material in a strategy of mimicry. In this sense, conceptualism is the doppelgänger of Warhol-type "Popism" in its helplessly ironic mimicry not of knowledge, but of the mechanisms of the falsification of knowledge, whose despotic and seductive forms of display are copied to make art objects. Like Pop, this conceptualism remains subjected to the effects of the historical process of political neutralization of art in the cold war period, and is one of the sharpest expressions of the pressures of that process. Neither Pop nor conceptualism can posit its social subject-matter in good faith. Unironic social subject-matter is a residual property of 1930s art, and "modernist" art begins from the idea that that era is not only "over" (this is the insistence of neocapitalism), but that it was an essential historical aberration produced by the clash of inherently totalitarian (European) cultures. The social indifference of postwar American art, which is symptomatized by the aesthetics of remoteness which constantly recurs in it, from Newman to, say, Jack Goldstein, is absolutely a reflex of the trauma of the collapse in 1939 of the ideals of an integrated social modern art.

Thus, if Pop is the cynical and amnesiac "social realism" of the new "'bureaucratic collectivism," Conceptual art is its melancholy Symbolism. In putting forward its forgotten card-files and printouts, its caskets of information, conceptualism recapitulates a kind of Mallarméan aesthetic: social subjects are presented as enigmatic hieroglyphs and given the authority of the crypt. This identification of publicity, bureaucracy, and academicism with cryptic utterances expresses an awareness of the participation of the universities and the bureaucracies in a corporate death-machine, an awareness which, of course, animated the student movement.

What is unique about Conceptual art in this context, therefore, is its reinvention of defeatism, of the quietism implicit in "puristic" art. The gray volumes of Conceptual art are filled with somber ciphers which express primarily the incommunicability of social thought in the form of art. They thus embody a terrible contradiction. These artists attempt to break out of the prison-house of the art business, its bureaucracy and its museums, and to turn toward social life, as Buchloh argues. But in the process of turning they reassume the very emptiness they wished to put behind them. This is because, as vanguard artists, they still see the social struggle as a moral necessity,

but in keeping with the ideological presuppositions of the period, they see it also as a historical impossibility, and they are mortified in front of the demand to struggle. A work by Kosuth—as by Johns, Morris, or Reinhardt before him—is seized by a nostalgia for a kind of political stance which he is sure it is no longer possible or even "useful" to maintain. Kosuth's works, exhibitions, and tomes created the mausoleum look that struck just the right note. They brought the tomblike aspect of Minimalist exhibitionism out from the "dead" gallery space into "life"—billboards, newspaper ads, etc. His work most of all resembles Warhol's, except that it has the conventional dark surface of profundity which stems from regret, and regret is what Warhol forgets.

Conceptual art carries out into the city only the mortified remains of socially critical art silenced by three decades of capitalist war, political terror, and "prosperity." Its display of these remains can only be exhibitionistic, and this exhibitionism is the expression of its bad, distraught conscience. Exhibitionism and public distress are therefore the final indicators that this work is art at all in the serious sense of the past. Nothing in its actual social content can any longer establish this. Rather, in its rueful immobilization before the mechanisms of falsification of language under the perspective of neocapitalism, it represents the terminus point of serious modern art, its scene of shipwreck.

However, in its very immobilization, Conceptual art does reflect the development, not directly of revolutionary ideas in culture, but of the emergence of certain preconditions for the development of such ideas. The reemergence of critical social thought into currency in America in the later 1960s, after a long period of eclipse and suppression, indicates that a new stage in the class struggle was opening at that time. The period of the stabilization of imperialism behind the U.S. dollar in 1944—the "postwar era"—had reached its end with the dollar crises of the late '6os and early '7os. The era of world inflation and destabilization had begun. With the end of the era of stabilization based upon inflationary "credit" policies, there also ends the basis upon which all the ruling class's cultural strategies of control in the realm of ideas and representations could be made effective. The end of the period of prosperity and purchased quiescence must be dated not at 1980 but ten years earlier. Nevertheless, this change was barely perceptible at the time, and is only revealed to us once it has reached its full expression in the direct threat to the current generation's cultural presuppositions in Reagan's campaign of inversion of the New Deal. Conceptualism's attempt at a new socially critical art must be seen as a reflection of this turn of events. The inadequacy of its formulation of these issues is a profound inadequacy, and is therefore decisive. Its inadequacy measures the gap which had been opened in the historical memory of modernism since 1939.

Buchloh repeatedly emphasizes that conceptualism attempted to revive the strategies of earlier critical modern art, particularly those of productivism and the

readymade, in order to articulate its major theme, the administrative enclosure of modern art by the culture industry. This was because conceptualism recognized, however incompletely, that these earlier works embody something decisive created by the first great revolutionary upheaval of the century. In struggling to reinvent the effect of these works, the Conceptual artists move toward a historical perspective, toward a kind of historical memory.

While the radical artistic groups of the 1920s and '30s were separating from the working-class movement, either forcibly or through disillusionment, those of the 1960s fitfully wandered in the opposite direction. A wide gap obviously remains. This gap is symbolized by the affection of conceptualism for the readymade. Historically, the readymade stands between the rebellious, antiauthoritarian fin-de-siècle art of Jarry, for example, and the polemical machine-art of productivism. In this, it looks both forward and backward. The backward look of the readymade is important because it redirects the historical memory of conceptualism toward an earlier historical period than that usually identified with Duchamp's effect, a period which parallels that of the 1960s in symptomatic ways.

This period is that of the long prosperous interlude of the later nineteenth century, the era which formed the "evolutionary socialism" and reformism characteristic of modern social democracy. This was a period in which one of the central—if not *the* central—cultural experiences was the nervous pleasure stimulated by a shower of cheap, machine-made commodities, a shower which washed the perspective of socialism out to the far horizon of history. This era is constantly evoked in Duchamp.

Conceptual art's reaching back to the readymade is a double gesture. While it does attempt to link the scandalousness of the readymade to later machine-art and therefore to the militant modernism of the 1920s and '30s, it also reveals another impulse. The impulse to reformulate the strategy of the readymade, in which the withdrawal of aesthetic resources from the work of art is combined with an ironic mimicry of the commodity form, reveals a perspective closer to that of the 1890s, in which the characteristic cultural combination is that of *l'art pour l'art* and reformism, than it is to that of the 1920s, when the militant modernism of productivism did not attempt to mimic existing commodity forms, but wished to completely rebuild them in the overall redesigning of society.

For conceptualism, the readymade, with its withdrawals and its mimicry, is the image of an "absolute criticism," a complete negation of the industry of art. But the readymade is simultaneously rooted in the outlook of this earlier period, in a prosperous critique of prosperity, in that its irony is rooted in its sense of the unshakability of the rule of commodity form over social and psychic life. This sense of unshakability stands behind all the slogans of "progress" to which the reformist leaders of social democracy constantly referred. The celebrated anxiety to which the readymade gives expression is that generated by the glimpse it gives of a future implied by the

eternity of the commodity, the endless rule of the abject object. The readymade, emblem of the sloganless critique of an utterly detached intelligence, confronts the hidden form of social rule with the image of its own expressive meagerness. The sense of inadequacy, and the consequent sense of the emptiness of history, which the ready-made creates is central to conceptualism's appropriation of it, and to Buchloh's emphasis on that appropriation. It forms *the* historical parallel which illuminates conceptualism's refusal of the political discourse of the interwar period (a period of slogans and polemics), its refusal of the memories it constantly evokes. This affection for the fin-de-siècle absolutism of the irony of Duchamp constitutes the amnesiac symptom in the yearning of the radicals of the 1960s for a "new politics."

Thus the radicalism of 1960s art, with its pervasive strategy of withdrawal of aesthetic properties and mimicry of "nonart" forms, is authentically neo-Duchampian. And in it, the impulse toward polemical aggression against art in the tradition of the 1920s and '30s is dominated by this method of the reduction of its own expressive capacities, its own assumption of a radical inadequacy. It is as if a militant Duchampianism blends with an involuntary Greenbergianism; the outcome is politicized purity. This is the burden conceptualism carries over into itself from its dependence upon "purified" abstraction and Minimalism, from its rootedness in the whole mythos of the New York School.

Conceptualism is complex because these conflicting tendencies remain unresolved within it. Indeed, if conceptualism is anything—aesthetically, politically, economically—it is irresolute. It is an incomplete development. Its first response to the enormous political upheaval begun in the 1960s was to appropriate social techniques in an assault on "Art," and this constitutes its radicalism. But insofar as it was unable to reinvent social content along with social technique, it fell prey to the same purism, even though this purism is now radicalized by being articulated in thoroughly Duchampian terms. Involuntarily and almost by default, conceptualism is encapsulated as "radical purism." By the mid-1970s, this led to a fundamental split in the development of the idea of Conceptual art, a split which announced the collapse of the whole thing. Some artists, like Huebler or Barry, now easily shed the trappings of the struggle for historical memory and moved toward orthodox commodity production, albeit of a refined and mildly ironic type. Others, such as the *Fox* group, attempted to extend the political element. Most of this work foundered in the academic and sterile Maoism which was the dregs of the New Left. This "leftist" conceptualism was able to go no further than the production of negatively polemical or "self-referential" indictments which expressed primarily their own unthinkability as works of art. Inadequacy was absolutized in the dreariness of the movement's decline.

This lackluster spectacle, however, brings conceptualism face to face with its nemesis, "Popism." By the mid-1970s, the economic ascendancy of Pop art had legitimated Warhol's interpretation of ironic mimicry and led to the eruption of an aes-

thetic of compulsive mimicry across the art market as a whole. Again, it is only from the point of view of the present moment that the extent of the domination of Warhol-type ideas throughout the last six or seven years is perceptible. As the conceptualist struggle for historical memory succumbs, the antithetical concepts which it attempted to control within itself burst forth with unprecedented vigor in the new "postconceptual pluralism." Everything is forgotten, everything is possible, everything is "great." But the issues at stake in conceptualism's collapse in fact make the movement recognizable as a crucial axis of transition between the distraught quietism of the New York School (which includes Minimalism) and an explosive revival of *both* revolutionary and counterrevolutionary ideas in art.[12] This makes conceptualism representative of the end of New York–type art.

Conceptualism's transcendence of New York–type art is the source of its almost organic internationalism. By the very premises of its perspective of a bureaucratic world culture industry, it breaches the authority of the old concept of national styles in art, to which Greenbergianism ultimately reverts. This same bureaucratic look permitted Conceptual art to free itself from the dependence on American corporate insignia which still identifies Pop so closely with New York–type art. Conceptualism makes explicit the Europe-America interchange out of which ideas like Buchloh's emerge.

Buchloh articulates the dialectic of his postconceptual functionalism most clearly at the conclusion of his essay on Asher:

> The crucial difference is between those forms of a decreed abolition of the aesthetic as the last sphere of critical negation—one that suits the prevailing interests of the day and is expressed as an excessive aestheticization of the world . . . and another tendency—inherent in the aesthetic and very much opposed to the "decreed abolition"—to dissolve its aesthetic character and gravitate toward reality with a view to changing it.[13]

This strategic self-dissolution of the aesthetic as a conscious antagonistic response to the "decreed abolition" of critical negation by the culture industry is the central term of Buchloh's thesis, and it is the essence of what he wishes to preserve from conceptualism. The act of the self-dissolution of the aesthetic, still instinctive in conceptualism, becomes conscious and deliberate in Buchloh. For him, if this dissolution were not deliberate, it would be nothing more than an instance of the operation of the "decree." But this supremely conscious act of negation is of course not original to Buchloh; it is Adorno's. For all its trappings of the productivist "redesigning of reality," this act is centered on the gesture of consciously willed abnegation, self-cancellation, and defeatism which Adorno concluded was the essential condition of art in a situation of advancing barbarism.[14] Although Buchloh appears to be struggling against defeatism in evoking productivist activism, his critique in fact has the

effect of extending and making conscious conceptualism's instinctive fusion of activism and defeatism. In the reigning ideological conditions of the supremacy of the Pop counterrevolution, such a fusion can only result in placing the residues of activistic strategies at the service of an imperious defeatism, which uses activism as an outer form, shield, or mask.

Buchloh is the first to emphasize the difference in social and historical conditions between the productivist era and our own. He recognizes that his program of moving art out of its protective enclave exposes it ever more directly to ruin at the hands of those forces controlling the city. These forces have no need to pretend a traditional form of commitment to serious modern art, having long since not only decreed its abolition, but actually having carried it out in their structural changes to the public sphere.

Thus, it appears that the "turn toward reality" demanded by Buchloh implies a new defeat for art. This defeat, however, is consciously anticipated; that is, it is the familiar manoeuvre of the pyrrhic victory, of political-cultural martyrdom, of the "contestation" which, although it cannot actually lead to victory, further incriminates social and cultural authority and aggravates the mood of society. Buchloh attempts to transcend Adorno's defeatism by exaggerating its voluntarism. Thus, defeatism is given guerrilla characteristics reminiscent of the *groupuscules* of 1968. This voluntarism has a long history, that of anarchism, and its strategies of counter-spectacle, sacrifice, and terror have been articulated consistently from Bakunin to Guy Debord. The contradictions of Buchloh's functionalism are therefore those which have historically bound the exasperated and indignant intellectuals to the icon of "total revolution."

This indignation which denounces everything in the name of an absolute difference, an absolute transformation (which is despaired of), has its consistent corollary, its Sancho Panza, in the perspective of the absolutely untransformed. This is of course the outlook of social democracy and its toadying, incremental approach to structural change. In renewing an idea of "prosperity" and reform, neocapitalism also renewed the political role of the social democratic movement, upon which it depends for all the forms of class collaborationism necessary in the corporate state. Both the fantasy of "total revolution" and its doppelgänger, the fantasy of "total reform," stem from the acceptance of defeatism. Buchloh's critique binds these together as the political presupposition of authentic art, and his unswerving championship of the cause of Daniel Buren exemplifies this. What Buren adds to Kosuth is primarily an oratory made necessary not simply by the inflamed hopes of the students of 1968, but also by the feverish reorientation of the threatened institutions, to whose deep reform this artist has sincerely dedicated himself.

When a work by an artist like Buren ventures forth into the city, it does so as a purified and neutralized cipher, dragging with it a residue of simple exhibitability.

This exhibitionistic cipher is the finished version of Buchloh's design of the monad of critical negation.

André Breton wrote, "Revolt is just a spark in the wind, but it is the spark which seeks the powder."[15] Buchloh's functionalism appears to wish to rekindle this spark—the conscious monad of negativity, revolt, and exposure, which trembles toward the social force it sees itself as destined to ignite. But in the self-imposed blankness of its own character, the cipher erases the identity of those forces in the city which can transform society. The consequence of this erasure is that the impulse of negativity negates itself in the very gesture in which it appears before "the public." But the abstract concept of "the public" is also the product of the historical loss of memory embodied by the erasure. The inability of "the public" in many cases to recognize a Buren, for example, as a work of art is only the corollary of the inability—or the refusal—of the artist to recognize behind the mask of the instrumental concept of "the public" the forgotten revolutionary class.[16] Misrecognition combines with non-recognition, and silence reigns. It is as if the spark, in the act of turning toward the powder, puts itself out.

Buchloh's critiques do not speak of class. This absence casts doubt upon his apparent integration of the Marxian concepts of use value and exchange value, references to which adorn his essays.[17] His picture of society is indistinct and abstract, except where the unopposed advance of barbarism is described in passages explicitly indebted to Adorno. Like his mentor, Buchloh preserves Marx's political-economic concepts primarily for the "objective" and scientific aura they bring to the process of hypostatization of other concepts such as reification and fetishism, from which they have been politically separated. This is symptomatic of his entire approach. Since Buchloh directs all his considerable energies toward breaking through the division between art as critical cognition in the aesthetic mode and the movement to "change reality," we must recognize in his inability to speak of any force in society which could carry through this change, this defeat of capitalist barbarism, the heavy legacy of Frankfurt School pessimism. This pessimism induces Buchloh to take from the collapse of conceptualism primarily the defeatist strain, the aspect or symptom of historical amnesia or denial within conceptualism. Buchloh's aggrandization of this element, however, leads inexorably to the problem of historical memory, and thus the intention of his criticism is fulfilled, although not in the way he expects. The exposure of the amnesia within Buchloh's cultivated defeatism leads us back to the question of the silence of communism, emblematized by Walter Benjamin forty-five years ago. Thus, Buchloh's position appears as a further consequence of the same historical shocks of the 1930s, mediated through the effects of the political neutralization of modern art on American terms in the postwar period.

The New Left movement in the art world of the 1960s and 1970s inherited much of this outlook, could not overcome its contradictions, and collapsed beneath it.

Nevertheless, much of the artistic work identified with the movement reflects not simply the inadequacy of this theoretical and political heritage, but also the struggle against that inadequacy. Buchloh's demands reflect this struggle more acutely than those of any other critic. But, without breaking from their defeatist social perspective, there can be no resolution of the dichotomy in his position between the functionalist desire for actualization of critical negation and the ironic autocritique of existing estrangement, resulting in withdrawal.

Within the functionalism Buchloh imputes to his favorite artists, therefore, these energies can only express themselves in twisting back and forth under the sign of the defensive antibarbarism inherited from Adorno. As soon as this withdrawn, even gloomy, sternness is relaxed, the functionalist work is indeed ruined by reality, turning into a helpless, mute, decorative object, as we see in Buren, or a witty piece of contextual virtuosity, as with many of Asher's lesser works.

Although this functionalism wishes to rematerialize critical thought in real social life, it is unable to actually do so without opening the historical question of its own distance from the Marxism it uses as its emblems. Opening these questions also implies the development of a new form of critique of the works in which, during the 1970s, it saw the greatest possibilities.

Without in any way denigrating that work, it must be recognized that Buchloh's criterion of functionalism has given it a canonical status as *the* critical discourse to which all other art is submitted. The instability of the position of the works of Graham, Buren, and Asher derives from functionalist theory's inability to recognize and account for conflicting factors in that work. The presence of these strains or non-functional elements indicate that not only do the social limits here outlined leave their traces on the effectiveness of this work in "changing reality," and constituting a resolved critique of administrative cultural institutions, but that these limits or problems find reflection in the deep structure and meaning of the works themselves. This throws into doubt their rather serene canonical existence in Buchloh's texts; it raises questions about the "progressiveness" so insistently imputed to them; but it may also make them more interesting, complex, and productive than they have seemed in functionalist terms. This is, of course, because they have not completely dissolved their character as aesthetic objects, they have not resolved their position in society. This is strikingly evident in the work of Dan Graham.

NOTES

1. Benjamin H. D. Buchloh, "Context-Function-Use Value. Michael Asher's Re-Materialization of the Artwork," in *Michael Asher: Exhibitions in Europe, 1972–1977* (Eindhoven: Stedelijk Van Abbemuseum, 1980), p. 43.

2. Walter Benjamin, "The Work of Art in the Age of Mechanical Reproduction," in *Illuminations*, (London: Jonathan Cape, 1970), p. 244.

3. See Theodor W. Adorno, "Freudian Theory and the Pattern of Fascist Propaganda," in *The Essential Frankfurt School Reader*, ed. Andrew Arato and Eike Gebhardt (New York: Urizen Books, 1978), pp. 118–37.

4. Benjamin, "The Work of Art," p. 220.

5. Max Horkheimer and Adorno, *Dialectic of Enlightenment* (New York: The Seabury Press, 1972), p. xviii.

6. Ibid., p. 22.

7. Adorno, *Philosophy of Modern Music* (New York: The Seabury Press, 1980), p. 133.

8. Buchloh, "Context-Function-Use Value," pp. 40–41.

9. Ibid., p. 41.

10. Ibid., p. 40.

11. Ibid., p. 43.

12. Since 1974–75, under Warhol's leadership, the counterrevolution has taken possession of the field. Narcissistic performance art and the new types of painting are foremost among his legions. The battle is in part over the interpretation of the art of the 1960s and the fate of theoretical discourse in art. Warhol strategically writes books about the sixties (*POPism*), and develops a propaganda organ based explicitly upon the suppression of theoretical language (*Interview*). Warhol has been seen as both a "radical" and a "reactionary" artist. Both designations are inaccurate; Warhol is a counterrevolutionary artist.

13. Buchloh, "Context-Function-Use Value," p. 43.

14. "The potential participation of the collective subject actually becomes real inasmuch as the artist eliminates himself and his authorship. More correctly, inasmuch as the collective subject as a historical necessity becomes potentially real, the artist accelerates this process of development by negating his role and withdrawing his obsolete functions in dialectical gestures of anonymity." (In reference to Stanley Brouwn.) Buchloh, "Formalism and Historicity—Changing Concepts in American and European Art since 1945," in *Europe in the Seventies: Aspects of Recent Art* (Chicago: Art Institute of Chicago, 1977), p. 95.

15. André Breton, *Arcane 17* (Paris: Sagittaire, 1944), p. 155.

16. "It is thus hardly surprising—however much it may have upset naive souls—that those monuments of false generality [i.e., the later monumental works of Oldenburg, Judd, Flavin, Serra, etc.—] have become the target of anonymous blind aggression. On the other hand, if the more thoughtful works of recent 'public' sculpture, such as Michael Asher's, venture at all from the sanctuary of the museum into open reality, they seem to bear in mind the mistreatment suffered by the individual in reality and define themselves formally and materially in such a way as either not to attract anonymous fury and mistreatment or not to expose themselves at all in the first place (at the expense of not being perceived—either by 'experts' or by the public—as works of art, accepting total disregard for the time being). For example with his new work *Les Couleurs. Une sculpture* (1975–1977), consisting of flags flown from the rooftops of museums, department stores, exhibition palaces at fifteen locations in Paris, to be viewed through telescopes or with the naked eye from the roof of the new Museum of Modern Art—a work that could be neither defaced nor destroyed—Daniel Buren turned that mistaken monumentality over to what must be the only form commensurate with it—ironical reflection." Buchloh, "Context-Function-Use Value," p. 36.

17. For example, Buchloh's "Epilogue on the idea of use value" in his essay "Moments of History in the Work of Dan Graham," in *Dan Graham: Articles* (Eindhoven: Stedelijk Van Abbemuseum, 1978), p. 77.

Dan Graham's Kammerspiel

Dan Graham's unrealized, and possibly unrealizable project, *Alteration to a Suburban House* (1978), generates a hallucinatory, almost Expressionist image by means of a historical critique of Conceptual art. In this work, conceptualism is the discourse which fuses together three of the most resonant architectural tropes of this century (the glass skyscraper, the glass house, and the suburban tract house) into a monumental expression of apocalypse and historical tragedy.

In 1978, at a moment when the denunciation of Conceptual art began to be openly articulated by advocates of new subjective, narcissistic, and frankly commercial attitudes, Graham constructs a profoundly expressive work on the basis of conceptualism. At a moment when conceptualism's suppression of the expressive element in art, once seen as that movement's radical achievement, is decried as the source of its failure and collapse, Graham transforms Conceptual methods into their opposites, drawing unexpected conclusions from them. These conclusions, embodied in the *Alteration* project, suggest a new historical moment in regard to Conceptual art, the emergence of a new period in its interpretation, and in regard to its historical significance.

Graham, too, begins from the failure of conceptualism's critique of art. But his intention is not to celebrate that failure and to throw away the lessons of the radical art of the 1960s in a theatricalized revival of the myth of authenticity. Rather, he intends with the *Alteration* project to build a critical memorial to that failure. And, in the spirit of the movement he memorializes, he builds it as a countermonument.

In developing the *Alteration* project, Graham begins from a distressed recognition of conceptualism's failure to rebuild art from its core outward, which was its aim. He reflects upon the forces unleashed in art by that failure, and his artistic language as a whole emerges from his struggle within the crisis of radical modernism exemplified for his generation by Conceptual art. What is the content of this notion of crisis?

Conceptualism intensified and clarified attitudes developed by the pair of artistic movements which emerged from the decline of Abstract Expressionism in a culture industry setting. Both the Minimalist and the Pop artists based themselves on a repudiation of the extravagant inwardness of the 1940s generation. Both groups stressed the impingement of the division of labor upon the image of the unified and organic artistic process which Abstract Expressionism took over from its European

Written in 1982. First published as "Dan Graham's Kammerspiel (1982)," in *Dan Graham*, exh. cat. (Perth: Art Gallery of Western Australia, 1985), pp. 14–40. Later published in *Real Life* magazine (New York) nos. 14 (Summer 1985): 14–18 and 15 (Winter 1985/86): 20–40, and in Wall, *Dan Graham's Kammerspiel* (Toronto: Art Metropole, 1991), pp. 7–83. The Art Metropole edition incorporates editorial changes not approved by the author. See the note on "A Draft for 'Dan Graham's Kammerspiel,'" p. 11.

Dan Graham. *Alteration to a Suburban House.* 1978. Architectural models in painted wood, plastic, and other synthetic material, 24'⁹⁄₁₆ x 25³⁄₁₆ x 36⅝" (63 x 64 x 93 cm). Collection Daled, Brussels

sources. Both were "Constructivist" in this regard, and therefore implicitly reopened an artistic argument which characterized the early decades of this century. That argument developed around the form art would take as society was liberated from the rule of capitalism, which was then seen to be in its "death-agony." But the aspect of both Pop and Minimal art which most affected the younger artists who became "Conceptual" was precisely the inability of both types to free themselves from the social aloofness and emotional indifference characteristic of post-1945 American art, which was expressed above all in Greenbergian formalism, the institutional orthodoxy of the corporatized art business. Minimalism's suburbanite asceticism and the smirking ironies of Pop representationalism both took on the aura of serenity imposed from above, of cultural "normalization," characteristic of cold war and corporate culture in the eyes of the young artists inspired by the anti-Vietnam upheaval and May 1968. Conceptual art emerged from the disappointment and dissatisfaction with these art movements, a disappointment over the fact that the social forces and ideas which had been stirred and revived by the aggressively mechanistic and antiexpressive aspects of the new art did not extend into the kind of radically explosive and disruptive expression desired within the cultural New Left. In the eyes of the Conceptualists, the cultural shock effects of Minimal and Pop art had, by the late 1960s, given rise only to a new, more complex, and distressed version of the art-commodity. This guilt-ridden commodity could do no more than dramatize its own problematic and marginal character as a source of surplus value and as transcendent form.[1]

In this crisis-ridden process of self-dramatization, there is a reversion to an earlier, unresolved dilemma of European modernism. The problem of the artistic critique of social unfreedom, which is disappointed or frustrated by political disasters and which is thereby transformed into monumental emblems of social and spiritual

crisis rather than breaking through into symbolizing liberation, was one faced by all the great modern movements of the "heroic" period of revolutionary upheaval (1905–25). The somber history of Abstract Expressionism shows that this tragic emblematicism was enshrined as the highest and most sublime value in the "triumph of American painting." The liberating shock of the assault of Pop and Minimal art on the enclosures of earlier work was aggravated and turned in a more critical direction by the subsequent spectacle of the great Rauschenbergs, Judds, and Flavins taking their places in the museums alongside the Picabias, Lissitzkys, and Rothkos. The reawakening of critical historical thought in the art of the 1960s corrodes the legitimacy of the very works which most directly initiated the process. Conceptual art's central intent is of course to interrogate the basis of that legitimacy. The question was posed: what is the process in which the cultural crisis is not resolved socially, but transmuted into sublime fixation upon immobilized symbols and fetishes?

Once again—and here the Conceptualists resumed aspects of the Surrealist-Constructivist terms of critique—the styles of modern art are attacked because of the institutions for which they are seen to form a kind of essential facade. Conceptual art interrogates modern art as a complex of institutions which produce styles, types of object, and discourse, rather than questioning art in terms of works of art first and foremost, as the academies taught.

This interrogation is inconceivable outside the critical context in which conceptualism developed. The political upheavals of the 1960s provided a fissure through which ideas, traditions, and methods of critical thought—primarily Marxist—suppressed and discredited by anathema and terror during the period which witnessed the collapse of the liberationist ideals which animated European modernism and the rise of totalitarian regimes in the 1930s, could make a dramatic return to the cultural field.

In general, Conceptual art draws its themes, its strategies and its content from the politicized cultural critique identified broadly with the New Left. The assault on the institutions of art draws, on the one hand, upon the revival of Frankfurt School ideas of the encirclement and falsification of avant-garde culture and its traditional critical consciousness by the culture industry, and on the other, upon Situationist strategies of guerrilla activism, which found their most complete expression in the student revolts of 1968. Thus, in a sense, the historical character and the limitations of conceptualism stem from its intellectual and political location midway between the *Dialectic of Enlightenment* and *The Society of the Spectacle*; that is, between the acerbic defeatism of the Adorno-Horkheimer position, which sees art as a transcendent concretion and emblem of existing unfreedom, and the desperate anarchism of Debord's indignant cultural terrorism. The actual works of art which organize themselves most deliberately around this dynamic display, its dual tendencies: they simultaneously struggle toward political immediacy in the sense of New Left activism and the "productivist" desire for resolution of social conflict, for a break or leap, and at the

same time tend toward concretization of the cultural dilemma of the falsification and ruination of art by mimicking that ruination, by reflecting it in their own structure.[2]

The functionalistic and activistic aspect of radical conceptualism attempts to break the vicious circle of falsification in a dialectical inversion, one which has its direct precedents in the reductivism of much 1960s art. This reductivism, which emphasized the work of art's resemblance to nonart, is the direct precondition for the "dematerialization" of the work of art into critical language. This transformation from emblematics to a directly critical and discursive form of expression is the central achievement of conceptualism.

The critical language developed within conceptualism is constructed from the discourses of publicity, journalism, academicism, and architecture. Artists like Graham, Daniel Buren, Lawrence Weiner, or Joseph Kosuth understand architecture as the discourse of the siting of the effects of power generated by publicity, information, and bureaucracy in the city. While conforming to the idea of bringing forward critical or analytical language as the antipode to the isolated, auratic art object, these artists treat this language not as a theoretical object (thus formulating a treatise as a work of art, as did Art & Language), but rather in terms of its physicality, its modes of production and enforcement in the urban arena. In this way, conceptualism participated in the development of the New Left's critique of the interdependence of academicism and publicity, in making explicit in many works the insight that both the university system and the media monopolies, having been purged of socially critical ideas during the cold war period, had become primary support-systems for new art in the same process in which they were inscribed in a complex of bureaucratic structures of authority and knowledge whose essential cognitive structure—one could almost say their epistemology—is publicity. The best-appreciated of this art—Kosuth's, for example—presents a condensed image of the instrumentalized, "value-free" academic disciplines characteristic of the American-type universities (empiricist sociology, information theory, positivist language philosophy) in the form of 1960s high corporate or bureaucratic design.

Conceptualism's exhibition strategy self-consciously presents the museum-gallery system, the institutional complex whose architectural look was foregrounded by Minimalism, as the crucial arena of this new synthesis. This is inseparable from the strategy of appropriating existing media forms such as magazines, TV, and billboards. In all this, the kinship with Pop is evident. But, unlike Pop, conceptualism attempts to incriminate the art business as the mechanism through which a corporatization of aesthetic production and thought is being carried out. This is understood as a social and political crisis in art in which crucial elements of the critical traditions of modernism are being liquidated.

The strategies of Dan Graham, Daniel Buren, or Joseph Kosuth are, each in their own way, informed (through the issues raised by the institutionalization of

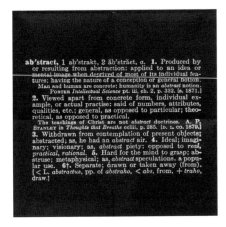

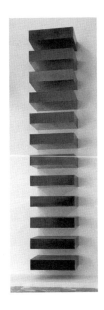

Joseph Kosuth. Untitled from *Four Titled Abstracts from S.M.S. no. 3, June 1968.* Offset print, one from a set of four, sheet: 19¹⁵⁄₁₆ x 19¹⁵⁄₁₆" (50.7 x 50.7 cm). The Museum of Modern Art, New York. Gift of Carol O. Stelle

Donald Judd. *Untitled* (Stack). 1967. Lacquer on galvanized iron, twelve units, each: 9 x 40 x 31" (22.8 x 101.6 x 78.7 cm). The Museum of Modern Art, New York. Helen Acheson Bequest (by exchange) and gift of Joseph Helman

Minimalism and Pop) by the combination of concepts drawn from the Frankfurt School tradition with related, historicist critiques of urbanism. This combination took the form of linked studies in the development of state and scientific institutions as mechanisms of social power and control, and research into the methods of siting these institutions within the modern city, or, more accurately, of the rebuilding of the modern city in terms of the strategic siting of these institutions. In Graham's case, these areas of thought are most directly identified with the writings of Barthes in the 1960s, and of Foucault and Tafuri through the 1970s. The influence of the Frankfurt School, but most particularly of Walter Benjamin, is evident in the connections these authors make between their specific objects of study and the psychosocial effects of these objects, in which mechanisms of power and domination are internalized by the atomized urban masses and involuntarily reproduced as profound estrangement.

These issues are expressed artistically in the rapid turn made by Conceptual artists toward techniques and procedures identified with the communications monopolies and state "information" agencies—the "new media" of 1960s art. Through the appropriation of these media in antagonism to those of traditional art, conceptualism attempts to break out of the institutional enclave of "Art" and intervene actively in the complex of social forces constituted by urban communication and representation systems. This intervention is constantly stimulated through critique of other art.

Minimal art is recognized as more than simply a new formalism because of the echo of Constructivism it retains, but it is at the same time criticized as no real negation of formalism. It is seen as a transitional form dominated by a Romantic and mystified concept of negativity. This negativity is preferred to the chronic affirmativeness of Pop, and so there is frustration and disappointment about the fact that the Minimalist "heroes" never make a decisive break from the positivism dominant

within American formalism.[3] Minimalism therefore appears to be no more than a "negativistic" version of formalism. As early as the end of the 1960s it had become clear that the Constructivist elements in Minimalism were only a feeble residue of socially aggressive aspects of the original movement, filtered through Bauhaus streamlining and American "systems" ideas. Minimalism, far from striving in the Constructivist spirit to break open its constricting architectural shell and assert itself as antithetical to constriction, endeavored above all to come to terms with its austere and elegant architectural containers, to glamorize them by means of a self-dramatizing acquiescence. The Minimal object, in this light, expresses above all the silencing of the Constructivist ideal, and the celebrated experiential shock provoked by a Robert Morris, for example, is historically speaking the shock of unfulfilled promises of freedom. The space held open by this absence of freedom is then occupied by the mute Minimal object, whose effect is precisely to demarcate the historical void which has brought it into existence. The problematic "objecthood" of Minimal art is an outcome of this.[4] This objecthood derives from another contradiction. Judd, for example, implied a social commentary by handing over the fabrication of his work to professionals. But at the same time, by means of his critical writings, he insulated the resulting object from the very same social discourse of meaning he invoked by directing attention to the effects of the division of labor. Thus, he posited the work as an irreducible, somewhat ineffable, very concrete "presence" (Morris's term). Minimalism's critics promptly recognized the resulting exhibitionism of the works as a symptom of their actual social reduction to the mystified state of a commodity soliciting fetishization. This "reductivism" was then criticized for its armored inwardness and indifference toward the social considerations which it incited and which actually sustained it as important art.

Nevertheless, reductivist tendencies formed a primary fascination in the 1960s because they resulted in the production of austere and mechanistic objects whose aggressive passivity and stylish indifference toward the spectator evoked feelings of alienation and dehumanization reminiscent of those experienced in everyday life. So the response of the Conceptualist critique was twofold and contradictory. On the one hand, it grasped the fact that the exhibitionistic "objecthood" of reductivist art accomplished only the reproduction of alienation and anxiety. It saw that anxiety was not really constituted as a subject of the work (which, because of its bonds with formalism, of course could not admit to having a "subject" at all), but was rather concocted as a theatrical effect to which the spectator was subjected, as he was subjected to publicity and commands in relation to objects in "normal" social life. On the other hand, it recognized this theatrical effect as having created at least an up-to-date physical art form which implied, however involuntarily and indifferently, concepts about the relationship between the experience of art and the experience of social domination. These concepts were rapidly turned against the art which helped stimulate them.

In this process, narcissism and fetishistic regression were identified with the theatricalized status of art objects in general. Conceptual art as "anti-object" is the result.

The gesture of elimination of the object had at its core the fantasy of the negation of the artwork as commodity. The recognition of the capitalist market as the foundation of all forms of domination in culture is, however, the insight which could be sustained in the conditions of enormous inflation which characterized the period beginning in the early 1970s. As speculative, inflation-driven capital enclosed and reorganized the art world, spectacularly driving up prices on a broad front, the anti-objects of conceptualism were "absorbed" and "negated" (to use the Marcusian terms of the period) as critical intervention by the aura of value which speculation imposed upon them. Conceptual art's feeble response to the clash of its political fantasies with the real economic conditions of the art world marks out its historical limit as critique. Its political fantasy curbs itself at the boundary of political economy. The struggle to transcend the commodity-form within capitalism is ideal and, at best, carries some value as a utopian vision. But there is a negative aspect of this avant-garde utopianism which must be accounted for. This is that the role of this fantasy of transcendence was that of an ideal which was not to be realized. In the atmosphere of rising social conflict which characterized the moment of the invention of conceptualism, the unrealizability of this fantasy could act as a utopian prod and challenge, a stimulus to further audacity. However, after about 1974, as the political tide began its shift away from challenge toward retrenchment and the rise of contrary cultural trends, the utopian ideal was transformed into its opposite, into disillusionment, and this transformation produced a collapse of great implosive force. The implosion of this ideal was thus the exact precondition for the new regime in the art world, the ironically self-conscious but nonetheless compulsive submission to marketing which is the central characteristic of the period from the mid-1970s to now.

It is therefore, paradoxically, the feeble or imploded utopianism of conceptualism which brings it close to Pop. In Conceptual art the accepted forms of institutionally purified social knowledge are packaged according to design and display codes for bureaucratically commoditized information. These codes are systematically appropriated as material in a strategy of mimicry. In this sense, conceptualism is the doppelgänger of Warhol-type "Popism" in its helplessly ironic mimicry of the mechanisms for control and falsification of information and social knowledge, whose despotic and seductive forms of display are copied to make art objects.

Neither Pop nor conceptualism can posit its social subject-matter in good faith. Unironic social content is considered to be a residual property of 1930s art, and "modernist" art in the American sense begins from the idea that the era is not only "over," dissolved by the advent of postwar neocapitalism, but moreover that it was nothing but an abysmal historical aberration produced by the clash of inherently totalitarian European political ideas—communism and fascism. In this perspective,

American-type "modernism" is the most crystalline cultural reflection of the idea of neocapitalism, with its proclamation of the transcendence of the era of capitalist crises through technocratic totalization and state-supported private monopolies, and its blissful anticipation of the "end of ideology." The social indifference of so much post-1945 American art, which is symptomatized in part at least by the aesthetic ideal of remoteness which recurs constantly in it, from Barnett Newman to, say, Jack Goldstein, is a reflex of the trauma of the collapse, around 1939, of the ideal of an integrated modernist art which could speak critically about the world.

Thus, if Pop is the amnesiac and cynical "social realism" of the new bureaucratic and monopolistic so-called "neocapitalist" order, Conceptual art is its melancholy Symbolism. In putting forward its forgotten card-files and printouts, its caskets of information, Conceptual art recapitulates a kind of Mallarméism: social subjects are presented as enigmatic hieroglyphs and given the authority of the crypt. This identification of publicity, bureaucracy, and academicism with cryptic utterances expresses an awareness of the participation of the bureaucracies and the universities in a corporate death-machine, an awareness which of course animated the student antiwar movement. The deadness of language which characterizes the work of Lawrence Weiner or On Kawara, for example, is exemplary and necessary. Its failure to express is its expression, and in this dialectic, Conceptual art becomes emblematic. Its emblematics rescue themselves, however, from complete capitulation to resignation by their antimonumentalism.

What is unique about Conceptual art is therefore its reinvention of defeatism, of the indifference always implicit in puristic or formalistic art. The gray volumes of conceptualism are filled with somber ciphers which express primarily the inexpressibility of socially critical thought in the form of art. They thus embody a terrible contradiction. These artists attempted to break out of the prison-house of the art business, its bureaucracy and its architecture, and to turn toward social life. But in the process of turning they reassumed the very emptiness they wished to put behind them. This is because they had been led by the protest movements to once again identify their own vanguardism with the moral necessity of political opposition, in imitation of earlier modernism. But at the same time they had not broken with the dominant neocapitalist perspective, which implied that this struggle was a historical anachronism, a moral exorcism meaningless outside a ritualistic sense of artistic heroism. Thus the radical Conceptualists were socially mortified by the reawakened moral implications of their own vanguardism. The emblematicism to which they capitulate is precisely the emblematics of mortification. The "mausoleum look" of much of the art they made is thus involuntarily expressive of its own self-conscious immobilization before the forms of power it is compelled to confront.

In bringing the tomblike aspect of Minimalist exhibitionism out from the "dead" gallery space into "life," on billboards, in newspapers, and so on, Conceptual

art carries out into the city only the mortified remains of social art which has been silenced by three decades of political "normalization." Its display of these remains can only be exhibitionistic, and this exhibitionism is the expression of its bad conscience. Exhibitionism and public distress are therefore the final indicators that this work is art at all in the serious sense of the past. Nothing in either its actual social content or its mimetic appearance can any longer really establish this. Rather, in its rueful immobilization before the mechanisms of falsification of language under the perspective of neocapitalism, it represents the terminus point of serious modern art.

However, in its very immobilization, Conceptual art does reflect the development, not directly of revolutionary ideas in society, but of the emergence of certain significant preconditions for the development of such ideas. The reemergence of critical social thought into currency in America in the later 1960s, after a long period of eclipse and suppression, indicates that a new stage in the social struggle as a whole was opening at that time. The period of the stabilization of imperialism behind the U.S. dollar, which began in 1944/45—the so-called "postwar era"—had reached its end with the dollar crises of the late 1960s and early 1970s. The current period of uncontrollable world financial destabilization and political conflict had begun. With the end of the era of stabilization based upon inflationary "credit" economic policies, there also ends the basis upon which all the ruling class's cultural strategies of control in the realm of ideas and representations could function. Essentially, the end of the period of paper-money prosperity and cooptation through various funding schemes dates from around 1970, although the effects of this basic transformation were generally sufficiently mediated that they could be ignored within the art world until recently. "Reaganomics" and the wholesale assault on all the social and cultural institutions which owe their existence to the postwar combination of New Deal corporatism and inflationary public spending on culture are making it clear that the cultural presuppositions of two or three generations of artists have entered a period of fundamental crisis.

Conceptual art's attempts at a new social art in the early 1970s must be seen in the context of these developments, which placed enormous obstacles in the way of the directions those artists wished to develop. Thus, the inadequacy of their artistic formulation of these issues is a profound and decisive one.

The failures of Conceptual art, measured against the possibilities the movement only glimpsed, are therefore, even as failures, the most incisive reflection of the gap which had opened in the historical and political memory of modernism after 1939.

Thus, the failed and unresolved aspect of conceptualism remains crucial. The movement appears today as, above all, incomplete. Its first response to the political upheaval begun in the 1960s was an appropriation of mechanical and commercial techniques in an assault upon "Art," and this constitutes the basis of both its radicalism and its potential faculty of historical memory. But insofar as it was unable to reinvent

social content through its socialization of technique, it necessarily fell prey to the very formalism and exhibitionism it began by exposing, though it managed in the process to drive that formalism to a new level of internal decomposition. Involuntarily, conceptualism had been encapsulated as a "radical purism." By the mid-1970s, this led to a fundamental split in the movement, a split which announced the collapse of the whole thing. Some artists, like Robert Barry or Douglas Huebler, now easily shed the final trappings of historicism and interventionism and moved into orthodox commodity production, albeit of a refined and mildly ironic type. Others, such as the *Fox* group, attempted to extend the political argument. Most of this work foundered in the sterile academicism which was the dregs of the New Left. This late "leftist" conceptualism was able only to produce negatively polemical, or "self-referential," indictments which reiterated the idea of their own unthinkability as works of art. Bureaucratic immobilization was absolutized in the dreariness of the movement's final phase.

This lackluster spectacle, however, brought conceptualism face to face with its essential nemesis, "Popism." By the mid-1970s, the economic and social ascendancy of Pop had legitimated Warhol's interpretation of ironic mimicry above all others, and led to the eruption of an aesthetic of compulsive and unreflective mimicry of all forms of culture, particularly the "successful" and "effective" ones, across the whole art market. As the conceptualist struggle for historical memory succumbed, the antithetical cultural forces which it wished to defeat burst forth with unprecedented vigor in the "postconceptual pluralism" of the late 1970s and the business-fetishism of the past four or five years. Everything is forgotten, everything is possible, everything is "great." But the issues at stake in Conceptual art's collapse make that movement perceptible as the crucial axis of transition between the distraught quietism of the New York School and an explosive revival of *both* revolutionary and counterrevolutionary ideas in art. This makes conceptualism representative of the end of New York–type art.

Its transcendence of the New York mythos is the source of its almost organic internationalism. By the very premises of its perspective of a bureaucratic world culture industry, it breaches definitively the authority of the old idea of national styles in art, to which all the other movements of the period ultimately reverted. The bureaucratic look of Conceptual art permitted it to free itself from dependence upon American corporate design insignia and production systems, which still identifies Pop and Minimal art so closely with the New York School look. Conceptualism makes explicit the Europe-America dialectic out of which all the critical theory of the period emerged. This dialectic is precisely the one through which Graham's work has developed.

The fact that his work has not been generally accepted as belonging to a New York–type canon is, in this light, less a blindness than a kind of determinate negative

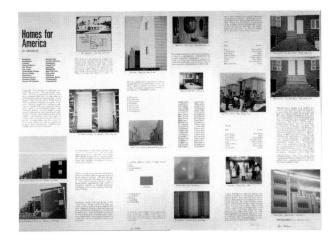

Dan Graham. *Homes for
America.* 1966. Layout
boards for an article for *Arts
Magazine* (New York),
December 1966/ January
1967. Printed text, handwrit-
ing, and black and white and
color photographs, 40⅞ x
30⅞" (102 x 77 cm).
Collection Daled, Brussels

recognition of its character. Since the mid-1960s, Graham's work has consisted of a critical interrogation of the discourses proposed by Pop and Minimal art, as they emerge in the critique of conceptualism.

By 1966, in his magazine article *Homes for America*, Graham had identified the central dialectic of Minimalism as existing between the reawakened movement to social discourse, in its direct implication of the architectural container, and its residual conformity to New York School pure abstraction. By ironically pointing out the "readymade" representational elements simultaneously evoked and repressed in the architectural parallels of Minimalist structures (in the popular form of a maga-zine photo-essay), Graham also identified the missing term in the Minimalist evoca-tion of Constructivism, the absent revolutionary teleology. The "gray humor" of *Homes for America*, with its mockeries of consumer choice in the suburban grid, returns to the Minimalist object the historical dilemma about which it is so ambiva-lent, that of the denied social roots of its own signification. Graham's semiotic and historically constructed exposure of the common architectural tropes within the Minimalist formal canon reveals the iron law that, in the relinquishment of the rev-olutionary social perspective which animated Constructivism's conflict with the meaning of the built environment, Minimalism's discourse must assume a double emptiness: that of the rigid mimetic eternity of the readymade and that of formal-ism.[5] This synthesis of the most rigorous sense of formalistic introversion of the art object with the idea of scandalous mechanistic proceduralism suggested by Marcel Duchamp had, of course, been established ten years before by Jasper Johns. "Neo-Dada" was one of the first terms used to designate Johns's work. The term was oblit-erated by the triumphal advance of "Pop art," but in it is preserved the element of Duchampian *kenosis*, the last-ditch artistic strategy of self-emptying, or ironic self-defeat. Pop art is based upon the gesture of the traditional artist's snuffing out of the vestiges of his historically specific distinction from other modes of production. Johns's works, in the decade of 1955–65 or so, retained a sense of sadness and fright about

this collapse of distinction, carried out on the rigidly occupied surfaces of his own paintings. Although extremely subdued and even repressed, the gloomy comfort of his surfaces retains an element of historical awareness to which Pop always displayed deep hostility. Pop art in fact marched triumphally over Johnsian melancholy, leaving the 1950s generation behind and drawing up a covert détente with the most institutionalized forms of insignia-making. In 1966 Graham redesigns Pop in the grim, gray style of "factography" in order to present an image of the miserable consequence of architectural thought in the postwar era, the barracks-like tract house. It is upon this structure that his thought consistently dwells over the years. In retrieving a sense of the social misery concealed across the abstract surfaces of the Pop-Minimal coalescence, Graham marks off the affirmativeness of both types of art. Minimalism is seen through *Homes for America* as a repressed social semiotics, one which is barred from accepting itself as such by its roots in idealist abstraction.

Homes for America is itself a form of Pop art, in that it mimics a certain kind of magazine article the way Lichtenstein copied comic strips. However, it establishes its particular form of mimesis as both Pop and antithetical to Pop. It does this partly by not being a traditional artwork. But, more importantly, this piece of "photojournalism" becomes the vehicle by means of which the social surfaces of American culture, brightened and celebrated by Pop, are reinvested with the gray, funereal, and somewhat distressing atmosphere of the Johnsian mid-1950s, the cold war era in which corporate emblems still retained vestiges of their then-recent function as war propaganda. The text of *Homes for America* discusses the development of tract housing after World War II. The insistent comparison of the new suburb to a barracks or prison is articulated in a language which combines journalistic concreteness with a sense of the deliriously labyrinthine. Graham's text is as Borgesian as are those of Robert Smithson, whose *Monuments of Passaic* is its closest parallel, and who played a part in having *Homes* commissioned as a "think-piece" for *Arts* magazine. Graham's intention with this work is to reveal the structural and historical isomorphism of Minimal and Pop art, and the consequences for both trends of the repression of historical memory he perceives in their methods. This repression is not directly linked with any particular attitude toward the political problems of urbanism since the 1920s, but the issue is evoked obliquely in the unveiling of the consequences of those problems both for architecture itself, and for both Pop and Minimalism, which appropriate material from the common or popular signifiers put in place by urbanism.

Thus, through a series of assumptions of roles or functions, *Homes for America* arrives at its position as unique within Conceptual art. Like much conceptualism, it attempts to breach the dominance of the established art forms and to articulate a critique of them. But unlike the more academic types of Conceptual art such as practiced by Art & Language, which could arrive only at a paradoxical state of establishing themselves as works of art negatively, by enunciating conditions for art which they

had no interest in actually fulfilling, Graham's photojournalistic format demands that his work have a separable, distinguishable subject-matter. Instead of making artistic gestures which were little more than rehearsals of first principles, as Kosuth or Art & Language were to do, Graham brings his analysis of the institutional status of art into being through the dynamism of a journalistic subject which is implicitly the inner truth of purer forms of art. This is, of course, the antithesis of the formalist abolition of subject matter. In a single gesture Graham establishes both the primacy of social subject-matter as the historically essential problem to be posed by conceptualism, and he identifies at the same time the single grand subject which will remain central to the development of the movement's historical self-consciousness: the city. *Homes for America* is the work in which Graham recognizes that the Conceptual critique indeed has an inherent subject, and the work in which he explicitly begins to investigate that subject, the historical development of the city as the site of cultural conflict. This investigation begins on the ground of conceptualism by posing anew the antithesis which was faced by the more revolutionary artists of the 1920s and '30s: that between the isolated and exalted "pure" work of art, the highest product of the distraught bourgeois self-consciousness, and the social machine as a whole which reproduces this distraught consciousness in the process of its own reproduction as city.

Homes for America is, however, of its time. It poses this historical contradiction not in terms of the explicit dynamism of Lissitzky or Tatlin. Although Graham manages to identify the historical consequences of the collapse of the hopes of the utopian artists and planners of the 1920s, he cannot rekindle them. He can go no further than making very specific the conditions resulting in the era when this hope appears to have been permanently eclipsed. Graham's reminiscence of the oppressive grayness of the 1950s sets off a further reminiscence of the history of earlier planning schemes whose liberating rhetoric has shrunken into the gratuitous structures of the suburban grid, the garden of subjection for a lost proletariat. For Graham in 1966, as for many other young artists, the key revelation of the city was in the shock of the absolute loss of hope. This loss of hope was as much a stimulant for critical memory as was indignation: the city of Antonioni provoked the memory of Giorgio de Chirico and André Breton as the city of Godard did the memory of John Heartfield or Meyerhold. Although his response to this shock shares neither Robert Smithson's black indignation nor his black humor, Graham appreciates both, and commits himself to the decipherment of this image of mechanistic domination. When Smithson leads the indignant Romantics into the desert, Graham remains in the city and the suburbs.

Homes for America is the finest of the group of magazine pieces of the late 1960s, all of which articulate the theme of the defeat of the ideals of rational, critical language by bureaucratic-commercial forms of communication and enforcement. The magazine pieces are structured as small, ironically insignificant defeats for liberationist ideas, as "defeatist interventions" in the mechanisms of ideological domination.

They are aimed at interrupting the flow of standardized, falsified representation and language, and inducing a "minicrisis" for the reader or viewer by means of the inversions they create. This strategy, carried out most insidiously and brilliantly in *Detumescence* (1966–69), parallels the creation of distancing effects in everyday environments by early Conceptualists like Weiner (particularly in his series of "removals"). This approach is reflected in the provocations and interventions characteristic of 1960s Situationism, in which an unexpected and confrontational gesture interrupts the established rhythm of relationships in a specific context, and induces a form of contestation, paradox, or crisis, thereby exposing the forms of authority and domination in the situation, which are normally imperceptible or veiled. The most notable artistic image of this approach is the unexpected "blank" or "cut" in the seamlessly designed social surface, and conceptualism's origins are filled with such blanks, erasures, tears, and cuts. These gestures interrupt the induced habits of the urban masses, and the interruption theoretically permits social repression, which is the veiled content of habit, to emerge in a kind of hallucination provoked by the work. This liberating hallucination is the objective of the work, and its claim to value. Such Situationist intervention is also related to Pop, but inversely, as is conceptualism; it aggravates Pop irony by means of *humour noir*, and attempts to elicit a recognition of the terroristic aspects of the normalized environment of images, things, spaces, and mechanisms.

Graham's magazine pieces fuse the Situationist-inspired strategy of the "cut" of *détournement*, or hallucinatory intervention, with that of the mimesis of bureaucratic forms of "factography." The interventions designed by him remain primarily concrete, functioning through the dynamics of specific subjects. Conceptualism, in relapsing into "radical formalism," also tended to empty the "cut" or intervention of its specific character, thereby absolutizing it as an extreme form of emblematic abstraction. Such interventions are reduced to decorativism, as in the case with many later works by Buren, for example.

Graham uses an actual text—an article, an advertisement, a chart—which constitutes its intervention through a structured difference with the norms of the genre in question. Thus, in these works, a specific social genre, existing functionally, is altered in a specific direction aimed at bringing out and making perceptible the underlying historical oppression.

Thus, *Homes for America*'s theme, the subjection of the romantic ideal of the harmonious garden suburb to the systems of "land development" is presented in the pseudo-readymade form of a "think-piece," or popular photo-essay. The photo-essay format is retained, mimetically, as the means by which the subject matter is altered and made perceptible in a negative sense. Graham's approach accepts the existing formalism of culture—its rigidified generic structure—as a first principle, and applies pseudo-readymade, pseudo-Pop, and authentically Situationist strategies to that formalism. The result is formalism intensified to the qualitative crisis point. The work makes its intervention in the context of the formalized emptiness of the existing genres, but does not create an antithetical emptiness, a purely abstract or emblematic intervention. In fusing the journalistic attitude which accepts the primacy of subject matter with the Situationist-Conceptualist strategy of interventionism and *détournement*, the work establishes a discourse in which its subject matter, a critique of Minimalism and Pop via a discussion of the architectural disaster upon which they both depend, can be enlarged to the point of a historical critique of the reigning American cultural development.

This approach becomes explicitly identified with architectural theory and discourse by 1973–74 via a series of video performance works, in which mechanisms of surveillance play a central role. The performance works, and the environmental "functional behavioral models," use window, mirror, and video control systems to construct dramas of spectatorship and surveillance in the abstracted containers of gallery architecture. But, following his existing ideas about the relation of the work of art to the implicit semiotics of its built environment, its institutionally designed container, the emphasis shifts throughout the 1970s from an experimental concentration on enactment or behavior ("performance") to work upon the actual institutional settings of these "dramas." Graham's work undergoes new influences, particularly from Daniel Buren, Michael Asher, and Gordon Matta-Clark, with the effect that architecture emerges as the determining or decisive art form, because it most completely reflects institutional structure and influences behavior through its definition of positionality.

The notion of intervention becomes that of "alteration" in taking on an explicitly architectural rhetoric, and, ironically, allies itself with Pop-inspired "postmodern" architectural practices in which renovations or alterations of existing structures become glamorous manifestos, as in the early work of Michael Graves, Frank O. Gehry, and Robert Venturi. Graham's fascination with the work of these architects, as well as with that of Aldo Rossi, in the later 1970s reflects the stimulus received not simply

from any "discovery" of architecture (which in any case dates from ten years earlier), but rather from a recognition that the semiotic and historical approach to the built environment which was central to his notion of Conceptual art had in fact entered directly into broad architectural practice at least partially through the influence of Pop. The emergence of this architectural activity to prominence represents at once for Graham both an indirect confirmation of his earlier insights about the conditions for critical cognition of the symbolic meanings built into the environment, and a new stimulus: to build.

The increasing public acceptance of an architectural attitude which depends strongly on ironic or anti-ironic notions of symbolization, as do those of Venturi or Rossi, for example, provides a new context for interventionist art, one which differs significantly from the "environmental" and "earth" art of the late 1960s and early 1970s. Those works operated in terms of the tension which existed between the purified and stylized institutional spaces reserved for art and the activistic desire for direct intervention in or direct reflection of social life. The romantic extremism of the earthworks of Michael Heizer, Walter de Maria, and Robert Smithson expressed deep dissatisfaction with the authorized artistic environments. Their solution was a new, expanded, and aggravated form of flight into the wilderness, a desperate and often unreflective reprise of the American frontier myth, mingled with psychedelic fantasies. This yearning for flight did, however, reflect the truth that environmental or monumental works undertaken within the city were doomed to absorption in culture industry terms. Urban sculpture projects instantly become new corporate monuments, as Smithson observed right away. During the 1970s, as sculpture unraveled its alternatives of romantic banishment from the city or ironic self-dissolution into mimetic, often near-invisible forms, some aspects of the Pop position unexpectedly provided possibilities. These involved, as did the work of Asher and Buren, an ironic mimesis of existing popular forms, such as signage, or architectural detail, but since Pop was not centered in sculpture (with the notable exception of Claes Oldenburg, who, however, inflected it more in the direction of a witty remonumentalization of the domestic object seen as erotic symbol), its mimetic energy could not extend directly into the built environment. The most significant achievements in this direction within Pop are Andy Warhol's completely designed museum shows during the 1970s, in which the stylized art-institutional spaces are restylized according to various kitsch models. The decisive influence of Pop—that is, that aspect of Pop which could provide a term capable of synthesis with the strategies of intervention developed by Situationist-conceptualism—did not emerge directly from Pop artworks. Rather, the ironic, mimetic, and distancing aspects which made Pop a significant factor in the development of the Conceptualist critique ten years earlier were for Graham mediated by their reflection in popular architectural practice. It was therefore in terms of Pop's delayed reflection in architecture that its "conceptual" aspects reemerged.

Dan Graham. *Housing
Development, rear view,
Bayonne, New Jersey*
(detail). 1966. From
Homes for America.
See p. 41

Graham, who had of course been photographing architecture from his anti-Pop, Minimalist viewpoint for many years, recognized in the mediation of Pop by architectural practice the term in which conceptual interventionism could be concretized. His work in the mid-1970s moves through a rapid and complex development which crystallizes in what B. H. D. Buchloh, in referring to Michael Asher, has called the "rematerialization" of the Conceptualist movement toward art practice as critical negation of the effects of culture-industry institutions.[6] Popular "post-Pop," "postmodernist" architecture provides Graham with a "readymade" terminology through which his critical ideas, previously "dematerialized" as performance, text, and photography, could move toward actual construction, or concretion, conceived in terms of the negativity implicit in the Conceptual critique.

Moreover, the rematerialization specific to Graham also has the consequence of permitting him to maintain his distance from the extreme contextualism of Asher and Buren, in many ways his closest colleagues in this period. Their work remains more bound to the museum (which tends to symbolize all architecture) insofar as they do not integrate their contextual self-consciousness with an existing architectural discourse which includes the expression of problems other than those commonly identified with art institutions.[7] Thus, while Asher and Buren tend to export the stylizations of the museum-gallery complex into various social spaces (subway billboards, banners, etc.) by virtue of the residual reductivist emblematicism of the inner space of their works, Graham reverts in a sense to the earlier approach which he and Smithson outlined in articles like "The Monuments of Passaic" and *Homes for America*. There, rather than developing a direct antithesis between museum space and the administered space of the public sphere in general, they indicated that that administered social space had within it, as its conditions of construction and organization, the precise problematic aspects which provided the artistic critique with its content. This of course implied art as an image or emblem of those problematics. Graham maintains the notion of combining a direct, almost journalistic image of the

Dan Graham. *New York
Office Building.* 1978. Black
and white photograph of a
photograph, 11 x 14" (27.9 x
35.6 cm). Art Gallery of
Ontario, Toronto

essential contradictions of the actual social environment with interventionist approaches, refusing to reduce his work to contextualist meditation on the "museum effect." The works of the mid-1970s, which combine window, mirror, video, and, increasingly, actual social sites (glass office buildings, shopping arcades, tract houses), elaborate the linguistic structures through which his in principle buildable and, more recently, actually built works develop. The *Alteration to a Suburban House* is developed in the midst of this series, and presides as the single most complex and suggestive work over a group of exemplary ones.

The *Alteration to a Suburban House* is constructed around a mirror axis, and, like a mirror, can be perceived in terms of that which is reflected in it, specifically, the other architectural forms whose symbolic effects and interconnections form its subject matter. The glass skyscraper and the glass house, both central expressions of the most exalted visions of modern architecture, and the suburban tract house, the genre of robot-architecture which provides the actual body upon which Graham operates, must be examined in terms of the symbolism which binds them together, and which the mirroric optics of the *Alteration* project make visible.

In his published text describing the project, Graham writes:

> The entire facade of a typical suburban house has been removed and replaced
> by a full sheet of transparent glass. Midway back and parallel to the front
> glass facade, a mirror divides the house into two areas. The front section is
> revealed to the public, while the rear, private section is not disclosed. The
> mirror as it faces the glass facade and the street, reflects not only the house's
> interior, but the street and the environment outside the house. The reflected
> images of the facades of the two houses opposite the cut-away "fill in" the
> missing facade.[8]

Later in the description, he compares his structure's effect with a "show window display," an "enlarged picture window," and a "metaphoric billboard." All these references remain fragmentary in the absence of their mediating term: the "full

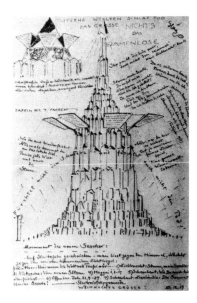

Bruno Taut. Glass tower. 1919. Drawing in a letter to the Gläsernekette. The Itzehoe Hablik-Archiv, Wenzel Hablik Museum—Stiftung Wenzel-Hablik-Museum, Itzehoe

sheet of transparent glass" is, conceptually, the glass curtain wall characteristic of International Style corporate towers. The essential first act of alteration to the physical body of the tract house is that its front wall is replaced with a glass wall characteristic of the ubiquitous office building and, through that, of the dramatic glass house. Historically, the glass wall—pioneered, centrally, by Mies van der Rohe—was not developed in relation to domestic architecture, but rather in large industrial and business structures. Mies essays the form constantly in his series of mostly luxury homes in the 1930s, and these plans and built houses gain their effect of radical modernity from the novel effects the ingression of vast expanses of glass has on the notion of "privacy."

The glass curtain wall, inherent in steel frame construction, is from the outset an intensely symbolic element, partly because it expresses in a new way a central liberal ideal: that of the visible society, open to the witness of the rational and alert citizen, a society without cabals and conspiracies characteristic of aristocratic and religious obscurantism. Furthermore, this ideal of clarity, openness, cleanliness, and visibility is explicitly the product of technological progress. The economy and lightness achieved by the building methods involved, expressed as spiritual values in Mies's famous slogans "almost nothing" and "less is more," contain also an ideal of near-mystical transfiguration which originates in the Expressionist reworking of Romantic themes of the crystalline and the alchemical. These entered the symbolic complex of the glass building during the period of its Expressionist origins around 1915. During the years of revolutionary upheaval, particularly in Berlin, the glass tower as symbol of wisdom, and of wisdom's retrieval of a fallen world, fused with the ideal of engineering and socialism to produce the image of the glass *Stadtkrone*, the minaret or spire of crystal around which the new city would harmoniously organize

itself. The revolutionary-Expressionist fantasies of Feininger, Taut, and Gropius expressed the hopes of the era which were to be symbolized by the crystalline tower of enormous proportions.[9] The liberal ideal of openness and the quasi-religious Expressionist tendency toward mystical monumentalism were held in an unstable equilibrium during the period of revolutionary upheaval. However, once the idea of a total German revolution collapsed in 1923, this coalescence began to unravel, revealing a newer symbolism which operates through the inversion of aspects of both of its major formative components. The terrifying, Gothic aspects of Expressionist monumentalism come to the fore in fantasies of technologized tyranny such as Fritz Lang's *Metropolis* (1927) at the same time that the relentless instrumentalism valorized in the New Objectivity movement indicated that a liberal state based on technology and bureaucracy led not to pacification of the environment and to freedom, but to the inscription of all citizens in vast abstract control mechanisms which in turn produced their own, abstract, impersonal, and technological forms of monumentalism.

By the 1940s, the period of the American Bauhaus and the American Mies van der Rohe, these Weimar culture images were both more streamlined and less perceptible in architecture itself, as Bauhaus and related ideals became more and more remote from their origins in revolutionary renewal and redesign and were inscribed within a sophisticated corporate system which, while liberal democratic in its rhetoric, had integrated all the massive systems of bureaucratic control and technological expedience identified with totalitarianism in the 1930s. In this context, the glass tower, as it comes to symbolize the new American neocapitalist city, exudes a sense of historical disillusionment, and by the time it is implicated in the critiques of the 1960s, it has become symbolic of the inversion of values suffered by the "modern movement." The notion of openness and transfiguration has been changed through the implosion of revolutionary ideals into an architectural emblem of lost or falsified openness, of an openness which contains the specifically modern form of oppression, one which appears to have no secret or hidden core forbidden to sight in the ancient sense of holiness and law, but which is nevertheless paradoxically invisible in that it seems to flow logically and automatically from the rationality of technique and organization itself, and not from the will of any self-conscious authority. This combination of disorienting, mirroric invisibility with a monumentalism which is rigid, systematic, and empty of satisfying symbols of power and authority makes the glass tower a disturbing phenomenon, one which becomes positively frightening at the point at which it is realized that its symbolic system has triumphed over the ponderous monumentalism of earlier, European-style totalitarianism. This implies that a new historical phase of oppression, more complex, sophisticated, and more deeply embedded in the habitual and the unconscious, has matured within capitalism. This system announces itself in these neutral and functional, systematic feats of precision design and engineering. They tend to signify the historical fact of the redefinition of

Ludwig Mies van der
Rohe. Court House,
Chicago Federal Center.
1964. View of facade

the ideal of rationality, the historically complete enclosure of the possibilities once hoped for from rationality as concretized in planning, by the institutions which they glamorize. This effect, of total enclosure of the realm of rationality by a monument to historical emptiness, indicates that the symbolization processes generated by these buildings are irrational in a new way, that they express the emergence of a new stage of social irrationality previously only latent in historical development.

The aesthetic effect of the glass tower is rooted in the precision of the welded and riveted steel grid, which permits an unprecedented expression of height, of vertical concentration, with minimal expression of weight and mass. Mass is further dissolved by the glass wall's play with daylight. By night, the building adds to this the dazzling effect of a mass of artificial lighting, turning itself into an ethereal and luminous diagram. These fantasy-inducing effects are exerted upon the building's users and spectators, and are based on the intensely unified spatial sense of almost Platonic regularity of the structure from street level to top.

This sense of regularity induced by the foregrounding of the unadorned structural grid permits a change in the way the passerby on the street imagines the space inside. Earlier tall buildings, including the great Deco skyscrapers, articulated their verticality with traditional architectural detail in order to mitigate the sheer effect of verticality, to harmonize it with the size of the other, smaller buildings surrounding it and, through the proportions of the street-level windows and ornamentation, with the scale of the human body in the street. Attention is both directed upward, inducing awe and fascination with the heights, and contained below the first floor architraves, thus simultaneously retaining a sense of familiar street scale. The fantasizing gaze directed upward, toward the sites always identified with power, is thus mediated constantly with architectural transitions, which exemplify the measured, conventionalized, and "natural" character of social distances symbolized by the top of the tall building.

The speed and intensity of the gaze which fantasizes about the building's heights is thus somewhat restrained, and the building's appearance provides a harmonious image of stages, both reasoned and habitual, for the shock of the enormous separation of the commanding heights and the common ground of the street. The skyscraper retains a "civilized" character even as it subjects society to unprecedented stress.

The "civilized" character of earlier skyscrapers is emphasized by the shock effects created by the glass grid, which eliminates all these ornamental harmonics and gallantries and, in doing so, introduces into the experience of architecture a new, less constrained form of fantasizing about power. By virtue of the grid, whose structure can be understood at a glance, the gaze of the man in the street can now ascend the building without the slightest delay. The building appears unmysterious, a simple quantity of regularly engineered space, at the upper reaches of which the privileged urban zone par excellence, the "executive level," is felt to be located. Transitions between social levels in the corporate or institutional structure housed by the build-ing are eliminated, but convention insists that the upper levels are the site of direc-torship, leadership, and power, because these are the implications of the commanding view of the city available at that height. With the removal of all intermediary factors in the uniform grid, the spectator's imagination moves instantly and at the same time in a matter-of-fact way up the system, to search out the site of command. Thus the space between the spectator and the perspectival vanishing point of his imagination is demystified in being easily calculable. But the same elimination of transitional indicators in the plan creates a new and more restless form of mystery or fascination, because the evenness of the grid forces the gaze to search without focus or repose. No single point can be located at which the fantasy about power which this architecture induces is brought to rest and satisfied. There is no pinnacle, no special opening, no privileged or ornamented point on the grid. In addition, the fantasizing eye is caught on the glass surface, whose reflectivity throws it in all directions depending on the light. The building, in the process of becoming perfectly rational in a functional, technical sense, obliterates the known or conventional indicators of the authority which it has come to symbolize. It becomes a monumental trap for the wondering gaze of the spectator, and in this process, reestablishes the architectural discourse of authority in terms of pure vision, of the dramatics of gazing. The spectator's atten-tion is drawn irresistibly upward to the enormous windows high above the street, and these windows, whose fabulousness is only augmented by the knowledge that they are just the same as those lower down, become the heart of the glass eye which is the building.

These windows subject the city and, implicitly, all of society, even all of life, to their inspection. Society, in the person of the man in the street, senses that the open-ness apparently symbolized by the glass tower is actually a mirroric effect. Rather than opening itself to the vision of the social body, it both throws that vision back

upon itself, and augments that symmetrical mirroring with its own asymmetrical inspection, a surveillance which cannot be observed. The city becomes an object of surveillance for the building, and this specular relationship expresses what the city knows of its real social relationship with the building: the building rules the city.

In the upper registers of the tower are the executive suites which, inverting an old urbanistic schema, become also the most prestigious and coveted living spaces. Before elevators, the poorer one was, the higher above the street one lived. The new technology, which in many ways was attendant upon the elevator, turns this framework upside down, and so luxury dwellings high above the ground become common symbols of success, authority, and modernity. In these dwellings, and the offices out of which they have evolved, the entire urban grid is revealed to the majestic gaze of the occupant, a gaze which cannot be returned symmetrically by anyone. The occupant can easily imagine the transcendent social invisibility which envelops him in the act of gazing at the city. At this point the occupant experiences the unique thrill of being theoretically invisible. This elevation to theoretical invisibility is the source of an exaltation whose content is in part the sheer intoxication of power in a power-hungry society, and is in part constituted by a wave of displaced energy: that of the man in the street who, in looking wonderingly upward, recognizes his own subjection to surveillance, and sees himself as only conditionally invisible, that is, as constrained within the regime of "privacy."

That the exaltation of the one is a condition of the constraint and subjection of the other is a commonplace, but it reflects a social truth, and thereby binds the glass tower to its opposite pole, the architectural form in which the form of subjection called "privacy" is symbolized: the unitary private home, which for the mass of men in the street has become the engineered tract house. Just as exaltation and subjection are bound together on a metaphoric axis of vision, the architectural mechanisms of exaltation and subjection generate each other on a corresponding social axis, which determines the shape of the city.

The exaltation of occupancy of the glass tower is not simply the effect of the monumental vision provided by height. It also emerges from the inversion of the relations of private and business life for the bourgeois occupant. The bourgeois class, in its ascent, more and more distinguished home, or living space, from work space, establishing in this process precisely the reified idea of unproductive "privacy" which tract housing imposes upon the proletariat and lower middle class. This separation was brought to its purest expression in the luxury garden suburb which, before the profusion of automobiles and the restructuring of cities in terms of that profusion, was the realization of the harmonious separation of business from private life. With the decline of the romantic garden suburb through freeway and tract housing development, the bourgeois ideal relocates simultaneously further out into the countryside, and inward, back to the cities, and up into the towers. In this return movement, the conventionalized

separation between home and office is breached. What Walter Benjamin called the "phantasmagorias of the interior,"[10] in which the reality principle which reigned in the office was suppressed in favor of fetishistic fantasies of private pleasure and contemplation, are reconstituted in a new and even more hallucinatory way when the office space is reoccupied and redesigned as a home. Home life in the glass tower now makes incessant subliminal reference to the fantasies of power which the office, with its performance principle, serves to support. As in Baudelaire's poem *The Double Room*, the luxury apartment, in its specific retention of the function of phantasmagoria, must exaggerate its effects to succeed in suppressing the image of the office, which the architectural shell incessantly evokes. As the two spaces become isomorphic, the process of phantasmagoria, which is the outcome of the suppression of the one by the other, is driven to an extreme state. The dwelling attempts a cancellation of the implications of the architecture, primarily by means of decor. This is impossible, since the decor is arrayed in contrast to the overwhelming glass surface, and the optics of power it suggests. Decor becomes detached from hominess and reverts to the status of commodity. The dwelling becomes *unheimlich* (unhomelike), uncanny.[11]

This uncanniness is however also a result of the effect of height. At the same time that the occupant feels exaltation, he also feels the effect of the grid. Social euphoria does not cancel the operation of conventional significations, but emerges out of a peculiar combination of them. Living within the grid system carries the implication of being enmeshed in an impersonal, automatic schema. Just as the occupant's scopophiliac exaltation draws energy from the subjection of those below, which is its external antithesis, it also draws upon an internal antithesis, which is as intellectually accessible to him as the building's system is to the man in the street. The occupant's euphoria derives from a sense of being directly enclosed, supported, and positioned by great social power. The dance of light materials, the elegance of engineering and calculation, generates a moment of bliss in which the disturbing effect of the grid is cancelled. The occupant's bliss, however, is as restless as the wonder of the man in the street for, even in the moment of its cancellation, the grid reasserts itself by transforming the signification of height. We are familiar with the vertiginous effects of heights, particularly of heights which are experienced symbolically as hubris. The glass tower embodies the hubris of business under monopoly capitalism, in which the ascent to the heights is recognized as the outcome of impersonal market relations in which the individual's qualities play an insignificant part. Living high up in the grid expresses anxiety about entrapment in an automatic system, and this anxiety is the inner reflex of euphoria. Euphoria or exaltation is therefore experienced all the more intensely in that it includes anxiety and struggles to suppress it. The exaggerated asymmetry of the occupant's gaze, which is the product of height, in turn reacts destructively on the sense of domesticity. The sense of the domestic, of private, family life, has been constructed in antithesis to that of work and public existence.

Metaphorically, the "private" is established in the urban system characterized by the glass tower in terms of its relation to those institutional forces and systems which protect it, in the abstract form of civil rights. In this era, the domestic and the private are those spaces which are intensely subjected to inspection and surveillance by ruling institutions, but which are protected to a certain extent from that surveillance by laws. Accessibility and subjection to surveillance, and the simultaneous legal protection from it, is "privacy." High up in the tower, the mechanisms of surveillance do not operate, or operate only weakly. The privileged space itself becomes the mechanism for surveillance of the city as a whole. This is in fact the foundation of its privileged state. The absence of surveillance produces an absence of privacy, and induces in the occupant, who has become a near-invisible eye, a contradictory sense of neglect, abandonment, loneliness, even damnation.

This nameless anxiety, this uncanniness, reflects the significance of heights as separation from the life of others, and from nature. Thus, the Romantic and Expressionist aspects of the glass tower, entwined in its origins, persist in an apparently post-Romantic and post-Expressionist period. They survive, however, in an inverted form. Where the utopians of the period of revolutionary optimism, figures like Scheerbart and the young Gropius, saw the glass building as a symbol of lucidity and transcendence through lucid technique, the post-World War II masters of the "pure" tower, primarily Mies van der Rohe and Philip Johnson, recognized it as a perfected mechanism which expresses with cold irony and detachment what the city has in fact become: a bad view.

Graham's explicit reference to Mies and to Johnson in the text of the *Alteration* project implies a historical interpretation of Mies's architecture which corresponds on a broader level with the implications of the fantasies his pure towers generate. Mies's glass buildings provoke a profound sense of historical sadness and negativity in the perfection of their aloofness from the environment they dominate. The subjection of the street and of the crowd of men and women in the street to the power embodied by the institutions the building glamorizes is the inner content of this aloofness, which is made necessary by the stresses of the actual social process of domination. The buildings' impassivity has a negative effect in that it magnifies the conditions of isolation and domination which have in fact brought it about. It can be argued that Mies, who experienced the revolutionary upheavals in Central Europe and even participated in them to a certain extent, recognized that later American architecture's conditions of existence were in fact the consequences of the delay, disintegration, and apparent annihilation of the revolutionary utopia which permitted architecture in the 1920s to dream of universal harmony through social planning. Even if Mies is characterized as personally anti-utopian—and his earliest glass building projects of 1920 already have a feeling of tyrannical glamour—this does not invalidate the possibility that his architecture attains a painful consciousness of the hopelessness of

the existing urban schemes in the monopolistically controlled cities. This consciousness is consistent with the psychic inwardness of the glass towers, their profoundly withdrawn character, their masterful transfiguration of the industrial materials identified with openness and visibility into the opposite effect, a contradictory withdrawal behind symbols of accessibility.

Mies's response to the historical catastrophe of the 1920 to 1950 period is to renounce the implicit utopian critique of the city contained within modernism, and to relinquish the city to its caesars, the speculators, bureaucrats, and real estate developers. His gesture of withdrawal is deliberate and his architecture, in its perfected emptiness, expresses his submission to the modern forms of power which have apparently vanquished all opposition and rule over a chaotic, estranged mass. His buildings reflect the atomization suffered by that mass at the hands of the institutions the building symbolizes. In their perfection of technique and proportion, these buildings relinquish the modernist utopia in an act of silent, stoic purity, and come to exist, as has been said, "by means of their own death."[12]

This self-consciously tragic negativism, which is a component part of the historical dialectic of modernism, has complex consequences. While it is the authentic expression of a certain type of modern artist and does contain a kind of final, hushed protest against the increase in unfreedom in society, its resignation—and its fetishizing of the ordered silence and emptiness of its own interior—make it the natural prey of just that caesarism to which it is in the process of capitulating. The puristic resignation and the spectacularized expertise of Miesian building becomes of course the prototype for the post-1945 corporate skyscraper style, and thereby provides the linguistic means, the formal and structural language, for the aggressive exploitation, in a "popular" and "positive" sense, of the same social values which this exalted architecture seems to negate in the act of prostrating itself before them.

Mies's architecture, in invoking through its purity the consciousness of its own vanquishment, maintains thereby a faint echo of the unfulfilled hopes of the period of optimism. It therefore remains significant as a negative symbol and, if it is looked at historically, takes on, however weakly, some characteristics of the antimonument. The socially critical content of this symbolization is, however, made available in inverted form. It provides useful concepts about atomization and anxiety, domination and indifference, first of all to the metropolitan caesars who own it and manipulate it in their own interest. Miesian architecture, in holding out this social knowledge in a passive, tragic gesture, relinquishes it to the enemies of architecture without a struggle. The sublime and tragic character of this gesture is the center of the claims of this architecture to transcendent meaning in a state of negativity. Its great historical role is to have placed into the hands of its executioners the concepts and methods it thought it had developed for ends other than its own suffocation. Graham's invocation of Mies, along with Johnson, is rooted in this sense of the suffocated character

Ludwig Mies van der Rohe.
Farnsworth House, Plano, Ill.
1945

Philip Johnson. Glass House,
New Canaan, Conn. 1949

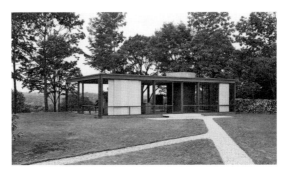

of architecture in the framework of the historical problematic which the artist, as a member of the American avant-garde, is trying to remember and comprehend.

Writing about Mies's houses of the 1930s, Tafuri and Dal Co argue:

> Nature was made part of the furnishings, a spectacle to be enjoyed only on condition that it be kept impalpably remote. The interpenetration between indoors and outdoors was treated as illusory: with no trouble at all, nature could be replaced by a photomontage . . . and become an object of contemplation. The natural relationship with the surroundings is a mystification to be replaced by an artificial construction, while nature is forced to become mere optical illusion with a value in no way superior to that of a painting. The glassed walls of Mies become the glass over a picture, a way of separating the viewer from the object viewed. . . . The rules of sight were given a scansion by the hieratic signs of the interiors, within which one moved about on preset routes, a visitor in one's own home, to whose eyes were presented various mute and intangible objects and panoramas.[13]

Graham refers specifically in his *Alteration* text to the glass houses built by Mies and Johnson in the late 1940s. The masters of the pure spectacular towers are also the architects who attempt to recuperate the domesticity which has been annihilated in their glass towers by means of the transit of glass technology to the suburban or rural setting. These pavilion-like structures are apparently committed to the opening up of the private interior space of the house to nature, light, and vista in a recapitulation

of the idea of the belvedere, the structure giving a beautiful view, the view which the city can no longer provide. The glass house seems to be a distinctly romantic gesture expressing the desire for closeness to nature and for absorbed contemplation of it. But this opening up is effected through the imposition of the glass wall, signifier of metropolitan euphoria and loneliness, between the two elements comprising the bourgeois domestic ideal—the closed homelike interior and the contained naturalness of the garden. The glass house produces an "excessive openness" through the implications it carries of the vertiginous asymmetry identified with modern metropolitan experiences of power. This excessive openness is the reflex of the excessive inwardness which is the state of mind corresponding to the new phantasmagorias of the glass interior, to the fetishization of the self's positionality within an anonymous and "perfect" system. Within this system, the self's sense of self is reduced to nothing more than its positionality on a set of axes.

In the glass houses, the idealized or fantasized intimacy of man with nature, one of the original dreams of the bourgeoisie, is rearticulated in the estranged language of surveillance and positionality. "Openness" is created by the function of the glass wall, and so all the implications of the anxieties of the asymmetrically unobserved occupant generated across that symbolic surface intervene in the conventionalized Rousseauian illusionism characteristic of the country "place," a place of rest, renewal, and withdrawal from business and the compulsion to perform. Withdrawal and relaxation become tense and compulsive. In the glass house, communion with nature and retreat into privacy cannot be realized except through the deliberate act of subjecting nature and privacy (now manipulated as images or calculable conceptualizations) to the mechanics of surveillance and domination. A new "power-protected openness," rooted in a psychic requirement for surveillance of nature and the reinvention of the theoretical invisibility provided by the glass tower in the face, or eye, of nature—a domination of surveillance itself—is generated by these buildings on their sites, the gardened woods which are the historically canonized image of the common humanity of the ruling class.

There are no mirrors in any of the open spaces of either glass house. Mirrors are restricted to their purely "functional" use in the closed "private cores" which contain the bathrooms in both designs.[14] Symptomatically, the mirror is a disruptive element in these schemes, which are otherwise totally given over to mechanisms of opticality. These mechanisms are condensed into the glass skin. The huge window-walls create a play of reflection and transmission of light according to the character of the daylight. Shifts in the direction, quality, and intensity of daylight create moments of the gaze's play with itself, which is the elemental fantasy induced by the house. The house creates strict conditions for this play.

During the day the interior of the house is relatively dim compared to the outdoor brightness. From outside, the tremendous reflectivity of the glass wall can screen

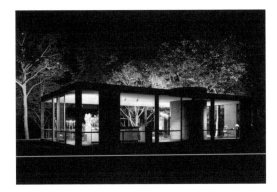

Philip Johnson. Glass
House, New Canaan,
Conn. 1949

the dimmer interior from view behind a mirror image of the surrounding landscape. Depending on the angle of vision, this effect is combined with one of backlighting— the view through the house to the landscape on the far side—which gives the interior a stage-set character.

From within, in daytime, the landscape is intensely introjected while remaining immured behind the glass, which may reflect the occupant somewhat. Any artificial augmentation of the interior lighting intensifies the mirroric capabilities of the inner surface, and may produce an image of the occupant superimposed in the landscape. Artificial lighting takes on a specifically theatrical connotation in that it immediately produces a self-image on the interior surface and, in doing so, interrupts the state of theoretical invisibility enjoyed by the occupant.

In the glass house, this condition is superimposed upon a controlled image of nature, the "good view" which the glass tower cannot provide. Artificial lighting, which produces mirror images, and which is anyway reminiscent of theatricality and the "unnaturalness" of urban existence, is therefore essentially in conflict with the state of euphoria produced by theoretical invisibility in these nonurban conditions. Faced with the spectacle of nature, theoretical invisibility appears to give up its authoritarian asymmetry, and therefore its anxiety, and to blend into an absorptive state of blissful contemplation. Mirror images of the occupant remind him of the mechanisms by which absorptive bliss is constructed. They interrupt the phantasmagoria of the interior by breaching the suppression of mechanism, calculation, all that is identified with "the office," the suppression which permits euphoria to occur. Within the house, therefore, the occupant engages in a complex game with nature and with the day itself. The dynamic of this game involves the natural uncertainty, given by the weather, about the chances for absorption in the natural spectacle free from mirroric interruptions. The house, then, effects control of nature, of the natural flow of time and light, and as long as its control remains uninterrupted, euphoric absorption can occur, and the anxiety inherent in theoretical invisibility can remain suppressed.

At night, conditions are drastically altered. First of all, the landscape disappears in blackness. Even the floodlighting used by Johnson does not mitigate the profound

disappearance of the natural spectacle upon which the occupant depends for the process of suppressing anxiety. The interior artificial lighting necessary at night transforms the interior surfaces of the glass walls into gigantic mirrors. These may be veiled with curtains. But drawing the curtains is itself an expression of anxiety, which is as greatly magnified in its significance as are all other gestures made in this house. Curtaining the windows expresses a repudiation of the closeness to nature which is the specific fantasy of the house, and which is of course the rationale for its siting. The glass houses are located on private wooded estates, insulated from the eyes of neighbors or passersby by distance, verdure, and law. Privacy is instituted at the boundary line of the property, not at the surface of the window. At night, when nature withdraws, leaving only blackness and absence behind, it becomes an eye in its invisibility and its emptiness. From the house, the blackness of nature's absence is of course seen through glass. This combination of slight shocks—that of the disappearance of the natural spectacle, the mirrorization of the interior, and the resulting reversal of asymmetry—gives rise to a return of anxiety in the familiar form of fear of the dark. Like all emotions incited by the glass house, this fear is exaggerated and intensified in that it is self-induced. The glass house plays with the night as it plays with day. But at night the compulsive nature of its play becomes more evident.

In its nocturnal play with the nothingness of nature's withdrawal, with the *néant* which petrified Mallarmé, the house invokes a state of terror. In the glass tower, the nocturnal terror is the terror of the caesars; in the glass house, it has a more elegant and miniaturized form. The princely character of this terror is reflected in its deliberate, strategic invocation, which automatically requires strategies to keep it at bay.

The glass house, understood as a symbolic system, solicits this state of terror in order to complete itself as symbol. Its Romanticism and its rootedness in structures of power and anxiety impel it to dominate the entire natural cycle.

The regime of theoretical invisibility and blissful absorption are, in the daytime, the outcome of the excessive openness of the house to the natural spectacle it dominates as property. This excessive, or "power-protected," openness is in turn the result of the magnification of the generic identity of the house as princely pavilion, belvedere, and retreat—in short, of its generic links with the residues of aristocratic life which, in the Romantic era, were rewoven into rococo tapestry of the ideal bourgeois existence. The rococo setting of the little house in a private park is itself the purest expression of the mandarinesque fantasy at the center of the bourgeois ideal of elegance in the face of nature. But if daylight is the mechanism which sustains this particular symbolism, then in the absence of daylight, at night, another symbolism is necessarily invoked, a symbolism closely allied with that of the isolated pavilion and the disembodied, theoretical being who occupies it. So it follows, as night follows day, that the equally Romantic, and equally cryptic, fantasy of vampirism must constitute the regulation of the house's game with itself in the hours of darkness.

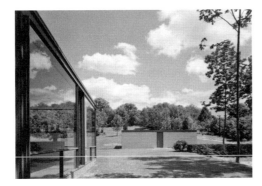

Philip Johnson. Guest
House, New Canaan, Conn.
1949

Philip Johnson. Glass
House, New Canaan, Conn.
1949. View with pond

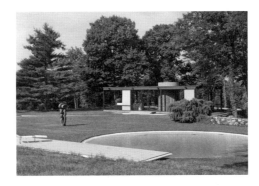

At night, the lonely pavilion becomes the abandoned crypt of Gothic tales, and the theoretical invisibility of the occupant, his aversion for reflections, indicates his affinity with the vampire, one of the supreme theoretical beings created by the troubled bourgeois imagination.

The vampire is neither alive nor dead, but exists in an accursed state of irremediable tension and anxiety. Although his symbolic identity is complex and goes beyond its function in this analysis, he embodies a certain sense of cosmic grief which is a diffracted image of a concrete historical uneasiness. The most relevant aspect of his symbolism for our purposes is that, from the point of view of liberal Romanticism, the vampire signifies not simply the unwillingness of the old regime to die, but the fear that the new order has unwittingly inherited something corrupted and evil from the old, and is in the process of unconsciously engineering itself around an evil center. The presence of the phantasm of the vampire in the modern, liberal consciousness signifies the presence of an unresolved crisis in the creation of the modern era itself. Thus the vampiric symbolism persists as a codified form of expression of unease regarding the inner structure of the modern social order and the psyche corresponding to it, particularly its commitment to calculation and rationality. The role of vampiric symbolism in the expression of uneasiness about the effects of calculation brings it always very close to the symbolism of the robot, the spellbound automaton, which the victims of the vampire's curse often resemble. The vampiric symbolism is a disturbance in the historical process of construction of theoretical beings—abstract

citizens—through technique, planning, contracts, and "value-free" calculation. The crisis of the mirror is the crisis of the self-consciousness of such beings. Vampirism is thus the "inner speech" of that being—the ruler, the caesar, the prince—whose theoretical invisibility is constructed as the great task of tragic modern architecture, the undead art.

By day, the vampire sleeps in his crypt and temporarily cedes the world to the living and to nature. By day, the glass house creates the phantasmagoria of blissful absorption into nature. But, just as the memory or fear of the vampire afflicts the daily activities of his potential victims, the symbolic system of the house has afflicted the possibilities of unity with nature. Behind the glass walls, nature, as picture, has already somewhat withdrawn from man. It is property and, if property had memory, it would be afflicted by it.

The mirroric state remains in partial abeyance by day. It takes effect primarily on the external surface of the glass and so is visible only to people outside the house, to passersby. But, symbolically, there are no passersby. There may be guests, in that the house plays the part of a rococo pavilion. But if there are guests, they imitate the prince who is their host. Guests create a rococo comedy in which the prince plays all the parts. But, essentially, guests have a strictly subordinate role to play in this fantasy of abandonment. In Johnson's scheme, they are immured in an almost windowless guesthouse.

In the absence of observers outside the house, only the eye of nature itself is subjected to the reflections emitted by the glass walls. And nature's withdrawal behind glass from the viewpoint of the occupant is complemented by its own withdrawal from itself, into reflection. The eye of nature is trapped and immobilized by reflection, it is blinded to a certain extent by the consequences of its own energy, light, which is turned into a means of domination over it. Asymmetry is affirmed in the double immobilization of nature, which is carried out complementarily on each surface of the glass. Anxiety is suppressed, and the serene fantasy of selfless absorption plays itself out, as domination blissfully loses sight of itself in its own effects.

By night, the occupant descends into a coolly contained state of terror; that is, into a state of anxious arousal deriving from the reversal of the optical axes. Nature, having withdrawn, its eye now invisible, appears nowhere on the glass where it had earlier appeared everywhere. Absorption is cancelled by the departure of its object, and what remains is only the mechanism of anxiety-suppression itself, which now becomes an object of contemplation. Artificial light is introduced, transforming the entire interior into a mirror. The occupant now sees himself reflected in every surface, and may even see reflections of reflections, depending on the intensity of the lighting.

At night, the vampire awakes. But the glass house is a trap for him, for at every glance he is traumatized by reflections, which reveal his impossibility, the travesty of life he signifies—but also, his deep abandonment and loneliness. Like nature during the day, the vampire at night is immobilized by the mechanism of the house. A par-

Philip Johnson in the Glass
House. 1949

allel appears, then, between the spectacle of nature withdrawn into a state of being
property and the spectacle of the vampire trapped inside a mirrored crypt. The mech-
anism of the house is the trap which vampirism springs upon itself. This self-induced
vampiric trauma, this onanistic paroxysm of the vampiric symbology, in which the
asymmetry of theoretical invisibility is apparently reversed into an "excessive visibil-
ity," forms the climax of the fantastic, *Igitur*-like drama of occupancy invented by
the house. The spectacle of the self-conscious revelation of the vampiric essence of the
state of mastery implied by theoretical invisibility is a Romantic climax: an image of
liberating trauma. In the trauma of self-revelation, the occupant, the vampiric eye,
fantasizes its own liberation from the anxiety of abandonment. The vampiric eye is
voluptuously crushed by the hallucinatory "truth" produced by the mirror, which shat-
ters the travesty of naturalness which was that eye's illusion of bliss and selflessness.
Trauma and bliss are fused together in a vain masochistic tableau of transfixed vam-
pirism in the extended moment of the hallucinatory return of asymmetry to its source.

In this extended moment of excessive visibility, the power of absorptive gazing, of
inspection, is transferred to the invisible eye of nature. Nature abruptly takes on vam-
piric powers, since it is now unreflected, indeed, cannot be reflected in the glass. Nature,
which is at night actually invisible, is thus endowed with an inverted vampiric intelli-
gence, a tragic memory of the alienation inflicted upon it. The immobility of the vam-
piric trauma is complemented with a new mobility of nature. The vampiric text often
includes an episode of the assault on the crypt or castle by the terrified peasants or vil-
lagers whom the vampire has driven to frenzy with his attacks. These villagers are the
fantastic incarnation, in the vampiric system, of Nature afflicted with something of
the intelligence of vampirism. They are the symbolic, but in that sense also the historic
"other" of the vampiric trauma, and when they attack the crypt they embody simulta-
neously an inspired revolutionary daring, but at the same time a frenzied, compulsive
violence which seems more like vampirism the more ferociously it attacks it.

In the specific system of the glass house, this assault is dramatized by drawing
the curtains. Drawing the curtains ends the bliss of onanistic trauma, and it reconsti-
tutes "privacy" in the most conventional sense. This assumption of privacy is a disaster,

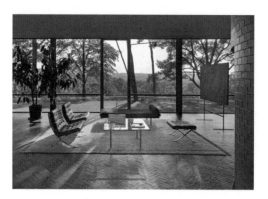

Philip Johnson. Glass
House, New Canaan,
Conn. 1949

it is the admission of defeat, because the real curtain for the house is the boundary
line of the property on which it is located. Drawing the curtains is a last-ditch ploy
when the spectacle of vampiric trauma becomes overwhelming, but it in fact provides
no relief. This is because it exposes a lack of confidence in the security of the bound-
ary line; it is a gesture which indicates panic, panic that the boundary has been
crossed by the "other," that property relations have been breached, and that the game
of domination and submission has been breached by an uncontrollable force, the mob.
Drawing the curtains is the historical defeatism of the ruling class. With the curtains
drawn, the house shrinks to the status of a private home whose social dominance is
unwarranted and unenforced. It waits to be swept away by history.

Thus, in the night, the house's game resolves itself into two forms of sleepless-
ness, two forms of waiting for the end. The first, which is arrogant and princely, is
that of the extended moment of vampiric trauma incited by mirroric glass, the parox-
ysm of absolute recognition of emptiness which is unbearable and which, in its per-
sistence and its symmetry, suggests Thanatos. The second form, which appears
subdued and modest, which pulls closed the curtains on its own hysteria and appar-
ently renounces the pleasures of asymmetry in a defeatist performance, is no less a
hysterical anticipation of death.

But, as in all games, the gloom and the terror are part of the effect, and the end
is nothing but the pretext for forgetting and beginning again. In the midst of this
play of self-inflicted terror, there is a soothing force. This force is also, paradoxically,
represented by the mirroric glass. In the daytime, a glimpse of the occupant's own
reflection is enough to interrupt the fantasy of absorption by reminding him of
mechanics, and therefore of the hidden isomorphism of the glass wall with the busi-
ness space—the "office"—which he is trying to forget in order to play at being close
to nature, and to life. At the climax of the mirroric trauma, this isomorphism is again
evoked, but the increased intensity of the situation provides a force capable of "chang-
ing the signs" on this evocation. What was a disturbance or an annoyance in the day-
time becomes a reassurance in the middle of the night. The linkage to the office, to
the real site of power, which was forgotten, first in absorption and later in terror, is

now remembered. It is summoned up by the extremity of the terrifying situation, like a hidden talisman. This remembrance is ecstatic and produces a new, intensified phantasmagoria of the interior, this time rooted in celebration of the "presence" of the office in the cellular structure of house. For the real social power which is remembered permits the restoration of confidence in the security of the boundary line, in the existing property relations. Restoration, as always, comes with a vengeance. New confidence in the property line creates a militant and faithful vampirism which, triumphing over the terror which it incessantly incites in itself, now blissfully faces the dawn and the end of the game.

Hence, the dramatic game of occupancy is that in which the subjective form of social mastery, created by the existing relations of property, is tested by subjecting itself to the terror it carries within itself, in order that it may recognize, in the moment of crisis, its absolutely valid form. In this ecstatic reaffirmation of things as they are, of power as it is, without any ideal, with only the hysterical mechanics of its endless game of power, the architectural project of the glass house reveals in pure form its historical fate: to live by virtue of its own death.

Graham's *Alteration* opens the perspective which interprets certain works of architecture as an expression of the nihilistic fantasies of the oppressor class. The work functions as radical conceptualism in terms of the intervention or "cut" it makes in the illusory seamlessness of social reality, which permits the repressed or veiled historical corruptions to flow forward into consciousness. But this flow takes place in the channels cut by the work.

The alteration is comprised of two operations. First, it fuses the glass wall symbol with the tract house, and secondly, it transforms the interior of the latter by means of the mirror.

The first operation can also be thought of as the resiting of the glass wall symbol, transferring it from the exclusive isolation of the wooded estate to the suburban grid. This resiting establishes the final interlinkage of architectural significations evoked by the work. Tract house, glass house, and glass tower are now united in a symbolic dialectic which articulates the condition of the urbanistic idea in this period of history from the viewpoint of the tradition formed in conceptualism.

The tract house signifies the historical form to which the ideal of harmony between city and nature has shrunken in the era of "post-totalitarian" corporate capitalism. It emblematizes the inversion of the ideal of rational social planning which was the outcome of the decline of the revolutionary wave after 1923. The tract house is the "new hut" which the monopolist system places on the grids of real estate which surround the urban cores. The planning of these grids is itself only the ghost of the ideal of planning, since all decisions are based upon the sustained extraction of surplus value and the maintenance of unimpeded surveillance and population control. The new hut is the outcome of a sequence of design decisions aimed at the consolidation

of an atomized state of "privacy" for the masses. The housing tracts are the inversions which the unresolved historical crisis of imperialism has imposed on the idea of the "garden suburb" and the "city beautiful." In place of the earlier planners' fundamentally social-democratic notion of a rhythmic articulation of the nature-house-community relationship, the postwar suburban system consists of a thoroughly reconstituted "natural" ambience decoratively ornamenting a rigid repetition of housing units established in terms of maximum value as real estate.

Nevertheless, certain aspects of social-democratic, New Deal imagery are permitted to carry over into the new system. The "garden suburb" is championed by both New Deal bureaucrats and philanthropic capitalists as a revivifying, tonic environment for fatigued workers whose problems, if left without amelioration in their private lives, might make them susceptible to social agitation. The "village" imagery preferred by early company-town builders and by reformist city-planners in the period between the wars is not discarded in the designing of the new suburb. The "regressive utopia" of small-town imagery, insistently promulgated by the mass media in general, forms the acquiescent facade for the actual rationalization of mass housing in terms of profit and social control.

Along with village imagery comes the repetitive mythology of family life, with its ritual values including profound roots in its own soil. The symbolism of "family," "community," and "private life" is the ideological basis for the maintenance of a barracks system in which masses are bound to their sites by mortgages and forced to become the consumers of private transportation in cars on freeways paid for out of their taxes. The "village community," nicknamed a "bedroom suburb," replicates the estranged and homeless character of city life, but it does so under the sign of a pacified and cured estrangement.

If the glass tower symbolizes the rulers' nihilistic self-consciousness of absolute alienation and historical emptiness, and the glass house the reduction of all of nature to an element in the game which that emptied consciousness plays with itself, then the tract house symbolizes the desperate state of subjection suffered by those who, unlike the consciously undead, still yearn naively for "joy." In this light, the suburban grid is the historical trap into which the working class and parts of the middle class have been driven by their real desire for liberation. This desire has, under the specific historical conditions obtaining in the period in question, been encapsulated by imperialism and reprojected in terms of an ordered subjection to a code rooted in estrangement, terror, and loss of identity.

Graham's act of resiting makes an ordinary tract house function partially as a glass house. Figuratively, this means to impose the vampiric discourse of exhibitionism and alienation upon the site which has been constructed as the illusory haven from vampirism. The direct imposition of a domineering discourse upon the domineered aims at stripping away the veil of "joy" in a radical act of exposure. The sym-

bolic content of this act must be traced in the meaning of each of the operations Graham proposes to carry out on the body of the tract house.

First, the house front is replaced with the glass wall. Second, the mirror is brought out of the private core it occupied in the glass houses, and enlarged to the same size as the glass wall. It is then positioned midway between the glass wall and the rear wall of the house. Finally, as a result of the previous operation, the relation between "public" (that is, visible) and "private" (invisible) spaces is altered. Most significantly, the bedrooms, which were located in the open zone of both glass houses, are returned to the private core, now located behind the mirror. In Graham's plan, bedrooms are reidentified with bathrooms as spaces which are not to be viewed.

The most spectacular effect of the two major operations is an inversion of the mirroric function of the glass wall. In daytime, the presence of the enormous mirror, with its superior reflectivity, relatively close behind the glass wall, greatly weakens the glass's reflective strength. Since the mirror reflects more light than does the glass, its reflections constantly pierce the latter, tending to return it to a state of transparency. This return of glass to transparency, to greater symmetry, under the impact of a superior reflectivity, interrupts the witty play with reflections which characterizes the glass house. The state of wit, implicit in the rococo imagery of the princely pavilion, is in fact suspended altogether.

Wit is rooted in irony, in saying by the inverse. Wit is not simply a matter of a reversal of meaning or implication, although it employs reversals, but rather of a dizzying turning inside-out, a play with the whole crystalline signifying chain. Mirroric reflection, however, is prosaic and witless. It functions through a mechanical reversal, necessary for sight. Hence, its traditional signification as a bearer of undesired truth. It has this signification, for example, in Lacan's famous "mirror phase," in which the infant regards himself visually in the mirror as the integrated entity, which he cannot yet subjectively experience himself as in his numerous infantile dependencies and incapacities. The "undesired" aspect of the truth borne by the mirror is more directly revealed in the example of the mirror's untimely revelations of psychic or spiritual disintegration where the (adult) viewer wishes to see the confirmation of an ideal of wholeness, mastery, and composure. The vampiric implications of this are obvious. Thus, the mirror, being witless, cannot lie, cannot bear the witticisms necessary for the social masquerade so essential to the distraught consciousness, the "consciousness of absolute inversion,"[15] the alienated, vampiric consciousness of the rulers.

In the *Alteration* the regime of wit is interrupted, the ideal of the blissful phantasmagoria of absorption is shattered by the overbearing presence of a mute and relentless reflective mechanism. Against the witty play of the vampiric nature-fantasy, the mirror asserts a trauma of undesired revelation. Graham's aggrandizement of the mirror creates a disruptive theatricalization of the mechanism of phantasmagoric

absorption, an inflexible reign of mechanistic "truth." Under this specular "reign of terror," the sinuousness of distraught, witty gamesmanship is immobilized. Graham's project appears to mount a terror campaign against the terminal nihilism of bourgeois consciousness.

Under this regime, all theoretical invisibility has been usurped by the mirror itself in a *coup d'oeil*. From the viewpoint of Situationist-conceptualism, this coup would be the prelude to liberation, if not liberation itself: the empty core of oppressive bourgeois nihilism has been shattered by a cunning guerrilla operation using weapons provided by nihilism itself. Here, theoretically, we should have the concretization of the revolutionary fantasy of interventionism. But what, in fact, is the new symbolic state which surges forward from this coup?

The site of theoretical invisibility has been irremediably theatricalized in the act of wresting it from an abstractly living eye and identifying it directly with a mechanism, the mirror. All living eyes are thereby immobilized within the regime of theatricalized mechanism. There is no symbolic transferral of asymmetry, that is, of social power, from one group to another, no reversal of asymmetry, no revolutionary leap. The glass house always subjected the outside to the inside, nature to the prince, and the glass tower subjected the outside urban mass to the gaze of the caesar in the interior. Graham's structure cancels the asymmetry between the occupant inside and the passersby outside. The mirror, in replacing the glass as the means which assures asymmetry, thereby cancels the relationships between interior and exterior which characterized the glass buildings. The "public" part of the interior of the altered house collapses as a space distinguished from the exterior as the surface of asymmetry fades inward, from glass to mirror. The mirror reflects the facades of the houses opposite, the passersby located between those houses and the altered one, and the occupant in the altered one, all in a single consistent perspective, which is interrupted only slightly by the weak reflectivity of the glass wall.[16] The perspective established by the mirror, in overriding the reflectivity of the glass, indicates that the occupant is now on an equal footing with the passersby, who meanwhile have become much more important. They position themselves before the huge mirror out of fascination, and even approach it, crossing the boundary line of the property and coming close to the glass.[17] The villagers of the vampiric symbology approach the mirrored crypt. By daylight, they witness the absolute immobilization of the shattered vampiric consciousness which has migrated from its isolated retreat to its pathetic trap in the suburban grid. In the unified mirroric perspective they receive the shock of recognition: this migrated and shattered consciousness is an image of their own. The stripping away of the standard facade, the veil of privacy, from the tract house reveals the common immobilization of all in the ruptured vampiric scheme created by the imbalance between the almost helpless glass facade and the tyrannical mirror. The mirror, the new facade of a new interior, clasps within its optics occupant and passersby, and

explicitly identifies them with each other, just as it identifies itself with the other house fronts which it also reflects.

The passersby, who were excluded from the fantasy of absorption in the glass house, and whose exclusion was in fact a prerequisite for the functioning of the fantasy, suffer a hallucinatory return. In this return, they do not win the prize of asymmetry, they do not assume mastery in a mirroric reversal. Rather, they suffer identification with the extreme state of homeless disintegration played out in the failed interior. The passersby are compelled to experience the climactic trauma of self-revelation and self-cancellation at the core of the vampiric consciousness's game, but they cannot experience it from a dominating, or even simply independent, position. They are inscribed essentially into that climactic moment, and participate in it as captive, fixated eyes. The vampiric eye which is crushed, and the captive eye which can only witness are locked together in a new symmetry characteristic of the witlessness of the mirror, which traps on its surface both witness and that which witnesses itself being witnessed, and congeals them in a feverish moment of universal disintegration, a moment which is absolute and which overrides the flow of time. The mirroric reign of terror, which annuls the operation of the vampiric wit which permitted the game of the glass house to proceed, annuls thereby the transformation of terror and disintegration into their opposites— that is, it annuls the play with time. Now the climactic moment of terror becomes an endless emergency regime which, through the great reflective machine, appropriates all light, natural or artificial. The machine dominates day and night. Time is thus extended infinitely from a single moment of crisis, from a single *coup d'oeil.*

An evil tension radiates from this masochistic work. It permanently prolongs the traumatic moment of truth, forbidding it to pass into any subsequent moment. This symbolic stoppage of time is an image of historical apocalypse. The asymmetry of social mastery symbolized by the play of light on glass is crushed and a hallucinatory symmetry emerges, an apocalyptic symmetry which is an image of the common disintegration of all under the glare of an optical device which sees all and blinds all with its excess of sight. The altered mirroric house ends the vampiric game of the rulers, in which history itself is enslaved and played with, through a permanent instance of catastrophe which outlaws any further movement of history. Graham's intervention in the nihilistic play of the rulers results in an image of the final eruption of nihilism. Thus it is an image of the failed liberation of the world.

This failure, however, produces a single, problematic space. This is the *maison close* which is located behind the mirror, impenetrable to vision. The "private spaces" established by Graham are as absolutized in their implosion as the public ones are in their projective disintegration, the bedrooms and bathrooms are as excessively closed as the front half of the house is open. They produce an image of the blind body, stripped of light and visibility, the indicators, in this system, of *communitas.* But are these spaces not empty?

The tract house is by convention a family home, whereas the glass houses are not, both having been built for solitary occupants. The sex of the imaginary occupant has been presumed male throughout this analysis. And, in spite of the fact that Mies's glass house was originally built for a female, Dr. Edith Farnsworth, the symbolic system of the house implies from every angle a male eye, a princely, vampiric consciousness. It is this male who invokes and undergoes the historical trauma. But, in its migration, or pilgrimage, to the tract house, the disintegration-trauma becomes a family affair. The vampiric eye, prince if not king in its own castle, becomes *père de famille*, and, as head and "hero" of the household, he steps forward to struggle, shielding the rest of the family. The public, spectacular front of the house is his theater. The blind cave behind is the outcome of his form of shielding; it is what is given by the father's vampiric heroism. The father bequeaths the absolute burial chamber, the cave or lightless crypt.

It might be tempting to romanticize the total darkness of this cave as itself an image of a new state of absolutized instinctuality, an instinctuality of the blind body traumatically produced by the catastrophe of specular nihilism, by the apocalypse of the calculating intelligence of male *Meisterschaft*. This instinctuality, though blind and violated, might have memory, traumatic memory—"second sight"—and therefore could become the basis for a female principle of survival and even renewal. This implication would be particularly tempting because of the threads of theoretical, particularly Lacanian feminism which Graham has consistently woven into his work; these might be grasped as the support for such a supposition. But, given the apocalyptic nature of the project's abolition of history, the notion of a surviving principle in it, female or otherwise, is nothing but a deus ex machina. As such, however, it is able to glimpse a history beyond the machine of the house, beyond the house's closure of such a possibility.

This feminist daydream in the midst of a nightmare may prevail, if only because each image of the end of history is itself encapsulated by the historical development provoked by the image. Graham's ostensible symbolism seems to end at the "house of the dead," and as such is definitely related to Aldo Rossi's gloomy Modena Cemetery project of 1971–82. There, along with the skeletal, de Chirico-like house made only of vacant windows, we notice the enigmatic conical form which, when reappearing at the entrance of the elementary school in Fagnano Olona (1972–76), becomes a chimney. This linking of a chimney with a cemetery of course suggests a crematorium, that "final hearth" of the human body, and another symbol of European totalitarianism. The image of the hearth as the core of the home is of course played with in Rossi's schemes in order to express the notion of homelessness to which he is so attached. The possibility of a surviving feminine principle in Graham's house may be embedded in the role played by a hearth in the architectural symbols involved in the *Alteration* project. In a study of Philip Johnson's glass house, Kenneth Frampton writes:

Aldo Rossi. *Project for the New Cemetery of San Cataldo, Modena.* 1976. Drawing

Aldo Rossi. Elementary School, Fagnano Olona. 1972

Johnson's Glass House is ordered about a brick cylinder which pierces the roof slab in such a way as to emphasize the autonomous status of the roof plane. The surface of the podium, on the other hand, is treated as an earthwork, its woven brick herringbone fusing (through the identity of the material) with the brick cylinder of the bathroom/chimney core. This is the fulcrum of Johnson's metaphor of the incinerated house, to which he referred in 1950 when he wrote: "The cylinder, made of the same brick as the platform from which it springs, forming the main motif of the house, was not derived from Mies, but rather from a burnt-out wooden village I saw once where nothing was left but the foundations and chimneys of brick. Over the chimney I slipped a steel cage with a glass skin. The chimney forms the anchor."

These laconic words not only suggest that the Glass House was based on the vision of a ruin, but that the ruin in question was almost certainly the blitzkrieged remains of a village. It may well be, as Peter Eisenman has suggested, that the Glass House is Johnson's cryptic monument to the horrors of war; that here beneath the flowers of Xanadu lies embedded the petrified remains of a lost ideal and an elegy for the dead. Equally indebted to both Mies and Malevich the status of this house as a work of art derives from its capacity to synthesize many diverse sensibilities at once. It is equally rich

outside the affinities of any particular style, and as our perception passes from one subtle inflection to the next it is successively prism, loggia, earthwork, ruin and tent. And yet is not this sophisticated intersection of many strands a final closure of bourgeois utopianism, a definitively reductive modernity, a folding in of humanism upon itself, the state of solipsism raised to unparalleled elegance, the end of a trajectory rather than a beginning?[18]

So within the scheme of the glass house the image of the hearth appears and is, moreover, central to its meaning. The fact that Johnson's fireplace carries a vestigial, anamorphic mirror (as indicated in note 12) indicates that he refuses simply to hand over the imagery of the hearth to the female element, but rather confiscates it for vampirism. Graham's project explicitly locates the fireplace in the living room, which is of course in the front, specularized space. Where Johnson ironically retains traditional hearth-and-home imagery as a muted counterpoint to the vampiric game in "anchoring" his house with the chimney, Graham utterly overrides it, completely subordinating the hearth, as well as the kitchen, to the mirroric regime. Thus, any feminine principle of survival and renewal to emerge like a phoenix from Graham's project will likely be a homeless one.

Frampton's assessment of the meaning of Johnson's house contains a historical misjudgment in the characterization of that work as the end of a trajectory of bourgeois humanism. Graham's alteration is to historical perspective as much as anything else: he shows that the end of bourgeois humanism is bourgeois nihilism, and the end of bourgeois nihilism is the spectacular masochistic apocalypse which produces no elegiac expression. Graham's interventionism is aimed at the exposure of the vampiric nihilism hidden within high bourgeois art-culture. The success of this exposure in the *Alteration* project, in turn, reveals the historical conditionality of the Conceptualist strategy of intervention itself. Conceptualist interventionism regards its exposure of nihilism to be its social ideal. Graham, in the relentless bleakness of his exposure, shows that the whole process of exposure turns on its being defeated by that which is exposed. Thus, he shows that the Conceptualist strategy of intervention, carried out as art's own ideal, is pure defeatism, defeatism almost raised to a higher power by its self-consciousness. This implies the theoretical and political limits of the Conceptualist critique, which intervened in society solely in its own name. It did so out of its mortified condition as avant-gardism, because it could not bring to the surface of its own conscious practice the repressed and forgotten name of the social force, the working class, whose revolutionary upheaval had animated and inspired the earlier avant-garde. The failure of conceptualism shows that art which challenges the existing order in its own name as art will find its inherent limit in absolute negativity, a negativity which is unfree in relation to the unfreedom which provokes it. Graham proves this in the abysmal outcome of his own intervention. This proof, which also

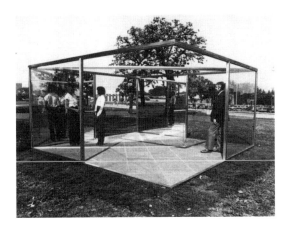

Dan Graham.
*Pavilion/Sculpture for
Argonne*. 1978–82.
Argonne National
Laboratory, Argonne, Ill.

proves the necessary bond between conceptualism and its subject matter, the problematic of urbanism, provides the perspective through which to recognize the *Alteration* project as an antimonumental memorial to conceptualism's limitations.

This work may indeed be unbuildable, but not for pragmatic reasons of patronage. It is unbuildable because its intervention in the oppressive architectural symbolgame is readable, and not esoteric. Glass symbolism is comprehended in every smashed window. Thus, Graham's work creates an utterly irresistible provocation in its vast expanses of glass whose pretensions to dominance are unwarranted and whose security is unenforced. The impossibility of this project is hinted at in the attacks on his smaller work, *Two Adjacent Pavilions* (1978–82), which was built in the park at Documenta 7 in Kassel in 1982. One cannot call the smashing of the glass walls of this work "vandalism" because such ruination is the precise complement to their own interventionism. It proves, if anything, that such interventionism has succeeded in escaping from esotericism and emerging into general comprehensibility. Glass is the material in which the Situationist-Conceptualist idea of the "cut" is most aptly expressed.

But the work, in the words of Lawrence Weiner, "need not be constructed." The *Alteration* project memorializes a past moment, the moment when art became a social critique in its own name, having failed to recognize any other, and thereby created itself defeatistically, as incapable of resolving the contradiction in whose name it constructed itself. "The work need not be constructed": this curious command, the order not to produce a monument, is precisely the order which Graham is finally able to obey. Thus, in a way he "completes" conceptualism in this intervention into its own image of itself. In this intervention, he makes visible its inherent defeatism. In totalizing defeatism, he possibly provides some terms for a negation of that defeatism. If this is true, his *Alteration* project would exist—in the mind only—as the first ruin in the building of a new Conceptual art.

1. In spite of his hostility to the Conceptualist idea of critique, the most lucid and suggestive discussion of the problematic of the "theatricality" of Minimalism remains Michael Fried's "Art and Objecthood," *Artforum* 5, no. 10 (Summer 1967): 12–23.

2. One of the central characteristics here is the imposition of bureaucratic, academic, or corporatist language forms into the domain of the experience of the work of art as both provocation and emblematics. Many examples can be taken from the work of Kosuth, Weiner, Bochner, Graham, Kawara, Darboven, and the various members of Art & Language, as well as from early works by Morris or LeWitt, for example.

3. Karl Beveridge and Ian Burn, "Don Judd," *The Fox* 2 (1975): 129–42.

4. In this light, its attempt to "defeat" or transcend the commodity form represents, perhaps, something more significant: a displacement or repression of a deeper artistic issue, that of the reinvention of social content in modernist art. Such a reinvention represents a material possibility, and therefore a new level of critical conflict within the cultural field and, for that matter, within the art market itself.

5. See "A Draft for 'Dan Graham's Kammerspiel,'" pp. 22–24 in the present volume, for an elaboration of the status of the readymade in Conceptualism.

6. Benjamin H. D. Buchloh, "Context-Function-Use Value, Michael Asher's Re-Materialization of the Artwork," in *Michael Asher: Exhibitions in Europe, 1972–77* (Eind-hoven: Stedelijk Van Abbemuseum, 1980).

7. Asher's remarkable *Installation at Münster* (1977), in which a small holiday trailer was parked at various sites throughout the city for the duration of an international sculpture exhibition, is closely related to Graham's position in that it reduces the more exclusive concentration on the museum or gallery evident in other works by Asher, and turns toward a specific complex of issues—a "subject"— deriving from the problematic of urbanism.

The resulting work is not reducible to the issue of the context of exhibition, although it includes it.

8. *Dan Graham: Buildings and Signs* (Chicago: The Renaissance Society at the University of Chicago, 1981), p. 35.

9. On the history of this iconographic development, see Rosemarie Haag Bletter, "The Interpretation of the Glass Dream: Expressionist Architecture and the History of the Crystal Metaphor," *Journal of the Society of Architectural Historians* XL, no. 1 (March 1981): 20–43.

10. Walter Benjamin, "Louis Phillippe or the Interior," from "Paris—the Capital of the Nineteenth Century," in *Charles Baudelaire: A Lyric Poet in the Era of High Capitalism* (London: New Left Books, 1973), p. 167.

11. Sigmund Freud, "The Uncanny" (1919), reprinted in *Studies in Parapsychology*, ed. Philip Rieff (New York: Collier Books, 1963).

12. Manfredo Tafuri, *Architecture and Utopia: Design and Capitalist Development* (Cambridge and London: The MIT Press, 1979), p. 148.

13. Tafuri and Francesco Dal Co, *Modern Architecture* (New York: Harry N. Abrams, 1979), p. 157.

14. Johnson's house contains, however, a reflective metal plate above the fireplace. The curvature of the chimney section makes this into a kind of anamorphic mirror. There is a relationship between the conditions of specularity established in the symbolic system of the house, and this anamorphosis, which is illuminated by Lacan's notion of the "phallic ghost," discussed in his lecture "Anamorphosis" in *The Four Fundamental Concepts of Psycho-Analysis* (London: The Hogarth Press and the Institute of Psycho-Analysis, 1977).

15. Georg W. F. Hegel, *The Phenomenology of Mind*, trans. J. B. Baillie (London: George Allen and Unwin, 1966), p. 543.

16. The relation between glass and mirror in these terms can be compared approximately with that created in Graham's *Public Space/*

Two Audiences (1976), although in that work lighting and spatial conditions are different. See the photographs in *Dan Graham: Buildings and Signs*, p. 22.

17. This act of crossing the property line and approaching the windows is the implied event of an earlier work, Graham's *Picture Window Piece* of 1974. There, however, the drawings for the work show a male passerby approaching a video screen positioned near the picture window of a tract house. He sees the image of a solitary female occupant on the screen and, presumably, through the window as well. See *Dan Graham: Video-Architecture-Television: Writings on Video and Video Works, 1970–1978*, ed. Buchloh (Halifax: The Press of the Nova Scotia College of Art and Design, and New York: at the University Press, 1979), pp. 35–36.

18. Kenneth Frampton, "The Glass House Revisited," *Institute for Architecture and Urban Studies. Catalogue* 9 (1978): 51.

Unity and Fragmentation in Manet

Manet, I think, had divided feelings about the tendency toward the disintegration of the classical unity of the "concept of the picture," which art history assumes he could perceive in his own work. Divided feelings are divided by force. The force that divided his feelings simultaneously permitted the paradoxical unification of his pictures. This unification emerges out of the same historical conditions which gave his works, particularly the "Salon-type" pictures of the 1860s, the character of an ironic, semiotic assemblage of heteronomous fragments or ciphers.

The condition of existing as an assemblage is incipient in his work. It is never allowed to express itself explicitly, and thereby constitute another type of picture. Manet retains a classical "type" or "concept," or what Ian Wallace calls an "idea" of the picture. This is what we might call the "Western" type of picture, and it is a monumentalizing type. Manet applies it to a range of subject matter relatively unfamiliar to it: *la vie moderne*. The provocations which form the language of his career take the form of illegitimate or ersatz monumentalizations. *Olympia* is, in this regard, a monumentalized subject whose monumentalization is not called for in the abstract law which appears socially in art as the typology of pictures. Thus, *Olympia* violates a taboo, and links modernism to such exposures of what Walter Benjamin called the "dream world" of the bourgeoisie.

I am less concerned at the moment with this aspect of exposure in Manet's work than with its relationship to historical transformations of the concept of the picture, and therefore the concept of its unity. This concept, or abstract law, articulated in the Academic, or Salon, typology of pictures (and, of course, in the hierarchy of genres), is profoundly affected by Manet's provocations. But, too, its historical crisis is an engine which engenders the kind of pictures which, in the period, are provocations.

This crisis is located in the interior relations of the picture, at the level of the mechanics of its concept. This level is that of the technical means by which the human figure, the human body, is established as both *painted* and *represented*. It is painted by means of the sensuous tracings of the painter's hand, arm and body; it is represented by means of a mechanism which inhabits it and marks its origins as modern subject: perspective.

The entire solidified corpus of European Academic painting, the institutionalized theater of meaning and significance which identified itself as that of painting,

Written in 1984. First published as "Unity and Fragmentation in Manet," in *Parachute* (Montreal) no. 35 (Summer 1984): 5–7. There accompanied by the following note by Wall: "This is a slightly revised version of a paper presented at the College Art Association annual Convention in Toronto in February 1984. It was my contribution to a session organized by Thierry de Duve of the University of Ottawa, entitled: *Judging Modernity: Manet Revisited*. The intention of this session was to discuss aspects of Manet's work which were relevant to our present cultural situation."

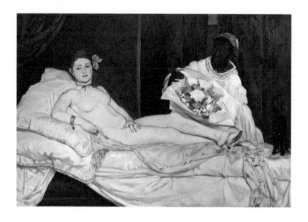

organizes itself on this axis of the painted and the represented, the "touched" and the "projected," the pagan and the professional. But, by 1860, this corpus had not just solidified into the codex of the "joint-stock company," the "department store" of the bourgeois Academy; it had become perceptible as a cultural body, even as a "body politic," which had internally decayed.

It is often said that the impact of photography, which usurped many of the utilitarian functions which held painting in place in the culture generally, was a shock effect which revealed this decay. Is Baudelaire's famous denunciation of photography in his *Salon of 1859* comprehensible as an interrogation of the degeneration of the technical and spiritual interior of the concept of the picture through which Salon painting lived? How could the culture of the "ethereal and immaterial" imagination be threatened by a mechanism external to it, a mechanism which, from without, from "science" and "progress," threatened to "impinge on the sphere of the intangible and the imaginary"? Baudelaire is a poet for whom absolute polarities are appearances only: *correspondences* predominate in his universe. Photography's "threat" to painting was precisely in the revelation it provoked, a revelation of a kind of *correspondence.* Photography reveals its own technical presence within the concept of the picture, and so it reveals the historically new meaning of the mechanized interior of the great spiritual art of painting itself.

The "interior mechanization" of modern painting was proclaimed as its truth at its origin. Piero della Francesca said, "All painting is nothing but perspective." From this vantage point, the inner drama of painting, the drama in which the concept of the picture is engendered in the modern "West," is articulated in a relationship of the painted body to perspective.

The painted body—the central term of the classical concept of the picture—is that "body of the other" traced and caressed by the moving hand of the painter. Thus, the painted body is the simultaneous trace of two bodies, and so is inherently erotic. And since, despite the sexist construction of art-historical language, the hand of the painter can be either male or female, and so can the painted body, painting

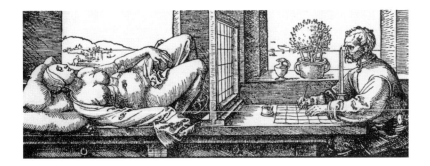

retains in its interior a kind of paganism, a polymorphousness, even an androgyny, which is suspicious of all asceticism, all unhappiness, and all estrangement.

This painted body, however, completes itself as picture by means of a mechanism, its ever-present armature, the mechanistic opticality of the perspectival code. The body is completed as picture in the projection of that kind of space which historically receives it and permits its fundamental theatrical act to take place. That act is the act of the body's encountering its own alienation from itself, its loss of its status as "couple," as two bodies bonded by the mark, in its disappearance into the spatial world of things and of measure along an optical, geometrical axis. It is along this axis that the painted, or the caressed, body becomes separated into space and becomes "single."

In this process the painted body is permeated with opticality and with geometry; it is, so to speak, disembodied by the action of its own projection into a thinglike world of measure. The inner drama of the picture is inescapable from this adventure of loss experienced by every painted and represented body, inescapable from the historical doubt thrown upon the caressed palpability of the figure by the kind of space which is its "natural" home. As picture, the body shimmers on the verge of being an optical projection, a specter, an effect of perspective. A projection always originates elsewhere than on a surface which can be touched. This is the source of the pathos of the "painterly hand" or mark, which characterizes modernist painting throughout its history.

Renaissance, Mannerist, and Baroque painting play all the variations of this dialectic; and historical—social, economic, political, and technological—modernization intensifies the grip of perspective on culture as a whole in the development of machines.

Once the consequences of this modernization process become experienceable as culture, painting's spiritual authority is disrupted. This spiritual (and erotic) authority rested on its "catholic," syncretic, and luxuriant inclusion of the palpability of the body within the rhythmic harmonies of an ideal space—an ideal church, an ideal text, an ideal city. Catholic, Baroque Europe modulated its mechanistic and progressive ideal with the curvature of the human forms which entwined to make its pictures.

The meaning and value of painting's mechanized interior is transformed in the modernization process. The peopling of the city with machines which takes place in the eighteenth and nineteenth centuries accelerates the disembodiment of the figure which was inherent in perspective but was contained and limited by the character of the *ancien régime*. The hollowing out or voiding of the pagan body by the systems of projection, opticality, and planning which were always present in painting takes place in the same historical process in which men, women, and children were bound to machines in the new division of labor. In *Capital*, Marx writes:

> While simple co-operation leaves the mode of working by the individual for the most part unchanged, manufacture thoroughly revolutionizes it, and seizes labour-power by its very roots. It converts the labourer into a crippled monstrosity, by forcing his detail dexterity at the expense of a world of productive capabilities and instincts; just as in the States of La Plata they butcher a whole beast for the sake of his hide or his tallow. Not only is the detail work distributed to different individuals, but the individual himself is made the automatic motor of a fractional operation, and the absurd fable of Menelus Agrippa, which makes man a mere fragment of his own body, becomes realized.[1]

Here, in 1867, is expressed the great inversion of the whole past form of "the human," the negation of the conditions under which all previous ideals of human unity could be sustained at the interior of cultural expression. Here, the division of labor and the machine industry generate phenomena whose cultural consequence is the revelation of the unravelling of the near-pastoral urban harmony of the classical ideal of earthly perfection, what ancient Greece called *kalokagathia*, with which perspective baptized itself in the Renaissance of Alberti, Piero, Leonardo, and Brunelleschi. Perspective becomes threatening at the moment that the determinate negation of the ideal of human wholeness and harmony is revealed in the Marxian image of the living body-part as the crux of culture.

Perspective proved itself as a totalization, a transcendent quantitative cosmic design, and gained the status of Law in the Academy. It did not, however, automatically thereby destroy the conditions for the harmonious expression of the human body and human experience, until historical development revealed capitalism's inherent negation of and hostility to the entire previous ideal of the complete development of the human being. In capitalism all bodies are projected as uniform functions of production and exchange, and can survive as bodies only in so far as they prove themselves as partial functions in the process of creation of surplus value. The culture of the commodity is a totality guaranteed by the process of reduction of the ideal of completeness, unity, and harmony, identified with the image of the body in *its* space, to a state of fragmentation and homelessness.

For nineteenth-century modernism, exemplified by Manet, the fragmentation

of the ideal of integrity and the harmoniousness of the body and its space—and so of the conditions for spatial representation—is not something imposed from outside the regime of the picture, from "industry" or "mass media." It emerges from within the historically law-governed concept of the picture itself. At the moment when science begins to appear culturally as marred with domination, painting begins its repulsion of itself from science, from the totality which produces the antithesis of integration, which produces the living body-part, the "mass ornament,"[2] the modern worker, consumer, and spectator.

Manet's expression of these conditions is so intensified that it is possible to see his work as a classicism of estrangement. The figures he paints and represents are simultaneously palpable, that is, traditionally eroticized, and yet disintegrated, hollowed, and even incipiently "deconstructed" by their inscription with this crisis of perspective. In this process of emptying, they become emblematic of the new "fragmentary" type of person produced within capitalism, the person who "empathizes with commodities."[3]

Some neoconservative critics of Manet's recent exhibition at the Metropolitan Museum in New York saw him as something less than a great painter, mainly because, in effect, he did not transcend the difficulties of his epoch. But his significance for us is in that apparent nontranscendence. It is the appearance of a nontranscendent cultural expression which alone can bring out the distress implicit in the "empathy with commodities." In *The Phenomenology of Mind*, Hegel says: "The distraught and disintegrated soul is . . . aware of inversion; it is, in fact, a consciousness of absolute inversion . . . The content uttered by spirit and uttered about itself is, then, the inversion and perversion of all conceptions and realities, a universal deception of itself and of others. The shamelessness manifested in stating this deceit is just on that account the greatest truth."[4] On the same page, Hegel also identifies the distraught consciousness with *wit*, and a page or two earlier talks about this complete inversion of reality and thought, this state of utter estrangement, as "pure culture."[5] This world-historical distress appears as the crisis of classical unity in Manet's pictures. This crisis is constituted by the positioning of the negated pagan body—the newly estranged body—within the negative persistence of perspective. Perspective for Manet cannot be abolished or transcended without abolishing the classical concept of the picture altogether and existing outside the law. At the same time, perspective's historical status as a law guaranteeing unity can no longer be experienced as a picture. In Manet, perspective begins its existence as a law which cannot live "in and for itself"; it persists only through the transgressions it provokes in the concept of the picture. Perspective is therefore a law guaranteeing estrangement in the experience of the painting.

Estrangement experienced in the experience of the picture has become our orthodox form of cultural lucidity. Cultural lucidity is, in Manet's example, rooted in a historical process in which the ancient concept of the harmony and unity of the body and its space is destroyed by society and reconstituted by the artist in a "ruined"

state, an emblematic state in which its historically negated or outmoded character and meaning become perceptible. In fact, without this perception, Manet's work may have been difficult to perceive as a picture, as something governed and guaranteed as a picture by the law. Many of his works apparently suffered this difficulty in their various first showings, particularly in the Salon.

For Manet, this state of unrelievable tension in front of the work is the specific antithesis to the somnambulistic state of "ersatz unity" which characterizes Salon pictures. The Salon masters of the Second Empire and the Third Republic were in fact far more *collagiste* in their eclecticism than was Manet in his dandyish witticism. But their perspective disavows its status as social ruin and strains to entrench itself as hypnotic, instrumental, and professional. These men are "experts."

Since Manet cannot break with perspective and its concept of the picture, the Salon remains the inescapable centerpoint of cultural lucidity for him, no matter how degraded it becomes. Its degradation, as evidence of the complete inversion of truth it embodies, makes the Salon the site of Hegel's "pure culture," and, as such, the immanent home of Manet's scandals.

In and around the Salon, Manet demonstrates decisively that the radical antithesis to instrumental, ersatz unity is not simply fragmentation, the culture of montage and of the snapshot which is already apparent in Impressionist informalism. The antithesis likewise is not a primitivist ideal of harmony constructed from archetypal bodies which alone can occupy the perfect space of unalienated perspective—or nonperspective—as in the proto-Symbolist works of Puvis de Chavannes or Gauguin. Manet's alternative consists in the negative, almost memorializing unification of the image around a ruined, or even a dead, concept of the picture.

The dead concept of the picture, when turned toward its immanent subject, "the painting of modern life," produces an image which is that of the mortification of modernity. With Manet, the realm of "pure culture"—the Salon, the regime of perspective—flares up and collapses into dust. In his work, the body of antiquity and of Baroque Europe appears in a picture for the last time.

Manet is the tombstone of the Salon. As such, he is outmoded by the developments in the new realms of modern art, the "independent spaces" which reached their first maturity in the 1870s and '80s, and which, in the intervening century, have become *our* site of absolute inversion, of "pure culture." Manet was in a real sense without followers after his death. He is still in the happy position of being without followers. But the contemporary culture of absolute fragmentation, which appears in and dominates the galleries of 1984 as both painting and photography, has emerged historically from the long transformation of the "independent spaces" of modern art of the nineteenth century, into the museumlike, Salon-like precincts of our era. Manet shows that a decisive expression of modernism originated from the process of revealing an internally mortified concept of the picture and that that exposure was

not bounded by the painting itself. Rather, it formed the social image of a decayed cultural epoch and in so doing, redefined cultural space. In this sense, it participated in the development of critical concepts about cultural space in general, concepts which were formulated sharply about fifty years after Manet's death by Brecht, among others. Brecht's notion of the "functional transformation" (*Umfunktionierung*) of modes of cultural production should be related to Manet's insistence on the "Western" image as a ruin. Such a labor of relation would possibly create a means of access to the closed interior of the image in the dead concept of the picture which forms the empty center of the "Salonism" of our period. This is a dual picture-type rooted in the institutionalized culture of fragmentation: totalized montage and "abstract art."

NOTES

1. Karl Marx, *Capital* (Moscow: Progress Publishers, 1965), 1:360.

2. The term is Siegfried Kracauer's. His essay "The Mass Ornament" was published in English in *New German Critique* no. 5 (Spring 1975): 67–76.

3. Walter Benjamin, *Charles Baudelaire: A Lyric Poet in the Era of High Capitalism* (London: New Left Books, 1973).

4. Georg W. F. Hegel, *The Phenomenology of Mind*, trans. J. B. Baillie (London: George Allen and Unwin, 1966), p. 543.

5. Ibid., p. 541. The sentence is: "This type of spiritual life is the absolute and universal inversion of reality and thought, their entire estrangement the one from the other; it is pure culture."

Gestus

My work is based on the representation of the body. In the medium of photography, this representation depends upon the construction of expressive gestures which can function as emblems. "Essence must appear," says Hegel, and in the represented body it appears as a gesture which knows itself to be appearance.

"Gesture" means a pose or action which projects its meaning as a conventionalized sign. This definition is usually applied to the fully realized, dramatic gestures identified with the art of earlier periods, particularly the Baroque, the great age of painted drama. Modern art has necessarily abandoned these theatrics, since the bodies which performed such gestures did not have to inhabit the mechanized cities which themselves emerged from the culture of the Baroque. Those bodies were not bound to machines, or replaced by them in the division of labor, and were not afraid of them. From our viewpoint, therefore, they express happiness even when they suffer. The ceremoniousness, the energy, and the sensuousness of the gestures of Baroque art are replaced in modernity by mechanistic movements, reflex actions, involuntary, compulsive responses. Reduced to the level of emissions of biomechanical or bioelectric energy, these actions are not really "gestures" in the sense developed by older aesthetics. They are physically smaller than those of older art, more condensed, meaner, more collapsed, more rigid, more violent. Their smallness, however, corresponds to our increased means of magnification in making and displaying images. I photograph everything in perpetual close-up and project it forward with a continuous burst of light, magnifying it again, over and above its photographic enlargement. The contracted little actions, the involuntarily expressive body movements which lend themselves so well to photography, are what remain in everyday life of the older idea of gesture as the bodily, pictorial form of historical consciousness. Possibly this double magnification of what has been made small and meager, of what has apparently lost its significance, can lift the veil a little on the objective misery of society and the catastrophic operation of its law of value. Gesture creates truth in the dialectic of its being for another—in pictures, its being for an eye. I imagine that eye as one which labors and which desires simultaneously to experience happiness and to know the truth about society.

Written in July 1984. First published in German and English as "Gestus," in *Ein anderes Klima: Aspekte der Schönheit in der zeitgenössischen Kunst/A Different Climate: Aspects of Beauty in Contemporary Art*, exh. cat. (Düsseldorf: Städtische Kunsthalle Düsseldorf, 1984), p. 37.

Into the Forest: Two Sketches for Studies of Rodney Graham's Work

Rodney Graham's work implicates itself in a complex of philosophical, aesthetic, historical, and social issues, and does so in novel and unexpected ways. The two interpretive sketches which follow attempt to trace a few significant aspects of what Graham has been doing for the past ten years.

I

Hegel, in his *Science of Logic*, distinguishes between two concepts of infinity: "affirmative" and "negative," or "bad," infinity. As a Romantic, objectivist, and modernist dialectician, he insists that finite and infinite reciprocally determine each other, that each exists in a dynamic relation of otherness with its antithesis:

> Finitude exists only as a passing beyond itself; it thus contains infinity, which is its Other. And, similarly, infinity exists only as a passing beyond finitude; it thus essentially contains its Other, and so is in itself its own Other. The infinite does not transcend the finite as a power existing external to the latter; rather it is the infinity of the finite to transcend itself.[1]

> The nature of the finite . . . does not meet the nature of the other as if it had no affinity to it, but, being implicitly the other of itself, thus undergoes alteration. Alteration thus exhibits the inherent contradiction which originally attaches to determinate being (i.e. limited, specific, finite being) and which forces it out of its bounds . . . everything finite (such as existence) is subject to change. Such changeableness in existence is to the superficial eye a mere possibility, the realization of which is not a consequence of its own nature. But the fact is, mutability lies in the notion of existence, and change is only the manifestation of what it implicitly is.[2]

Here the thinker of 1812 puts forward the new philosophy of restlessness, the logic of which he explicitly recognized as revolutionary. The "affirmative infinity" of the finite, the tendency of the existing world to "force itself out of its bounds," is the original conceptual image of the historical storm of transformation which we call modernity and which Hegel immediately recognized as the meaning of the French Revolution. But the dialectical, transcendent concepts of living nature and rational history themselves contain *their* Other, and release its novel and monstrous forms in

Written in 1988. First published as "Into the Forest: Two Sketches for Studies of Rodney Graham's Work," in *Rodney Graham: Works 1976–88*, exh. cat. (Vancouver: Vancouver Art Gallery, 1988), pp. 9–37.

the unintended consequences of revolutionary world-reconstruction. In the process of its own dialectical movement, this modernity, this revolutionary and progressive development, reveals some of its own negative features. These features are the historical content of Hegel's concept of "bad" infinity. Hegel describes bad infinity:

> If we let somewhat and another . . . fall asunder, the result is that some becomes other, and this other is itself a somewhat, which then as such changes likewise, and so on *ad infinitum*. This result seems to superficial reflection something very grand, the grandest possible. But such a progression to infinity is not the real infinite. That consists in being at home with itself in its other . . . Much depends on rightly apprehending the notion of infinity, and not stopping short at the wrong infinity of endless progression . . . In the attempt to contemplate such an infinite, our thought . . . must sink exhausted. It is true indeed that we must abandon the unending contemplation, not however because the occupation is too sublime, but because it is too tedious. It is tedious . . . because the same thing is constantly recurring. We lay down a limit: then we pass it: next we have a limit once more, and so on forever . . . To suppose that by stepping out and away into that infinity we release ourselves from the finite, is in truth but to seek the release which comes by flight. But the man who flees is not yet free: in fleeing he is still conditioned by that from which he flees.[3]

Hegel strictly limits the function of this infinite in the movement of his dialectic: "We have here an abstract progress which remains incomplete because there is no progress beyond this progress itself."[4] But the term "abstract progress" refers not only to the logician's sardonic account of the humdrum grinding on of repetitious activity and the flight from it; it is also an image of mechanistic, routinized "progressive" modernity. In this modernity, which is ours, there is indeed "no progress beyond this progress," and, as we now can clearly see, culture begins to sink into exhaustion, regression, despair, and ruination. The glorious revolutions of the eighteenth and nineteenth centuries invented the concept of freedom which shines in Hegel's concept of transcendent infinity. But the unglimpsed outcome of the bourgeois revolutions included the release of mechanistic energies which Romanticism feared and disdained, but which still rule us both as direct conditions of social life and as orthodox philosophy, economics, technics, and aesthetics.

"Bad infinity" and its later extrapolations—repetition-compulsion (Freud), the "eternal return of the same" (Nietzsche), the circuits of Money-Commodity-Money (Marx)—are the permanent, symptomatic appearance-forms of capitalist "progress." With the prescience of the objective idealist, Hegel discerned the bond between the phenomena of abstract progress which dominate our modernity and the deep veins of catastrophe-potential haunting it. Freud, to take only one symptomatic example, identified the compulsion to repeat as the mark of a "death instinct" in his study

Beyond the Pleasure Principle, which he published in 1920. The concept of a "will to death" in Freud's picture of modernity has, of course, been critically analyzed as not so much a scientific element of psychoanalysis as a projection of Freud's own fin-de-siècle, pessimistic, subjective views, views which align him with thinkers like Spengler. But even those who do not accept Freud's sociology have recognized in the notion of a death instinct operating in history an image, however distorted, of actual social and psychic forces which produce and reproduce misery.

Georg Büchner had the idea to write *Lenz* as a novel in 1835, but he never completed it. It remains as a fragment, its last line ending with three dots. Taken from the real journals of Herr Oberlin, the pastor involved in the tale, it tells part of the story of J. M. R. Lenz, an obscure author and distant friend of Goethe, who lived for a time with Oberlin and his family at Waldbach. During this time, Lenz was in a state of psychosis brought on by, among other things, a collapse of religious belief. *Lenz* combines poetic descriptions of mountain scenery with elliptical, condensed accounts of the unhappy man's behavior and thoughts. Pitiless anxiety and despair torment him; he can neither live nor make an end of his life, though he repeatedly, but ineffectually, attempts suicide. Terrified of leaving his friend Oberlin, "the only being who had any existence for him," he is eventually taken away to Strasbourg, where the story ends with the statement, "And so his life went on. . . . "

In Rodney Graham's *Lenz* (1983), the first 1,434 words of C. R. Mueller's English translation of Büchner's fragment are folded back on themselves. Graham found two points near the beginning of the story where the words "the forest" occur in such a way that one can read up to their second appearance and then loop back into the text which follows their first with no loss of coherence. He had the text laid out and typeset to produce this effect. The resulting four-page segment was then printed over and over again, forming what the artist calls "a continuous sequence of loop-like repetitions." Eighty-three of these segments, having been judged to comprise a mass of pages thick enough to be categorically recognizable as "a book," were clothbound and enclosed in a matching slipcase.

Graham's amputation and cloning of Büchner's story may be interpreted as an erudite and misanthropic witticism, bringing Büchner together with the apparently antithetical figure of Raymond Roussel, the author who fascinates Graham more than any other. Roussel's mechanistic methods preside over Graham's textual work, which is characterized by cunningly factored interpolations, masterful stylistic parodies, word counting, word hunting, object making, and the profusion of boundaries and "coigns of vantage."[5] *Lenz* could also be seen as a variant on the post-structuralist program of "appropriation" which was fashionable in the early '80s, and which required the "reframing" of existing works, the reprocessing of them by means of self-conscious procedures emphasizing the ideological nature of representations in general.

But out of these syntheses and appropriations, *Lenz* generates its own peculiar

Rodney Graham. *Lenz*.
1983. One of ten cloth-
bound books with slip-
cases, each: 8¹⁵⁄₁₆ x 5 ⅞ x 1⅜"
(22.7 x 15 x 3.5 cm), and
twenty prospectuses, each:
9 x 5¹¹⁄₁₆ x ¹⁄₁₆" (22.9 x 14.5 x
0.1 cm)

destructiveness: it attempts to annihilate the inner logic of the most radical example of modernist literature. The canonical status of Büchner's *Lenz* as such an extremist work is therefore central to Graham's intention. In a move reminiscent of Derridean or Deleuzian analyses, he seems to extract a core of unsurpassable despair and dystopian anxiety from the original, and configures it not as literature, but as a nonlinguistic, form-ruining force which annuls the residual, "traditional" humanism of Büchner's extremist literature, and he does this strictly by means of a principle of repetition.

In Büchner's story, Lenz encounters Oberlin, attaches himself to him as a spiritual son in opposition to the wishes of his own real father, and then, through his own derangement, is separated from the gentle pastor. Generically, the work is a miniature modern tragedy, and as such confirms the progressive project of radical modern art, which dialectically continues great traditions by breaking with them on their own ground.

In Graham's text-object, Lenz meets Oberlin and his family after a distressing journey through the mountains, is taken in as a guest, endures a harrowing night, and then, in the morning, along with his host, sets out on horseback into the mountains again. All this is exactly as in the opening pages of the original. Shortly after, however, by means of the loop in the text, Lenz loses Oberlin and they both forget their previous meeting. Lenz once more endures his solitary anxiety in the mountains, and then meets Oberlin again, as if for the first time. And, to quote Hegel, "so on forever."

Graham's adulteration of Büchner's original is entirely organized in terms of repetition-compulsion, and parallels the "child's game" described by Freud in *Beyond the Pleasure Principle*. Just as the little boy in Freud's book repeatedly flings away his toy and pulls it back again by the string to which it is attached, Graham's *Lenz* expels his new father, Oberlin, from the narrative, only to "reel him back" just afterward. Moreover, Oberlin, too, repels his spiritual son in just the same manner. In the *fort-da* game, the little boy threw away his object, making it "gone" (*fort*, in German), in order to "satisfy an impulse . . . which was suppressed in his actual life, to revenge himself on his mother for going away from him."[6] In this light, we can see that Graham's

intervention has the effect, and possibly the purpose, of concentrating on the antagonisms in the father-son relationship which Büchner leaves implicit. Graham's text eliminates the novelistic openness of the original narrative and cancels the resolution of the conflict, locking both parents and children into a fixated condition of perpetual reenactment. All are playing the child's game. The cruelty here is apparently a logical consequence of the work's overall relationship to modernist literature.

Graham's object is a literary "thing" which is not really a book but which must appear as a book. The "thing" that appears as such is a pure manifestation of repetition-compulsion, pure in the sense that it is made visible not through an act of literary creation but through the organized ruination of literature. This ruination is effected not by writing a book but by binding one.

For Graham, the nature of radical or even revolutionary literature as exemplified by Büchner is construed as a relation between an absolutely problematic process of writing and the mechanical automatism of modern object-production. Graham's *Lenz* implies that language is fundamentally transmuted when it takes the form of a book, a product which is technically a succession of identical components ordered in the logic of the binding process. Such a level of doubt might be cruelly immobilizing, but, like many other upsetting things, it has a noble history in French avant-garde literature from Mallarmé and Laforgue through Jarry and Lautréamont to Roussel. Graham, in the tradition of Roussel and therefore of *humour noir*, embraces the fascination with the modernist Other of literature, what André Breton called its "mechanical simulacrum."[7]

The mechanization of literary production and the emergence of an industrial literary product is the great shock which inaugurates modernist literature. The book, as the fundamental form of the literary commodity, can therefore be experienced not as literature at all, but as the external form of its negation, an exoskeletal clamp into which machinery has driven speech. Just as the ancient cultures rooted in oral literature disintegrate in the triumphal advance of writing up through the period of Romanticism, so in turn writing, the most translucent trace of the modern Western spirit, fades out in the ruts cut by machines. The idea that creative turmoil reveals something essential about itself in coming to rest in a manufactured literary object leads to the fear that the turmoil itself is manufactured, that all writing is "automatic writing," and that creative subjectivity is merely an effect of an apparatus or an institution of Literature. Literature dies as the poetics of the wide world, but survives in the strait gate of its own industrialization. The book is therefore the tomb of the rhythmic, heroic word. The program of modernist literature, or what has called itself "anti-literature," lives in this romantic, bourgeois tragedy of its own devising.

Lenz reverses this scenario. Rather than incarcerating a poetic act between the covers of the book-machine, Graham applies a set of covers to his mechanically generated literary interior, apparently in order to terminate its self-replication. Without

Leonard Frank. *Clear-Cut Landscape.* 1941

the intervention of the book covers after eighty-three repetitions, the *Lenz*-machine would clone itself endlessly, growing like a runaway chain reaction. The possibility of meaning, in the sense established by radical literature, is thus expelled from the space between the covers. The textual mass becomes a void, and reading it is an exhausting tedium from which everyone must flee. The best way to read *Lenz*, therefore, may be to close its cover and look into the physical void of its empty slipcase.

Slipcases normally protect books against damage from without. Graham's slipcase for *Lenz* has an opposite and essentially emblematic function: it emphasizes the antagonism generated by the release of pure bad infinity by reiterating the terminating, constraining intervention of the covers. The slipcase is a restraining device. Generically, it is the prototype for Graham's book-sculptures of 1987–88,[8] and the antitype for his other major textual work, *The System of Landor's Cottage* (1987). In *Lenz* Graham plays the "child's game," in *Landor's Cottage* he takes the classical "father's position" and labors to actually write a novel.

II

The image of a forest devastated by clear-cut logging has become decisive in the culture of critical discourse in British Columbia. Continuous campaigns of protest, lobbying, civil disobedience, and education are now required to preserve the few remaining stands of ancient timber and their related ecosystems. The success of these efforts is far from assured. The masters of British Columbia's semicolonial, natural resource–based economy regard the natural world as simply an obstinate material form of future money which must be transmuted into real money as quickly as possible. The standing tree is an affront to these "owners of nature,"[9] whose totem poles must lie in piles on trucks. The same tree, however, remains a real, living totem to the citizen-ecologists struggling to retain tracts of land for the sake of a rational future. This urgent political and economic conflict preserves and renews ancient totemic meanings and transforms real tracts of land into what Ernst Bloch called "wish-landscapes," utopian visions of possible harmony, but also into terror images of looming catastrophe.

Eugène Atget. *Saint-Cloud,
fin août, 6 heures et demie.*
1924. Albumen silver print,
7 x 9⅜" (18 x 24 cm). The
Museum of Modern Art,
New York. The Abbott-Levy
Collection. Partial gift of
Shirley C. Burden

The culture of ecological protest is bound to the Romantic apprehension of the tree as an emblem of the unity of the natural world and the nobility of the individual within it. Progressive education and agitation strive to awaken a repressed but spontaneous love of the tree, and to draw the necessary critical lessons about the disastrous character of capitalist development from the new ethical recognition. Romantic progressivism understands itself as a "warm" cultural stream, counterposed to the cold logic of capitalist "abstract progress," which eats forests to produce commodities of dubious utility. The old antagonism between city and countryside flares up anew in this conflict, as it must, and reminds us once again that we have not mastered this relationship, as we have not mastered so many others, that we are dominated by the form of our domination of nature, that we are dragging shut the Gates of Eden.

Set in this iron opposition to nature, no city can make itself green enough to paint over the gray glint of calculation. Our lovely tree-lined malls and avenues, the *Schlossgartens* of capitalist democracy, insinuate a negative ecology. The ensembles of oaks and elms are ranked like colonial troops and, in their resigned elegance, teach the citizens to respect the central plan.

Each of these trees loses its identity in the process of its inclusion in the parody of palace gardening which is contemporary urban planning. It is divested of what might be called its "natural selfhood," and is obliged to function like the "young Negro in a French uniform . . . saluting the tricolour," whom Roland Barthes discussed in *Mythologies.*[10] Barthes claimed that that image served the youth's own real colonial masters as a mythic representation of the rationality and justness of their domination of parts of Africa. Here, the tree does the same thing in relation to the false reconciliation of city and countryside. This phantom harmony is the gemstone of ideological consciousness.

The infinite but bounded productivity of nature, its potential as human homeland, and the ethical aesthetic of praxis derived from the empathetic study of nature by the great tribal, Romantic, modernist, and socialist thinkers—these precious things are negated by the "Great Owners'" inversion of values, which legitimates the

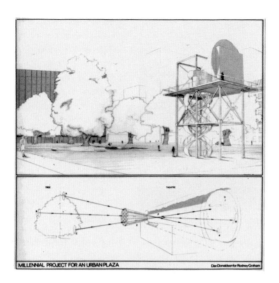

Rodney Graham. *Millennial Project for an Urban Plaza.* 1986. Drawing by Dan Donaldson for Rodney Graham. Vancouver Art Gallery

scourging of earth and forest in the hunger for numbers. And, in the same social process in which the beautiful productive trees of the forest are counted out of existence by unplanned overharvesting, the unproductive trees of the cities are strategically marshalled into position in the ideological struggle. How easy it is to fall back into the belief in the still-existing harmony of city and country when Vancouver seems nestled in the cyclic life of thousands of these decorative sentinels!

But if we consider the overall social identity of the mass of urban foliage in terms of the mythic or ideological role it is compelled to play in the economic tragedy of the environment, we recognize indeed that a tree may not, in a sociological sense, anymore simply be a tree, if ever it was since the onset of modernity.

Urban planting emphasizes ensembles of greenery, composed of numbers of tree-emblems arranged repetitively along streets or clustered picturesquely in open spaces and parks. Rarely do we see an isolated tree in the city. The reason for this is profoundly ideological. The lone tree is the great ancient symbol of the mortal individual, rooted in the totality of nature yet suffering its solitary destiny. In an epoch when the totality of nature begins to suffer mortally, we begin to be able to see it as an individual. In this, the totemic and holistic vision of tribal, aboriginal cultures is re-recognized by non-natives as scientific truth. The ecological movement is inspired by this tragic sense, and its propaganda is filled with the *basso continuo* of lament. The spectacle of the tragic death of something nobler than ourselves is the sublime shock which can inaugurate radical transformation. In this epoch, a tree standing self-consciously alone in the city would, better than any other monument or form of propaganda, evoke the environmental tragedy which indicts our economy, our culture of cities, our social order.

In his *Millennial Project for an Urban Plaza* of 1986, Graham in fact isolates a tree in front of a fantastically modernistic building which houses a camera obscura. Reaching back to Romantic and visionary artistic traditions and forward toward a wish-landscape

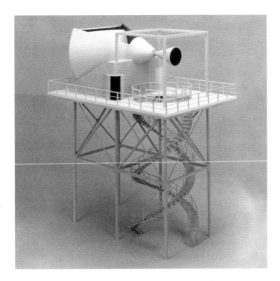

Rodney Graham.
Millennial Project for an Urban Plaza. 1986. Architectural model, fabrication by Dan Donaldson, 27¾ x 24¾ x 16¾" (70.5 x 62.9 x 42.5 cm). Vancouver Art Gallery

of patience and reconciliation, the *Millennial Project* is a radical symbol which reworks and transmutes the orthodox imagery of progressivist environmentalism.

Seven years earlier, in 1979, Graham made another large-scale camera obscura which also produced the image of a solitary tree. This camera, built in a farmer's field near Abbotsford, can now be seen as a structural prototype for the *Millennial Project*, although it is an independent work. Graham may have had in mind Ferdinand de Saussure's example when he selected a single tree for his image. Saussure's little drawing of a tree was used as a universal sign in a discussion of the relation between signifier and signified. Its universality was assumed: all humans know what a tree is, hence its image can refer not only to itself, but to the concept of an "image" in general. Jacques Lacan, in his essay "The Agency of the Letter in the Unconscious, or Reason Since Freud," called Saussure's example "the classic . . . illustration by which (the usage of the concept 'sign') is normally introduced."[11] In this earlier work, Graham adopts a scientistic classicism in using the image of a single tree to suggest an abstract relationship. The ideological potency of this image and its universality in a real-environmental sense appears only later, in the *Millennial Project*.

Camera Obscura followed the model of the "earth projects" and related experiments of the 1960s and '70s. It required its audience to drive out of town into the working countryside to experience the actual image, but provided objectified substitutes for that direct encounter in the architectural model and the inverted photographic print which were displayed in a gallery. The work could not be seen as a whole in any one place, and its disunity expressed a sense, well-recognized in the public discourse of the time, of the widening split between city and country, glimpsed against a background of the decay of regional agriculture under the domination of American agribusiness, which supports the aimless suburbanization of great British Columbian farmland.

Graham's two other major works of "nature theater," *Illuminated Ravine*, also

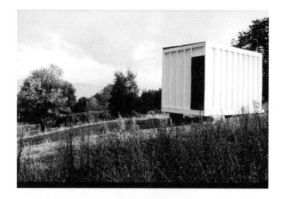

Rodney Graham. *Camera Obscura*. 1979. Installation near Abbatsford, British Columbia. Vancouver Art Gallery

Rodney Graham. *Camera Obscura*. 1979. Architectural model. 20⅝ x 35⅞ x 18" (52.5 x 91 x 45.8 cm). Vancouver Art Gallery

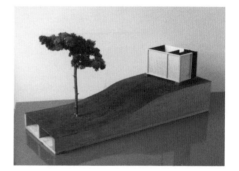

Rodney Graham. *Camera Obscura*. 1979. Chromogenic color print. Vancouver Art Gallery

from 1979, and the film *Two Generators* of 1984, also dealt with the relations between urban and rural, "developed" and "underdeveloped" locales. In *Illuminated Ravine*, the audience was invited into the friendly woods surrounding the Simon Fraser University campus to observe the illumination of a small ravine by mercury-vapor lights powered by a gas generator. The engine's racket and exhaust made the place seem like a worksite in the pioneering resource industries, while the flickering light produced a dreamlike image of nature closed in upon itself under our distanced gaze.

Illuminated Ravine created an agitated, transient model of our real relation to parklands and nature reserves: it recognized them as stage sets, isolated objects of alienated contemplation. The work built upon its audience's growing awareness of environmental abuse to make perceptible the neurotic aestheticism inherent in the contemplation of special parts of nature dissociated from the laboring totality. *Illuminated Ravine* explicitly staged this isolation of nature and spectators from each other, and made the experience of a "special place" one of anxiety and guilt rather than absorptive repose.

Two Generators, made five years later, twisted this structure around. In *Illuminated Ravine*, contemplativeness was indeed formulated as a neurotic trait but, in a

Rodney Graham.
Illuminated Ravine.
1979. Installation view

Rodney Graham. *Two
Generators.* 1984. Still
from a black and white
film, 4:30 minutes, pro-
jected repeatedly for
60–90 minutes. Art
Gallery of Ontario,
Toronto

Rodney Graham. *Two
Generators.* 1984. Label of
the film's box, designed by
the artist. Art Gallery of
Ontario, Toronto

Freudian sense, as one that may be indispensable for any cultural development which might lead away from neurosis and repression. *Two Generators* seems to return to repression as the inescapable interior of culture. The film closes off direct contact with the outdoors, and places its audience firmly back inside the cinema-machine. It seems to abandon the process of development of a mobile and potentially critical audience as it draws away from the unpredictability and complexity of the actual experience of nature which the earlier works maintained. Thereby, it reconstitutes the Faustian myth of the cinematic "culture of spectacle," in which only the intrepid filmmakers adventure to remote locations, while the audience consumes the adventure-product in the somnolent monumentality of their Cineplexes.

This work in some ways abjures the experimentalism and progressivism of *Illuminated Ravine* and participates in the new, ironic spectacularism of the early 1980s. But Graham's film cannot be interpreted simply as neo-spectacularism, despite its big-screen presence and high-volume soundtrack. It is only four minutes long, and is projected repeatedly for an hour or more. The house lights are raised after each projection and then lowered again after an interval for rewinding the film. Seeing the film for an hour is like watching the institution of cinema as a whole operate over

a long period of time. The compulsion to repeat which marks a work like *Lenz* so deeply of course plays its part here as well. *Two Generators* acts out a negativistic reflex in relation to both *Camera Obscura* and *Illuminated Ravine*, a retreat from the open environmental experimentalism of the '70s, a symptomatic return to the image-bunker. This retreat is itself experimentally structured, though, and *Two Generators* occupies the institution of cinema antagonistically. Through its representation of nature, it reduces the institutional experience of cinema to a topological model of the city-country crisis. In a way reminiscent of the radical films of the 1960s—of Godard, Straub-Huillet, Kubelka, or Warhol—it develops intense oppositions between picture and sound, and between the conventional expectations of movie audiences and their constant interruption in the course of the film's projection. These internal fractures are not only alienation effects in classical '60s terms but also symptoms of a work deeply divided against itself. Thus, the feelings of guilt evoked by the *Illuminated Ravine* are cinematically magnified. The audience is conceived of as totally separated from nature: *Two Generators* is a very cool emblem of the "unhappy consciousness."

In *Illuminated Ravine* the forest is depicted as a mass, an ensemble of foliage whose individual elements are barely distinguishable as they fill the banks of the depression. Like all rivers, the river in *Two Generators* flows into consciousness as the image of the eternally ungraspable and mysteriously de-individuated state of being of the nonhuman. On an iconographic level, both these works depart from the contemplation of the emblem of the tragic individual upon which *Camera Obscura* was focused. Both works, at the same time, intensified tendencies in Graham's work toward formal radicality and social experimentalism. Some important aspects of this intensification derive from the exclusion of the trace-image of the individual provided by the single tree. The absolutization of separation in *Two Generators* has a sublime quality which derives in large part from the feelings of de-differentiation and dissolution of identity associated with the image of a flowing torrent. Nature is iconically identified in these works as the opposite of individuation, while the irritant of machine noise and the great luminous eyes of lamps stand for a principle of humanity, but one which contains strong destructive and alienating characteristics, traits possibly more identifiable with impersonal forces of technique than with human subjectivity. Both works, then, to different degrees, tend away from an image of civilization in the traditional, modern, Western sense of culture rooted in the centrality of the individual and of law aimed at that individual's preservation and development. Their formal radicality and emotional severity are also compatible with this tendency, in which central aspects of humanistic modernity are dissolved by forms of art or discourse which have been disenchanted with humanism's pieties. The mechanistic, Foucauldian side of Graham's work, exemplified by *Two Generators*, turns around this principle of de-individuation, which makes perceptible the hostility of city-dwellers to the natural world in which they no longer recognize themselves.

From the viewpoint of progressivism, therefore, *Two Generators* could be interpreted as a cold and despairing capitulation to the logos of overdevelopment, as a psychic model of inescapable unhappiness which, ironically, helps prepare culturally for future mercury spills and clear-cutting. Such a one-sided assessment of this rather masochistic work is invalidated in principle, however, by the continuous reappearance in Graham's art of the image of the rational individual, either as a natural symbol, as in the *Millennial Project*, or in the exemplary concentration on Freud which he has articulated over the past decade in a varied group of works.

The solitary tree makes a triumphal, hallucinatory return in the *Millennial Project*. Here a single tree is brought out of the organized anonymity of urban foliage and positioned, while still in its infancy, centrally in an open plaza. This gesture is magnified by the architectural eye which is trained upon the seedling. The project evolves as the camera obscura awaits the growth of the tree to its full maturity, at which point it will fill the screen.

In the *Millennial Project*, the functional shed of the earlier *Camera Obscura* is transformed into a curious and intricate yellow pavilion, whose protruding compound pinhole resembles some visionary piece of nineteenth-century astronomical equipment. And, in a generic sense, this compound eye is indeed astronomical, because it sees far away, not into space but into time, not into the heavens but into the city. *Millennial Project* is thus a time machine, as its title indicates. The open-beam design of the support structure with its double-helical staircases is reminiscent of that other great urban optical device erected a hundred years ago in Paris by the Jules Verne of engineering, Gustave Eiffel. Barthes wrote about the Eiffel Tower, "To perceive Paris from above is infallibly to imagine a history; from the top of the Tower the mind finds itself dreaming of the mutation of the landscape which it has before its eyes; through the astonishment of space, it plunges into the mystery of time."[12]

Eiffel's tower produces a mural, a comprehensive panoramic history; since it is higher than everything else, it subjects the rest of the city to the historicizing and reflexive gaze it stimulates. Graham's tower is, by contrast, the work of a miniaturist. It is interested in a specific microcosm: the life of a single tree, a phenomenon so close and so ordinary as to have become literally insignificant—that is, not recognized anymore as a sign for anything. By means of its dramatic isolation and the counterposing to it of an amusing structure along a strict optical axis, this insignificance is negated and the tree, which had lost its identity in the urban *Schauplatz*, recovers it in two ways. Firstly, the tree becomes a resplendent image of itself, rescued from its status as Rococo decor and "street furniture" by a new contemplative gaze—astral, sympathetic, cheerful, and cunning. Secondly, it becomes again a tragic image, both in its traditional function as symbol of mortality and, through that, as emblem of the numbered mortality of the trees of the working forest, which the city renders invisible culturally even as their remains inhabit it as building material.

The subject matter of Graham's time machine is the finite longevity of any part of nature and of nature as one infinite individual. In proposing this work, Graham projects by implication the type of city which must contain and preserve it: a city in which the existing environmental catastrophe can be publicly experienced as its own inner tragedy. It is then a different city, a future city which rejects its previously catastrophic forms of development. The *Millennial Project* is therefore utopian, a dialectical telescope through which we see what it is we actually are by glimpsing the future we cannot as yet create. This is maybe what Ernst Bloch was talking about in *The Principle of Hope* when he wrote, "Utopian consciousness wants to look far into the distance, but ultimately only in order to penetrate the darkness so near it of the just lived moment, in which everything that exists both drives and is hidden from itself. In other words: we need the most powerful telescope, that of polished utopian consciousness, in order to penetrate precisely the nearest nearness."[13]

The *Millennial Project* augments the lamenting and accusatory voice of progressive environmentalism in British Columbia with its paradoxically monumental projection of a living tree far into the future. The work teaches us that we cannot produce a different, better environmentalism only through the language of lament for the disappearance of parts of nature, but we must also anticipate and imagine forward into the culture of survival. The patient optimism of the project has the utopian confidence to carry forward even the existing emblems of the Owners of Nature and include them in its vision. The camera obscura is painted "Finning Yellow," the color of the logging equipment made by this major supplier.

NOTES

1. Georg W. F. Hegel, *Science of Logic*, trans. W. H. Johnston and L. G. Struthers (London: George Allen and Unwin, 1929), 1:159.

2. Hegel, *Logic*, from *The Encyclopedia of Philosophical Sciences*, trans. William Wallace (London: Oxford University Press, 1892), p. 174.

3. Ibid., p. 175.

4. Hegel, *Science of Logic*, 1:155.

5. Rodney Graham, *The System of Landor's Cottage* (Brussels: Yves Gevaert, and Toronto: Art Gallery of Ontario, 1987), p. 19.

6. Sigmund Freud, *Beyond the Pleasure Principle* (London: Pelican Freud Library, 1985), 11:285.

7. André Breton, *Anthologie de l'Humour Noir*, 1939 (New York: French and European Publishers, 1986), p. 289.

8. It is also related to a recent small sculpture made by Graham in 1988: a lacquered wood slipcase (for a rare 1916 first edition of Ferdinand de Saussure's *Cours de linguistique générale*) the back of which articulates a Donald Judd–like progression of raised "nerves," like those which frequently decorate the spines of nineteenth-century books and which themselves functioned to cover the knots of the binding threads.

9. The phrase is borrowed from Michael T. Taussig's book *The Devil and Commodity Fetishism in South America* (Chapel Hill: The University of North Carolina Press, 1980).

10. Roland Barthes, *Mythologies*, trans.

Annette Lavers (London: Paladin, 1973), p. 116.

11. Jacques Lacan, *Ecrits: A Selection*, trans. Alan Sheridan (New York: W. W. Norton, 1977), p. 150.

12. Barthes, "The Eiffel Tower," in *The Eiffel Tower and Other Mythologies*, trans. Richard Howard (New York: Hill and Wang, 1979), p. 11.

13. Ernst Bloch, *The Principle of Hope*, trans. N. Plaice, S. Plaice, and P. Knight (Cambridge, Mass: The MIT Press, 1986), 1:12.

An Outline of a Context for Stephan Balkenhol's Work

It seems as if Stephan Balkenhol's sculpture has developed in a process of reaction against the orthodoxies of radical modernist plastic art. The double triumph of the aesthetic of the utterly fragmented form and its obverse, the militantly unified structure, a triumph which characterizes the art of the past twenty years, creates today the situation in which a sculptor might turn toward that problematic object which is always both unified and fragmented: the human body.

In the work of Beuys above all—or of Kounellis, of Anselmo, indeed of Arte Povera artists in general—the regime of the fragmentary has been fully legitimated. This fragment, be it a shard of plaster cast, a bit of sausage, or a bundle of twigs, exists as a meaningful symbol only in a context of historical and social reflection on the fate of art and its pretensions. The history of the catastrophes of our epoch, that history which Arte Povera recognized as having invalidated modern culture's earlier claims to universal truth, gave to its startling assemblages of objects the sense of power which comes from an act of scrupulous renunciation. This renunciation—of claims to any overarching authority in culture—was the prelude to a new experimentalism which excited the art of the 1960s and 1970s, and created the perspective of a new plastic language, open, tentative, and incomplete by nature, and so filled with vistas of possibility and hope.

Coterminous with this new opening up of the forms of plastic art, the tightened and disciplined works of Judd or Andre indicated that any authentically new stage of sculptural development would have to include the negative moment of the serial, the inorganic, and the predictable, in short, of all those aspects of the built environment which created the sense of alienation so endemic to the urbanism of the 1950s and 1960s.

The sculptural production of the period since about 1964 shows a constant dialectical movement between radically shattered and fragmented procedures and equally radically unified, condensed, and systematized ones. Often, these contradictory tendencies are visible in the work of a single artist, for example in that of Serra, or of Ulrich Ruckriem, who was Balkenhol's teacher in Hamburg in the late 1970s.

Both major positions exclude representation as an aim of sculpture. With few exceptions, the mimetic aspects of art are replaced with the organic creation of plastic symbolic situations, as in Beuys or Kounellis, or with nonobjective systematics, as with

Written in 1988. First published in German as "Bezugspunkte im Werk von Stephan Balkenhol," in *Stephan Balkenhol*, exh. cat. (Basel: Kunsthalle, Frankfurt: Portikus, and Nuremberg: Kunsthalle, 1988), n.p. First published in English as "An Outline of a Context for Stephan Balkenhol's Work," in *Stephan Balkenhol: Über Menschen und Skulpturen/About Men and Sculpture*, exh. cat. (Rotterdam: Witte de With Center for Contemporary Art, and Stuttgart: Cantz, 1992), pp. 98–101.

Stephan Balkenhol. *Niche Figure*. 1991. Installation view in Städelgarten, Frankfurt. Painted wood

Judd. The evolution of these tendencies in fact depends on the act of exclusion of the mimetic function from sculpture and its replacement with new, experimental directions.

Along with the mimetic function, however, there disappears something very ancient and very immediate: the potential for a spontaneous form of recognition of meaning. The image of the human body remains the most directly comprehensible emblem. Across national traditions and limitations of education and language, the recognition of the attitudes, physiognomy and gestic action of the body produces a space permanently open to philosophical plastic reflection. The process of spontaneous social recognition of meaning grounds the conditions for a reception of sculpture which breaks the new bounds of the established world of art and its orthodoxies, and permits the mass of conflicting forms of cultural literacy and desire which circulate in society to impinge directly on artistic practice, or at least on reception. This interferes with the trajectory of radical modernist plastic art, which had to counterpose itself to the "popular world" of figures and figurines, in lofty or degraded forms, which always constituted the official ideology of modern public culture. The destruction of the logos of the statue has been the continuous project of modernist sculpture since Duchamp and Tatlin. However, the resulting new forms, rooted in an erudite ideology of radical openness, have begun to display their own hardened and sanctified surfaces, their own museal pomp, their own monumental closure against the everyday world in the glamour of their triumph. In the glow of this new aura, younger artists worry that the victorious fragment has produced a universalism as dubious as the monuments it has toppled. Moreover, the fragment, which is by nature cryptic in the sense that Walter Benjamin defined, appears to have obscured the human body of the spectator him- or herself, that body whose reflection is searched for in every examination of objects.

The emphasis in the sculpture of the 1970s and 1980s on the nonbodily aspects of experience, on the experience of objects, whether fragmented or condensed, tends toward a polarized and static subject-object relationship. In this, the object, no matter how densely it is installed in a historical or semantic context, stands opposed to the body of the spectator as a theoretical thing, a thing which is at once sharply distinct from the body and which replaces it at the focal point of culture. This experience of the replacement of the body by things is an experience of essential alienation. The creation of a cutting, illuminating experience of alienation has rightly been given a central place in the project of experimental modernist art. However, the construction of a culturally reified subject-object relationship, congealed into an exclusive concentration on objects, becomes exaggerated, one-sided, and false when the spectator can no longer recognize him- or herself, as a theoretical social presence, in the world of things. During the 1980s, under conditions of a militant market-ideology in culture, the intensified glamour of the object-commodity has tended to expel the spectator from artistic space. Objects—and their representations, which are also objects—appear to populate the world of culture all on their own, and bodies, seemingly sidelined into obsolescence, can only peer into culture from a defunct exterior.

Under these conditions, the generation which has learned from Arte Povera and from Minimalism worries its way toward a reconsideration of the problem of the statue and its permanent functions as body-symbol and bearer of gestic meaning. Balkenhol, as a member of this generation, encounters again, from a new perspective, the problem of the statue's universalizing pretensions.

The traditional notion of the universality of meaning produced by the statue, particularly the nude, which had descended almost intact from the Greeks through to Rodin, was ruined decisively in the epoch of modernistic totalitarianism, when fascist and Soviet art both returned to the stereotype of the noble nude in an expulsion of the challenging forms of the early avant-garde. The aggravated new monumentalism of the nude and the uniformed hero in the work of official artists in these regimes was explicitly opposed to the experimental plastic forms of Duchamp, Tatlin, Rodchenko, or Picasso, forms in which the actual historical process of the fragmentation of the human being through the effects of the capitalist division of labor was made visible by means of mechanomorphic images in which human figures are intermingled with objects. This avant-garde mechanomorphism was unacceptable to the tyrannies of the 1930s because it managed to express a sense of the catastrophic character of the modernity within which both Russia and Germany were enmeshed. The famous mechanistic figures—Duchamp's readymades, de Chirico's *Great Metaphysician*, the Surrealist assemblages—provided means to perceive the shock and suffering which were produced in the elaboration of modernization, in which men, women, and children were tied economically to machines at the core of the production process. This perception produced an extreme reaction against the classical ideal of statuary, whose

Stephan Balkenhol. *Big Man with Green Shirt.* 1988. Paint and wood

Stephan Balkenhol. *Big Head (Man).* 1992. Paint and wood

essence was the harmonious unity of the human body. The avant-garde movements understood that industrialized modernity destroyed the social bases for such a notion of the human image, and that, under such conditions, any further promotion of the traditional ideal of statuary would be in the service of a deceptive ideology of "unity," the unity of the power-state. Thus, statuary, either nude or uniformed, collapsed as a legitimate sculptural form. Its place was taken by practices specifically antithetical to it, practices which investigated the spaces which were opened by the statue's disintegration as a valid emblem of the ideal state. The new practices themselves, in their programmatic openness, their refusal to establish firm boundaries between exterior and interior, sought to emblematize a different state, a more democratic, ecological one rooted more securely in the fragile life experiences of concrete individuals.

But the utopian impact of radically open sculpture has waned. The evident capacity of the fragmented structures of the 1970s' plastic art to function as decorative elements in the grand museological complexes of the art world of the 1980s raises the question of how these object-clusters transcend the condition of art-commodity and retain a sense of profound meaning, however conditional. The newer "post-Conceptual" object-art, which revels ironically in its commodity status, has aggravated the kind of doubts raised by the art which preceded it. It has not created these doubts; rather, it parasitically feeds off them, against a backdrop of social despair and complacency. The possibility of recovering the potential of the statue as an emancipatory body-symbol, one which could take up the project of experimental sculpture, not dispense with it, depends on its reappearance as a specifically de-universalized emblem. The statue form cannot again intervene in sculpture by simply re-assuming its function as model of a human ideal, as in classicism. Neither can Expressionism's

inversion of this classicism, the idealism of exemplary suffering, provide an answer. At the same time, the nightmare history of the uniformed statue precludes a direct reinvention of the emblematic *figura* of an occupation or role in life, such as was accomplished so impressively by nineteenth-century sculpture in the tradition of works such as Constantin Meunier's *Blacksmith*. The new statue, as it might now be proposed in Balkenhol's work, is rarely nude, and it carries no attributes of occupation, labor, or engagement. It develops as an incompletely particularized human figure, neither wholly shrunken into meager individuality and solitude, nor a transcendent *Denkmodell*, either classicistic or Neo-Expressionist. It is, strictly speaking, a monad: an isolated, condensed being, sharing some of the romantic symbolism connected to the image of the solitary tree out of which it is carved.

Balkenhol's pale monadic figures, isolated from both universality and concrete social individuation, usually appear before us simply attired, in a dress or trousers and a shirt. They are like people who have recently come out of the hospital after a serious illness, who cannot yet really return to active life but who can get dressed normally and face things again. Like convalescents, their primary occupation is to complete their recovery. Soon they may take up their tools and reenter their complex, stressful social relationships. The emotional world of these sculptures is arrested by their historical-aesthetic position: they are centered between a possibly volatile renunciation of the radical negations which brought the experimental forms of the 1970s into prominence, and a thoroughgoing restoration of the idea of the socially emblematic human figure as it really must live, work, and suffer in the cities of 1988.

Balkenhol's sculptures suggest that the monadic figure may be freed from its old identity as universal abstract emblem, and so could exist not as a nostalgic residue of a past form of unity, an oppressive reminder of the "good old days," but as a dialectical interrogation of the unachieved harmony of the existing world. Distressed by the apparent decay of open-form sculpture into cultural decor, Balkenhol's figures attempt to stand outside open form. His monad is thus a counterexperimental form, obliged to interrogate the language of experimental sculpture, to contemplate its peculiar silences from the viewpoint of the familiar human body. This is a body which has been erased in the stresses of the struggle for the negation of oppressive, frightening statues, statues of colossi.

Photography and Liquid Intelligence

In *Milk*, as in some of my other pictures, an important part is played by complicated natural forms. The explosion of the milk from its container takes a shape which is not really describable or characterizable, but which provokes many associations. A natural form, with its unpredictable contours, is an expression of infinitesimal metamorphoses of quality. Photography seems perfectly adapted for representing this kind of movement or form. I think this is because the mechanical character of the action of opening and closing the shutter—the substratum of instantaneity which persists in all photography—is the concrete opposite kind of movement from, for example, the flow of a liquid. Rodney Graham has expressed this perfectly in his *Two Generators*, which shows a river flowing at night under artificial illumination. There is a logical relation, a relation of necessity, between the phenomenon of the movement of a liquid, and the means of representation. And this could be said to be the case with natural forms in general: they are compelling when seen in a photograph because the relation between them and the whole construct, the whole apparatus and institution of photography is of course emblematic of the technological and ecological dilemma in relation to nature. I think of this sometimes as a confrontation of what you might call the "liquid intelligence" of nature with the glassed-in and relatively "dry" character of the institution of photography. Water plays an essential part in the making of photographs, but it has to be controlled exactly and cannot be permitted to spill over the spaces and moments mapped out for it in the process, or the picture is ruined. You certainly don't want any water in your camera for example! So, for me, water—symbolically—represents an archaism in photography, one that is admitted into the process, but also excluded, contained, or channelled by its hydraulics. This archaism of water, of liquid chemicals, connects photography to the past, to time, in an important way. By calling water an "archaism" here I mean that it embodies a memory-trace of very ancient production-processes—of washing, bleaching, dissolving, and so on, which are connected to the origin of techne—like the separation of ores in primitive mining, for example. In this sense, the echo of water in photography evokes its prehistory. I think that this "prehistorical" image of photography—a speculative image in which the apparatus itself can be thought of as not yet having emerged from the mineral and vegetable worlds—can help us understand the "dry" part of photography differently. This dry part I identify with optics and mechanics—with the lens and the shutter, either of the camera or of the projector or enlarger. This part of the photographic

Written in January 1989. First published in French and English as "Photographie et intelligence liquide"/"Photography and Liquid Intelligence," in Jean-François Chevrier and James Lingwood, *Une Autre Objectivité/Another Objectivity*, exh. cat. (Milan: Idea Books for Centre Nationale des Arts Plastiques, Paris, and Prato: Centro per l'Arte Contemporanea Luigi Pecci, 1989), pp. 231–32.

system is more usually identified with the specific technological intelligence of image-making, with the projectile or ballistic nature of vision when it is augmented and intensified by glass (lenses) and machinery (calibrators and shutters). This kind of modern vision has been separated to a great extent from the sense of immersion in the incalculable which I associate with "liquid intelligence." The incalculable is important for science because it appears with a vengeance in the remote consequences of even the most controlled releases of energy; the ecological crisis is the form in which these remote consequences appear to us most strikingly today.

Now it is becoming apparent that electronic and digital information systems emanating from video and computers will replace photographic film across a broad range of image-making processes. To me, this is neither good nor bad necessarily, but if this happens there will be a new displacement of water in photography. It will disappear from the immediate production-process, vanishing to the more distant horizon of the generation of electricity, and in that movement, the historical consciousness of the medium is altered. This expansion of the dry part of photography I see metaphorically as a kind of hubris of the orthodox technological intelligence which, secured behind a barrier of perfectly engineered glass, surveys natural form in its famously cool manner. I'm not attempting to condemn this view, but rather am wondering about the character of its self-consciousness. The symbolic meaning of natural forms, made visible in things like turbulence patterns or compound curvatures, is, to me, one of the primary means by which the dry intelligence of optics and mechanics achieves a historical self-reflection, a memory of the path it has traversed to its present and future separation from the fragile phenomena it reproduces so generously. In Andrei Tarkovsky's film *Solaris*, some scientists are studying an oceanic planet. Their techniques are typically scientific. But the ocean is itself an intelligence which is studying them in turn. It experiments on the experimenters by returning their own memories to them in the form of hallucinations, perfect in every detail, in which people from their pasts appear in the present and must be related to once again, maybe in a new way. I think this was a very precise metaphor for, among many other things, the interrelation between liquid intelligence and optical intelligence in photography, or in technology as a whole. In photography, the liquids study us, even from a great distance.

Roy Arden: An Artist and His Models

I

In Roy Arden's archival works of the 1980s, local history is depicted under the sign of catastrophe. The derailed locomotives, impounded vehicles, smashed windows, and beaten protestors, the dismembered festivals, the silenced and furious citizens pronounce the lesson of the civic archive: local history is determined by the "world historical," that phantom of high conflict which, like plague, visits places and brands memory with their names.

For Arden, "genius loci" is constituted of small bits and pieces of feelings of pain and loss. The emblematic event is dispossession, and one could claim that all his archival pieces are allegories of dispossession, in which the conflicts and defeats of British Columbia's past are depicted as splinters of the panorama of runaway modernity, which has become the radically serious image of history and historicity established by modernist art and discourse.

In works like *Rupture* and *Abjection* (both 1985), Arden forced together two types of photograph—reprinted archival negatives and monochrome panels. In *Abjection*, the monochromes were made by exposing photographic paper directly to light; in *Rupture*, by photographing a clear blue sky. Monochromes are always emblems, and these monochromes are emblematic of the historical tempest which causes crisis and defeat, but which cannot be photographed directly, only indicated allusively and theoretically. The effect of this evocation of sublimity is to cast down the pictures paired with the monochromes onto a sort of rubbish-heap. This heap is the local, ravaged by the global. It is exemplified by the figure in *Rupture* who has been tossed into the gutter by the police, and who gazes lamely across the square on which he has been depicted toward the storm that has blown him down. The lump, the ripped and scattered remnant, the crumpled shred, are the foundation stones of Arden's iconography and his philosophy of form. His taste for broken and ignoble shapes reflects his interest in photographers like Wols and Heinrich Zille, and in the problematic of *Sachlichkeit*. The German word *Sachlichkeit* is usually translated as "objectivity," as in *Neue Sachlichkeit* or New Objectivity, that "cool" art movement of the later 1920s and 1930s, which contested the aesthetic of rhythmic expressivism which characterizes both Expressionism and productivism, and which makes them seem like opposite sides of a single coin.

Interest in the *sachlich*, the neutral, the thinglike, implies an acceptance of the failure of rhythm in the world, and the impropriety of one of representation's grand

Written in 1993. First published as "An Artist and His Models" in *Roy Arden*, exh. cat. (Vancouver: Contemporary Art Gallery, 1993), pp. 5–26. Reprinted here is the revised version published in *Parachute* (Montreal) no. 74 (April–June 1994): 5–11.

Roy Arden. *Rupture* (detail).
1985. One of nine diptych
panels, silver dye bleach and
gelatin silver prints, 28⅛ x 17⅛"
(71.5 x 43.5 cm). Vancouver
Art Gallery

Roy Arden. *Rupture*. 1985.
Nine diptych panels, silver
dye bleach and gelatin silver
prints, each: 28⅛ x 17⅛" (71.5 x
43.5 cm). Vancouver Art
Gallery

projects, the negating of this failure in an "aesthetic dimension," to use Herbert
Marcuse's phrase. When a thing is broken and thrown on the refuse heap, it falls off
the highroads of history. The bold, fresh lines of movement no longer refer to it, its
contours slump, its volumes are crumpled, its surface withers, its defeat as a part of
the livingness of life and being is manifest, and it becomes an object of aversion,
cadaverous and abject. It is at this moment that it truly comes into being as an object.
The *sachlich* marks the category of things in their alienated state; that which is *sach-
lich* is that which has been expelled from a certain universe of form and rhythm and
which has, possibly imperceptibly, begun its migration to another one.

That universe is something akin to the mainstream of idealist and Romantic
aesthetics of modern art. On this highroad, the work of art tends to be composed as
an expression of the dynamic unity of nature. In this perspective, a work whose
theme might be the conflict between its elements formulates that disunity on the
basis of a rhythmic ground which binds, stages, and contains the conflict. The work
is thus a transcendental ground of a disunity that does not envelop it, but which, on
the contrary, is recovered from its potential formlessness and brutality by the dance
of its own rendering, composition, and expression. This allows us to claim that, in a
work of art, nothing is destroyed, even, and especially, that which is depicted as being
or having been destroyed. This is the basis for the idealist tradition's claims for the
healing and redemptive character of art.

But this manner of redemption is contested by the *sachlich*, and its corollary, the *informe*, the formless (derived in France contemporaneously with the *sachlich* by Georges Bataille in his critique of Surrealism).[1] The contestation is not over an aesthetic of redemption as such. Rather, the folds of the concept are deepened during this period. Arden's reworking of *Sachlichkeit* moves redemptive aesthetics toward an encounter with wounds which will not heal, no matter how much care and observation are devoted to them. In incorporating the incurable and irreparable injury, an aesthetic of catastrophic facticity is able to make visible the unwitting cruelty of an art whose emphasis is on the wholistic, without thereby renouncing either the opposition to cruelty or an interest in the unity of a work. In Arden's archive, the rage of the wounded and defeated character or thing is not calmed. The sundering of the work into two irreconcilable panels, the fracture at the interior of the visibility of the images displayed, and the constant presence of an emblem of indifferent force are the formal means by which he configures a state of pain.

Although this configuration is recognized as a work of art, historically legitimating the pain it displays, the experience of pain is not relieved and does not permit the beholder to assume that recognition and legitimation guarantee the transfiguration of those who suffer. The work of art brings into view the deep humiliation of the victim, but does not evoke a state beyond victimization. Arden's works reflect the difficult and unstable situation of a culture built, as it must be, on the legitimate rage of victims, and so challenge art's reputation for having curative powers. *Sachlichkeit*, in the sense he brings to it, suggests that art cannot redeem the victim, who will always be marked as such, and will bear the mark as the black glyph of sovereignty. Art's aim is to remove the victim's crown and to depict his wounds in a secular construction. In the forms thereby revealed—that of the hurt itself, and that of the work of art that makes it visible—history is evoked as a process which cannot be comprehended in terms of hurt and the joy of healing. An artist is not a doctor. In art, the past is not displayed as healed, but as being in the process of creating symptoms which we will experience in the present, or as the present, the present moment in which the work is looked at.

Arden's purpose in combing the civic archives, then, is to transform our experience of the city's present moment and to make that transformation visible as a symptom of our absorption in a historical process of conflict and dispossession, a process in which we have come to exist as citizens, cohabitants, and reproducers of the city. This conflict is modernity and, though expressly not registered in the orthodox Romantic aesthetics which still dominate artistic thinking in British Columbia, is the great unifying and dissonant rhythm which "rhythmic" art cannot abide. Artists and spectators in Vancouver are beginning to pay attention to our own brutal Romanticism, in which vain recreation on mountain, beach, and island betrays its triumphalism, its exultation over the battering nature can take from us and still present its soothing, healing mask. This apparition of nature is the spell cast on B.C. people by the genie

of the world market, who blows hurricanes of surplus value and failed sovereignty through the place. From under the spell, nature is naturally experienced as dynamic rhythm, joyful movement, dance—as the prophetic "compulsion of rhythm" which, as Nietzsche says in *The Gay Science*, "binds the future." In that book he also asks, "What could have been more useful for the ancient, superstitious type of man than rhythm?"[2] This type of man—a priest, a poet, a doctor—sets cultures on the path of maya, prophecy, and the sacred. Nietzsche locates the "origin of poetry" in the use of rhythm to gain the ear of the gods. In a place farthest from that orifice are resettled those who lack this kind of rhythm, or who have lost it. Arden opens his archive somewhere in this neighborhood, where countertraditions are fabulated.

II

During the past four or five years, Arden's interest has shifted away from the archival model of photography toward another which could be referred to as the "photojournalistic model." The idea of a model of practice informs his thinking, and, in order to study the character of the new photographs, we must look at the idea of such a model, and then at the specific model or matrix of models with which Arden is involved. It is possible, analytically, to identify at least three such principal structural models in contemporary photography, or art-photography: the "archival," the "photojournalistic," and the "cinematographic."[3]

Strictly speaking, "archivalism" abjures the making of new photographs and commits its practitioner the liberty only to re-present existing material. The redesign of the mode of presentation and the development of principles of selection become the central artistic problems. Arden, of course, was never a "pure" or "hard" archivalist, although he has made some of the most significant archivalist works of the last decade. In those works, his own photographs are not registered as pictures, but as emblematic monochromes made through a sort of "elementalism" which emphasizes the fundamentals of the photographic process and misleads us into thinking that Arden is not "being a photographer."

The problem of "being a photographer" is, of course, fundamental to any model-making thought about photographic practices, since the models propose identities for those who work within them, or at their boundaries. From this perspective, "being a photographer" tends to mean making pictures "as if one were conforming to the model in question." That is, the notion of a model of practice implies an experimental treatment of procedures, relations, and the identities conventionally associated with them. Thus, artistic work in photography involves a mimesis of prevalent concepts of what the medium is, or can be. For example, an archive is, properly speaking, the construction of an institution operating over time according to rules, protocols, and traditions. An individual photographer might hypothesize a practice which resembles the construction of an archive. August Sander in the 1930s or, more recently,

Bernd and Hilla Becher are examples of this. Rather than accepting that what is being done is in fact the construction of an archive, however, we must instead focus on the act of mimesis which is taking place in order for the photographer to create a body of work. This suggests that artists are able to make photographs in a process of imitation of the overlapping institutional and generic networks by means of which photography is known, and that their pictures are valid artistically insofar as this imitation is visible in them. Arden's work of the 1980s did set in motion this sense of mimesis, and so participated in the project of critique with which archivalism is associated. Nevertheless, concealed within this identity are others, which have emerged slowly over the past several years.

If there could be said to be a dialectical structure for the photojournalistic model, it is organized in terms of an opposition between the prosaic and the poetic. Written journalism has consistently been thought of as the exemplar of prose, and, since Mallarmé, as the fundamental antagonist of poetry. The prosaic came to signify the regime of instrumental rationality, of means-ends calculation, in which all things obtain a fixed, positive identity through their inscription in a mechanistic system of utility and exchange. The poetic flowered through a withdrawal, a secession, from instrumentalism and positivism, and the conflict between the lyrical, intellectual poet and the cynical, effective journalist—the person Nietzsche called a "moral prostitute"—has been staged in these terms since Baudelaire's time.

The prestige of written journalism obscured perception of the fact that its prosaic literary structure was not simply augmented by photography. Classical discussions about photography in its first half-century concentrated on the factographic, indexical nature of the image. This scientific and objectivistic concept of photography yoked it to the kind of positivism upon which what one might call journalism's "grammatology" was constructed. This reflected the social subordination of the photographer to the writer, something that has characterized the institution of journalism throughout its history.

The "postclassical" period of photographic theory and debate, which opened in the 1920s, emphasized the distinction between the prosaic mode of written journalism, and another mode which characterized the experience of photographs. This new mode is more and more identified as poetic, or at least, as more like poetry than prose. André Breton's novel *Nadja*, published in 1928, is one of the most incisive formulations of this new sense of the complicated relationship between photograph and text, and Breton's use of Jacques-André Boiffard's extremely "straight" pictures to illustrate his prose-poem established a new prototype. A few years later, when Walter Benjamin contemplated the dialectical conflict between a photograph and its caption, the first analytical conclusions were drawn from the Surrealists "photographic" critique of prose, conclusions which determined one of the most significant directions taken by the discussion of photography for the next fifty years.[4]

The distinction between picture and caption implies a distinction between the photographer and the writer of captions, a prose writer. It further implies that, since the caption is prosaic, the photograph may not be. Indeed, it implies that the photograph probably cannot be. For, if it were, the need for photography in journalism would never have arisen, since, if photography were structured like prose, it would not be likely to add anything significant to a prose account. But, photography not only added something significant to journalism, but can be said to have transformed it altogether.

In the earlier explanation of the medium's documentaristic validity, it was claimed that photography resembles controlled prosaic depiction because it is a scientific, collective production whose results are obtained by means of the setting in motion of natural processes in the form of technology. It not only participates in the increasing rationality of the modern world and culture, it is emblematic of the rationalization of what previously could only be articulated at all through the idiosyncrasies of art. This indexicality seemed to resemble the identification of prose journalism with a factual account, a genre of writing whose legitimacy is rooted in the controls it displays over idiosyncrasy, which it defines as inaccuracy. Journalism defines prose as controlled and reviewed writing, and the validity of its factual accounts is established by the structure of editorial review, which tests written material according to historically evolved (and, admittedly, continually evolving) social and political criteria, criteria which editors never tire of reiterating in their editorials.

What Breton's experimental novel revealed was that the identity of prose journalism and photography was an illusion, albeit a socially necessary one. The striking effect of this on the level of theories of representation was the sense that photography is not structured like prose. This hypothesis suggested ways in which one could articulate the affinity of photography and journalism, based on the notion that they are fundamentally unlike processes related dialectically as a conflict and interpenetration of opposites.

The experience of a photograph is an experience of the immediate and the simultaneous. Any occurrence, recorded photographically, is seized in the process of its development or unfolding and made available as a synchronic construct, a single condensed phenomenon in which all the unconcluded energies of movement and interaction are arrested as a pattern. This patterning is the means by which photography resembles earlier forms of pictorial art, in which the illusion of an occurrence or event was constructed by means of an act of composition. As a synchronic phenomenon, photography has a necessary, and necessarily dialectical, relationship to the phenomenon of the event, to the diachronic, to the narrative, the chronicle, the account. It cannot, fundamentally, formulate an account; a photograph can be interpreted as having a relationship with an account or a narration only by means of an analysis of its technical incapacity to encompass such structures. This analysis might be called a "narratology" of photography. The experience of photography is associative and

Roy Arden. *Pneumatic Hammer (#2)*, *Vancouver, B.C.* 1992. Chromogenic color print, 40 x 50" (101.6 x 127 cm). Los Angeles County Museum of Art

Roy Arden. *Landfill, Richmond, B.C.* 1991. From the series Landscape of the Economy. Chromogenic color print, 6 x 7' (182.9 x 213.4 cm). The Museum of Modern Art, New York. Purchase

simultaneous, and in this respect it resembles basic modern concepts of the poetic employment of language. In poetic writing, meaning is not built by means of a consistent pattern of controlled movements along lines organized as sentences; rather, the poem is made of lines which typographically may resemble sentences but which lift the requirement to be read the way sentences are read. This is a form of writing and reading which relinquishes any necessary relation to the chronicle and to the chronological concept of an act of writing or reading. For example, when Roland Barthes developed his concept of photography in the opposition of "studium" and "punctum," he was formalizing aspects of a "poetics" of photography.[5]

It is this sense of the structural unlikeness of photography to prose which established a deep foundation for the dramatic antagonisms which have characterized the history of photojournalism, or at least the history of the photojournalist's path to self-recognition as an artist, an artist maybe of a new type, an artist in a new social position, whose life and career constitute a new social or cultural drama.

This new drama is rooted in the inner conflicts of photojournalism as an institution, in the context of the other autonomous institutions of modern society and its culture. The new form of artist or artist-figure which emerged in this process was the photographer-employee who for various reasons abandons his employee status, strikes

out on his own and confronts the market for pictures directly, as a free agent, a free-lancer, a picture-maker who works "on spec" for a variety of possible clients or purchasers. The career of Walker Evans is exemplary here. Evans did much of his major work in the context of assignments from magazines like *Fortune*, and from the U.S. government during its most liberal period. His situation was extraordinary because of the experimental attitude of his editors, and, consequently, the relative freedom he was permitted. For Evans, it was a short step from magazine work to open, personal experimentation supported by other employment or government grants—that is, into the economic situation most characteristic of the fine artist in the free market.[6] Evans, and others like him, identified the open situation of the speculative picture-maker with the poetic condition of photography as art, and, working across the hazy boundary between employee and independent agent or contractor, enacted once again a fundamental social condition of modern art. At the beginning of the modern period, the traditional fine artist also passed through this development, breaking from the state academic system out into the uncertain world of capitalist culture, ruled by public opinion, fashion, and anxiety—that is, ruled by the press.

So, ironically, the photojournalist, having discovered that he, or his forebears, was instrumental in bringing into existence the modern art world and shaping the lives and characters of its occupants, must himself pass through this same development, but, historically speaking, for the second time. Here we recognize that the journalist-photographer is in a mimetic relationship to the modern artist, and must experience the passage from employee to speculative producer at secondhand, that is, dramatically. He follows a path trodden once before. Photojournalism's path to self-consciousness involves its mimesis of the idea of the artist as it was constituted by the aesthetic thought of the nineteenth century and later brought under intense critical scrutiny by the avant-garde of the 1920s and 1930s.

Thus we can see that around 1930 there had come into being an art-concept of photojournalism, which is something quite different from photojournalism itself. This concept was the outcome of the experiences of people like Evans, who expressed their own ambivalent sense of self-identity by playing with the boundary between photojournalism as such and photojournalism as a concept within the context of modernist art theory and practice. This play of ambivalence was the new form of answer to the question "Is photography art?," framed as it was by avant-gardists like Benjamin, who recognized the ways in which photography's development and increasing sophistication reconstituted the concept of art altogether.

This art-concept of photojournalism, we can call, along with Roy Arden, the "photojournalistic model," which takes its place as one of the fundamental manners in which photography operates as modernist art. We recognize it, then, as one of the most significant productions of the avant-garde of the earlier part of this century.

Our relations to that first avant-garde, or "historical avant-garde" as Peter Bürger

calls it, seem to have been changed historically to the point where it is not possible anymore to reenact the avant-gardist mimesis of modern art by means of photography. The art-concept of photojournalism, as it was popularized by successive generations of photographers and became one of the principal arenas for lyrical expressive activity in the work of people like Brandt, Klein, Frank, or Friedlander, subsequently underwent a "second critique" at the hands of the generation of the 1970s and 1980s, a critique animated by new political suspicions about the culture which sustained and valorized avant-gardism, and by Derridean and Foucauldian concepts of representation and writing.

In this process, the injunctions brought to bear against unmediated expressivism in art in general were focused intensely on the art-concept of photojournalism, or what has been called "art photography." The deconstruction of the creative aspects of art photography in the work of critics like Craig Owens, Allan Sekula, or Abigail Solomon-Godeau emphasized photography's inscription in systems of power and control, of commerce, disinformation, and the fetishism of technology. The Foucauldian thesis of "power-knowledge" invalidated the notion of a radical poetics of photography as Breton or Rodchenko had articulated it, and left-Benjaminian critics began their project of an immanent critique of the metaphysical presumptions of Western avant-gardism.

The most striking artistic reflection of these critical ideas was, of course, appropriationism, or, technically speaking, rephotography, as practiced by people like Sherrie Levine or Richard Prince in New York. Rephotography proclaimed that all the photographs that could mean anything not only had already been taken, but that the process of institutionalization to which they had necessarily been subjected had already falsified their meaning and invalidated the emancipatory projects upon which the ethical world of their poetic project was founded. The new project was to drain the aura of meaningfulness from photographs in general, and reveal them as generic products of a network of systems of power. This effect could be most strikingly achieved in a demolition of the special aura of art photography. The frailness of this aura, its roots in the ambivalence of the earlier avant-garde, meant that the new critique would be extremely effective because it reiterated the doubts held by that earlier vanguardist generation, doubts which had set the whole process of art photography in motion in the first place. Although some of the more spectacular effects of this new critique were achieved in relation to the mass media, as in the work of Barbara Kruger, the dismantling of the poetic basis for art photography is the more profound problem.

In his response to this, Arden has been guided in part by the example of Dan Graham, whose entire photographic oeuvre is a central point of reference for an understanding of the historical evolution of the photojournalistic model since the mid-1960s. Graham has been influential in turning attention away from a subjectivistic

interpretation of photojournalism and, to that extent, in recovering important aspects of the vanguardist problematics of Walker Evans's work.[7]

Graham's strictures on his own photojournalism have guaranteed that it exists always on the kind of boundary established by the ambivalence of figures like Evans, that it be art only in a negative and self-dramatized way—but that it be art unequivocally in that way.

Graham draws from photojournalism proper the category of utility, linked with that of investigation and witness. In foregrounding the practical and socially informative aspects of his photography, he is able to establish conditions for picture making which, while involved with pictorial issues, avoid any reengagement with pictorialism. The problematic sense in which Graham's pictures are and are not ends in themselves, the feeling that they serve some social purpose, some new productivist program, is at the root of any validity they achieve as a critical statement, "text," or expression. Graham's work reveals the poetic character of photography's usefulness. Arden is taking this notion further into the domain of aesthetic appearance and the autonomous condition of the picture, a point somewhere between Graham and Andreas Gursky.

Graham's casualness and rough technique are aspects of his project of destabilizing genres and institutions, and reveal the countercultural and vanguardist legacies in his work. In contrast, the enlargement and formalization of Arden's images reflect his awareness of the new pictorialist tendencies of the 1980s. As his pictures are made slightly grander, sharper, and more strictly composed, they approach the generic boundary of the poetic utilitarianism mapped out by Graham and his photojournalistic precursors. They seem to wish to appear as autonomous pictures, thereby reminding us of Atget, Sander, or Robert Adams. But where Gursky or Thomas Struth take their photographs over the divide, into the realm of the Salon, Arden, like Graham, halts at the threshold. His photos hover just at the point of resembling autonomous works of pictorial art. They reflect both the moment at which photojournalism becomes art, and the last one in which it remains lyric, miniature, and utilitarian—that is, in which it remains reportage.

Arden has troubled himself about this maybe more than any other artist. This concern has animated his evolution from a rigorous archivalist position toward one which regrounds itself in a practice of representation, and of art as fundamentally representational. But his sense of representation is one which articulates itself, its own criteria of validity, by means of his deliberate, experimental refunctioning of the art-concept of photojournalism. This movement was anticipated in what we could call the "photojournalistic elementalism" of the monochrome panels of his archival works.

The fact that Arden made his monochromes by purely photographic means suggests that they were conceived to function as boundary-markers in which his ideas about art-photography and its poetic, even allegorical, nature could be tested out. Undoubtedly, the monochrome as a form of art is by nature a boundary phenomenon.

For Arden, the threshold is that between the extinction of active photography in the melancholic, splenetic scrutiny of past as catastrophe, and a resumption of representation in the "now" of accelerating modernity. This was expressed in *Rupture*, where the archival photos are the "then" and the blue squares of sky the "now," and this bifurcated organization repeats itself in several other works of that group. So, the reasoning goes, if the monochrome is "now" and it is a photograph, it cannot be different, as such, from any other photograph of "now." Later, as the mantle of historicity, or "historification," enfolds it, it will become a "then," and then its difference from the "then" of its other panel will be weakened. The monochrome panel becomes identifiable as the mode of photojournalism resorted to by people committed to scrutiny of the kinds of images made by the generation for whom the art-concept of photojournalism was a means of liberation—that is, the generation of 1938, the year in which the archival photos in *Rupture* were made, the year The Museum of Modern Art exhibited and published Walker Evans's *American Photographs*.

Arden's movement from scrutiny to representation implies that, in the "now," the legitimacy of practices of representation as a concept of art derives from their historical origins in practices of critical scrutiny, in critiques of representation. It is in this sense that a contemporary assumption of a practice of representation cannot be seen as a "return" to anything which precedes the critiques elaborated first by the historical avant-garde, and then by those who have subjected avant-gardism to a "second critique." Arden's photographs enter into mannerisms necessitated by the peculiar relations between representation and its critiques. Representation, as an institutionalized practice, or concept of practice, can be thought of as being constituted by this relationship. One could put it more strongly, and say that what now can legitimately be called representation is *only* that which is constituted by this relationship.

Despite the rhetorical and politicized character of much of the discourse of the past ten or fifteen years, the critiques of representation that developed in that time did not accomplish their apparent aim of invalidating the practice. That aim, however, may only have been an apparent one, an effect of the inevitable exaggerations of political rhetoric. The statist, patriarchal, and phallocentric characteristics of the cultures which invented and sustained both classical representation and its modernist successors have of course been brought out emphatically by the new critiques, and the current state of research and debate continues these projects. Such essentially political and ideology-critical analyses, however, have not disturbed the cultural or aesthetic validity of the practice of representation as such, and have had only a limited effect in the area of reception theory.

One of the factors in this is the fragility and limitedness of the contestatory artistic models put forward by the champions of the "new iconophobia." Rephotography, contextualism, and new, more suave versions of productivist strategies have worked out their problematics very quickly, lapsed into epigonism, and lost the angle of attack

they enjoyed at the beginning of the 1980s. What persists at the center of the debate are not, paradoxically, the recent "alternative" forms, but the representational forms which can uniquely sustain over time the intensity and sophistication of the theoretical and critical energies which were released, apparently, against representation. This, and the complexly flawed structure of the critiques themselves, suggests that their most significant consequence is the increased self-awareness of the practice of representation itself. Thus the famous "crisis of representation" cannot be thought of as one in which the legitimacy of representation as such is at stake, but rather as a new stage in the development of that practice, one which interrogates it profoundly and experiments with alternatives, often in the name of postmodernism and of poststructuralism. These alternatives lead in new directions, but do not succeed in disturbing the foundations for the centrality of representation in modern culture and art. The crisis is comprehensible primarily as an immanent dialectical condition of representation itself, one which emerges under some new historical conditions and imposes new priorities. What might be called the "iconophobic critique" of domination signifies a new sophistication of modernist cultural and critical thinking, a widening of thought into realms of volatile negativity and dialectical method, but not a dissolution of representation and its corollary, law. In fact, it does not yet signify anything more than a recognition of the lawlike character of representation, its kinship with the legalistic spirit.[8]

Arden is an artist who has recognized himself as one of those who, struck by the disappointing results of "new critical" art forms or styles, has been obliged to investigate anew the validity of representational practices. His new photographs put into play the problematic status of the art-concept of photojournalism, and thereby, mimetically, in a conscious dramatic action carried out in a specific and politically charged local context, reestablish a poetic notion of photography as a mannerism with truth value.

NOTES

1. Georges Bataille, "Formless" (1929), in *Visions of Excess: Selected Writings, 1927–1939*, ed. and trans. Allan Stoekl (Minneapolis: University of Minnesota Press, 1985), p. 31. The photographer whose work has the closest affinity with Bataille's notion is Wols.

2. Friedrich Nietzsche, *The Gay Science* (1887), trans. and ed. Walter Kaufmann (New York: Vintage Books, 1974), p. 140 (Book II, Section 84).

3. Regarding the "cinematographic model" see M. M. Baktin, "Epic and Novel," in *The Dialogic Imagination: Four Essays*, ed. Michael Holquist, trans. Caryl Emerson and Michael Holquist (Austin: University of Texas Press, 1981).

4. Walter Benjamin, "The Author as Producer," 1934, reprinted in *Reflections*, ed. Peter Demetz, trans. Edmund Jephcott (New York: Harcourt Brace Jovanovich, 1978), pp. 230–31.

5. Roland Barthes, *Camera Lucida: Reflections on Photography*, trans. Richard Howard (New York: Hill and Wang, 1981).

6. See *Walker Evans at Work*, with essay by Jerry L. Thompson (New York: Harper & Row, 1982).

7. See the exhibition catalogue *Walker Evans and Dan Graham* (Rotterdam: Witte de With Centre for Contemporary Art, 1992), with essays by Jean-François Chevrier, Allan Sekula, and Benjamin H. D. Buchloh.

8. A developed discussion of the issue is presented by Gillian Rose in her books *Hegel Contra Sociology* (London: The Athlone Press, 1981) and *Dialectic of Nihilism: Post-Structuralism and Law* (London: Basil Blackwell, 1984).

Monochrome and Photojournalism in
On Kawara's Today Paintings

We can begin to study On Kawara's paintings with the observation that he has written something on a monochrome. This is different from writing or lettering something on a blank surface or an empty piece of paper. For us, a new piece of canvas is not blank, though a new piece of paper or a new piece of foamcore might be. A new piece of canvas is already a monochrome; that is, it is already a certain kind of painting. I'm sure I don't have to rehearse here all the reasons why this is so, except maybe I should say that it is the historical identity and character of what we call "avant-gardism" that compels us to experience an empty canvas this way. Perhaps I should also say that the aesthetic categories created or revolutionized by the avant-garde have become objectivities for us, inescapable and necessary structures, transcendental conditions for the experience of works of art.

More than any other single type of painting, the monochrome marks a threshold. The moment the figure-ground relationship is suppressed or transcended is the moment we break with the whole tradition of figuration, of art as essentially figuration. When Rodchenko produced his "tri-monochrome" *Pure Red Color, Pure Yellow Color, Pure Blue Color* (1921) he proclaimed that with this gesture a new artistic and cultural model had come into being. The new art form leaves behind the introversions of representation and illusionism, the world of craft, wizardry, and isolation, a neurotic world of substitution. It breaks away from "bourgeois art," which it interprets as the art of all ruling groups isolated from humanity as a whole. It recognizes everything that nineteenth-century art had inherited from the aristocratic cultures of the past, all the political cynicism in the manipulation and metamorphosis of power symbols that once had been the prerogative of kings but that had fallen into the hands of ordinary citizens in the new democracies of modern times. Rodchenko's model of painting was a critique of bourgeois aestheticism and was based on a radical critique of bourgeois democracy.

For the avant-garde of the 1920s, the revolution created the conditions (or the "preconditions") for new cultural models, new models of creation, production, and literacy. The existing models, the bourgeois forms of art, were redefined as "obsolete." They correspond to what Marx called "the prehistory of humanity." The "death knell" for painting was sounded by the new kinds of sovereignty established in modern constitutional states, and the new technologies produced by capitalist inventiveness. By

Written in 1993 and delivered as a lecture at the Dia Center for the Arts, New York, on December 16, 1993. First published as "Monochrome and Photojournalism in On Kawara's Today Paintings," in Lynne Cooke and Karen Kelly, eds., *Robert Lehman Lectures on Contemporary Art* (New York: Dia Center for the Arts, 1996), pp. 135–56.

On Kawara. *Monday, Dec. 17. 1979*. Synthetic polymer paint on canvas, 18¼ x 24⅜" (46.2 x 61.7 cm). The Museum of Modern Art, New York. Blanchette Hooker Rockefeller Fund

the 1920s, all the historical, social, and spiritual projects associated with the skilled practice of figuration had been completed. The monochrome is the last glance, the last moment of the great figurative, musical, poetic art of painting.

Had Rodchenko's social revolution not been unsuccessful, the whole generic structure of art would have been radically transformed, presumably in the direction of a more complete, more symphonic, more synaesthetic productivism, an emancipated play-structure of environmental aesthetics. But because this did not happen, and because bourgeois art continues, the monochrome remains the boundary-marker of a point we have not been able to reach, a reminder of the culture we have not been able to create. As such, the monochrome stands outside painting, outside all genres and all aims of painting. It stands as a reflection of the historically completed character of all genres, all projects undertaken as figuration.

The special status of the monochrome implies that the incomplete social transformation of art is now the transcendental ground for the continuation of all actually existing genres of painting. The continuation of the genres is a mark of the arrested state of historical transformation and progress. From this viewpoint, all the genres now continue through the act of putting something on top of a monochrome—by effacing, supplementing, or disfiguring a monochrome. Thus, all painting is by definition a return to painting, a revival or restoration of it.

The act of putting something on top of a monochrome is, then, the act of resuming the development of the traditional generic structure of modern painting. What is specifically resumed in any individual case depends on what is added to the monochrome. In Kawara's case, it is the date on which the painting has purportedly been made. The presence of the date compels us to redefine Kawara's work in relation to a particular genre: history painting. This is to say that Kawara's work is not history painting in any direct sense, but its identity has been constructed in a negative relation to that genre, a negative relation established specifically by the orders of avant-gardist discourse.

Diego Velázquez. *Surrender of Breda*. 1634–35. Oil on canvas, 10' ⅞" x 12' 1" (307 x 370 cm). Museo Nacional Del Prado, Madrid

Edouard Manet. *The Execution of the Emperor Maximilian of Mexico, June 19, 1867*. c. 1867. Oil on canvas, 8' 3¹⁵⁄₁₆" x 9' 10¾" (252 x 302 cm). Städtische Kunsthalle Mannheim

Why should the writing or lettering of a date on a monochrome compel us to bring Kawara's Today series into contact with history painting rather than with some other genre? Traditionally, history painting has been defined as an imaginative depiction of an event that is considered significant, usually in the context of dynastic or national formations. Generally, the event has already been depicted or recounted in some way before the painter begins to work. That is, it has already been configured as the problematic entity, "the historical event." The historical event, in being real, is presumed to have taken place at some particular time; that is, it has come into conjunction with the calendar and has been given a date. The essential thing about a historical event is this fact of its occurrence in measured time, so the subject of a history painting is distinguished from the subject of any other genre by the necessity of its bearing a date.

In history painting, the floating and subjective character of the art of painting is disciplined by the ineradicable validity of the known occurrence, an occurrence that can be named just by the citation of a date—for example, July 14, 1789, Bastille Day, a day that becomes a festival, a public holiday, and is singled out as such on calendars. Great history paintings, like Velázquez's *Surrender at Breda* (1634–35), to choose

Pablo Picasso. *Guernica*. 1937.
Oil on canvas, 11' 5¹⁵⁄₁₆" x 25'
7⅞" (350 x 782 cm). Museo
Nacional Centro de Arte
Reina Sofia, Madrid

among the traditional ones, or Manet's *The Execution of the Emperor Maximilian* (c. 1867), to choose maybe the first modernist one, are obviously rhetorical, ideological, conforming, or dissenting poetic expressions, subjective "readings" of the same sources other people were reading at the time. This kind of painting was thrown into crisis by photography—or, more specifically, by photojournalism. The historical period as well as the character of this transformation can itself almost be delimited in terms of paintings and their dates. During the sixty-nine years that elapsed between the making of Manet's *Execution* in 1867 and Picasso's *Guernica* in 1937, photojournalism as such came into existence and began to dominate historical discourse. Photojournalism, in the form of both motion and still pictures, can be said to have canceled the social bases for history painting, and even for all the attendant and "lesser" genres, like the "painting of modern life." But, even though the social bases have changed, the structure of the genre of history painting remains in our consciousness, at least as a memory within the realm of painting, the "body politic" of the "society of painters."

Maybe it is time to think about the death of the death of painting. Once types of painting are revealed as "obsolete," they begin to appear to us as relics of a former age. I believe this to be a sociological illusion, a part of the avant-garde rhetoric that gambled everything on the concepts of discontinuity and the "epistemological break." The historical condition of painting and the vanguard's radical experiments in it are determined not by the fact that the older genres have died but by the fact that they haven't, even though vanguardists think they should have.

The radically analytical, "molecular" investigations of avant-garde painting beginning around 1900 developed by means of the interrogation and dismemberment of specific pictorial types. Picasso and Braque made Analytic Cubism in still lifes, portraits, and a few landscapes. Mondrian developed his abstract art from landscapes, too. Malevich developed Suprematism from a Cubo-Futurist version of *la peinture de la vie moderne*, and he also "refunctioned" traditional icon painting. The discourse of radical painting claims that these artists and those who followed them into abstraction and further experimentation revolutionized painting as such, that they transformed what could be termed the "ontology of painting," or maybe the "social ontology of painting." But, the truth of this claim needs to be mediated by an aware-

ness that access to the "Being" of painting as such is possible only by experiments made on and within specific types of paintings. In the process of making these experiments, painters invented the new types of abstract art and the monochrome, and at the same time they placed the old genres in a new, negative condition.

It has been argued that the "lower genres," like still life, were reworked by Cézanne, Picasso, or Mondrian because they were the freest spaces for experimentation within the traditional institutions of painting. The Goncourt brothers had earlier traced this idea of the potential radicality of the lower genres back to the eighteenth century, connecting it to the modernism of "light" Rococo art and opposing it to the old-fashionedness of the more carefully controlled and loftier types like history painting and state allegory. The revolutionization of painting was said to have been carried out in the lower genres, and it has been considered adequate therefore to think that the lower genres stood for "painting as such," painting comprehended historically as an art and an object of an aesthetics.

This is an interesting model, one that is most interesting for its boundaries, especially since it is itself a model of a search for boundaries. From the beginning, modernist painting saw itself as a speculative project aimed at making visible the transcendental conditions that permit a picture to be seen as a picture. Traditional painting was an art of picturing. The break with the making of pictures, stimulated as it was by new technologies of imaging like photography, led to two distinct yet interdependent directions. The first was that of nonrepresentational painting: the opening of new visual realms, the creation of spaces and experiences not bounded by pictorial laws and precedents. The second, of course, was the analysis of those laws as the invisible laws of the visual and of the relation of the visual to the pictorial. This was the content of the critique of illusion and illusionism. But it was the obsolescence of traditional types that formed the basis for this reflexivity. If modernist painting developed by reflecting on its own conditions and criteria, the obsolete genres are the mirror in which these conditions become visible. Analytical painting comes to know itself in this mirror, comes to know itself in the knowledge it discovers or produces regarding the internal relations of the pictures that preceded it and made it possible and necessary. Analytical modernist painting inherited academic knowledge about genre, but developed that knowledge into something new by making works that were models of both their own internal relations and those of the genres out of which they themselves emerged in a revolutionary process.

But what has happened to the higher genres? In particular, what has happened to history painting which, along with religious works and allegories of the state, was once the highest? One of the most suggestive studies of this question was made by Frank Stella in his Harvard lectures, published as *Working Space* in 1986. Stella's analysis is also relevant for the light it throws on forms of thinking that to a certain extent can be identified with the New York School idea of art. Stella argues that

Frank Stella. *The Marriage of Reason and Squallor.* 1959. Enamel on canvas, 7' 6¾" x 11' ¾" (230.5 x 337.2 cm). The Museum of Modern Art, New York. Larry Aldrich Foundation Fund

important formal and structural aspects of Baroque dramatic painting were taken up by abstract art, then rejected by it, and need to be taken up again. He claims that his own work, especially that of the past fifteen years, is a model for such an engagement.

Stella shows that the forms of High Baroque dramatic painting, as exemplified by Caravaggio in the south and Rubens in the north, were developed as a structure of action, composition, and atmosphere for the higher genres. So, the presence of a Baroque structure in a work is a trace or sign of that work's relation to those genres. This is not to say that such formal structures do not appear in lower genres; they obviously do, but their rhetoric of turbulence and massiveness is less at home in depictions of relatively undramatic motifs. The complexity of Caravaggio's work is in part the result of his unprecedented combination of high-genre formal rhetoric with low-genre stagecraft. This combination helped to ignite the whole idea of a modern painting, and has had an influence on the aesthetics of the cinema as well. Stella suggests that dramatic relationships can be expressed by nonrepresentational forms, the way a composer of pure music could evoke epic or dramatic moods without having the means to represent them. We can take this analogy seriously because of our experience with symphonic or art music, and our familiarity with the traditional analogy of art to music in post-Romantic art theory. The idea that an "abstract baroque" could do what the higher genres of traditional art did is not necessarily an impressive one, because it rests on a metaphor for, not a concept of, representation. It does suggest, however, that visual drama has a Baroque structure, and that moving away from that structure has deep implications for abstract art.

Stella is attempting to preserve an idea of painting as an art of high imagination and advanced technique in an era that sees itself as having crossed the threshold of representation. The abstract baroque intends to preserve and develop the idea of painting as a profound and poetic expression of a significant theme and to defend this idea against both academic versions of representational art and the reduction of abstract art to banality. Stella sees artists like Franz Kline, Jackson Pollock, Barnett Newman, or Mark Rothko as having accepted the inner codifications of the higher

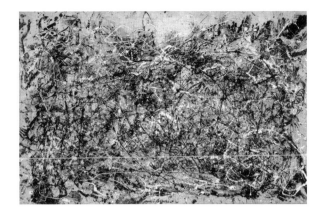

Jackson Pollock. *Number 1.* 1948. Oil and enamel on unprimed canvas, 68" x 8' 8" (172.7 x 264.2 cm). The Museum of Modern Art, New York. Purchase

genres but having rejected the identification of those structures with the institutions that had been their home for centuries—the church and the aristocratic state. This rejection was couched as a refusal to conform to any conventional iconographic program. In the 1940s, the radical cause of abstract art fused with needs for the expression of new moods of persecution, guilt, and anxiety. The result was the startling and innovative reconfiguration of the higher genres in Abstract Expressionism, a reconfiguration that brought things to a state of crisis.

Because this reconfiguration was done in the experimental spirit of radical abstract art, the New York School painters also carried on the program of reflexive analysis that had, as we have seen, developed in the deconstruction of the lower genres. The consequence of this fusion of high and low was a new epic-lyric art, rooted not in conventional symbols but in a self-critical, reflexive approach to form. The New York School painters combined a symphonic massiveness of affect with a reductivist interrogation of painting's capacities. At times, paintings by Newman or Rothko hint at the postulation of an epic monochrome, a work that would simultaneously transcend the categories of traditional art and go beyond a spirit of critique into a new realm, a new form of culture. These artists shook the structure of painting and gave a whole new mood—a loftier, more tragic mood—to reductivism.

This new mood has less to do with investigating the ontology of the art object than with casting a lyrical but penetrating glance at the essentials of the obsolete high genres, and thereby making a definitive statement about their obsolescence. A comparison of, for example, Kline's *Siegfried* (1958) with Picasso's *Massacre in Korea* (1951), done within a few years of each other, gives a sense of how Kline's type of painting continues the impulse toward the higher genres, and how it reveals the limitations of any direct attempt within modern art to continue them as such. Kline's painting excerpts the dynamic elements, those that can express a sense of high drama, and suggests that the codes of pictorial art can no longer approach these essentials. *Massacre in Korea* is lost in musings on conventionalism, in being obsolete, not in inventing the conditions of visibility for the state of obsolescence of the high genres.

Barnett Newman. *Vir Heroicus Sublimis.* 1950–51. Oil on canvas, 7' 11⅜" x 17' 9¼" (242.2 x 541.7 cm). The Museum of Modern Art, New York. Gift of Mr. and Mrs. Ben Heller

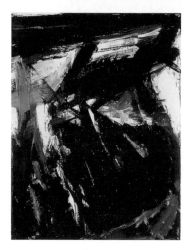

Franz Kline. *Siegfried.* 1958. Oil on canvas, 8' 6¹⁵⁄₁₆" x 6' 9⅛" (261.5 x 206.1 cm). Carnegie Museum of Art, Pittsburgh. Gift of the Friends of the Museum

In important aspects of Abstract Expressionism, the higher genres remain present, though radically mutated. They are reconstituted in a paradoxical state of absolute subjectivism, an anticonventionalism that is so different from what the higher genres were traditionally about that it is surprising that there is any indisputable connection at all. But the continuity of this generic identity takes place negatively. It can be thought of as that which survives a radical reduction to essentials and which, while it cannot appear directly, can nevertheless be experienced in the work. Abstract Expressionism fails as history painting, maybe it fails as high allegory, too. But the logic of Abstract Expressionism is that its failure allows the essentials of the older and collapsed genres to make an indirect appearance again as "the new," as that element of the archaic which, in unexpectedly recurring at the site of its negation, permits the complex and almost inexplicable sense of revolutionary innovation.

This dialectic of negativity, this image of painting's achievement taking the form of revelatory failures, is one of modernism's most significant inventions. The earliest rationale for abstract painting was that it would reform the whole domain of the visual and create a new universal visual language, one whose horizons would be more vast and open than anything pictorial art could create. Slowly, the legitimacy of this attitude has weakened, as it has been recognized that the transcendence of the pic-

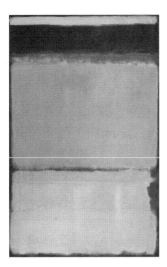

Mark Rothko. *No. 10.* 1950.
Oil on canvas, 7′ 6⅜″ x 57⅛″
(229.6 x 145.1 cm). The
Museum of Modern Art,
New York. Gift of Philip
Johnson

Pablo Picasso. *Massacre in
Korea.* 1951. Oil on plywood,
43⁵⁄₁₆″ x 6′ 10¹⁵⁄₁₆″ (110 x 210 cm).
Musée Picasso, Paris

torial and the breakaway from bourgeois art would not take place in the way the radi-
cal avant-garde had theorized. At this moment, which we can speculate represents an
end moment for avant-gardism, there emerges the doctrine that the legitimacy of the
new forms of painting is based not on their actual transcendental force but on their
failure to be this force (a force they could have imagined themselves to be but did not
actually succeed in becoming). At this moment, painting enters a new relationship
with its own history and with the notion of obsolescence upon which it had posited
its own legitimacy. This new negativism, which was epitomized philosophically by
Theodor Adorno's *Aesthetic Theory* (1969), has its roots in the debates of the 1920s
but did not become a dominant factor in the definition of modernist painting until
a younger generation began to reflect critically on the idea of avant-gardism, from a
distanced position, in the 1950s.

What Peter Bürger calls the "neo–avant-garde" began with an expression of the
disappointments felt by younger, postwar artists at the unfulfilled claims of the radi-
cal movements of the 1920s and '30s. In this atmosphere of reevaluation, the subjec-
tivism of Abstract Expressionism and Art informel was subjected to the sharpest
criticism. Younger painters—Stella prominent among them—recognized that the aims
of painting in the higher genres were both achieved and not achieved by figures like

Jasper Johns. *Flag.* 1954–55. Encaustic, oil, and collage on fabric mounted on plywood, three panels, 42¼ x 60⅝" (107.3 x 153.8 cm). The Museum of Modern Art, New York. Gift of Philip Johnson in honor of Alfred H. Barr, Jr.

Newman, Rothko, or Clyfford Still. It was achieved in that these artists managed to imbue the formal and technical procedures of experimental abstract painting with the sort of moral imperative enjoyed by the epic works of the past. It was not achieved because, in the process of formal revolutionization, a logic of reductivism set in and artists began to valorize the rejection of capacities in painting, the divestiture of means, and an aesthetics of silence and failure (in place of an aesthetics of conflict and transformation). This was the authentic expression of those artists who had "made works" instead of "refunctioning institutions," as Brecht defined it, who had abandoned and betrayed the revolution. The guilt was theirs, and they claimed it.

The younger painters of the 1960s were obliged to begin at an intersection in the logic of reductivism. From there, they recognized that although Abstract Expressionism had provided many of the terms for a continuation of the structural and generic redefinition of painting and a redefinition of its obsolescence, its grandiose lyricism was an obstacle to the elaboration of a new analytical approach. These artists were struck by the routinization of subjectivist painting, the sense that the "spontaneous" had exhausted itself or had hidden itself from what New York School painting had been. The first strong statements of Jasper Johns, for example, were recognitions of the departure of spontaneity from painting and its unexpected reappearance in prosaic signs and symbols.

It is at this point—in the mid-1950s—that Stella sees the eclipse of the idea of an abstract baroque. No doubt he sees his own paintings of the late 1950s and early 1960s implicated in the new prosaic, investigative attitudes, the rejection of drama and complexity, the argument that further knowledge of the nature of painting as such could not be gained directly in terms of the higher genres. Those forms seemed to be too literary, too full of extraneous moral feeling, too pretentious to be able to focus on the conditions of their own construction. The reductivist painting of the 1960s was a return to the domain of the lower genres and to the attitudes characteristic of Cubism and Constructivism. So it is not surprising that the monochrome reappeared as a central issue at exactly that moment.

Andy Warhol. *Five Deaths Seventeen Times in Black and White*. 1963. Kunstmuseum Basel

The revival of interest in the experimentalism of the 1920s meant not only a new concern with monochrome painting but also a renewed attention to the functions of photography, specifically photojournalism. Andy Warhol's *Five Deaths Seventeen Times in Black and White* (1963) explicitly demonstrates the polarity, or relationship, between these two constructs. The panel with the images is a zone in which the already read, already seen, already forgotten images of photojournalism are reiterated. The other panel provides only the ground for a possible, or imaginary, repetition, one which does not take place. Warhol has formulated as precisely as possible the two levels at which the art of painting is compelled to renounce the kinds of projects and capacities that had been identified with it historically up to that point. First, on the image side, the painting announces that what it has to express or formulate is the historical and technological fact that photojournalism has taken over the normative agency for the depiction of events and for the construction of historical images. It suggests that what is left for painting to do is to reflect on the conditions of its own displacement and on the resulting irony that paintings can be made under these negative terms. Secondly, the monochrome side casts doubt on the image side. It further suggests that even the reflection of photojournalism is unnecessary, or at least that it is not certain that it is a ground condition for the continuation of self-critical painting. The monochrome panel in *Five Deaths Seventeen Times* tells us that, in the context of the domination of photojournalism, painting's essential practice may be to prepare a surface for a reflection of its own relation to photojournalism. But this surface is one in which a *specific* reflection does not take place. This "does not" is really a "should not."

The image of the car crash is an instance of photojournalism and of the system of reproduction of images as a whole. The problem is that in being an instance of photojournalism it is also necessarily the instance of the appearance of a specific subject matter. Any specific subject, by requiring an emotional and associative response from the spectator, tends to create an atmosphere of legitimization for the representation of that subject. That is, once the artist permits the spectator to become involved with a specific subject, he or she is postulating that the means by which that subject is made

visible is therefore a viable means for involvement with the subject. But with Warhol, of course, this validity is just what is questionable. His repetition of the photograph tends to emphasize the questionable nature of any involvement with representations constructed by either photojournalism or by painting. Thus, legitimacy is withdrawn from a representation in the act of re-presenting, or reiterating it, as the case may be here. This is what was—and remains—so striking about these works.

So, the monochrome panel takes the process of ironic delegitimation a step further than does the one with the images on it, and both parts of the process are presented simultaneously, side by side. This suggests that since the presentation of representation constitutes an expression of the lack of validity of what is being represented and the act of presenting it, then the logical conclusion of the process is the presentation of the absence of representation (and of a specific absence of a specific representation in this case). A monochrome is once again the logical and conclusive form of painting within the logic of reductivism and the predominance of photojournalism.

The monochrome now comes to signify the erasure of the legitimation of the whole complex made up of painting as figuration and photojournalism as social norm. It reiterates the claims made by the radicals of the 1920s, but this time without the same horizon of social change. What was "positively negative" for Rodchenko becomes something else here. This logic was an important part of the experimental art of the 1960s and '70s. What we might call the tropes of Conceptual art are bound to certain structural hints in Warhol's picture. The idea of a monochrome surface bearing a questionable mark or image recurs constantly in the work of Joseph Kosuth, John Baldessari, Art & Language, Ed Ruscha, Lawrence Weiner, Daniel Buren, and Kawara himself. Painting tends toward sign painting. At the same time, the whole problem of photojournalism enters art again in the many new experiments with "photo-documentation."

In a monochrome, by definition, no event can make an appearance. The appearance of events in art is what is negated by the monochrome, and this negation is its aim. Photojournalism, on the other hand, aims at nothing but making events visible as pictures. But photojournalism as such does not function as art—or, at least, not as modernist art. There is a moment, around 1930, when a new phenomenon emerges. This is the state of mutual imitativeness in which photojournalism begins to appear as art and art as photojournalism. Two important early formulations of this were Walter Benjamin's essay "The Author as Producer" (1934) and Walker Evans's exhibition and book *American Photographs* (1938). What was created in these and other works was what I would call the "art-concept of photojournalism." This innovation was based not on the achievements of photojournalism but on its boundaries, its inadequacies, even. The journalistic photograph is made viable as art by concentrating attention on its limitations. This closely resembles (and even imitates) the frame of mind in which painting recognizes itself in the concept of its obsolescence.

André Breton. *Nadja* (Paris: Gallimard, 1928). Spread with a photograph by Jacques-André Boiffard

Both Evans and Benjamin were influenced by Parisian Surrealism, and I think we can go back to 1928, to André Breton's *Nadja*, his novel or prose-poem illustrated with photographs, to find the first expression of an art-concept of photojournalism. What Breton did in *Nadja* was to make it evident that the dualism between text and photograph (or, in Benjamin's terms, the relation between photograph and caption) was grounded not on the prose of written journalism but on poetry, on a poetic concept of both prose writing and picture making. Breton's concept of poetics was deeply implicated in the idea, first emphasized by French Symbolism, that poetry did not define itself in a dualism with prose as such, prose as a whole, but specifically with journalism. Mallarmé had made this issue absolutely explicit for Symbolism. The realm of the poetic was established by a conscious and even militant secession from the logos of property, the state, and the laws of identity, which are framed as language above all in journalism. The aim or task of poetry was to realize the negation of the instrumentalization of language. Symbolist poetry, like abstract art, wanted to open doors to new dimensions of being, realms that had been closed off by progressivism and rationalism in what Martin Heidegger in 1938 called "the age of the world picture," the age of high capitalism, cinema, and the press.

In the first historical phase of the critical definition of photography, the dominant note was sounded by those who emphasized the likeness of photography to machine products, to the factual and the prosaic. It was a great poet, Charles Baudelaire, who launched this mode of discussion with his denunciation of photography in 1859. "Poetry and progress," he said, "are like two ambitious men who hate one another with an instinctive hatred, and when they meet on the same road, one of them has to give place." This, written by maybe the greatest connoisseur of hatred in the history of poetry, indicates the bond he sensed between poetry and photography. And it was this bond that became the issue with Breton and with the second critical phase in the attempt to theorize photography as art. *Nadja* revealed that the identification of prose

journalism with photography was an illusion, albeit a socially necessary one; that is, it was—and is—an ideology. The striking effect of this revelation on theories of representation was the sense that photography is not structured like prose.

The experience of a photograph is one of immediacy and simultaneity. Any occurrence recorded photographically is seized in the process of its unfolding and condensed into a single image in which all the inconclusible energies of movement and interaction are arrested as a pattern. This patterning is the means by which photography resembles earlier forms of pictorial art, in which the illusion of an event was constructed through a process of rendering and composition, a slow process, one which takes time. As a synchronic phenomenon, as an arrested image, the photograph has a dialectical relation to the event, to the narrative, to the account, to the chronicle. A photograph cannot, fundamentally, be an account. It can only be interpreted as having a relationship to an account by means of an analysis of its technical incapacity to encompass such a structure. This analysis could be called a "narratology" of photography. The experience of a photograph is associative and simultaneous, and in this respect it resembles our experience of poetry. In poetic writing, meaning is not achieved by means of a consistent structure of controlled movements along lines made up of sentences. Rather, the poem is made of lines that may resemble sentences typographically but which abrogate the requirement to be read the way sentences are read. So there is a break with any necessary relation to the chronicle.

This sense of the unlikeness of photography to prose established the foundation for the antagonisms that have characterized the history of the photojournalist's path to self-recognition as an artist. These antagonisms derive from the inner conflicts of photojournalism as an institution. The new form of artist who emerged in this process was the photographer-employee who, for various reasons, abandons his employee status, strikes out on his own, and confronts the market for pictures directly, as a free agent. Walker Evans's career is exemplary here. He and others like him identified the open situation of the speculative picture maker with the poetic condition of photography as art and, working across the hazy boundary between employee and independent creator, found themselves once again in a narrative of modern art. At the beginning of the modern period, the traditional fine artist also passed through this development, breaking from the state academic system out into the uncertain world of capitalist culture, ruled by public opinion, fashion, and anxiety—that is, ruled by the press.

So, ironically, the photojournalist, having discovered that he (or his forebears) was instrumental in bringing into existence the modern art world and shaping the lives and characters of its occupants, must himself pass through this same development, but, historically speaking, for the second time. Here, we recognize that the photojournalist is in a mimetic relation to the modern artist and must experience the passage from employee to speculative producer at secondhand, that is, dramatically. He follows a path trodden once before. Photojournalism's path to artistic self-consciousness involves its mimesis of

the idea of the artist as it was constituted by the aesthetic thought of the nineteenth century and later brought under intense critical scrutiny by the avant-garde of the 1920s and 1930s. By 1930, the art-concept of photojournalism had come into being, and it was a concept quite different from photojournalism itself. It was a way for photojournalism to imitate art and thereby to arrive at the need to define itself in terms of its limitations, rather than in a celebration of its seemingly infinite capacities. In this way, the art-concept of photojournalism came to see itself as if it were the modernist painting it had helped to engender, that is, to see itself as delegitimated and obsolete *avant la let tre*. In establishing photography as art by being poetry and by being obsolescent—that is, as being inadequate as an image of its subject matter—the art-concept of photojournalism participates in the avant-garde's interrogation of art by its own means and simultaneously opens the door to a third critical phase in theorization. This began with the parodic redeployment of the idea of photo-documentation in Conceptual art, performance, and Land art around 1966, and was later codified in the new critiques of art as photography articulated by writers of the late 1970s and early '80s who were decisively influenced by conceptualism and post-structuralism.

The monochrome as the transgeneric or postgeneric moment of painting, photojournalism as the mimesis of avant-garde autocritique: these two big conceptual "knots" are brought together repeatedly in On Kawara's paintings. Kawara's gesture of repetition is the road on which Baudelaire's two ambitious antagonists confront one another. But, here, neither gives way. The confrontation is repeated ad infinitum, becomes permanent, and the dilemma becomes the foundation for a production. There will not be a resolution of this dilemma, partly because it has become a ritual, a necessary staging of a metaphysical crisis. And partly because the staging takes place on the stage of the last theater built by the avant-garde—the stage of art in its negative state of being, a state of lament for itself which has been defined as the negative form of its validity.

I need now to return once more to the framework of history painting. The confrontation in Kawara's painting is marked as such by the only point of agreement between the antagonists: the dates. These dates can be read both on the paintings and on the pages of newspapers usually included in the boxes containing the paintings. Both painting and photojournalism have been brought to a point of historical self-consciousness, whose content is the insistence that neither of them can produce any valid rendering of any subject. Painting has arrived at this state by reflecting back into itself a self-image it thought it saw in photographs. Photojournalism made it by imitating the reaction of the painter. This confrontation can be thought of as a double mimesis, a sort of comedy of misrecognitions. Be that as it may, the product of the confrontation is that no result can be derived from either of these arts which resembles claims made by any genre of representation or any type of figuration, painted or photographic. Kawara's painting since 1966 is one of the most consistent expressions of

the project of realizing painting by a renunciation of all its means—and this includes photojournalism as a means of renunciation, not a cause for renunciation.

Only Warhol and Gerhard Richter have come to similar conclusions and have developed them as rigorously. Both Warhol and Richter became involved with photojournalism as part of a recreation of a sort of *peinture de la vie moderne*, to use another of Baudelaire's famous phrases. In "The Painter of Modern Life," Baudelaire wrote the scenario for the definitive transformation of the noble genres, what he called "philosophical painting," into the low genres. The painting of modern life took over all the qualities of high imagination from allegory and history painting and reconfigured those art forms explicitly in terms of journalism. Constantin Guys was the model of the artist as journalist and, what is more, as freelancer. Baudelaire set the stage for the emergence of modernist painting as the dissolution of the higher genres into the low and, at the same time, as the search for the specter of the high genres in the low. In the same manner, history, the phantom and *éminence grise* of the nineteenth century, was sought in the now. The work of Richter and Warhol in the 1960s was a kind of continuation of the idea of the painting of modern life as much as it was Pop art.

We could speculate that the whole world of the high genres has vanished, like Proust's childhood, and exists now only in their always present, constantly disappearing reflection in the low, in scenes of everyday life, in the now. As low-genre art, history painting becomes a painting of now, of "history in the making." It also, however, becomes part of an analytical project in which it observes its own disappearance into the lens which regards it. Kawara's painting project is permanently fixated on today. It seems as if every structural aspect of the historical movement of the forms of art I've tried to describe here comes to constitute a part of his painting's physical makeup, as if each part of his work—container, canvas, newspaper—were an emblem of the forces that have caused it to come into existence. In perfect modernist fashion, the content of the work is the experience of its forms and its materiality. But the forms are also the outcome of a speculative movement of artistic intelligence that observes not only history itself but also what it regards as necessary and binding limitations on the possibility of anything historical appearing as an image in art, any art.

Each Today painting is a marker of a moment that the painter feels obliged to let pass without making any image of it. The painter recognizes that a historical moment, the now, has arrived, and has found him in front of his empty canvas. At this moment, the painter recognizes the canvas as a monochrome, as already a painting, and this recognition commits him. It commits him to affirm that any mark he adds to the existing painting will return it to the apparently ceaseless and futile play of genres, to the play of disappearance and restoration that seems to be painting's comedy. This opportunity, the invitation to participate in this comedy, is presented each day, and each day the painter declines it. Instead of painting, he letters the date of his

Gerhard Richter. *Festnahme 1* (Arrest 1) from the series October 18, 1977. 1988. Oil on canvas, 36¼ x 49¾" (92 x 126.5 cm). The Museum of Modern Art, New York. The Sidney and Harriet Janis Collection, gift of Philip Johnson, and acquired through the Lillie P. Bliss Bequest (all by exchange); Enid A. Haupt Fund; Nina and Gordon Bunshaft Bequest Fund; and gift of Emily Rauh Pulitzer

Gerhard Richter. *Tote* (Dead) from the series October 18, 1977. 1988. Oil on canvas, 24½ x 28¾" (62 x 73 cm).The Museum of Modern Art, New York. The Sidney and Harriet Janis Collection, gift of Philip Johnson, and acquired through the Lillie P. Bliss Bequest (all by exchange); Enid A. Haupt Fund; Nina and Gordon Bunshaft Bequest Fund; and gift of Emily Rauh Pulitzer

refusal to paint. This refusal, of course, mars the monochrome on which it is marked as much as would, for example, the face of a dead young woman (as in *Tote* from Richter's series 18 Oktober 1977, of 1988). But it mars it differently.

Richter's *Tote*, and the series to which it belongs, attempts to actualize the chimera of high history painting glimmering within the problematic of painting and photojournalism. It hypothesizes that painting might still have the means to do this, if the times, the mood, and the subject all come together just right. 18 Oktober 1977 seems to be an attempt to redeem history painting from the double negatives in which it has been placed. Its ambivalence at even seeming to base itself on a concept of the possibility rather than on the prohibition of representation can be felt in the tendency toward effacement of the image which can be seen in, for example, *The Arrest, 1*. It is as if Richter is expressing a wish that these pictures could have remained the monochromes they began as, and not become the disfigured monochromes they are.

Kawara's disfiguration is less dramatic to be sure. In fact, it is not dramatic at all, since there is no image on the canvas. The day's image is expelled to the selection

from the newspaper that accompanies the painting. These photographs, whose captions used to give the painting what the artist calls a "subtitle," are instances of photojournalism unredeemed by not having been transformed into paintings. But they are not, by that token, unredeemed photojournalism, because photojournalism is present in Kawara's work only in the state of having been transformed by its mimetic relation to an artwork it cannot inflect. The photographs follow the path of renunciation broken by the paintings. Their presence poses a question about representation and, by implication, about whether art retains any figurative capacities at all. But the question is answered in the negative—and in advance.

Kawara disfigures his monochromes to make an elemental, lucid, gesture of support for the monochrome as the principle of judgment of art. This gesture renounces the figurative or form-creating capacities of his art. The moment of now must pass unpainted but nevertheless must be acknowledged as that specific something which is not to be made visible. In declining to make a history painting, or a painting of the now of history, Kawara's painting points to the orders of the world which have defeated it and which now escape it, or which he believes should escape it. Painting, for him, continues in a state of repetition; each day, its lack of viable means is announced afresh, and this announcement once again reminds us of the time elapsed since this condition began.

Old history painting related to the calendar as festivals do; it showed what happened to create a special date, even a sacred date. Great history paintings bring together two such dates, the one depicted and the one on which the painting was made. Traditional art subordinated the glory of the second date to that of the first: its festivals were public affairs. Modern art brought the second date into such prominence that the possibility of there even being a first date all but vanished. In the state to which modern art has brought us—that of the obsolescence of all the genres—painting's only festival is that of its own continuation. Painting is celebrated and mourned as such; that is how it is made today. Kawara's dates are what we might call the absolute expression of this situation. The painter has only his own act to memorialize. At this vanishing point of both painting and photography, infinite dilemmas arise. One of them is the disenchantment of time.

The starting point for this essay, the idea of discussing On Kawara's work in relation to photojournalism, was suggested in conversation by Ydessa Hendeles.—JW

"Marks of Indifference":
Aspects of Photography in, or as, Conceptual Art

PREFACE

This essay is a sketch, an attempt to study the ways that photography occupied Conceptual artists, the ways that photography decisively realized itself as a modernist art in the experiments of the 1960s and 1970s. Conceptual art played an important role in the transformation of the terms and conditions within which art-photography defined itself and its relationships with the other arts, a transformation which established photography as an institutionalized modernist form evolving explicitly through the dynamics of its autocritique.

Photography's implication with modernist painting and sculpture was not, of course, developed in the 1960s; it was central to the work and discourse of the art of the 1920s. But for the '60s generation art-photography remained too comfortably rooted in the pictorial traditions of modern art; it had an irritatingly serene, marginal existence, a way of holding itself at a distance from the intellectual drama of avant-gardism while claiming a prominent, even definitive place within it. The younger artists wanted to disturb that, to uproot and radicalize the medium, and they did so with the most sophisticated means they had in hand at the time, the autocritique of art identified with the tradition of the avant-garde. Their approach implied that photography had not yet become "avant-garde" in 1960 or 1965, despite the epithets being casually applied to it. It had not yet accomplished the preliminary auto-dethronement, or deconstruction, which the other arts had established as fundamental to their development and their *amour-propre*.

Through that autocritique, painting and sculpture had moved away from the practice of depiction, which had historically been the foundation of their social and aesthetic value. Although we may no longer accept the claim that abstract art had gone "beyond" representation or depiction, it is certain that such developments added something new to the corpus of possible artistic forms in Western culture. In the first half of the 1960s, Minimalism was decisive in bringing back into sharp focus, for the first time since the 1930s, the general problem of how a work of art could validate itself as an object among all other objects in the world. Under the regime of depiction—that is, in the history of Western art before 1910—a work of art was an object whose validity as art was constituted by its being, or bearing, a depiction. In the

Written in 1995. First published as "Marks of Indifference: Aspects of Photography in, or as, Conceptual Art," in Ann Goldstein and Anne Rorimer, eds., *Reconsidering the Object of Art: 1965–1975*, exh. cat. (Los Angeles: The Museum of Contemporary Art, 1995), pp. 247–67.

process of developing alternative proposals for art "beyond" depiction, art had to reply to the suspicion that, without their depictive or representational function, art objects were art in name only, not in body, form, or function.[1] Art projected itself forward bearing only its glamorous traditional name, thereby entering a troubled phase of restless searching for an alternative ground of validity. This phase continues, and must continue.

Photography cannot find alternatives to depiction, as could the other fine arts. It is in the physical nature of the medium to depict things. In order to participate in the kind of reflexivity made mandatory for modernist art, photography can put into play only its own necessary condition of being a depiction-which-constitutes-an-object.

In its attempts to make visible this condition, Conceptual art hoped to reconnect the medium to the world in a new, fresh way, beyond the worn-out criteria for photography as sheer picture-making. Several important directions emerged in this process. In this essay I will examine only two. The first involves the rethinking and "refunctioning" of reportage, the dominant type of art-photography as it existed at the beginning of the 1960s. The second is related to the first, and to a certain extent emerges from it. This is the issue of the de-skilling and re-skilling of the artist in a context defined by the culture industry, and made controversial by aspects of Pop art.

I. FROM REPORTAGE TO PHOTODOCUMENTATION

Photography entered its post-Pictorialist phase (one might say its "post-Stieglitzian" phase) in an exploration of the border-territories of the utilitarian picture. In this phase, which began around 1920, important work was made by those who rejected the Pictorialist enterprise and turned toward immediacy, instantaneity, and the evanescent moment of the emergence of pictorial value out of a practice of reportage of one kind or another. A new version of what could be called the "Western Picture," or the "Western Concept of the Picture," appears in this process.

The Western Picture is, of course, that tableau, that independently beautiful depiction and composition that derives from the institutionalization of perspective and dramatic figuration at the origins of modern Western art, with Raphael, Dürer, Bellini, and the other familiar *maestri*. It is known as a product of divine gift, high skill, deep emotion, and crafty planning. It plays with the notion of the spontaneous, the unanticipated. The master picture-maker prepares everything in advance, yet trusts that all the planning in the world will lead only to something fresh, mobile, light, and fascinating. The soft body of the brush, the way it constantly changes shape as it is used, was the primary means by which the genius of composition was placed at risk at each moment, and recovered, transcendent, in the shimmering surfaces of magical feats of figuration.

Pictorialist photography was dazzled by the spectacle of Western painting and attempted, to some extent, to imitate it in acts of pure composition. Lacking the

Alfred Stieglitz. *Flatiron Building.* 1902–3. Gravure on vellum, 12⅞ x 6⁹⁄₁₆" (32.7 x 16.7 cm). The Museum of Modern Art, New York. Purchase

André Kertész. *Meudon.* 1928. Gelatin silver print, printed 1963, 16⁷⁄₁₆ x 12½" (41.8 x 31.8 cm). The Museum of Modern Art, New York. Gift of the photographer

means to make the surface of its pictures unpredictable and important, the first phase of Pictorialism, Stieglitz's phase, emulated the fine graphic arts, reinvented the beautiful book, set standards for gorgeousness of composition, and faded. Without a dialectical conception of its own surface, it could not achieve the kind of planned spontaneity painting had put before the eyes of the world as a universal norm of art. By 1920, photographers interested in art had begun to look away from painting, even from modern painting, toward the vernacular of their own medium, and toward the cinema, to discover their own principle of spontaneity, to discover once again, for themselves, that unanticipated appearance of the Picture demanded by modern aesthetics.

At this moment the art-concept of photojournalism appears, the notion that art can be created by imitating photojournalism. This imitation was made necessary by the dialectics of avant-garde experimentation. Nonautonomous art forms, like architecture, and new phenomena such as mass communications became paradigmatic in the 1920s and '30s because the avant-gardes were so involved in a critique of the autonomous work of art, so intrigued by the possibility of going beyond it into a utopian revision of society and consciousness. Photojournalism was created in the framework of the new publishing and communications industries, and it elaborated a new kind of picture, utilitarian in its determination by editorial assignment and novel in its seizure of the instantaneous, of the "news event" as it happened. For both these reasons, it seems to have occurred to a number of photographers (Paul Strand, Walker Evans, Brassaï, Henri Cartier-Bresson) that a new art could be made by means of a mimesis of these aims and aspects of photography as it really existed in the world of the new culture industries.

This mimesis led to transformations in the concept of the Picture that had consequences for the whole notion of modern art, and that therefore stand as preconditions

for the kind of critique proposed by the Conceptual artists after 1965. PostPictorialist photography is elaborated in the working out of a demand that the Picture make an appearance in a practice which, having already largely relinquished the sensuousness of the surface, must also relinquish any explicit preparatory process of composition. Acts of composition are the property of the tableau. In reportage, the sovereign place of composition is retained only as a sort of dynamic of anticipatory framing, a "hunter's consciousness," the nervous looking of a "one-eyed cat," as Lee Friedlander put it. Every picture-constructing advantage accumulated over centuries is given up to the jittery flow of events as they unfold. The rectangle of the viewfinder and the speed of the shutter, photography's "window of equipment," is all that remains of the great craft-complex of composition. The art-concept of photojournalism began to force photography into what appears to be a modernist dialectic. By divesting itself of the encumbrances and advantages inherited from older art forms, reportage pushes toward a discovery of qualities apparently intrinsic to the medium, qualities that must necessarily distinguish the medium from others, and through the self-examination of which it can emerge as a modernist art on a plane with the others.

This force, or pressure, is not simply social. Reportage is not a photographic type brought into existence by the requirements of social institutions as such, even though institutions like the press played a central part in defining photojournalism. The press had some role in shaping the new equipment of the 1920s and 1930s, particularly the smaller, faster cameras and film stock. But reportage is inherent in the nature of the medium, and the evolution of equipment reflects this. Reportage, or the spontaneous, fleeting aspect of the photographic image, appears simultaneously with the pictorial, tableaulike aspect at the origins of photography; its traces can be seen in the blurred elements of Daguerre's first street scenes. Reportage evolves in the pursuit of the blurred parts of pictures.

In this process, photography elaborates its version of the Picture, and it is the first new version since the onset of modern painting in the 1860s, or, possibly, since the emergence of abstract art, if one considers abstract paintings to be, in fact, pictures anymore. A new version of the Picture implies necessarily a turning point in the development of modernist art. Problems are raised which will constitute the intellectual content of Conceptual art, or at least significant aspects of that content.

One of the most important critiques opened up in Conceptual art was that of art-photography's achieved or perceived "aestheticism." The revival of interest in the radical theories and methods of the politicized and objectivistic avant-garde of the 1920s and 1930s has long been recognized as one of the most significant contributions of the art of the 1960s, particularly in America. Productivism, "factography," and Bauhaus concepts were turned against the apparently "depoliticized" and resubjectivized art of the 1940s and 1950s. Thus, we have seen that the kind of formalistic and "resubjectivized" art-photography that developed around Edward Weston and Ansel Adams on

the West Coast, or Harry Callahan and Aaron Siskind in Chicago in those years (to use only American examples), attempted to leave behind *not only* any *link* with agit-prop, but even any connection with the nervous surfaces of social life, and to resume a stately modernist pictorialism. This work has been greeted with opprobrium from radical critics since the beginnings of the new debates in the 1960s. The orthodox view is that cold war pressures compelled socially conscious photographers away from the borderline forms of art-photojournalism and toward the more subjectivistic versions of Art Informel. In this process, the more explosive and problematic forms and concepts of radical avant-gardism were driven from view, until they made a return in the activistic neo–avant-gardism of the 1960s. There is much truth in this construction, but it is flawed in that it draws too sharp a line between the methods and approaches of politicized avant-gardism and those of the more subjectivistic and formalistic trends in art-photography.

The situation is more complex because the possibilities for autonomous formal composition in photography were themselves refined and brought onto the historical and social agenda by the medium's evolution in the context of vanguardist art. The art-concept of photojournalism is a theoretical formalization of the ambiguous condition of the most problematic kind of photograph. That photograph emerges on the wing, out of a photographer's complex social engagement (his or her assignment); it records something significant in the event, in the engagement, and gains some validity from that. But this validity alone is only a social validity—the picture's success as reportage per se. The entire avant-garde of the 1920s and 1930s was aware that validity as reportage per se was insufficient for the most radical of purposes. What was necessary was that the picture not only succeed as reportage and be socially effective, but that it succeed in putting forward a new proposition or model of the Picture. Only in doing both these things simultaneously could photography realize itself as a modernist art form, and participate in the radical and revolutionary cultural projects of that era. In this context, rejection of a classicizing aesthetic of the picture—in the name of proletarian amateurism, for example—must be seen as a claim to a new level of pictorial consciousness.

Thus, art-photography was compelled to be both anti-aestheticist and aesthetically significant, albeit in a new "negative" sense, at the same moment. Here, it is important to recognize that it was the content of the avant-garde dialogue itself that was central in creating the demand for an aestheticism which was the object of critique by that same avant-garde. In *Theory of the Avant-Garde* (1974) Peter Bürger argued that the avant-garde emerged historically in a critique of the completed aestheticism of nineteenth-century modern art.[2] He suggests that, around 1900, the avant-garde generation, confronted with the social and institutional fact of the separation between art and the other autonomous domains of life, felt compelled to attempt to leap over that separation and reconnect high art and the conduct of affairs in the world, in

order to save the aesthetic dimension by transcending it. Bürger's emphasis on this drive to transcend Aestheticism and autonomous art neglects the fact that the obsession with the aesthetic, now transformed into a sort of taboo, was carried over into the center of every possible artistic thought or critical idea developed by vanguardism. Thus, to a certain extent, one can invert Bürger's thesis and say that avant-garde art not only constituted a critique of Aestheticism, but also reestablished Aestheticism as a permanent issue through its intense problematization of it. This thesis corresponds especially closely to the situation of photography within vanguardism. Photography had no history of autonomous status perfected over time into an imposing institution. It emerged too late for that. Its aestheticizing thus was not, and could not be, simply an object for an avant-gardist critique, since it was brought into existence by that same critique.

In this sense, there cannot be a clear demarcation between aestheticist formalism and various modes of engaged photography. Subjectivism could become the foundation for radical practices in photography just as easily as neo-factography, and both are often present in much work of the 1960s.

The peculiar, yet familiar, political ambiguity *as art* of the experimental forms in and around conceptualism, particularly in the context of 1968, is the result of the fusion, or even confusion, of tropes of art-photography with aspects of its critique. Far from being anomalous, this fusion reflects precisely the inner structure of photography as potentially avant-garde or even neo–avant-garde art. This implies that the new forms of photographic practice and experiment in the sixties and seventies did not derive exclusively from a revival of antisubjectivist and antiformalist tendencies. Rather, the work of figures like Douglas Huebler, Robert Smithson, Bruce Nauman, Richard Long, or Joseph Kosuth emerges from a space constituted by the already matured transformations of both types of approach—factographic and subjectivist, activist and formalist, "Marxian" and "Kantian"—present in the work of their precursors in the 1940s and 1950s, in the intricacies of the dialectic of "reportage as art-photography," as art-photography par excellence. The radical critiques of art-photography inaugurated and occasionally realized in Conceptual art can be seen as both an overturning of academicized approaches to these issues, and as an extrapolation of existing tensions inside that academicism, a new critical phase of academicism and not simply a renunciation of it. Photoconceptualism was able to bring new energies from the other fine arts into the problematic of art-photojournalism, and this has tended to obscure the ways in which it was rooted in the unresolved but well-established aesthetic issues of the photography of the 1940s and 1950s.

Intellectually, the stage was thus set for a revival of the whole drama of reportage within avant-gardism. The peculiar situation of art-photography in the art market at the beginning of the 1960s is another precondition, whose consequences are not simply sociological. It is almost astonishing to remember that important art-photographs

could be purchased for under $100 not only in 1950 but in 1960. This suggests that, despite the internal complexity of the aesthetic structure of art photography, its moment of recognition as art in capitalist societies had not yet occurred. All the aesthetic preconditions for its emergence as a major form of modernist art had come into being, but it took the new critiques and transformations of the sixties and seventies to actualize these socially. It could be said that the very absence of a market in photography at the moment of a rapidly booming one for painting drew two kinds of energy toward the medium.

The first is a speculative and inquisitive energy, one which circulates everywhere things appear to be "undervalued." Undervaluation implies the future, opportunity, and the sudden appearance of something forgotten. The undervalued is a category akin to Benjaminian ones like the "just past" or the "recently forgotten."

The second is a sort of negative version of the first. In the light of the new critical skepticism toward "high art" that began to surface in the intellectual glimmerings around Pop art and its mythologies, the lack of interest of art marketeers and collectors marked photography with a utopian potential. Thus, the thought occurred that a photograph might be the Picture which could not be integrated into "the regime," the commercial-bureaucratic-discursive order which was rapidly becoming the object of criticisms animated by the attitudes of the student movement and the New Left. Naive as such thoughts might seem today, they were valuable in turning serious attention toward the ways in which art-photography had not yet become Art. Until it became Art, with a big A, photographs could not be *experienced* in terms of the dialectic of validity which marks all modernist aesthetic enterprises.

Paradoxically, this could only happen in reverse. Photography could emerge socially as art only at the moment when its aesthetic presuppositions seemed to be undergoing a withering radical critique, a critique apparently aimed at foreclosing any further aestheticization or "artification" of the medium. Photoconceptualism led the way toward the complete acceptance of photography as art—autonomous, bourgeois, collectible art—by virtue of insisting that this medium might be privileged to be the negation of that whole idea. In being that negation, the last barriers were broken. Inscribed in a new avant-gardism, and blended with elements of text, sculpture, painting, or drawing, photography became the quintessential "anti-object." As the neo–avant-gardes reexamined and unravelled the orthodoxies of the 1920s and 1930s, the boundaries of the domain of autonomous art were unexpectedly widened, not narrowed. In the explosion of postautonomous models of practice which characterized the discourse of the seventies, we can detect, maybe only with hindsight, the extension of avant-garde aestheticism. As with the first avant-garde, postautonomous, "poststudio" art required its double legitimation: first, its legitimation as having transcended—or at least having authentically tested—the boundaries of autonomous art and having become functional in some real way; and then, secondly, that this test, this

new utility, result in works or forms which proposed compelling models of art as such, at the same time that they seemed to dissolve, abandon, or negate it. I propose the following characterization of this process: autonomous art had reached a state where it appeared that it could only validly be made by means of the strictest imitation of the nonautonomous. This heteronomy might take the form of direct critical commentary, as with Art & Language; with the production of political propaganda, so common in the 1970s; or with the many varieties of "intervention" or appropriation practiced more recently. But in all these procedures, an autonomous work of art is still necessarily created. The innovation is that the content of the work is the validity of the model or hypothesis of nonautonomy it creates.

This complex game of mimesis has been, of course, the foundation for all "endgame" strategies within avant-gardism. The profusion of new forms, processes, materials, and subjects which characterizes the art of the 1970s was to a great extent stimulated by mimetic relationships with other social production processes: industrial, academic, commercial, cinematic, etc. Art-photography, as we have seen, had already evolved an intricate mimetic structure, in which artists imitated photojournalists in order to create Pictures. This elaborate, mature mimetic order of production brought photography to the forefront of the new pseudoheteronomy, and permitted it to become a paradigm for all aesthetically critical, model-constructing thought about art. Photoconceptualism worked out many of the implications of this, so much so that it may begin to seem that many of Conceptual art's essential achievements are either created in the form of photographs or are otherwise mediated by them.

Reportage is introverted and parodied, manneristically, in aspects of photoconceptualism. The notion that an artistically significant photograph can any longer be made in a direct imitation of photojournalism is rejected as having been historically completed by the earlier avant-garde and by the lyrical subjectivism of 1950s art-photography. The gesture of reportage is withdrawn from the social field and attached to a putative theatrical event. The social field tends to be abandoned to professional photojournalism proper, as if the aesthetic problems associated with depicting it were no longer of any consequence, and photojournalism had entered not so much a postmodernist phase as a "postaesthetic" one in which it was excluded from aesthetic evolution for a time. This, by the way, suited the sensibilities of those political activists who attempted a new version of proletarian photography in the period.

This introversion, or subjectivization, of reportage was manifested in two important directions. First, it brought photography into a new relationship with the problematics of the staged, or posed, picture, through new concepts of performance. Second, the inscription of photography into a nexus of experimental practices led to a direct but distantiated and parodic relationship with the art-concept of photojournalism. Although the work of many artists could be discussed in this context, for the

Richard Long. *A Line Made by Walking*. 1967. Black and white photograph and pencil on board, photograph: 14¾ x 12¾" (37.5 x 32.4 cm). Tate, London

sake of brevity I will discuss the photographic work of Richard Long and Bruce Nauman as representative of the first issue, and that of Dan Graham, Douglas Huebler, and Robert Smithson of the second.

Long's and Nauman's photographs document already conceived artistic gestures, actions, or "studio events"—things that stand self-consciously as conceptual, aesthetic models for states of affairs in the world, which, as such, need no longer appear directly in the picture. Long's *England 1968* (1968) documents an action or gesture, made by the artist alone, out in the countryside, away from the normal environs of art or performance. Generically, his pictures are landscapes, and their mood is rather different from the typologies and intentions of reportage. Conventional artistic landscape photography might feature a foreground motif, such as a curious heap of stones or a gnarled tree, and counterpoint it to the rest of the scene, showing it to be singular, differentiated from its surroundings and yet existing by means of those surroundings. In such ways, a landscape picture can be thought to report on a state of affairs, and therefore be consistent with an art-concept of reportage. Long's walked line in the grass substitutes itself for the foreground motif. It is a gesture akin to Barnett Newman's notion of the establishment of a "Here" in the void of a primeval terrain. It is simultaneously agriculture, religion, urbanism, and theater, an intervention in a lonely, picturesque spot which becomes a setting completed artistically by the gesture and the photograph for which the gesture was enacted. Long does not photograph events in the process of their occurrence, but stages an event for the benefit of a preconceived photographic rendering. The picture is presented as the subsidiary form of an act, as "photo-documentation." It has become that, however, by means of a new kind of photographic mise-en-scène. That is, it exists and is legitimated as continuous with the project

Bruce Nauman. *Failing to Levitate in the Studio.* 1966. Gelatin silver print, 20 x 24" (50.8 x 60.9 cm). Collection the artist

Cover of *Artforum* 8, no. 1 (September 1969), with photograph of Robert Smithson's *First Mirror Displacement* (1969)

Robert Smithson, "The Monuments of Passaic," *Artforum* 6, no. 4 (December 1967), p. 49

of reportage by moving in precisely the opposite direction, toward a completely designed pictorial method, an introverted masquerade that plays games with the inherited aesthetic proclivities of art-photography-as-reportage.

Many of the same elements, moved indoors, characterize Nauman's studio photographs, such as *Failing to Levitate in the Studio* (1966) or *Self-Portrait as a Fountain* (1966–67/1970). The photographer's studio, and the generic complex of "studio photography," was the Pictorialist antithesis against which the aesthetics of reportage were elaborated. Nauman changes the terms. Working within the experimental framework of what was beginning at the time to be called "performance art," he carries out photographic acts of reportage whose subject matter is the self-conscious, self-centered "play" taking place in the studios of artists who have moved "beyond" the modern fine arts into the new hybridities. Studio photography is no longer isolated from reportage: it is reduced analytically to coverage of whatever is happening in the studio, that place once so rigorously controlled by precedent and formula, but which was in the process of being reinvented once more as theater, factory, reading room, meeting place, gallery, museum, and many other things.

Nauman's photographs, films, and videos of this period are done in two modes or styles. The first, that of *Failing to Levitate*, is "direct," rough, and shot in black and white. The other is based on studio lighting effects—multiple sources, colored gels, emphatic contrasts—and is of course done in color. The two styles, reduced to a set of basic formulae and effects, are signifiers for the new coexistence of species of photography which had seemed ontologically separated and even opposed in the art history of photography up to that time. It is as if the reportage works go back to Muybridge and the sources of all traditional concepts of photographic documentary, and the color pictures to the early "gags" and jokes, to Man Ray and Moholy-Nagy, to the birthplace of effects used for their own sake. The two reigning myths of photography—the one that claims that photographs are "true" and the one that claims they are

not—are shown to be grounded in the same praxis, available in the same place, the studio, at that place's moment of historical transformation.

These practices, or strategies, are extremely common by about 1969, so common as to be de rigueur across the horizons of performance art, earth art, Arte Povera, and conceptualism, and it can be said that these new methodologies of photographic practice are the strongest factor linking together the experimental forms of the period, which can seem so disparate and irreconcilable.

This integration or fusion of reportage and performance, its manneristic introversion, can be seen as an implicitly parodic critique of the concepts of art-photography. Smithson and Graham, in part because they were active as writers, were able to provide a more explicit parody of photojournalism than Nauman or Long.

Photojournalism as a social institution can be defined most simply as a collaboration between a writer and a photographer. Conceptual art's intellectualism was engendered by young, aspiring artists for whom critical writing was an important practice of self-definition. The example of Donald Judd's criticism for *Arts* magazine was decisive here, and essays like "Specific Objects" (1964) had the impact, almost, of literary works of art. The interplay between a veteran litterateur, Clement Greenberg; a young academic art critic, Michael Fried; and Judd, a talented stylist, is one of the richest episodes in the history of American criticism, and had much to do with igniting the idea of a written critique standing as a work of art. Smithson's "The Crystal Land," published in *Harper's Bazaar* in 1966, is an homage to Judd as a creator of both visual and literary forms. Smithson's innovation, however, is to avoid the genre of art criticism, writing a mock travelogue instead. He plays the part of the inquisitive, belletristic journalist, accompanying and interpreting his subject. He narrativizes his account of Judd's art, moves from critical commentary to storytelling, and reinvents the relationships between visual art and literature. Smithson's most important published works, such as "The Monuments of Passaic" and "Incidents of Mirror-Travel in the

Yucatan," are "auto-accompaniments." Smithson the journalist-photographer accompanies Smithson the artist-experimenter and is able to produce a sophisticated apologia for his sculptural work in the guise of popular entertainment. His essays do not make the Conceptualist claim to be works of visual art, but appear to remain content with being works of literature. The photographs included in them purport to illustrate the narrative or commentary. The narratives, in turn, describe the event of making the photographs. "One never knew what side of the mirror one was on," he mused in "Passaic," as if reflecting on the parody of photojournalism he was in the process of enacting. Smithson's parody was a way of dissolving, or softening, the objectivistic and positivistic tone of Minimalism, of subjectivizing it by associating its reductive formal language with intricate, drifting, even delirious moods or states of mind.

The Minimalist sculptural forms to which Smithson's texts constantly allude appeared to erase the associative chain of experience, the interior monologue of creativity, insisting on the pure immediacy of the product itself, the work as such, as "specific object." Smithson's exposure of what he saw as Minimalism's emotional interior depends on the return of ideas of time and process, of narrative and enactment, of experience, memory, and allusion, to the artistic forefront, against the rhetoric of both Greenberg and Judd. His photojournalism is at once self-portraiture—that is, performance—and reportage about what was hidden and even repressed in the art he most admired. It located the impulse toward self-sufficient and nonobjective forms of art in concrete, personal responses to real-life social experiences, thereby contributing to the new critiques of formalism which were so central to Conceptual art's project.

Dan Graham's involvement with the classical traditions of reportage is unique among the artists usually identified with Conceptual art, and his architectural photographs continue some aspects of Walker Evans's project. In this, Graham locates his practice at the boundary of photojournalism, participating in it while at the same time placing it at the service of other aspects of his oeuvre. His architectural photographs provide a social grounding for the structural models of intersubjective experience he elaborated in text, video, performance, and sculptural environmental pieces. His works do not simply make reference to the larger social world in the manner of photojournalism; rather, they refer to Graham's own other projects, which, true to Conceptual form, are models of the social, not depictions of it.

Graham's *Homes for America* (1966–67) has taken on canonical status in this regard. Here the photo-essay format so familiar to the history of photography has been meticulously replicated as a model of the institution of photojournalism. Like Walker Evans at *Fortune*, Graham writes the text and supplies the pictures to go along with it. *Homes* was actually planned as an essay on suburban architecture for an art magazine, and could certainly stand unproblematically on its own as such. By chance, it was never actually published as Graham had intended it. Thereby, it migrated to the form of a lithographic print of an apocryphal two-page spread.[3] The print, and

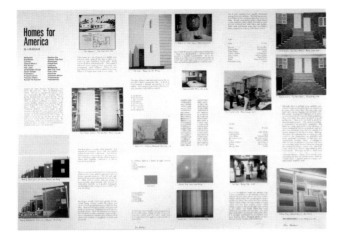

Dan Graham. *Homes for America*. 1966. Layout boards for an article for *Arts Magazine* (New York), December 1966/ January 1967. Printed text, handwriting, and black and white and color photographs, 40⁵⁄₁₆ x 30⁵⁄₁₆" (102 x 77 cm). Collection Daled, Brussels

the original photos included in it, do not constitute an act or practice of reportage so much as a model of it. This model is a parody, a meticulous and detached imitation whose aim is to interrogate the legitimacy (and the processes of legitimation) of its original, and thereby (and only thereby) to legitimate itself as art.

The photographs included in the work are among Graham's most well-known and have established important precedents for his subsequent photographic work. In initiating his project in photography in terms of a parodic model of the photo-essay, Graham positions all his picture-making as art in a very precise, yet very conditional, sense. Each photograph may be—or, must be considered as possibly being—no more than an illustration to an essay, and therefore not an autonomous work of art. Thus, they appear to satisfy, as do Smithson's photographs, the demand for an imitation of the nonautonomous. *Homes for America*, in being both really just an essay on the suburbs and, as well, an artist's print, constituted itself explicitly as a canonical instance of the new kind of anti-autonomous yet autonomous work of art. The photographs in it oscillate at the threshold of the autonomous work, crossing and recrossing it, refusing to depart from the artistic dilemma of reportage and thereby establishing an aesthetic model of just that threshold condition.

Huebler's work is also engaged with creating and examining the effect photographs have when they masquerade as part of some extraneous project, in which they appear to be means and not ends. Unlike Smithson or Graham, though, Huebler makes no literary claims for the textual part of his works, the "programs" in which his photographs are utilized. His works approach Conceptual art per se in that they eschew literary status and make claims only as visual art objects. Nevertheless, his renunciation of the literary is a language act, an act enunciated as a manoeuvre of writing. Huebler's "pieces" involve the appropriation, utilization, and mimesis of various "systems of documentation," of which photography is only one. It is positioned within the works by a group of generically related protocols, defined in writing, and it is strictly within these parameters that the images have meaning and artistic

Douglas Huebler. *Duration Piece #7, Rome* (detail). 1973. Three of fourteen black and white photographs and statement, overall: 39¼ x 32¼" (99.7 x 81.9 cm)

status. Where Graham and Smithson make their works through mimesis and parody of the forms of photojournalism, its published product, Huebler parodies the assignment, the "project" or enterprise that sets the whole process into motion to begin with. The seemingly pointless and even trivial procedures that constitute works like *Duration Piece #5, Amsterdam, Holland* (1970) or *Duration Piece #7, Rome* (1973) function as models for that verbal or written construction which, in the working world, causes photographs to be made. The more the assignment is emptied of what could normatively considered to be compelling social subject matter, the more visible it is simply as an instance of a structure, an order, and the more clearly it can be experienced as a model of relationships between writing and photography. By emptying subject matter from his practice of photography, Huebler recapitulates important aspects of the development of modernist painting. Mondrian, for example, moved away from depictions of the landscape to experimental patterns with only a residual depictive value, to abstract works which analyze and model relationships but do not depict or represent them. The idea of an art which provides a direct experience of situations or relationships, not a secondary, representational one, is one of abstract art's most powerful creations. The viewer does not experience the "re-representation" of absent things, but the presence of a thing, the work of art itself, with all of its indwelling dynamism, tension, and complexity. The experience is more like an encounter with an entity than with a mere picture. The entity does not bear a depiction of another entity, more important than it; rather, it appears and is experienced in the way objects and entities are experienced in the emotionally charged contexts of social life.

Huebler's mimesis of the model-constructive aspects of modernist abstract art contradicts, of course, the natural depictive qualities of photography. This contradic-

tion is the necessary center of these works. By making photography's inescapable depictive character continue even where it has been decreed that there is nothing of significance to depict, Huebler aims to make visible something essential about the medium's nature. The artistic, creative part of this work is obviously not the photography, the picture-making. This displays all the limited qualities identified with photoconceptualism's de-skilled, amateurist sense of itself. What is creative in these works are the written assignments, or programs. Every element that could make the pictures "interesting" or "good" in terms derived from art-photography is systematically and rigorously excluded. At the same time, Huebler eliminates all conventional "literary" characteristics from his written statements. The work is comprised of these two simultaneous negations, which produce a "reportage" without event, and a writing without narrative, commentary, or opinion. This double negation imitates the criteria for radical abstract painting and sculpture, and pushes thinking about photography toward an awareness of the dialectics of its inherent depictive qualities. Huebler's works allow us to contemplate the condition of "depictivity" itself and imply that it is this contradiction between the unavoidable process of depicting appearances and the equally unavoidable process of making objects that permits photography to become a model of an art whose subject matter is the idea of art.

II. AMATEURIZATION

Photography, like all the arts that preceded it, is founded on the skill, craft, and imagination of its practitioners. It was, however, the fate of all the arts to become modernist through a critique of their own legitimacy, in which the techniques and abilities most intimately identified with them were placed in question. The wave of reductivism that broke in the 1960s had, of course, been gathering during the preceding half-century, and it was the maturing (one could almost say, the totalizing) of that idea which brought into focus the explicit possibility of a "conceptual art," an art whose content was none other than its own idea of itself, and the history of such an idea's becoming respectable.

Painters and sculptors worked their way into this problem by scrutinizing and repudiating—if only experimentally—their own abilities, the special capacities that had historically distinguished them from other people—non—artists, unskilled or untalented people. This act of renunciation had moral and utopian implications. For the painter, a radical repudiation of complicity with Western traditions was a powerful new mark of distinction in a new era of what Nietzsche called "a revaluation of all values."[4] Moreover, the significance of the repudiation was almost immediately apparent to people with even a passing awareness of art, though apparent in a negative way: "What! You don't want things to look three-dimensional? Ridiculous!" It is easy to experience the fact that something usually considered essential to art has been removed from it. Whatever the thing the artist has thereby created might appear to be, it is first and foremost that which results from the absence of elements which have

hitherto always been there. The reception, if not the production, of modernist art has been consistently formed by this phenomenon, and the idea of modernism as such is inseparable from it. The historical process of critical reflexivity derives its structure and identity from the movements possible in, and characteristic of, the older fine arts, like painting. The drama of modernization, in which artists cast off the antiquated characteristics of their métiers, is a compelling one, and has become the conceptual model for modernism as a whole. Clement Greenberg wrote: "Certain factors we used to think essential to the making and experiencing of art are shown not to be so by the fact that Modernist painting has been able to dispense with them and yet continue to offer the experience of art in all its essentials."[5]

Abstract and experimental art begins its revolution and continues its evolution with the rejection of depiction, of its own history as limning and picturing, and then with the deconsecration of the institution which came to be known as Representation. Painting finds a new telos, a new identity and a new glory in being the site upon which this transformation works itself out.

It is a commonplace to note that it was the appearance of photography which, as the representative of the Industrial Revolution in the realm of the image, set the historical process of modernism in motion. Yet photography's own historical evolution into modernist discourse has been determined by the fact that, unlike the older arts, it cannot dispense with depiction and so, apparently, cannot participate in the adventure it might be said to have suggested in the first place.

The dilemma, then, in the process of legitimating photography as a modernist art is that the medium has virtually no dispensable characteristics, the way painting, for example, does, and therefore cannot conform to the ethos of reductivism, so succinctly formulated by Greenberg in these lines, also from "Modernist Painting": "What had to be exhibited was not only that which was unique and irreducible in art in general, but also that which was unique and irreducible in each particular art. Each art had to determine, through its own operations and works, the effects exclusive to itself. By doing so it would, to be sure, narrow its area of competence, but at the same time it would make its possession of that area all the more certain."[6]

The essence of the modernist deconstruction of painting as picture-making was not realized in abstract art as such; it was realized in emphasizing the distinction between the institution of the Picture and the necessary structure of the depiction itself. It was physically possible to separate the actions of the painter—those touches of the brush which had historically always, in the West at least, led to a depiction—from depiction, and abstract art was the most conclusive evidence for this.

Photography constitutes a depiction not by the accumulation of individual marks, but by the instantaneous operation of an integrated mechanism. All the rays permitted to pass through the lens form an image immediately, and the lens, by definition, creates a focused image at its correct focal length. Depiction is the only

possible result of the camera system, and the kind of image formed by a lens is the only image possible in photography. Thus, no matter how impressed photographers may have been by the analytical rigor of modernist critical discourse, they could not participate in it directly in their practice because the specificities of their medium did not permit it. This physical barrier has a lot to do with the distanced relationship between painting and photography in the era of art-photography, the first sixty or so years of the twentieth century.

Despite the barrier, around the middle of the 1960s, numerous young artists and art students appropriated photography, turned their attention away from auteurist versions of its practice, and forcibly subjected the medium to a full-scale immersion in the logic of reductivism. The essential reduction came on the level of skill. Photography could be integrated into the new radical logics by eliminating all the pictorial suavity and technical sophistication it had accumulated in the process of its own imitation of the Great Picture. It was possible, therefore, to test the medium for its indispensable elements, without abandoning depiction, by finding ways to legitimate pictures that demonstrated the absence of the conventional marks of pictorial distinction developed by the great auteurs, from Atget to Arbus.

Already by around 1955, the revalorization and reassessment of vernacular idioms of popular culture had emerged as part of a new "new objectivity," an objectivism bred by the limitations of lyrical Art Informel, the introverted and self-righteously lofty art forms of the 1940s and 1950s. This new critical trend had sources in high art and high academe, as the names Jasper Johns and Piero Manzoni, Roland Barthes and Leslie Fiedler, indicate. It continues a fundamental project of the earlier avant-garde—the transgression of the boundaries between "high" and "low" art, between artists and the rest of the people, between "art" and "life." Although Pop art in the late fifties and early sixties seemed to concentrate on bringing mass-culture elements into high-culture forms, already by the 1920s the situation had become far more complex and reciprocal than that, and motifs and styles from avant-garde and high-culture sources were circulating extensively in the various new culture industries in Europe, the United States, the Soviet Union, and elsewhere. This transit between "high" and "low" had become the central problematic for the avant-garde because it reflected so decisively the process of modernization of all cultures. The great question was whether or not art as it had emerged from the past would be "modernized" by being dissolved into the new mass-cultural structures.

Hovering behind all tendencies toward reductivism was the shadow of this great "reduction." The experimentation with the "anaesthetic," with "the look of non-art," "the condition of no-art," or with "the loss of the visual," is in this light a kind of tempting of fate. Behind the Greenbergian formulae, first elaborated in the late 1930s, lies the fear that there may be, finally, no indispensable characteristics that distinguish the arts, and that art as it has come down to us is very dispensable indeed.

Gaming with the anaesthetic was both an intellectual necessity in the context of modernism, and at the same time the release of social and psychic energies which had a stake in the "liquidation" of bourgeois "high art." By 1960 there was pleasure to be had in this experimentation—a pleasure, moreover, which had been fully sanctioned by the aggressivity of the first avant-garde or, at least, important parts of it.

Radical deconstructions therefore took the form of searches for models of the "anaesthetic." Duchamp had charted this territory before 1920, and his influence was the decisive one for the new critical objectivisms surfacing forty years later with Gerhard Richter, Andy Warhol, Manzoni, John Cage, and the rest. The anaesthetic found its emblem in the Readymade, the commodity in all its guises, forms, and traces. Working-class, lower-middle class, suburbanite, and underclass milieux were expertly scoured for the relevant utilitarian images, depictions, figurations, and objects that violated all the criteria of canonical modernist taste, style, and technique. Sometimes the early years of Pop art seem like a race to find the most perfect, meta-physically banal image, that cipher that demonstrates the ability of culture to continue when every aspect of what had been known in modern art as seriousness, expertise, and reflexiveness had been dropped. The empty, the counterfeit, the functional, and the brutal themselves were of course nothing new as art in 1960, having all become tropes of the avant-garde via Surrealism. From the viewpoint created by Pop art, though, earlier treatments of this problem seem emphatic in their adherence to the Romantic idea of the transformative power of authentic art. The anaesthetic is transformed as art, but along the fracture-line of shock. The shock caused by the appearance of the anaesthetic in a serious work is calmed by the aura of seriousness itself. It is this aura which becomes the target of the new wave of critical play. Avant-garde art had held the anaesthetic in place by a web of sophisticated manoeuvres, calculated transgressive gestures, which always paused on the threshold of real abandonment. Remember Bellmer's pornography, Heartfield's propaganda, Mayakovsky's advertising. Except for the readymade, there was no complete mimesis or appropriation of the anaesthetic, and it may be that the readymade, that thing that had indeed crossed the line, provided a sort of fulcrum upon which, between 1920 and 1960, everything else could remain balanced.

The unprecedented mimesis of "the condition of no art" on the part of the artists of the early sixties seems to be an instinctive reflection of these lines from Theodor Adorno's *Aesthetic Theory*, which was being composed in that same period:

Aesthetics, or what is left of it, seems to assume tacitly that the survival of art is unproblematic. Central for this kind of aesthetics therefore is the question of how art survives, not whether it will survive at all. This view has little credibility today. Aesthetics can no longer rely on art as a fact. If art is to remain faithful to its concept, it must pass over into anti-art, or it must develop a sense of self-doubt which is born of the moral gap between its continued existence

John Cassavetes. *Faces.*
1968. Still from a black
and white film, 130 min.

and mankind's catastrophes, past and future . . . At the present time significant
modern art is entirely unimportant in a society that only tolerates it. This
situation affects art itself, causing it to bear the marks of indifference: there is
the disturbing sense that this art might just as well be different or might not
exist at all.[7]

The pure appropriation of the anaesthetic, the imagined completion of the ges-
ture of passing over into anti-art, or non-art, is the act of internalization of society's
indifference to the happiness and seriousness of art. It is also, therefore, an expression
of the artist's own identification with baleful social forces. This identification may be,
as always in modernism, experimental, but the experiment must be carried out in
actuality, with the risk that an "identification with the aggressor" will really occur
and will be so successful socially as art that it becomes inescapable and permanent.
Duchamp gingerly seemed to avoid this; Warhol perhaps did not. In not doing so, he
helped make explicit some of the hidden energies of reductivism. Warhol made his
taboo-breaking work by subjecting photography to reductivist methodology, both in
his silkscreen paintings and in his films. The paintings reiterated or appropriated pho-
tojournalism and glamour photography and claimed that picture-making skills were
of minor importance in making significant pictorial art. The films extended the argu-
ment directly into the regime of the photographic, and established an aesthetic of the
amateurish which tapped into New York traditions going back via the Beats and inde-
pendents to the late 1930s and the film experiments of James Agee and Helen Levitt.
To the tradition of independent, intimate, and naturalistic filmmaking, as practiced
by Robert Frank, John Cassavetes, or Frederick Wiseman, Warhol added (perhaps
"subtracted" would be the better word) the agony of reductivism. Cassavetes fused
the documentary tradition with method acting in films like *Faces* (1968), with the
intention of getting close to people. The rough photography and lighting drew atten-
tion to itself, but the style signified a moral decision to forego technical finish in the
name of emotional truth. Warhol reversed this in films like *Eat, Kiss,* or *Sleep* (all
1963), separating the picture-style from its radical humanist content-types, in effect

Andy Warhol. *Kiss.* 1963.
Still from a black and white
film, 50 min. The Museum
of Modern Art, New York

using it to place people at a peculiar distance, in a new relationship with the specta-
tor. Thus a methodological model is constructed: the nonprofessional or amateurist
camera technique, conventionally associated with anticommercial naturalism and exis-
tential, if not political, commitment, is separated from those associations and turned
toward new psychosocial subjects, including a new version of the glamour it wanted
to leave behind. In this process, amateurism as such becomes visible as the photo-
graphic modality or style which, in itself, signifies the detachment of photography
from three great norms of the Western pictorial tradition—the formal, the technical,
and the one relating to the range of subject matter. Warhol violates all these norms
simultaneously, as Duchamp had done before him with the Readymade. Duchamp
managed to separate his work as an object from the dominant traditions, but not until
Warhol had the picture been accorded the same treatment.[8] Warhol's replacement of
the notion of the artist as a skilled producer with that of the artist as a consumer of
new picture-making gadgets was only the most obvious and striking enactment of
what could be called a new amateurism, which marks so much of the art of the 1960s
and earlier 1970s.

Amateurish film and photographic images and styles of course related to the
documentary tradition, but their deepest resonance is with the work of actual ama-
teurs—the general population, the "people." To begin with, we must recognize a con-
scious utopianism in this turn toward the technological vernacular: Joseph Beuys's
slogan "every man is an artist," or Lawrence Weiner's diffident conditions for the
realization and possession of his works reflect with particular clarity the idealistic side
of the claim that the *making* of artworks needs to be, and in fact has become, a lot
easier than it was in the past. These artists argued that the great mass of the people
had been excluded from art by social barriers and had internalized an identity as

"untalented" and "inartistic," and so were resentful of the high art that the dominant institutions unsuccessfully compelled them to venerate. This resentment was the moving force of philistine mass culture and kitsch, as well as of repressive social and legislative attitudes toward the arts. Continuation of the regime of specialized high art intensified the alienation of both the people and the specialized, talented artists who, as the objects of resentment, developed elitist antipathy toward "the rabble" and identified with the ruling classes as their only possible patrons. This vicious circle of "avant-garde and kitsch" could be broken only by a radical transformation and negation of high art. These arguments repeat those of the earlier Constructivists, Dadaists, and Surrealists almost word for word, nowhere more consciously than in Guy Debord's *The Society of the Spectacle* (1967): "Art in the period of its dissolution, as a movement of negation in pursuit of its own transcendence in a historical society where history is not directly lived, is at once an art of change and a pure expression of the impossibility of change. The more grandiose its demands, the further from its grasp is true self-realization. This is an art that is necessarily *avant-garde*; and it is an art that *is not*. Its vanguard is its own disappearance."[9]

The practical transformation of art (as opposed to the idea of it) implies the transformation of the practices of both artists and their audiences, the aim being to obliterate or dissolve both categories into a kind of dialectical synthesis of them, a Schiller-like category of emancipated humanity which needs neither Representation nor Spectatorship. These ideals were an important aspect of the movement for the transformation of artistry, which opened up the question of skill. The utopian project of rediscovering the roots of creativity in a spontaneity and intersubjectivity freed from all specialization and spectacularized expertise combined with the actual profusion of light consumer technologies to legitimate a widespread "de-skilling" and "re-skilling" of art and art education. The slogan "painting is dead" had been heard from the avant-garde since 1920; it meant that it was no longer necessary to separate oneself from the people through the acquisition of skills and sensibilities rooted in craft-guild exclusivity and secrecy; in fact, it was absolutely necessary not to do so, but rather to animate with radical imagination those common techniques and abilities made available by modernity itself. First among these was photography.

The radicals' problem with photography was, as we have seen, its evolution into an art photography. Unable to imagine anything better, photography lapsed into an imitation of high art and uncritically recreated its esoteric worlds of technique and "quality." The instability of the concept of art photography, its tendency to become reflexive and to exist at the boundary line of the utilitarian, was muffled in the process of its "artification." The criteria of deconstructive radicalism—expressed in ideas like "the conditions of no art," and "every man is an artist"—could be applied to photography primarily, if not exclusively, through the imitation of amateur picture-making. This was no arbitrary decision. A popular system of photography based on a minimal

level of skill was instituted by George Eastman in 1888, with the Kodak slogan, "you push the button; we do the rest." In the 1960s, Jean-Luc Godard debunked his own creativity with the comment that "Kodak does 98 percent." The means by which photography could join and contribute to the movement of the modernist autocritique was the user-friendly mass-market gadget camera. The Brownie, with its small-gauge roll-film and quick shutter, was also of course the prototype for the equipment of the photojournalist, and therefore is present, as a historical shadow, in the evolution of art-photography as it emerged in its dialectic with photojournalism. But the process of professionalization of photography led to technical transformations of small-scale cameras, which, until the more recent proliferation of mass-produced SLRs, reinstituted an economic barrier for the amateur that became a social and cultural one as well. Not until the 1960s did we see tourists and picnickers sporting Pentaxes and Nikons; before then they used the various Kodak or Kodak-like products, such as the Hawkeye, or the Instamatic, which were little different from a 1925-model Brownie.[10]

It is significant, then, that the mimesis of amateurism began around 1966; that is, at the last moment of the "Eastman era" of amateur photography, at the moment when Nikon and Polaroid were revolutionizing it. The mimesis takes place at the threshold of a new technological situation, one in which the image-producing capacity of the average citizen was about to make a quantum leap. It is thus, historically speaking, really the last moment of "amateur photography" as such, as a social category established and maintained by custom and technique. Conceptualism turns toward the past just as the past darts by into the future; it elegizes something at the same instant that it points toward the glimmering actualization of avant-garde utopianism through technological progress.

If "every man is an artist," and that artist is a photographer, he will become so also in the process in which high-resolution photographic equipment is released from its cultish possession by specialists and is made available to all in a cresting wave of consumerism. The worlds of Beuys and McLuhan mingle as average citizens come into possession of "professional-class" equipment. At this moment, then, amateurism ceases to be a technical category; it is revealed as a mobile social category in which limited competence becomes an open field for investigation.

"Great art" established the idea (or ideal) of unbounded competence, the wizardry of continually evolving talent. This ideal became negative, or at least seriously uninteresting, in the context of reductivism, and the notion of limits to competence, imposed by oppressive social relationships, became charged with exciting implications. It became a subversive creative act for a talented and skilled artist to imitate a person of limited abilities. It was a new experience, one which ran counter to all accepted ideas and standards of art, and was one of the last gestures which could produce avant-gardist shock. This mimesis signified, or expressed, the vanishing of the great traditions of Western art into the new cultural structures established by the mass

Edward Ruscha. *Some Los Angeles Apartments.* 1965. Spread from artist's book. The Museum of Modern Art Library

media, credit financing, suburbanization, and reflexive bureaucracy. The act of renunciation required for a skilled artist to enact this mimesis, and construct works as models of its consequences, is a scandal typical of avant-garde desire, the desire to occupy the threshold of the aesthetic, its vanishing point.

Many examples of such amateurist mimesis can be drawn from the corpus of photoconceptualism, and it could probably be said that almost all photoconceptualists indulged in it to some degree. But one of the purest and most exemplary instances is the group of books published by Edward Ruscha between 1963 and 1970.

For all the familiar reasons, Los Angeles was perhaps the best setting for the complex of reflections and crossovers between Pop art, reductivism, and their mediating middle term, mass culture, and Ruscha for biographical reasons may inhabit the persona of the American Everyman particularly easily. The photographs in *Some Los Angeles Apartments* (1965), for example, synthesize the brutalism of Pop art with the low-contrast monochromaticism of the most utilitarian and perfunctory photographs (which could be imputed to have been taken by the owners, managers, or residents of the buildings in question). Although one or two pictures suggest some recognition of the criteria of art-photography, or even architectural photography (e.g., "2014 S. Beverly Glen Blvd."), the majority seem to take pleasure in a rigorous display of generic lapses: improper relation of lenses to subject distances, insensitivity to time of day and quality of light, excessively functional cropping, with abrupt excisions of peripheral objects, lack of attention to the specific character of the moment being depicted—all in all a hilarious performance, an almost sinister mimicry of the way "people" make images of the dwellings with which they are involved. Ruscha's impersonation of such an Everyperson obviously draws attention to the alienated relationships people have with their built environment, but his pictures do not in any way stage or dramatize that alienation the way that Walker Evans did, or that Lee Friedlander was doing at that moment. Nor do they offer a transcendent experience of a building that pierces the alienation usually felt in life, as with Atget, for example.

UNION, NEEDLES, CALIFORNIA

Edward Ruscha. *Union, Needles, California* from *Twentysix Gasoline Stations*. 1963. Artist's book. The Museum of Modern Art Library

Edward Ruscha. *Every Building on the Sunset Strip*. 1966. Artist's book of nine joined sheets folded fifty-three times vertically, with offset halftone reproductions, folded: 7 x 5½" (17.8 x 14 cm). The Museum of Modern Art Library

The pictures are, as reductivist works, models of our actual relations with their subjects, rather than dramatized representations that transfigure those relations by making it impossible for us to have such relations with *them*.

Ruscha's books ruin the genre of the "book of photographs," that classical form in which art-photography declares its independence. *Twentysix Gasoline Stations* (1963) may depict the service stations along Ruscha's route between Los Angeles and his family home in Oklahoma, but it derives its artistic significance from the fact that at a moment when "the road" and roadside life had already become an auteurist cliché in the hands of Robert Frank's epigones, it resolutely denies any representation of its theme, seeing the road as a system and an economy mirrored in the structure of both the pictures he took and the publication in which they appear. Only an idiot would take pictures of nothing but the filling stations, and the existence of a book of just those pictures is a kind of proof of the existence of such a person. But the person, the asocial cipher who cannot connect with the others around him, is an abstraction, a phantom conjured up by the construction, the structure of the product said to be by his hand. The anaesthetic, the edge or boundary of the artistic, emerges through the construction of this phantom producer, who is unable to avoid bringing into visibility the

"marks of indifference" with which modernity expresses itself in or as a "free society."

Amateurism is a radical reductivist methodology insofar as it is the form of an *impersonation*. In photoconceptualism, photography posits its escape from the criteria of art-photography through the artist's performance as a non-artist who, despite being a non-artist, is nevertheless compelled to make photographs. These photographs lose their status as Representations before the eyes of their audience: they are "dull," "boring," and "insignificant." Only by being so could they accomplish the intellectual mandate of reductivism at the heart of the enterprise of Conceptual art. The reduction of art to the condition of an intellectual concept of itself was an aim which cast doubt upon any given notion of the sensuous experience of art. Yet the loss of the sensuous was a state which itself had to be experienced. Replacing a work with a theoretical essay which could hang in its place was the most direct means toward this end; it was conceptualism's most celebrated action, a gesture of usurpation of the predominant position of all the intellectual organizers who controlled and defined the Institution of Art. But, more importantly, it was the proposal of the final and definitive negation of art as depiction, a negation which, as we've seen, is the telos of experimental, reductivist modernism. And it can still be claimed that Conceptual art actually accomplished this negation. In consenting to read the essay that takes a work of art's place, spectators are presumed to continue the process of their own redefinition, and thus to participate in a utopian project of transformative, speculative self-reinvention: an avant-garde project. Linguistic conceptualism takes art as close to the boundary of its own self-overcoming, or self-dissolution, as it is likely to get, leaving its audience with only the task of rediscovering legitimations for works of art as they had existed, and might continue to exist. This was, and remains, a revolutionary way of thinking about art, in which its right to exist is rethought in the place or moment traditionally reserved for the enjoyment of art's actual existence, in the encounter with a work of art. In true modernist fashion it establishes the dynamic in which the intellectual legitimation of art as such—that is, the philosophical content of aesthetics—is experienced as the content of any particular moment of enjoyment.

But, dragging its heavy burden of depiction, photography could not follow pure, or linguistic, conceptualism all the way to the frontier. It cannot provide the experience of the negation of experience, but must continue to provide the experience of depiction, of the Picture. It is possible that the fundamental shock that photography caused was to have provided a depiction which could be experienced more the way the visible world is experienced than had ever been possible previously. A photograph therefore shows its subject by means of showing what experience is like; in that sense it provides "an experience of experience," and it defines this as the significance of depiction.

In this light, it could be said that it was photography's role and task to turn away from Conceptual art, away from reductivism and its aggressions. Photoconceptualism was then the last moment of the prehistory of photography as art, the end of the old

regime, the most sustained and sophisticated attempt to free the medium from its peculiar distanced relationship with artistic radicalism and from its ties to the Western Picture. In its failure to do so, it revolutionized our concept of the Picture and created the conditions for the restoration of that concept as a central category of contemporary art by around 1974.

NOTES

1. See Thierry de Duve's discussion of nominalism in *Pictorial Nominalism: On Marcel Duchamp's Passage from Painting to the Readymade*, trans. Dana Polan with the author (Minneapolis: University of Minnesota Press, 1991).

2. Peter Bürger, *Theory of the Avant-Garde*, 1974, trans. Michael Shaw (Minneapolis: University of Minnesota Press, 1984).

3. A variant, made as a collage, is in the Daled Collection, Brussels.

4. Friedrich Nietzsche, "Ecce Homo," in *On the Genealogy of Morals and Ecce Homo*, ed. Walter Kaufmann, trans. Kaufmann and R. J. Hollingdale (New York: Vintage Books, 1967), p. 290.

5. Clement Greenberg, "Modernist Painting," in *Clement Greenberg: The Collected Essays and Criticism*, vol. 4, *Modernism with a Vengeance, 1957–1969*, ed. John O'Brian (Chicago: at the University Press, 1993), p. 92.

6. Ibid., p. 86.

7. Theodor Adorno, *Aesthetic Theory*, trans. C. Lenhardt (London: Routledge & Kegan Paul, 1984), pp. 464, 470.

8. See de Duve's argument in *Pictorial Nominalism* that the readymade can/should be nominated as painting.

9. Guy Debord, *The Society of the Spectacle*, trans. Donald Nicholson-Smith (New York: Zone Books, 1994), p. 135 (thesis 190).

10. Robert A. Sobieszek discusses Robert Smithson's use of the Instamatic camera in his essay "Robert Smithson: Photo Works," in *Robert Smithson: Photo Works*, exh. cat. (Los Angeles: Los Angeles County Museum of Art and Albuquerque: University of New Mexico Press, 1993), pp. 16, 17 n. 24, 25 n. 61.

About Making Landscapes

I make landscapes, or cityscapes as the case may be, to study the process of settlement as well as to work out for myself what the kind of picture (or photograph) we call a "landscape" is. This permits me also to recognize the other kinds of picture with which it has necessary connections, or the other genres that a landscape might conceal within itself.

Plato, in *The Statesman*, wrote: "We must suppose that the great and the small exist and are discerned not only relative to one another, but there must also be another comparison of them with the mean or ideal standard. For if we assume the greater to exist only in relation to the less, there will never be any comparison of either with the mean. Would not this doctrine be the ruin of all the arts? For all the arts are on the watch against excess and defect, not as unrealities, but as real evils, and the excellence of beauty of every work of art is due to this observance of measure."

This fundamental criterion of idealist, rationalist aesthetics—that of the harmonious and indwelling mean of normative abstract standard—remains important in the study of development in the conditions of capitalist, or anticapitalist, modernity. But it is important as a negative moment because the most striking feature of historical, social, and cultural development in modernity is its unevenness.

Contemporary cultural discourse, which prides itself on its rigorous critique of idealism, has almost invalidated the idea of the harmonious mean, characterizing it as a phantom of rationalism. At the same time, the survival of the concept of measure, as the universal standard of value in the exchange of commodities, implies that measure is for us not a moment of transcendental revelation and resolution, but one of inner conflict and contestation—the contestation over surplus value, which implicates and binds all of us. From this immanently negative and antagonistic perspective, development can only be overdevelopment (aggravated development) or underdevelopment (hindered, unrealized development).

Translating these opposites into stylistic terms, we could see overdevelopment as a sort of mannerist—Baroque phenomenon of hypertrophy and exaggeration—a sort of typical postmodern "cyberspace." Underdevelopment suggests a poetics of inconclusiveness, filled with a secessionist rural pathos. But the "Arte Povera" of underdevelopment is no less malformed than its opposite; both are formed by an antagonistic or alienated relation to the concept of measure, and their unity around this concept is a threshold between aesthetic thought and political economy. So one way of approaching the problem of the "politics of representation" is to study the evolution of a picture

Written in 1995. First published in German and English as "Über das Machen von Landschaften"/"About Making Landscapes," in *Jeff Wall: Landscapes and Other Pictures*, exh. cat. (Wolfsburg: Kunstmuseum Wolfsburg, 1996), pp. 8–12.

as it works itself out in relation to the acts of measuring which constitute its very form. (For example, in the Academic tradition the relation between the shorter and longer sides of a pictorial rectangle were subject to prescriptive harmonic interpretation.)

In classicism the work of art is made by imagining the picture's or statue's subject as perfectly harmonious in its internal proportions, and then depicting that subject in a composition and on a rectangle, both of which are equally well measured. That is, both are exercises in harmonics. The measure and proportions of the picture themselves imply, and reflect, the serenity of ideal social relations.

Baroque aesthetics expressed both this Poussinian form and others, —for example that which we may identify with Brueghel's sixteenth century "anticipatory baroque"— oddly, complexly balanced compositions filled with bumpy, ragged, rough forms, simultaneously regular and irregular, hectic, complicated, carnivalesque, and fractalized.

It's inconvenient to suggest (after Bakhtin) that Brueghel's grotesque, or the movement toward it, is the "true" modern one, the one in which the negativity of modern measure, the nonidentity of the phenomenon with itself, the intangibility of meaning, is best made visible. I prefer to evade the polarization implicit in such a conclusion. The negative moment of measure may also be formulated as an *excess* of measure, in the manner of caricature. Harmony may therefore be thought of as a special, even a "sovereign," instance of the grotesque.

However that may be, we could anyway say that in a modern type of picture there will tend to be a distinction, or disparity (if not an open conflict) between the over- or underdevelopment of the motif or phenomenon pictured, and the still successfully measured and harmonious nature of the picture itself. The experience of the tension between form and content records and expresses mimetically something of our social experience of tormented development, that which is not achieved or realized, or that which, in being realized, is ruined—and also all the unresolved gray areas in between, where hope and alternatives reside.

Studying settlement forms is therefore not separable from working out picture types; it's not possible to do the former without doing the latter. A successful picture is a source of pleasure, and I believe that it is the pleasure experienced in art that makes possible any critical reflection about its subject matter or its form. That pleasure is a phantom affirmative moment, in which the pattern of development of settlements is experienced as if people didn't really suffer from it.

My landscape work has also been a way to reflect on internal structural problems in other types of pictures. In doing that, it's been possible to rethink, for myself, some rather obvious and conventional things about the genre of landscape as a genre.

Most evidently, a picture tends toward the generic category of landscape as our physical viewpoint moves further away from its primary motifs. I cannot resist seeing in this something analogous to the gesture of leave-taking, or, alternatively, of approach or encounter. This may be why a picture of a cemetery is, theoretically at

least, the "perfect" type of landscape. The inevitably approaching, yet unapproachable, phenomenon of death, the necessity of leaving behind those who have passed away, is the most striking dramatic analogue for the distant—but not *too* distant— viewing position identified as "typical" of the landscape. We cannot get too distant from the graveyard.

So we could reason that the peculiar or specific viewing distance at which the picture-type "landscape" crystallizes is an example of a threshold phenomenon or a liminal state. It is a moment of passage, filled with energy, yearning, and contradiction, which long ago was stabilized as an emblem, an emblem of a "decisive moment" of vision or experience, and of course of social relationships too.

In making a landscape we must withdraw a *certain distance*—far enough to detach ourselves from the immediate presence of other people (figures), but not so far as to lose the ability to distinguish them as agents in a social space. Or, more accurately, it is just at the point where we begin to lose sight of the figures as agents that landscape crystallizes as a genre. In practical terms, we have to calculate certain quantities and distances in order to be in a position to formulate an image of this type, especially in photography, with its spherical optics and precise focal lengths.

I recognize the "humanist" bias in this construction, and the recurrence of the idealist notion of measure in it, but I think it's valid as a way of thinking analytically about the typology of pictures, which, unlike some other art forms, are radically devoted to the semblances of the human being. This is just one of the senses in which we have not gotten "beyond" idealist aesthetics.

To me, then, landscape as a genre is involved with making visible the distances we must maintain between ourselves in order that we may recognize each other for what, under constantly varying conditions, we appear to be. It is only at a certain distance (and from a certain angle) that we can recognize the character of the communal life of the individual—or the communal reality of those who appear so convincingly under other conditions to be individuals.

Modernist social and cultural critiques and theory have concentrated on revealing the social semblance, the social mask, of liberal idealism's most important phantom, the "subject," sovereign, individuated, and free. What has been at stake is the visibility of the determinations which, insofar as they are repressed in or as social experience, make possible the appearance of this "ideological ghost," this creature of "second nature." If that were to be an artist's intention, it could probably be realized entirely through a self-reflexive approach to a "humanist" typology of landscape as I've outlined it. In modernity's landscapes, figures, beings, or persons are made visible as they vanish into their determinations, or emerge from them—or more likely, as they are recognized in the moment of doing both simultaneously. Thus they are recognized as both free and unfree; or possibly misrecognized, first as unfree, then as free, and so on. Another way of putting this is that, in a landscape, persons are depicted

on the point of vanishing into and/or emerging from their property. I think this phe-
nomenology is analogous to, or mimetic of, real social experience, extra-pictorial
experience. The liminal condition of landscape has been for me a sort of measure, or
mean. I have been trying to reflect on and study other constructs, other picture-types,
which I feel have in some important senses crystallized out of landscape.

Frames of Reference

In 1977, when I started making my large color pictures, it was still possible to talk about photography in, or as, art, in a way that wasn't terribly different from the way it was talked about in 1970 or 1960. The classic idea of art photography was still predominant, and what I think of as the "new art photography" was just emerging. Cindy Sherman's work was just becoming known, as was Sherrie Levine's, and the students of Bernd and Hilla Becher had just begun to make their pictures, but had yet to exhibit them. Walker Evans was alive and working until 1975.

At the time, I was indirectly reacting to that classic idea, and liked the same photographers I like now—Evans, Atget, Frank, and Weegee. But I was more immediately interested in the work of Robert Smithson, Ed Ruscha, and Dan Graham, because I saw their photography as emerging from a confrontation with the canons of the documentary tradition, a confrontation that suggested some new directions. I also noticed and liked Stephen Shore's and Garry Winogrand's work, partly because of the cool and knowing view of the American street and suburbs and partly because of the acceptance of the actual, vulgar colors of things. That vulgarity seemed to be related to whatever there was of a new way of seeing the world in Pop art and, through that, back to the rough, improvisatory aesthetic of the New York School.

If I really thought about photography as photography, or about photography as art pure and simple, I had to admit that Evans, Atget, and Strand were better than Smithson or Ruscha. But the problem was that the "better" seemed foreclosed at the time. Classic art photography had been perfected, it seemed to me, and anything that would be done in the present, by me or by anyone, would be a lesser achievement. That was probably just the common defense mechanism of artists when they are confronted with the work of their betters. Any way of foreclosing the encounter with the term "better" is a cop-out in art. With hindsight, it's obvious to me that there was no reason not to just continue where Evans left off, making small pictures in the guise of a reporter. When Levine presented her photographs of Evans's pictures, I interpreted the work as her saying "study the masters; do not presume to reinvent photography; photography is bigger and richer than you think it is, in your youthful pride and conceit."

I had always studied the masters and respected the art of the past. I had a bit of a hard time during the '60s because I needed to work in and through a situation that simply assumed the art of the past was "obsolete" (to use the Leninist terminology of the time) and that the only serious possibilities lay in reinventing the avant-garde

Written in 2003. First published as "Frames of Reference," *Artforum* (New York) 42, no. 1 (September 2003): 188–92.

project of going beyond "bourgeois art." Clearly, this was nothing more than the
paradigm of the moment, but it was a long moment. Some people see this condition
of the neo-avant-garde's predominance lasting from 1955 to 1978, almost a quarter
century. So I remained ambivalent about "studying the masters," at least for a while.
And that had something to do with ignoring Levine's admonition. The fact that
nobody seemed to notice that her work was an admonition, or at least that it contained
a hidden, cryptic admonition, is no excuse for ignoring it.

Looking back on it now, I think my ambivalence in studying the masters was
one of the most important things that happened to me or that I imposed on myself.
Two problems seemed to have emerged as a result: Which masters? And how does one
study the masters the way they themselves studied the masters they encountered?

My answer to the first question was to study not just the masters of the photo-
graphic tradition, the result in part of thinking about Smithson, Ruscha, and others
who deployed or employed photography in Conceptual, post-Conceptual, and para-
Conceptual art. (Later I wrote about this in "Marks of Indifference.") Like Duchamp
and later Warhol, those artists didn't separate photography from other art forms and
other media; it wasn't taken as an art form all to itself, with special criteria and stan-
dards. Taking it that way was called "photo-ghetto thinking," and young artists like
me thought that was a symptom of the decline in quality of work that wanted to con-
tinue the traditions of classic art photography.

There is obviously a dilemma here, one lacking an obvious solution. To consider
photography only within its own frame of reference, within the context of the stan-
dards established by the documentary tradition, seemed to condemn it to a restricted
status given the "expanded field" of '60s and '70s art. Every young Conceptual artist
using photography but refusing to be called a photographer could point to the boring

Garry Winogrand. *New York City*. 1969. Gelatin silver print, 8¾ x 13⁷⁄₁₆" (22.3 x 33.2 cm). The Museum of Modern Art, New York. Gift of Mr. and Mrs. James Hunter

Sherrie Levine. *After Walker Evans #3*. 1981. Gelatin silver print, 10 x 8" (25.4 x 20.3 cm)

examples of traditional photography as evidence of the need to escape the confines of the tradition and its aesthetic norms.

Unfortunately, this blending of photography with other things, like painting, printmaking, or three-dimensional art forms, almost immediately led to the unconvincing hybrids that are so sadly characteristic of art since then. An equally strong argument could hence be made that escaping the confines of "photography" was a road to ruin because there were no valid criteria in the intermedia world, nor could there be any. Photography, it could be argued, had a very specific nature as an art form and a medium, and combining it with other things resulted in nothing new as photography but only the reduction of photographs to elements in a collage aesthetic that was not subject to judgment in photographic terms, and maybe not subject to any aesthetic judgment at all.

With this in mind, I realized I had to study the masters whose work, either in photography or in other art forms, didn't violate the criteria of photography but either respected them explicitly or had some affinity with them. That meant, not necessarily in order of importance: photographers as such and artists working in photography who avoided the multimedia approach, who in some way subjected themselves to the serious aesthetic problems of photography (both Evans and Dan Graham, for example); and artists in other forms or media whose work I felt was connected to those aesthetic ideas in some ways, ways I couldn't necessarily always explain to myself, but which I sensed and believed existed—traditional painters like Manet, Cézanne, and Velázquez, more recent artists like Pollock and Carl Andre, whose works showed me something else, which I'll get to shortly, cinematographers such as Néstor Almendros, Sven Nykvist, or Conrad Hall, and film directors and writers like Luis Buñuel, Rainer Werner Fassbinder, Robert Bresson, Terrence Malick, and Jean Eustache.

Jackson Pollock. *Full Fathom Five*. 1947. Oil and mixed mediums on canvas, 50⅞ x 30⅛" (129.2 x 76.5 cm). The Museum of Modern Art, New York. Gift of Peggy Guggenheim

I think it is pretty apparent how cinematographers, cineastes, and traditional painters contribute to the aesthetics of photography, and so there's no need to go into that in any detail here. In recognizing these affinities, I was just continuing things that were already part of the classic photographic idea. Photography, cinema, and painting have been interrelated since the appearance of the newer arts, and the aesthetic criteria of each is informed by the other two media to the extent that it could be claimed that there is almost a single set of criteria for the three art forms. The only additional or new element is movement in the cinema.

I had been impressed by Jackson Pollock's work since I first saw it as a child in the late '50s. I studied it and saw it more deeply during the '60s, in part through the writings of Clement Greenberg and Michael Fried. I realized that the physical immediacy and scale of Pollock's work were qualities that, for me, created the affinity with photography. That affinity was the enigmatic element in my earlier fascination with his work, I now believe. When Frank Stella and Carl Andre, among others, extended aspects of Pollock's notion of scale, they separated the issue from the immediate context of Pollock's painting style and from many of the overly codified "'50s" values his work exemplified. That freed some formal and technical aspects and energies and made it possible for them to be taken elsewhere.

Even while I loved photography, I often didn't love looking at photographs, particularly when they were hung on walls. I felt they were too small for that format and looked better when seen in books or as leafed through in albums. I did love looking at paintings, though, particularly ones done in a scale large enough to be seen easily in a room. That sense of scale is something I believe is one of the most precious gifts given to us by Western painting.

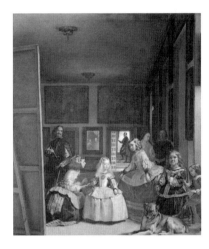

Carl Andre. *144 Lead
Square*. 1969. Lead, 144
units, overall: ⅜" x 12' x
12' (1 x 367.8 x 367.8 cm).
The Museum of Modern
Art, New York. Advisory
Committee Fund

Diego Velázquez. *Las
Meninas*. 1656. Oil on can-
vas, 10' 6⅛" x 9' (318 x
276 cm). Museo del Prado,
Madrid

People who write about art often think my work always derives in some direct
way from the model of nineteenth-century painting. That's partly true, but it has
been isolated and exaggerated in much of the critical response to what I'm doing. I'm
totally uninterested in making reference to the genres of earlier pictorial art. I
extracted two things, primarily, from the Western pictorial tradition up through the
nineteenth century: the first was a love of pictures, which I believe is at the same time
a love of nature and of existence itself. The second was an idea of the size and scale
proper to pictorial art, and so proper to the ethical feeling for the world expressed in
pictorial art. This is the scale of the body, the making of pictures in which objects and
figures are limned so that they appear to be on about the same scale as the people
looking at the picture. I don't mean by this that there are no other valid or interest-
ing approaches to the size of a picture; I mean that life scale is a central element in
any judgment of an appropriate scale.

The painting and some of the sculpture done by the New York School and the
generation that came after intensified this sense of scale and physicality. My involve-
ment with that art as a young person helped me to connect what bothered me about
photography with qualities in other art forms that held valuable indications for
aspects of photographic making. A sculpture by Andre seemed to me to have affinities
with Velázquez's *Las Meninas* because they were both of the same scale. You could,
imaginably, stand on an Andre while looking at *Las Meninas* and the whole experi-
ence would be resonant because the artists, so different in other respects, were in

accord about the relation of their object to the body of the spectator who would see it, as well as, of course, to their own bodies while they were making it.

Michael Fried's great essay "Art and Objecthood" (1967) argues in some ways against the isolation of and emphasis on the physical presence of art objects. He proposes that, when works of art allow themselves to be reduced to their apparently fundamental ontological status as physical objects and relinquish the illusionism that has always distinguished them, something significant is lost. Fried understood "illusionism" to mean not traditional perspectival illusion but its subsequent form as the "optical" qualities of what he thought to be the best abstract painting of his time. I understood opticality to refer both to abstract painting as Fried intended but also to traditional pictorial illusionism and, as part of that, to the optical character of photographs. I was fascinated to watch Fried abruptly shift his focus from abstract art to nineteenth-century pictorial art at the end of the '6os. I intuited that there was an important affinity between his interests and mine.

I read "Art and Objecthood" to say that if an artwork simply cast its lot with physicality and immediacy, it lost its essential possibility as serious art and was reduced to a repetitive staging of the encounter between an object or group of objects in the world and a person looking at that object. It soon became obvious that it was arbitrary what the object was. To those who wanted to go beyond the canonical criteria of Western art, this "staging" of the encounter with the remnant of an artwork appeared to be a new and profound direction. But time has not treated that attitude well. Fried showed that illusion is essential. That aspect of his work connected for me with the problem of the size of photographs, and I realized that, in making photographs in or near life scale, photography could be practiced to a certain extent differently from the way it had been.

This was not a question of making "big photographs" any more than it was a question for Velázquez of making "big paintings." The new sense of scale was not significant in itself, and in isolation it is nothing new, since photographs have been enlarged since enlargers were first produced.

I was interested in the debate about what both Greenberg and Fried called "literalism," even though I had no trouble recognizing the superior quality of the critique of literalism. I was interested in the problem, even though I felt it had been solved, because I don't think there is a "loser" in a dispute carried on at a high level. So even though I wanted my work not to be literalist, I appreciated the way Judd or Andre forced the issue of present time and present space; it made the question of life scale more complex and interesting to me than it would have been if it were just a reworking of seventeenth- or nineteenth-century pictorial approaches.

Some people have thought that the backlighting of my color pictures created a sort of "bracketing" of them such that their mere existence as "pictures of things in the world" could be looked at askance and the physical constituents of their making could show itself explicitly. That connects them to avant-garde attitudes about reveal-

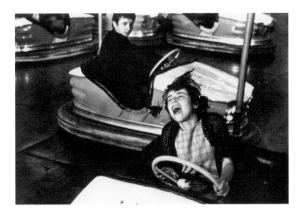

Robert Bresson. *Mouchette.*
1967. Still from a black and
white film in 35 mm, 78 min.

ing the making of the work in the experience of it and prevents them from being
"just traditional pictures of things." That's probably true, but for me the backlight-
ing was much less important in this regard than what I thought of as a sort of preser-
vation of some aspect of literalism in the construction of the picture.

The change in scale signified a complex of slight shifts of emphasis in the aes-
thetic canon of art photography. In my mind, or at least in one part of my mind, I
wasn't moving very far from the canonical aesthetics of art photography. At the same
time, I began to call my photography "cinematography."

I was involved in working out the formal and aesthetic matter of scale in a
frame of reference in which the lessons I wanted to learn from painting were partly
identified with and even confused with those to be gotten from the cinema. Scale had
nothing to do with this, because I don't think there is much if any relationship
between the way we see moving pictures in the cinema and the way we experience
static pictures hanging on a wall in a lighted room.

"Cinematography" referred simply to the techniques normally involved in the
making of motion pictures: the collaboration with performers (not necessarily "actors,"
as neorealism showed); the techniques and equipment cinematographers invented,
built, and improvised; and the openness to different themes, manners, and styles. It was
probably an overstatement to identify these things strictly with filmmaking and not
with still photography, since photographers, to a greater or lesser extent, have used
almost all the same techniques and approaches; but it helped me to concentrate on what
was needed to make pictures with the kind of physical presence I wanted.

In 1973, *Artforum* published Roland Barthes's "The Third Meaning: Notes on
Some of Eisenstein's Stills." I appreciated the way Barthes "stilled" the film experi-
ence and studied single frames as if they were more essential than the moving image.
This emphasized the fact that films are made up of still photographs that we experi-
ence in a very specific, even peculiar way. We are looking not so much at the photo-
graphs but at flashes of their projection, too brief to permit the picture to be seen as
it is, which is static, like all photographs. That helped me concentrate on the fact that

Rainer Werner Fassbinder. *Fox and His Friends*. 1975. Still from a color film in 35 mm, 123 min.

the techniques we normally identify with film are in fact just photographic techniques and are therefore at least theoretically available to any photographer.

But it was not a question of imitating filmmaking techniques or making pictures that resembled film stills. It was only a question of following the thread of the recognition that films were made from photographs and were essentially acts of photography. I had no particular aim in mind, only my sense of the criteria of pictorial art as they had evolved and which stood over me as a standard of quality.

The notion of "cinematography" was the cause of one of the most complex and confusing results of the situation I'd created for myself. Filmmakers such as Fassbinder or Godard moved between very different manners and styles from film to film, or even within single films. The openness and complexity of their photographic approach were at once impressive and disturbing, since it seemed to play havoc with the idea of "style" itself. Cinema appeared to be a form in which multiple, even contradictory approaches were reconciled without effort, as if that were a natural condition of the form itself. There was obviously an element of pastiche, of ironic reference to various other films and styles in this approach, but that seemed to me to be less important than the experiential condition of the abrupt shift from style to style, or manner to manner, that worked so well in films like *Fox and His Friends* or *Passion*, and which I did not see much in the work of still photographers. The fact that Godard and Fassbinder might have been imitating their own masters, like Fuller or Sirk, with greater or lesser doses of irony, was apparent but insignificant.

At the same time, the entirely unified environments created by the realist or neorealist works of the same period, like Pasolini's *Accatone* or *The Gospel According to St. Matthew*, Bresson's *Mouchette*, and Eustache's *The Mother and the Whore*, clearly stated another fundamental aesthetic proposition, which was rooted in documentary photography and was happy to be so, that required no stylistic mannerism, no referentiality, no "intertextuality." Those films were committed to the directness guaranteed by the nature of documentary photography and were easily the match in terms of quality for anything else. They were usually better than anything else.

Pier Paolo Pasolini. *Accatone*.
1961. Still from a black and
white film in 35 mm, 120 min.

Pier Paolo Pasolini. *The
Gospel According to St.
Matthew*. 1964. Still from a
black and white film in
35 mm, 137 min.

But not absolutely better. From Fassbinder's dream scenes and erotic fantasies it is a brief step in time, space, and culture to the high artifice of studio cinema and to imaginary worlds outside the framework of documentary treatment. Cinematography as such did not suggest a choice to be made between the imaginary space of the studio and the seamless actuality of the documentary approach. The Brechtian spirit in which Jean-Marie Straub and Daniele Huillet made *Not Reconciled* in 1966 or *Othon* in 1969, films I saw in the early '70s, also suggested that there was a theoretical and even political stake in pursuing the thread of stylistic or technical indecisiveness, in not choosing between fact and artifice, in working only in the shadow of choice, in hesitating.

Part II: Interviews

Typology, Luminescence, Freedom: Selections from a Conversation between Jeff Wall and Els Barents

Jeff Wall is an artist, art historian, and teacher. He lives and works in Vancouver, Canada, where he was born. His work has become known in Europe since 1981 through his inclusion in such exhibitions as *Westkunst*, Documenta 7, *Nouvelle Biennale de Paris*, and in several solo shows. The interview published here was carried out on the nights preceding the opening of his exhibition at the Stedelijk Museum, Amsterdam, in September 1985.

In his work, Wall has created a complex relationship between historical knowledge and the current state of society, between the effects of high art and those of advanced technology. He wants to confront high art with the sensuality and the pictorialism of mass culture, and mass culture with the intellectual, political, and aesthetic traditions of the avant-garde.

His pictures are characterized by great attention to subject, detail, composition, and technique. The dramatization of his subjects is rooted in a process of meticulous construction of appearances through a method akin to both cinematography and traditional oil painting. In this, he is attempting to establish strictly contemporary terms for a recovery of the qualities and functions of the older pictorial art which he considers a still-living part of culture.

In the interview, Wall discusses his intention to interrelate the diverse aspects of his production and his intellectual reflection on it. He considers theory to be essential to the development of his work. He believes that the process of illumination of practice by cultural theory distinguishes critical aesthetics from those attitudes which begin from the idea of the "end of the avant-garde" and end in reconciliation with official forms of culture and thought.

ELS BARENTS

TYPOLOGY

ELS BARENTS: Since 1978 you've produced twenty works. In some early pieces, particularly *The Destroyed Room* (1978) and *Picture for Women* (1979), you related your pictures to specific art-historical sources. But more recently your attitude toward this procedure seems to have changed. The emphatic connection to specific historical works of modernist art seems to have mutated, if not disappeared.

Conducted in Amsterdam in September 1985. First published in German as Els Barents, "Typologie, Luminiszenz, Freiheit: Auszüge aus einem Gespräch zwischen Jeff Wall und Els Barents," in *Jeff Wall: Transparencies* (Munich: Schirmer/Mosel, 1986), pp. 95–105. First published in English as Barents, "Typology, Luminescence, Freedom: Selections from a Conversation with Jeff Wall," in *Jeff Wall: Transparencies* (New York: Rizzoli, 1987), pp. 95–104.

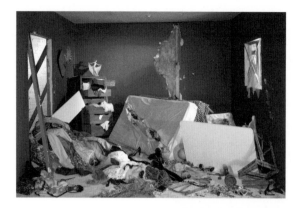

Jeff Wall. *The Destroyed Room.* 1978. 62⅝" x 7' 10⅛" (159 x 234 cm)

Eugène Delacroix. *The Death of Sardanapalus.* 1827. Oil on canvas, 12' 10⁵⁄₁₆" x 16' 3¼" (392 x 496 cm). Musée du Louvre, Paris

JEFF WALL: In my earlier pictures I was trying to be a little more dogmatic, trying to establish my position, my theoretical relations with Conceptual art and through that with what I think of as an avant-garde "countertradition." This was in 1978, at the beginning of the new painting. It was a new subjectivistic period, and I was in certain ways trying to hold out against it, trying to continue an idea of historically and theoretically informed production, an idea which was, at that time at least, being identified with a failed cultural politics—that of the '60s and '70s—a defunct, nostalgic avant-gardism. When I first started making these photographs I thought it was important to make a definite reference to other works. For example, when I made *The Destroyed Room*, I worked in reference to the design of commercial window displays of clothing and furniture. I think of these as *tableaux morts* as opposed to *tableaux vivants*. At the time, they had become very violent, mainly because of an influence from the punk phenomenon which was quickly filtering into the whole cultural economy. At the same time, the picture's subject matter had something to do with aggression, violence, and revenge in domestic life. I was very interested in Delacroix's *Death of Sardanapalus*, partly because I was lecturing on Romanticism. I think the *Sardanapalus* is a very important picture, historically and psychologically, because it shows the eroticized ideal of military glory which characterized the Napoleonic period being turned inward, back toward domestic life at the end of that epoch, at the

Jeff Wall. *Picture for Women.* 1979. 56¼" x 6' 8½" (142.5 x 204.5 cm)

Edouard Manet. *Bar at the Folies-Bergère.* 1882. Oil on canvas, 37'⁵⁄₁₆ x 51⁵⁄₁₆" (96 x 130 cm). The Samuel Courtauld Trust, Courtauld Institute of Art Gallery, London

beginning of modern, bourgeois, neurotic private life. This painting interested me as a kind of crystal. My subject was made with this crystal, by passing my ideas and feelings through the historical prism of another work. I felt that this made the subject richer, more suggestive, more aggressive. It was important to filter *The Destroyed Room* through this other picture because I think I was trying to establish a space for myself by suggesting which historical directions and problems were important to me. I know that in some ways this is a very artificial way of going about things, very manneristic even, but it was a way to begin, and I had to begin.

EB: But people can respond to *The Destroyed Room* without having to be familiar with Delacroix's picture. *Picture for Women* is different; it seems to be so strongly related to Manet's painting *Bar at the Folies-Bergère* that one can't really appreciate it without engaging in some kind of art-historical or cultural study.

JW: *Picture for Women* is a "remake" of Manet's picture. The *Bar* had really impressed me; I'd seen it repeatedly in the Courtauld Gallery in London when I was a student. I wanted to comment on it, to analyze it in a new picture, to try to draw out of it its inner structure, that famous positioning of figures, male and female, in an everyday working situation which was also a situation of spectacularity, that regime of distraction and entertainment which Manet dealt with. I made my picture as a theoretical

Jeff Wall. *Milk.* 1984.
6' 2¼" x 7' 6¾" (187 x 229 cm)

diagram in an empty classroom. Maybe for Manet this spectacular regime was some-thing immediate; but at the time I made *Picture for Women* these things had become openly theoretical, political issues, mainly through the influence of the women's move-ment in the art world. There were lessons being learned throughout the period, so maybe the classroom setting has something to do with this. I think that, at that time, it was not so unusual to be bringing together a kind of theoretical activity—study, if you like—with the enjoyment of pictures.

It was also a remake the way that movies are remade. The same script is reworked and the appearance, the style, the semiotics, of the earlier film are subjected to a commentary in the new version. This dialectic interests me. It's a judgment on which elements of the past are still alive. It's standard procedure in the theater, where the same plays are produced over and over again, interminably. And as long as paint-ing remains "painted drama"—which it always does, in my opinion—then these issues of the dramas of the past and their representations in the present, whether staged or painted or photographed, must be at the center of the problematics of paint-ing and its relations with other technologies of representation.

It's true, as you say, that my more recent pictures don't really have this relation to a specific work. The relations seem now to be more to pictorial typologies, generic structures, or laws which appear as modes of spatial organization, types of figure-ground relations and things like that.

EB: Works like *No* and *Milk*, for example, are dramatic. A sense of dramatized mean-ing is very evident in them. A more recent work, *Diatribe*, on the other hand, seems very undramatic, even ordinary. Yet I know you value it highly. During some of our talks you claimed that it has a generic relation to classicistic art. How does this pic-ture work with pictorial typologies?

JW: With *Diatribe*, I wanted to make a picture of a group in the street. I've done a sort of series of these "street pictures," beginning with *Mimic* in 1982. It was not

Jeff Wall. *Doorpusher*. 1984.
8′ 2¹⁄₁₆″ x 48¹⁄₁₆″ (249 x 122 cm)

clear to me beforehand just what I wanted the picture to look like. I don't like to repeat myself formally; I prefer each subject to also propose a certain kind of picture. Pictorial typology and the range of subjects are linked, too, I think.

When I'm making a picture, I spend a lot of time in my car driving around the city, "location scouting." I'm usually looking for a certain combination of elements, a kind of street, certain architectural typologies, and so on. Naturally, I always search with something specific in mind. But this idea, which is usually the early concept of the picture, is quite abstract and indistinct. So searching tends to become wandering, a kind of *flânerie* which is conducive to musing. In this process the concept becomes more sensuous, gets related to a real mood, and finally to an actual place. This place is always more complex spatially or pictorially than I had first imagined it, always far more interesting and rich in suggestion. For example, in *Milk*, I had thought of the figure against a blank wall. But the actual site is far more differentiated, and the gap between the buildings has for me an effect similar to the unexpected openings in the perspective of Mannerist paintings. The same kinds of things occur in working out the people, the costumes, the objects. Sometimes the location is the first thing established, sometimes it's a person, even an object, like the headphones in *Stereo*. The picture gets made as these elements are concretized. It's a construction made out of a complex of real things, all of which are at the same time symbolic.

Sometimes a place has become fixed in my memory—maybe for many years— and a specific picture turns out to have been kindled by that memory. That was the case with *Doorpusher*, where the battered and burned door—this door which seems to be sinking back into the wall—was one I'd seen repeatedly for seven or eight years.

Nicolas Poussin. *Landscape with Diogenes.* c. 1647. Oil on canvas, 63" x 7' 3" (160 x 221 cm). Musée du Louvre, Paris

Jeff Wall. *Diatribe.* 1985. 6' 7⁵⁄₁₆" x 7' 6¹⁄₁₆" (203 x 229 cm)

It was at the back of the studio building where I teach. I'd often pass it after dark, fatigued from the classes that day, but with my mind racing the way it does after long discussions with students. When I began *Doorpusher*, I searched all over town for appropriate doors, making Polaroids of them, until I realized that this door had been in the picture all along. Something similar occurred with the basement setting of *Abundance*. It's in the same building. So anyway, for *Diatribe*, I was looking for a straight road at the edge of the city, and I couldn't find one. Then finally I saw this curved lane and thought "This is it." It's like something is in the back of your mind, you don't know it in advance, but you recognize it when you actually experience it. That's why wandering is important; the unconscious gets to play, the whole personality is involved, and you get away from planning and a sort of narrow decision-making kind of behavior. I think this is particularly important for me because my technique has to be so rational and calculated. Art isn't that rational, even if it appears to be.

When I recognized this space, this lane, I recognized a whole lot of other things that I wanted in the picture which I wasn't aware of before. I realized that this road set up a spatial situation that strongly recalled the classical landscapes of Poussin. He rarely, if ever, uses sharp perspectival recession because it's too dramatic, too irrational.

Poussin knew that the vanishing point of the perspective system is the irrational point which permits you to call the whole rational structure into question, and so he usually hides it, as all classicists do. He always likes to have quite flat planes overlapping to produce a gently receding space, a sober, measured kind of poetry typical of classical composition.

The subject of *Diatribe* is talking and walking. The Socratic ideal of knowledge includes the idea of the peripatetic character of philosophy. Socrates strolled about the polis, meeting people in an everyday urban context, and having conversations with them. Diogenes did the same. Nietzsche took up the same idea, and was thinking of Socrates when he said that philosophizing should never be done sitting down. For this strolling philosophy, the experience of the city, of the marketplace and the public spaces which invite encounters, was seen to stimulate thought. In the past, of course, this thought has always been male, or has been identified with a male producer, a "philosopher." I liked the idea that it would now be these young, impoverished mothers, who aren't identified with philosophical knowledge and critique, who would be enacting this.

The picture was set off by seeing a group like this—one woman vehemently talking to the other. I began studying these young mothers, who were mostly living on welfare. I parked near playgrounds, clinics, supermarkets, and laundries. I noticed that these women had become quite invisible on the street. People ignore them. They seem to have become emblematic of some insoluble contradictions. Working-class family life can never correspond to the bourgeois model set for it by the capitalist state. Even the recently ended period of prosperity didn't really transform the working class into a part of the bourgeoisie as many critics insisted. Wage slavery and "the reserve army of labor," the unemployed who depend on the state, are still here in force. The norms imposed by the state bureaucracies are never attained by workers, particularly those at the bottom. The imposition leads only to further aggravation, only makes the miserable dilemma of the ideal of the family under the conditions of wage labor more acute. Proletarian maternity is just as much a bourgeois scandal as proletarian prostitution is, but it's just the other side of the same coin. Prostitution is always directly spectacular; maternity is only spectacular if it can be eroticized, either with religious symbolism or with violence, or both together. The only impoverished mothers who are spectacularized today are those who disintegrate in violence of some kind, or else the "super-madonnas." For the rest, that is for almost all, it's the opposite, invisibility. They've become almost like pariahs, in terms of the public space anyway. Like Socrates, Diogenes was a public nuisance. I've always been amused by his aphorism, "In a rich man's house the only place to spit is in his face." Diogenes seems to have accepted the fact that philosophical knowledge and approval from above could not be reconciled in the kind of class society he lived in. He performed as one of society's "least-favored members." Sartre said that the truth about society could be

expressed only through the eyes of its least-favored members. It seemed to me that these women were in such a position. So they have a generic, objective relation to the traditional aims of critical philosophy. Thus I could represent them, typologically, through the classicistic structuring of the picture, as engaged in such discourse.

So the women coming around the curve in the road and the space resolving itself in a classicistic way suggest to me the relationship between critical antiquity and critical modernity. The title word, "diatribe," comes from Greek and defines at least two ancient forms of critique—a "vehement denunciation" and a "rhetorical argument with an absent third party." I didn't become conscious of this inner content of the picture until I had actually discovered this particular space in my own process of moving through the city.

It is the meanings of the typology of pictures which makes these significations possible and objective. This typology is a material means, it's a material part of the process of making pictures, not just an arbitrary intellectualization. All my pictures are made like this. *Diatribe* is a more or less typical case.

LUMINESCENCE

EB: The technological form of backlit transparencies is a sort of "super-photography." It relates to aspects of mass spectacle as well as to bureaucratic ways of presenting information. Your metal boxes emit a light which makes the images very absorbing, and because the photography is so clear we are invited to look at the pictures very closely. But at the same time, they seem to be immaterial projections that can be seen just as well from a distance. Despite their very realistic subject-matter, the transparencies have a dreamlike presence. The intensity of color and light and the large scale of the works create a dimension that's hard to describe. I know you place great importance on the interconnections between different technologies that create this effect, and also on the interconnections between these technologies and the art of painting, which you admire tremendously. How did you develop this set of connections for yourself?

JW: I hadn't been to Europe for four or five years, since I lived there in the early '70s. Then in 1977 I went back for a holiday with my family. Among other museums, I visited the Prado for the first time and looked at Velázquez, Goya, Titian. I remember coming back to Vancouver and thinking once again how powerful those pictures were, how much I loved them. And also how they contained innumerable traces of their own modernity.

But I also felt that it was impossible to return to anything resembling the idea of the "painter of modern life," as Baudelaire termed it. And yet I think that in many ways for modernism that's a fundamental term, "the painter of modern life." Because there is no more appropriate occupation. It's a complete occupation because the art

form, painting, is the greatest art form and the subject is the greatest subject. But, as I said, I felt very strongly at that time that it was impossible, because painting as an art form did not encounter directly enough the problem of the technological product which had so extensively usurped its place and its function in the representation of everyday life. It's interesting because of course this was just at the time when a lot of young artists were rediscovering painting. I remember being in a kind of crisis at the time, wondering what I would do. Just at that moment I saw an illuminated sign somewhere, and it struck me very strongly that here was the perfect synthetic technology for me. It was not photography, it was not cinema, it was not painting, it was not propaganda, but it has strong associations with them all. It was something extremely open. It seemed to be the technique in which this problem could be expressed, maybe the only technique because of its fundamental spectacularity. That satisfied the primary expectation of the product of technology, which is that it represents by means of the spectacle.

I think there's a basic fascination in technology which derives from the fact that there's always a hidden space—a control room, a projection booth, a source of light of some kind—from which the image comes. A painting on canvas, no matter how good it is, is to our eyes more or less flat, or at least flatter than the luminescent image of cinema, television, or the transparencies. One of the reasons for this is that the painting or the ordinary photograph is lit with the same light that falls in the room and onto the spectator him- or herself. But the luminescent image is fascinating because it's lit with another atmosphere. So two atmospheres intersect to make the image. One of them, the hidden one, is more powerful than the other. In a painting, for example, the source or the site of the image is palpably in front of you. You can actually touch the place where the image comes from, where it is. But in a luminescent picture the source of the image is hidden, and the thing is a dematerialized or semi-dematerialized projection. The site from which the image originates is always elsewhere. And this "elsewhere" is experienced, maybe consciously, maybe not, in experiencing the image. Rimbaud said "Existence is elsewhere," and Malevich once wrote, "Only that which cannot be touched can be sacred." To me, this experience of two places, two worlds, in one moment is a central form of the experience of modernity. It's an experience of dissociation, of alienation. In it, space—the space inside and outside of the picture— is experienced as it really exists in capitalism: there is always a point of control, of projection, which is inaccessible. It is a classical site of power. I see it as an analogue of capitalist social relations, which are relations of dissociation. We are permitted to play the game of transformation of nature, the great festival of metamorphosis, only by going through capital, by being subjected to the laws of capital. For example, you can't turn seeds into plants without going through, or into, capital. Ask any farmer. Something becomes inaccessible to us as we work on it. Thus we are both in the game and separated from it at the same time. The technological product, as we currently

experience it from within capitalism, recapitulates this situation in its experiential structure, which gives us something very intensely and at the same time makes it remote.

Furthermore, the fascination of this technology for me is that it seems that it alone permits me to make pictures in the traditional way. Because that's basically what I do, although I hope it is done with an effect that is opposite to that of technically traditional pictures. The opportunity is both to recuperate the past—the great art of the museums—and at the same time to participate with a critical effect in the most up-to-date spectacularity. This gives my work its particular relation to painting. I like to think that my pictures are a specific opposite to painting.

EB: Before you began to make these transparencies you were for some years very interested in making films. You had no success in that, but it has obviously had a strong influence on how you approach your still pictures.

JW: I think that the process of film-making is in important ways analogous to the methods of painting, at least to those aspects of painting which interest me the most. I'm referring to the regulated aspects of an art form, those which have the function of the public or social construction of meaning, as opposed to the more immediately expressive factors. Regulation implies a regulating force, an institution. Institutionalization always implies repetition. Repetition is maybe the foundation of institutionalization. Regulation, repetition, formalization, abstraction. These are the basic modernist, bureaucratic approaches to things.

The starting point of a normal, commercial film is usually quite abstract—a business deal, some market projections. The process of concretization develops through a pretty formalized division of labor, and so conventionalized methods operate at every stage: lighting codes, set design, acting technique, casting services, etc. This bureaucratic, and hence theoretically informed cooperation resembles the production processes of the old academic fine arts. The old academies are the prototypes of corporate cultural production and corporate, regulated products, just as much as the idea of the factory is. So in such situations the image is the outcome of a complex division of labor. The idea of individual artistic imagination, or creativity, isn't dispensed with, as structuralists and other positivists claim, but is plunged realistically into the actual world of social relationships, particularly the antagonistic and objectivistic relationships involved in the production of value in capitalism. Both the corporatized painter of the past and the filmmaker now are obliged to transform the incessant abstractionism of the modern production process into a work of art. That's an old struggle, the struggle with the historically evolved social forms of production, which tend toward conventionalization, simplification, and formulaic repetition. The struggle is to realize something unique, profound, sensuous, and true through the actual movement of socialized abstractions, which are directed away from these qualities, toward maybe a kind of

emptiness. But society contains this emptiness and its opposite, and both appear in the work of art. To me, cinematography consists in this extreme paradox, this photographing of abstractions in the dream of producing the opposite out of them. This dialectic appeals to me because it isn't limited by any ideas of the spontaneous production of the effect of life in the image. The spontaneous is the most beautiful thing that can appear in a picture, but nothing in art appears less spontaneously than that.

So I think that cinematography is aesthetically more developed than the more spontaneous photographic aesthetic, the one identified with Cartier-Bresson, for example. The reliance on immediate spontaneity thins out the image, reduces the level at which the permanent dialectic between essence and appearance operates in it. Although the picture which is made is often very meaningful and beautiful, I'm not convinced that the beauty isn't in a way limited by its dependence on the immediate surface of things. That kind of photography becomes a version of Art Informel; despite its formal richness, it is condemned always to gaze at the world in wonder and irony rather than engage in construction.

I also think that, artistically, photography established itself on the basis of cinema, and not the other way around. This has to do with the interconnections between cinema, painting, theater, and photography. Ian Wallace and I have spent a lot of time talking about the fact that once cinema emerged, the narrativity that had previously been the property of painting was expelled from it. Until this time, painting was quite explicitly painted drama, and so it was always in a multivalent relationship with theatrical ideas. Our pictorial experience of drama was created by painting, drawing, etching, and so on. But the cinema, unlike the forms of performance it canned and played back, is a performance picture. Cinema synthesized the functions of painting and of theater simultaneously on the technical basis of photographic reproduction. So in that synthesis the mechanics of photography were invested with tremendous meaning, a meaning they will now always have.

FREEDOM

EB: Your view of society is not really a pleasant or happy one, it seems. Your figures are always under some kind of pressure or restraint, no one seems to be doing what they want to be doing in life. Your world appears to be ruled by an iron hand. There are a lot of laws in it. But you talk about how society contains opposites always. How do you think this "opposite" manifests itself in your pictures?

JW: I'm aware that my pictures have a feeling of unfreedom about them. Their subject matter is unfreedom, too. The form and the technique tend to have a hyperorganized, rigid character, everything is strictly positioned. I want to express the existing unfreedom in the most realistic way. Take for example *Bad Goods*. This picture is constructed as a kind of triangle, one point of which is outside the image. The heap of

Jeff Wall. *Bad Goods.* 1984.
7' 6⅟₁₆" x 11' 4⅜" (229 x
347 cm)

rotting lettuces is the apex, and the two other corners are made up of the British
Columbia Indian in the picture, and the spectator in front of it. Both the spectator and
the Indian are looking at the lettuces and at each other. But their social relation to
that lettuce may be different. I say "may be" because the audience for pictures is
changing as the economy worsens. Some spectators are getting a lot richer, some
maybe poorer. The Indian may need some of the lettuce to eat. If so, he'll have to
scrounge through it and find what is not rotten. His view of the lettuce is partially
determined by his class position, by his poverty, which is quite typical of, in this case,
the native Indian people in British Columbia, where I live. Many of them exist in the
city apparently as victims of modernization, of development, of "progress," of capi-
talism. They are often depicted as just that, victims of capitalism, and not much more.
I fear and dislike these sorts of representation. But this Indian, in my view, will never
move toward the lettuce as long as the spectator is also there, as long as the triangle
exists. This triangle separates two people from each other, and in doing that it is a
kind of diagram of the consequences of the economy. In the economy, natural prod-
ucts separate people from each other because they are also always forms capital takes.
Lettuce, like any commodity, is just capital in a kind of natural disguise. Ideally,
humans are united over food. But I suppose that presumes there's food for everyone.
The Indian will not move toward the lettuce, he will not be seen as just a victim, as
a "beggar" or whatever category you want to set up. He will not perform. That is his
performance. His unfreedom is more important to him than food. He is not just a vic-
tim, he is also a fighter. In *Bad Goods* the whole structure of the picture is based on
this figure's necessary unfreedom, and his expression of it. The only concept of free-
dom in it is, I guess, Hegel's: freedom is the rational recognition of necessity.

In my pictures feeling, too, is heavily constrained. I think that every figure I
have made is filled with suppressed emotion, which isn't allowed to be seen directly.
In *Milk*, for example, the man's body is tense and rigid with inexpressivity. It's the
object which is exploding. In my pictures there is a lot of nongesturing, or very small,

Jeff Wall. *Mimic*. 1982.
6' 5¹³⁄₁₆" x 7' 5¹⁵⁄₁₆" (198 x
228.5 cm)

compulsive gesturing, what I call "micro-gesture." The men's gestures in *No* or *Mimic* are micro-gestures. These are gestures which seem automatic, mechanical, or compulsive. They well up from somewhere deeply social, somewhere I don't primarily identify with the individual's unconscious as such. The abusive white *lumpenproletarian* in *Mimic*, for example, is making a gesture, pulling up his eyelid in a mimesis of the Oriental eye. In my dramatization of it for myself, I thought of it happening so quickly that nobody in the picture is really aware of it. The white man's gesture is welling up with incredible rapidity from his own personality, and he hasn't any control over the expression. It has an automatic, compulsive character. This is related to its extreme economy. It's so economical that it has an artistic quality. This is related to the title of the picture, because mimesis is the root of art. When this particular type of man undergoes certain kinds of stress, stimulation, or provocation, this kind of thing emerges. I don't think it's accidental; it's determined by the social totality, but it has to come out of an individual body. Unreflected social action involves a regression of the individual, an accumulating conformism. What is conformed to in this regression isn't the surface of society as much as its depths, its inner contradictions. This regression is the way individuals live the truth about society without having that truth pass through any process of reflection. Since the regression contains a truth, or involuntarily expresses one, it is a sort of inverted form of profundity. This regression can also be looked at as the subjective side of actual, objective social regression, as the consequence of the waste of human capacities, which is getting worse all the time.

In both *Mimic* and *Doorpusher*, even in *Milk*, I tried to show men who retained certain capacities, skills, or strengths, but who could develop no creative use for them. The "mimic" in *Mimic* is a tragic figure, in part, to me, because, as I mentioned, mimesis is the germ of art, here turned into a weapon of war. These little gestures of hate are precursors of worse things to come. The young derelict in *Doorpusher* has, as they said about safecrackers in the old movies, the "hands of a concert pianist," sensitive, capable, almost magic hands. These men have been thrown on the garbage pile,

along with their natural abilities and possibilities. I don't mean to make a symmetry between victim and aggressor in the case of *Mimic*, but I want to make a very realistic image of this particular type of aggressor. By "very realistic" I mean an image which shows the inner contradictions of this figure, its socially determined quality, and also its otherness to itself.

Now, as to the question of the presence of the "opposite" to this structure of compulsion in my work: I thought for quite a while that it was first of all important to present that actuality of things, to go away from a subjectivistic dreamworld of art, to show something of the dirt and ugliness of the way we have to live. So there's a negativity. I don't think I have to justify this negativity, but I will say that in my thinking about this I have been strongly influenced by the discussions and disagreements that Walter Benjamin and Theodor Adorno had during the late 1930s. Benjamin talks about the "ruins of the bourgeoisie." To me, the figure of the lower middle-class and working-class man, woman, or child is the most precise image of this ruin. Here we can also locate the image of the destitute person, who is always part of the working class, the subproletariat. But this ruined person, or ruined class, can be looked at in different, even completely opposed ways. It's very possible to use this image of a ruined class as consolation and reinforcement, to absolutize the ruination of things and thereby come to the view that this is the eternal order of nature. Benjamin called this "left-wing melancholy." I feel that it is most true to see both the existing damage and at the same time to see the possibilities which have been covered over by that damage. The effects of capitalism are like scar tissue which has encrusted a living body. This living body retains the possibility to become something else, although it will have to become that carrying its scars and wounds along with it. These scars are enlightenment. The image has to express that, too. I don't think there is a limit to the sadness we can feel when we look at the damage, but sadness, melancholy, isn't the only thing to feel in this situation.

So, in all my pictures I think there's a trace, a moment, in which there is a kind of lucid awareness of the existing unfreedom. This moment may not be identified with all the people in the picture, maybe only with some, or one. In the drama, the heavy weight of unfreedom is at the point of becoming visible, becoming an object of rational reflection. This implies that there is usually a crisis being depicted, a moment in which the personalities undergo an experience which places their existence in question. I'm trying to show this situation, this "liminal," or threshold situation, in which a person is both himself and not himself at the same instant. This nonidentity with oneself is the germ of all transformation and development. It can be represented in all sorts of ways, but in photography it's especially difficult. Photography tends to show the immediate surface of the world, and so people rightly dislike it as banal, mechanical, and abstract. It's not a medium in which the sense of the nonidentity of a thing with itself can be easily or naturally expressed; quite the

opposite. A photo always shows something resting in its own identity in a mechanical way. That's why I don't make "portraits." All the people in my pictures appear there not as themselves, but are playing the part of someone else, someone maybe not very much like themselves.

They are performing, so they are "other." I think it's possible, through the complex effects of techniques derived from painting, cinema, and theater, to infuse the photographic medium with this dialectic of identity and nonidentity. And the reason I want to do this is to represent both the surface of damaged life, and its opposite, the possibility of another life, one which will come out of this one as its negation. It cannot come from anywhere else. We can imagine it, we can make pictures of it. So when we experience the picture, we experience a kind of dissociation. The key experience for modernist art is this dissociation of identity, I think. In it, we see both our actual existence for what it is and, at the same time, catch a glimpse of something extremely different. Something better.

EB: When you talk about "something better" you are talking about progress, about a better world. This is an idea which is identified with an avant-garde position. This position, as you say, has been widely considered as nostalgic and invalid in today's society. But you nevertheless persist in holding on to it.

JW: Yes, that's true. I mentioned that I thought there is a "countertradition" within modernity. This countertradition is what I identify as "avant-garde." I don't believe in the media sense of the idea of "avant-garde," the Walt Disney version. The term itself is inaccurate, with its connotations of constant, relentless, almost amnesiac forward movement. But the term has become established, and we have to use it, even though I'm not at ease with its implications.

The classically accepted concept of the avant-garde as a form of culture which centered itself in a contestation over the social value of art is one which I accept. This contestation over value is central because our society is a class-divided, antagonistic one. So there are contesting ideas in every aspect of life. There is no unity as such in capitalism, and so the representation of figures within it always contains a sense of this "otherness" we were talking about before. You can analyze the roots of this contestation, or struggle, in culture in any number of ways, but all of them, in my opinion, remain rooted in class conflict. So the analysis continuously encounters the problem of value or, if you like, the mystery of value. The mystery of value is the fundamental mythic content of modernity. Money is God, totem, fetish; what we have always thought of as mythic or totalizing thought is simultaneously an economic psychology. The grand myths of metamorphosis which lie at the basis of Western culture are, I believe, enacted anew in the production, exchange, and consumption of every commodity. The surface of life is a hieroglyphic expression of the actual value-forms in society. So representation confronts the inner nature of the social order auto-

matically in giving its account of that surface and its relation to that surface. The question of the value of a cultural product, an image, an object, an artwork, has been at the center of the development we call the avant-garde. The readymade, the Productivist/Constructivist/Surrealist critique, are all incomprehensible without understanding their concentration on the problem of value. Every specific expression, every subject of a picture, to exist as a part of this tradition, is obliged to reflect on the conditions under which its social value is established. In doing so, it becomes part of the fundamental contestation over value. This gives the work of art its educative function: it creates conditions in which the inner workings of society, and therefore also the inner developments and metamorphoses of the individual psyche, can be perceived, experienced sensuously as pleasure, and at the same time can be thought of, can be reflected upon for their truth. I don't think that an artist today can have any real motivation to investigate this problematic without having some sense of the limitations of the existing order, some sense of its disastrous character. Why try to contest, otherwise? There's plenty of decorating to be done. Having some sense of these limitations implies having the concept of an alternative. This alternative has no predetermined privileged cultural form, but it nevertheless has a role to play in culture. And that role was articulated in ways which are still important by avant-garde practice and theory.

We can't remain at the level of the historical or classical avant-garde, but at the same time we can't launch ourselves subjectively into a new epoch of some kind. I believe that the idea of a "post-avant-garde" situation is a kind of wish fulfillment. The wish is that the kinds of contradictions and conflicts which shape culture under capitalism have been transcended, that we're in a new epoch. The new epoch has allegedly been brought about by computers, by the "failure of socialism," by all kinds of things. It's called "neocapitalism," or "postindustrial society," or something like that. There are innumerable experts and pundits outlining this new world. People seem to be hoping that the image of capitalist modernity as the regime of unfreedom and empty suffering which was developed, in part, by the avant-garde critique has somehow been invalidated, and that therefore the whole language of this critique no longer holds good for investigating the world. I see this kind of hoping against hope as an ideological phantasm. There is still capitalism, and monopoly capitalism at that. The relations of subjection which are reproduced every time a commodity is made are still being reproduced billions of times a day. Suffering and dispossession remain at the center of social experience. But at the same time and for the same reasons the contestation continues at every moment. This conflict is permanent in class society. It may not be so immediately visible on the surface of culture these days, but it remains in motion beneath that surface. It cannot be wished or fantasized away. It always promises to appear; avant-garde culture is based on this possibility.

The countertradition I'm interested in is not just an art movement, it is a whole

political culture. And because its politics are based on the material possibility of change, art plays a prominent role in it. It does so because it provides this complicated glimpse of something better that I mentioned before. The glimpse of something "other" which you experience in art is always a glimpse of something better because experiencing art is, as Stendhal said, the experience of a *"promesse de bonheur,"* a promise of happiness.

EB: And how do you think your pictures, which are so attentive to the unfreedom and unhappiness of the present, give a promise of happiness?

JW: I always try to make beautiful pictures.

Representation, Suspicions, and Critical Transparency: An Interview with Jeff Wall by T. J. Clark, Claude Gintz, Serge Guilbaut, and Anne Wagner

BIOGRAPHICAL BACKGROUND

SERGE GUILBAUT: Let's start with the beginning of your questioning, in the '70s.

JEFF WALL: I think it is most pertinent to talk about photography to begin with. What I was doing at the end of the 1960s and the beginning of the 1970s was transformed with the adoption of photography because, since childhood, my background was painting and drawing. By 1967 I had been painting for quite some time already, and had gone through Minimalist art, like a lot of people my age. Between 1966 and say 1970 I'd learned about and appreciated what Judd and Flavin were doing, and was influenced by it. Also—and here again I was like a lot of other people—I had simultaneously been interested in Pop art and Duchamp and the whole genealogy that goes back through that.

I think photography became important under those circumstances because it signified the mechanical, technological problem for all those people who had grown up assuming they were interested in images, pictures, and representations. And I think for all the people who had come out of that background, photography reemerged around 1965 as the problematic. Between 1965 and 1970, I think many young artists, or people who wanted to be artists, realized that some things, as much as they were loved, were beginning to look closed to them—for example "high modernist" painting in the lineage of Pollock and Stella. And this was made very, very clear to us at that time by the work of someone like Judd. For those who wanted to remain in the world of imagery, photography seemed like the only open space.

SG: Some others did video.

JW: Video was bonded to the photographic field in that period. All the frustrated painters who realized that the whole ideology out of which they emerged was now in

Conducted in Paris in 1989. First published in German as T. J. Clark, Claude Gintz, Serge Guilbaut, Anne Wagner, and Jeff Wall, "Repräsentation, Mißtrauen und kritische Transparenz: Eine Diskussion mit Jeff Wall (1989)," in Wall, *Szenarien im Bildraum der Wirklichkeit: Essays und Interviews*, ed. Gregor Stemmrich (Amsterdam and Dresden: Verlag der Kunst and Fundus Books, 1997), pp. 189–234. Excerpts published in English and German as "Three Excerpts from a Discussion with Jeff Wall/Drei Auszüge aus einer Diskussion mit Jeff Wall," *Parkett* no. 22 (1989): 82–85, and in English as "Representation, Suspicions and Critical Transparency: An Interview with Jeff Wall by T. J. Clark, Serge Guilbaut and Anne Wagner," *Parachute* (Montreal) no. 59 (July–September 1990): 4–10. Printed here is the first unabridged version of the interview to be published in English.

a position to be looked at in a new way felt they had to move toward some kind of encounter with photography and video. The other related issues were of course Conceptual art and performance; I think at that time photography, video, performance, and Conceptual art were thought of as a single, complex thing.

So my history is really about the acceptance of photography as something I couldn't get away from, even though it was not my first interest. I often feel in a certain way that I was exiled into photography, having come out of the world of painting and drawing.

SG: What was the reason for this type of rejection of closure?

JW: I think Pop art, Minimal art, and Conceptual art were all knotted together. Pop art and Minimal art were really two facets of a single phenomenon. Conceptual art emerged as what I consider the first cogent critique of that phenomenon. That new situation involved the return or the reemergence of important aesthetic ideas of the 1920s and '30s, all those partly utopian ideas about the transcendence of bourgeois art forms through technology, the immanent critique of bourgeois aesthetics, and the ability of what we call an avant-garde to form this critique. For me, this was all condensed into the phenomena of Minimal art and Pop art. It may be that this recovery of past avant-garde ideas took place even though many of the American minimalist artists weren't focused on it, or, like Judd, were repressing their connections with the problematic constructivist notions of the transcendence of bourgeois art forms either through technology or objective technical production. That broke open the whole idea of subjective art in the '60s, just the way Pop art interfered with people's notions that they "themselves" were making their pictures. Pop art had a disturbing effect; it changed artists' practice even though they weren't Pop artists.

ANNE WAGNER: When did you find out that photography would go along with writing for you?

JW: Around 1966, '67, or '68, through the examples of work like that of Ed Ruscha, Dan Graham, and Robert Smithson. They developed a sort of model of an art which didn't look like art—at that time that was one of the things you were always looking for, to escape the rather high-handed way "art" looked. The fusion of text and photograph was central to that.

The beginning of Conceptual art was about writing, it was entirely rooted in the idea that a written text could stand in for an artwork. And that was shocking. But one of the connections I had personally was my interest in some of the Weimar and Soviet artists of the '20s, in photomontage and its interconnection with critical text. In some ways, for me it went from Pop and early Conceptual art back in time to people like Tretyakov and Heartfield and to a certain extent to the critical writings of Brecht and Benjamin.

Remember that it was just at that moment that the writings of the Frankfurt School and many related things were first being translated into English. Benjamin was first translated about 1970. Marcuse, of course, was being widely read, and he was one of the conduits into the whole corpus of critical ideas and theories appearing and becoming relevant for English-speaking people then.

SG: What was that generation of artists looking for in reading those texts?

JW: We were really bored with subjectivist, abstract, expressionist, existentialist, romantic art, for any number of reasons, as I said. People were fascinated by the new, they were fascinated by the media, and all those kinds of things that would lead one to a sense that there was a utopian content inside of these newer art forms, and a hope that they really would be beyond "bourgeois art"—and Pollock, for example, seemed more and more like "bourgeois art."

At that time there was a momentum to what I see now as an "ultraleft" view of artistic activity. I look at my original copy of Benjamin's "The Author as Producer," for example, and it's all heavily annotated, having been so carefully studied. I remember thinking, "This is really ultraleft," but I was nevertheless very influenced by it. I thought that Benjamin was taking a position so extreme that it almost dissolved any residual possibility of making an artwork in the bourgeois sense.

My reading was, of course, a reaction to political life at the time, and the kinds of political decisions people were making—political decisions not in the normal or surface sense, but ones that had to do with how you imagined being an artist. And this was a part of the reaction against things that really did feel closed at that time—what I'm calling "subjective art." It felt that way in part of course because the accomplishments in it were so great. I admired the whole trajectory of artists from Matisse and Picasso to Rothko, Pollock, and then to Stella and Judd. Something had really been achieved, and yet it felt as if there was no room for me in that world. And so there were many ideological arguments with that work that became more and more pressing. For me all these problems crystallized through photography.

CLAUDE GINTZ: In a sense, Minimalism was also against subjectivity and expressionism, so what made you think at that time that Minimalism had to be rejected?

JW: I think that everybody who was twenty years old then learned an immense amount from looking at Judd and Flavin, Andre. They relearned what the readymade meant. I was astonished that Flavin could rent lighting equipment and make an exhibition, and then, theoretically at least, send it all back. It seemed that there was no property form, that it was entirely liberated from that, and at the same time it still had an appearance that was incredibly rigorous, incredibly nonsubjective, very cued into the way the built environment looked. Flavin's, Judd's, or Andre's work had all those kinds of things that anybody who was interested in what I would call a

nonidealistic art form would be struck by. For me, seeing Minimal art was always a real learning experience and a stepping-stone into something else.

CG: Do you think that Minimal art has a linguistic structure?

JW: I think it generated one.

CAPITALISM AND REPRESENTATION

T. J. CLARK: There seems to be a tension in your work. Your ideological framework remains quite fiercely and intransigently a critique of late capitalism, or neocapitalism; there is a determination to hold on to a critical idea of capitalism, this very specific regime of representation, or ordering and control of human behaviors, which still cries out to be represented. Now that framework is associated with a particular period in the late '60s early '70s. It is connected with a tradition of critical reflection that led to a great deal of suspicion of the artwork. The work of art was seen as implicated in a regime of representation and a regime of distribution, and was thought of as perhaps an entity to be criticized among others as belonging to the capitalist field.

Now this goes along, in your mind, with another determination to hang on to certain possibilities you hold to be valuable and salvageable from the tradition of art-making, and indeed particularly from the tradition of painting. These have to sal-vaged, continued. There does seem to be a high tension there, between your ideas so closely associated with a current of thought that moved inexorably toward a radical skepticism about art and representation, and your determination nonetheless to hold on to and remake that unified, even monumental art object, with its character as artis-tic commodity.

JW: I hope it's clear that, on the one hand, my thinking was formed in the situation in which the whole new suspicion of representation crystallized, but on the other, that at a certain point I absolutely diverged from that direction, recognizing what I feel to be a fundamental boundary within it. In the later '60s and early '70s, new people, young people, recovered radical philosophical and cultural traditions, which hadn't played an important part in art and the thinking about art since before World War II. But that recovery was problematic. The reception of the '60s of the radical critical thought of the 1920s was fragmentary, was reinvented, partly failed. It contained some contradictions which I couldn't accept, one of them being that the ideology cri-tique bound up with representation would have to lead to the liquidation of represen-tation as a viable practice inside of this regime which is identified with capitalism. I identify this regime with capitalism and anticapitalism simultaneously; that is why I got interested in Social Realism and saw it as the other side of the coin of modernist art, and was intrigued by it.

Partly through Conceptual art's replacement of the image or the object with lin-

guistic forms, the legitimacy of composing a representation, in any traditional sense, was withdrawn. I think this became a cultural orthodoxy of the New Left, and, through that, in a complex way, of poststructuralist thought. A lot of this new ideology's critical work, derived from the terms of the debate in the 1930s between Benjamin, Brecht, Adorno, Bloch, and George Lukacs, was itself unresolved. The most problem-ridden position was held by Lukacs, who insisted that typical "Western," "realistic" representations, images rooted in profound historical typologies, had immense pedagogic power, and that could not simply be dispensed with by suspicion of representation as such. There was an inability in the critical times of the early '70s to recognize that there was a potential continuity within cultural traditions; they had not been destroyed by the regime of capitalism, they existed within it in a problematic way. I think there was an amnesiac aspect in the attitude toward representation that emerged in the early '70s. I think it has to do with puritanism; I do believe there was in the New Left an unacknowledged, puritan iconophobia that did create an amnesiac element and obliged those people to forget or repress aspects of the critical language they were basing themselves on.

TJC: Although there are many paradoxes there, there is a terrible puritanism to most versions of Lukacsian respect for representation. And there was, or there could be, in the late '60s and early '70s, a wonderful antipuritanism to certain kinds of ludic varieties of suspicion of representation, sometimes wonderful and sometimes rather feeble. I don't necessarily see the regime of the Happening as puritan, do you?

JW: No, I don't, and also there was an intense conflict at that time, up until the middle to late '70s, between aspects of counter-culture, shall we call them that, that came out of the same period with each other. There is a polymorphous, anti-Judeo-Christian, ludic, carnivalesque element which I see as rooted around more the performing art of the time, in rock music for example. All the performing and imagistic elements were hanging together in an important way. The problematic part was coming to terms with the revival of ideology critique, in that those people who were most interested in taking up an ideology critique found themselves taking up a position counter to the possibility of imagistic continuity. The places where the images were happening tended to look like they were being co-opted.

George Lukacs is not a particularly popular figure, and not one I am particularly fond of, except that, in basing his aesthetic ideas on classical and romantic aesthetics from Goethe, Lessing, Hegel, and Kant down, he emphasized the notion of the typical and representative figure, story, or gesture, the notion of the representative generic construction.

TJC: If push came to shove, would you say that you agree that there is something in that post-Romantic tradition in the drive toward the typical and instructive representation that you believe is true?

JW: Absolutely.

SG: It seems that in your work you like to take parts of the intellectual discourse already articulated in the 1920s by Lukacs through his interest in the "instructive representation," as Tim [T. J. Clark] said earlier. It seems that some of your ideas reiterate those formed during the 1920s, but under the pressure of Conceptual art, so to speak, you managed to reshape those things into a contemporary discourse. How did you manage to keep these two critical moments alive in the blasé age of the 1980s? Don't you think it is a problem when one develops a critical discourse extracted from the 1920s, even if revitalized through the debates of the 1960s and 1970s, and applies it in the specific environment of the 1980s?

JW: Are you talking about the 1920s or the 1820s? [Laughter.] First of all, I don't think about decades like that, as so distinct from each other. In a central way, the debates of the 1960s and 1970s were about the concepts of avant-gardism and modernist culture which were put forward in the 1920s and 1930s, and so on. I think there are continuities. The most orthodox way of thinking about culture now is to talk always about discontinuities, breaks, ruptures, leaps. As Walter Benjamin said, the only way to think legitimately about tradition is in terms of discontinuities. I accept that, but I think that it is possible to forget the meaning of something in ritually referring to it all the time. So it's necessary, too, to develop language-forms which express the continuous aspects of the development of vanguardist culture, or postmodern culture, or whatever you want to call it. Discontinuity does not exist in isolation from what seems to be its polar opposite, so I think it is just as valid to talk about reinventions and rediscoveries, not to mention preservations. Some of the problems set in motion in culture not only in the 1920s, but in the 1820s, and even in the 1790s, are still being played out, are still unresolved, we are still engaged in them. I guess that's why, at a certain point, I felt that a return to the idea of *la peinture de la vie moderne* was legitimate. Between the moment of Baudelaire's positioning this as a program and now, there is a continuity which is that of capitalism itself. There have been so many theories about how capitalism has changed; it has changed but it still continues, changed, renewed, decayed, and opposed in new ways. The opposition to and critique of capitalism—the whole of what could be called "anticapitalist culture"—has also emerged and become a foundation of the concept of modernism and modern art, too. I feel I'm working within and with a dialectic of capitalism and anticapitalism, both of which have continuous histories within, and as, modernity.

AW: In your work you're trying to make evident a continuity between a representational practice which is your own, and some sort of narrative painting of modern life. But at the same time you claim that this is to be done as photography.

One of the questions raised for me in reading recent criticism of your work is about whether photography itself has become its most problematic aspect in the later

1980s. Your work is being seen by Abigail Solomon-Godeau, for example, as a kind of academic photography "which traffics in the real on the level of social relations while bracketing them on the level of representation." This is from her essay "Beyond the Simulation Principle," in the catalogue for the exhibition *Utopia Post Utopia* at the ICA in Boston in 1988, and her analysis is meant as a deflection of your work's ability to secure critical reading for itself because of its nature as photography.

JW: This is typical of a point of view which holds that the regime of "Western" representation is absolutely complicit with the capitalist order. "Absolutely" in the sense of a solidified structure that Adorno, for example, would have immediately pounced on as "identity thinking," as lacking mediation. I think this view of representation has emerged, historically, in the capital cities. This kind of "post-Structuralism" in relation to photography is a construction of those centers, in which many people are not only consumers of images, but work in or close to the huge image-circulation industries.

The economy of image recirculation in the capitals is so pervasive and so important in everyday cultural life that it has produced a sort of "illusion of the epoch." In those circumstances, images become totally movable properties—they have no contextual identity, they appear to be absolutely separated from the referent by the institutions and the media monopolies that own them, they seem no longer to have any relationship to nature, but only to their own movement inside the business cycle. These theories have emerged in such conditions, and they lack self-reflexivity. In occluding the possibility that there is a relation between technology and nature in the process of representation, in rejecting that to the point where a critic like Baudrillard could seem to be convincing with his argument that there is no longer any relationship between what is represented and its image, and that therefore the representations form a kind of ecstatic Alexandrian discourse among themselves, this viewpoint has its real social basis. Up to now, nobody I know of has attempted a critical sociology of these intellectual trends, but I imagine that some interesting things would come out of it. On another level there has always been a dialectical critique of such thinking, one which claims that all production occurs within our relationship to nature, and that the moment of natural perception is not occluded, but is reproduced, in the process of representation. When we are forced into the position of having to deny that we continue to have a relationship with nature in the representational process, then I think we have gotten to the point where theoretical thinking is being taken over by something else. There is faith operating there, and there are unresolved elements, let's call them sub-philosophical elements, operating there.

TJC: Also interest operating there.

JW: That's right. To say, for example, that when I take a photograph of something, and then display that photograph, that the thing itself is made absent in the process and to say, moreover, that the reality of that thing is suppressed in its representation

is to make an exaggerated, spurious "critical" or "political" point. We cannot remain at the level of this elementary formal paradox, which proves nothing about what is far more important, namely the ability of representation to be adequate in terms of meaning, to its referent, to its subject.

TJC: Particularly because, according to that train of thought, there is absolutely no point at which the referent will ever be present. So it is not photography that is especially complicit or villainous, all representation is equally culpable.

JW: Or even maybe designation, all naming. To me what lies behind all this is a sense that the internal social conflicts of modernity are over. If the regime of representation triumphs over nature, and therefore over its referent and its spectators, that to me is a cipher for the view that the ruling order of society has permanently triumphed over those it oppresses. It's a position that is totally defeatist in any traditional sense of social theory. It's an acceptance that the theories of progressive social transformation are finished.

SUBJECT POSITIONS

TJC: My question starts from a couple of things, from being interested in the way that, in your earlier pictures, you were present within the image. Indeed, one of them was declaredly a self-portrait. Whereas that became not true at all after a certain point.

Now, this links up, in my mind, with the critique of representation, the suspicion of the art object which, as you've discussed earlier, was so powerful in the 1960s and 1970s. This critique said words to the effect that representation is to be put aside, or excluded, because it reproduces a regime of subjectivity, a regime of the reproduction of subject positions, with the artist as the key subject position reproduced. And that subject position is itself under maximum suspicion, as it is seen as the stabilizer, or the cement of all those positions of viewing, reception, passivity, deference, which stand in the way of criticism. That still seems to be a powerful and worrying aspect of the 1960s spiel.

Now, as we've said, you wish to retain some of the sensibilities of painting as representation. And that is associated for you with a different suspicion, suspicion of the photographic aesthetic of the spontaneous. That seems to you particularly inappropriate in the conditions of late capitalism, because of the ways in which the nature of things in now kind of deeply repressed, within, below, or behind appearance. You have some interesting things to say about the way in which the nature of things may be significant in actions, gestures, and interchanges between people in late capitalism. I noted, for example, this phrase from "Gestus" where you spoke about "controlled little actions," the typical, significant ones, "more condensed, meaner, more collapsed, more rigid, more violent" than those apparent in earlier phases of capitalist culture. In other words, more deeply repressed. But in terms of the reproduction of subject

Jeff Wall. *The Storyteller*. 1986. 7' 6⅜" x 14' 4⅛" (229 x 437 cm)

positions, isn't there a danger that this imagery of the controlled, the contracted, the emptied, the rigid, the collapsed in the everyday life of late capitalism will end up being read primarily in terms of your control of the tableau? Could it be argued that what is happening here is that all these characters and situations are being derealized and deanimated in order to be rerealized and reanimated as part of your own tableau, that finally the picture is one of the artist's means of control over things? It seems to me that you are dicing with an extreme difficulty here. I understand your reasons for pushing this imagery to the edges of emptiness. But it seems that it opens itself up to a reading as your own puppet show, and that you haven't actually exited from the transparencies.

JW: I would never claim to have exited from my work. Are you saying that it could be received as just subjective, pure mise-en-scène in a subjective sense?

TJC: Yes, although the alternative would not be simply objective, but some type of critical subjectivity, some subjectivity determined to exteriorize itself or declare that its view of the scene can be defended in objective terms.

JW: I feel I'm doing that. You are then raising the question of the presence here of a concept of truth guiding the mise-en-scène.

TJC: Yes, and I'm questioning this notion of the isolated, hypnotically powerful, controlled artwork as a means to entrench the image as part of a certain regime of art. And that regime is so closed, so completely entered into in your work, that there seems to me the possibility that the picture dictates to the viewer a reading in terms of the kind of subjectivity which has had to be criticized deeply in the past two decades.

JW: Good question! You've raised several problems, but there's one I want to respond to first. You seem to be saying that most of my pictures are constructed in an atmosphere of unfreedom and constraint. It's true that in some of my writing and conversation about my work I've concentrated on that. But I think that there are many which are quite different. Pictures like *Diatribe*, *The Storyteller*, *The Thinker*, or *The Guitarist* can be posited as part of a sort of a program which is distinct from works

like *No*, *The Agreement*, or *Mimic*. To make it simple, there is The Good and there is The Bad. There are conditions under which one is obliged to show the almost terminal imprisonment of people in repressed, exploitative relationships. That is a large part of the program of what we used to call "realism," and I can adhere to that. But I remember having an interesting discussion a few years ago with a friend, Susan Harrison, and she said that it seemed that artists (I think she meant male artists) think they're being more "critical" and "objective" if they show misery. But she said you could be just as critical and objective, if that's what you want to be, about joy and friendship. This affected me a lot in my thinking about the development of a version of the "painting of modern life." The social order itself, when you look at it studiously, never ceases to provide support for a program or images of subjection and unfreedom, and we need those images, but not exclusively. So I have worked on pictures about resistance, survival, communication, and dialogue, scenes of empathy and empathetic representations. I actually think that there is no polar, separate distinction between those two streams in what I'm doing; the distinction is more fluid. So much for the easy part of your question.

Now, to address your critique, which suggests that these images, whatever their subject matter or mood, lack any validity as critical understandings of the world and collapse into a subjectivity which cannot establish any criteria for themselves outside a kind of spectacular legitimacy as art—

TJC: There may be a problem with a word you've used: triangulation. Certain of these images depend on a kind of regime of positions implied with the triangle which includes the viewer. But triangulation implies the viewer as a unitary site, as an eye. This reproduces a very strange illusion of viewing, bound up with the whole aesthetic of individualism. It may be true that the work is made by one person, but it is not necessarily true that it is to be viewed by one person, or one person thinking of themselves importantly as one. It may be that it is important for one person to think of themselves importantly as one of many.

JW: I think that this problematic of the "unified subject" has become a bit of a sacred cow, a bit of an orthodoxy. Going back to our discussion about the avant-garde of the earlier part of the century, it's clear that, at least since 1920, the mythified, self-identified artist figure and through him, in a way, the modern political, social subject of bourgeois society in general, has gone through a devastating critique, one which has many dimensions, and from which everyone seriously involved in art has learned a great deal. But I think there has also been an absolutization of the notion of the fragmentation of the subject, just as there has been of the work of art, the image. This absolutely fragmented phenomenon has been set in the place of the totally unified idea of the subject of the previous period. I have to see this as an oscillation within a simple discourse rather than a new, or fundamentally different, evolution.

TJC: Let me interject here and say I agree with you, but you see I was gesturing toward an exit from that when I said that instead of the viewer conceiving him or herself as a monad, fragmented or nonfragmented, it may be possible (and most works made through history have shown it to be possible) for works of art to be constructed for viewers who did not think of themselves as monads.

JW: But I think that all good works of art have always done that. There are no closed works of art, really. My experience of the works that I have really admired is a kind of out-of-body experience. That is, it's a kind of phenomenology of identification and dis-identification which is continuously happening, and which is essential to the experience, and even the possibility of experience.

TJC: But look, the art of the nineteenth and twentieth centuries proposed or came to accept that the monadological viewing position was its fate. In the end that was theorized as a fate that was thrust upon it by capitalism.

JW: By property relations . . .

TJC: Yes, absolutely, and by a certain regime of subjectivity and individualism within which they operated.

JW: Personhood.

TJC: Yes, personhood. So what I'm saying is that there is a tremendous field of force pulling the art object back into a structure which reproduces the monadology of the first maker of the action of the work. I'd like to hear more about the way you see your work as pulling against that field of force.

AW: I think that this is also the risk that the work runs, that is, that it seems that some works are projected toward a specific audience, and others maybe toward a quite different one.

JW: You're right that I don't really see the audience as unified or homogeneous. It is essentially splintered, inwardly divided. So it's possible (although I don't focus too much on this in practice) that my pictures are worked out with certain splinters of the audience in mind, or at least in the front of my mind. But in general my primary objective is to create a sort of identity crisis with the viewer in some form, maybe even a subliminal one. I do go through a sort of continuous process of "imagining the viewer." I think all artists, in the process of making a work, hypothesize an audience, invent an imaginary audience which is exactly the one which will appreciate that work profoundly. When Stendhal dedicated *The Red and the Black* to "the happy few" he was doing that. This is a utopia of artists, the hypothetical world and its imaginary population.

Another way of looking at it is that one sets in motion a sequence of identifications, recognitions, misrecognitions, de-identifications and reidentifications, in which

the audience is continually decomposed, fractured, reformed, and reidentified with itself. Anybody who has had a long relationship with a work of art knows how that happens over time.

sg: I thought your work was precisely different from that attitude. I thought that in fact what made its force was the rejection of the love affair with the floating signifier. I thought you did not permit the work to be in a sea of meanings in which spectators could fish at random.

jw: No, I don't mean it that way. I think that this process of misrecognition, of a crisis of identification in relation to representations, happens in all experience, even in personal or interpersonal experience. In that sense it is objective, a condition of experience as well as a content of it.

The fact that I accept the fact that viewers of works cannot be marshalled into seeing the work in any specified way doesn't mean that I accept the idea that no signification necessarily means anything specific. There's a difference between the two attitudes. The process of experience of a work, while it must be open to the associations brought to it by different people, is still structured and regulated and contains determinations. I think it is controlled, above all, by genre, by the generic character of the picture types and the types of subject. Bakhtin said that genre was the collective, accumulated meaning of things that has come through time and the mutations of social orders. It is the foundation of the guarantee of objectivity, the basis of the "truth content" of representation which Tim was asking about.

Now to return to the problem of the conceptualization of the unified subject we were talking about before. I think that this process, this phenomenology if you like, which forms the interior of the experience of any representation, in no way supports the idea of a unified, monadic subject, at least it does not do so to the extent to which the kinds of critique that Tim was referring to insisted. The idea that previous concepts of the self were rock-solid, impacted monadological ones was one of those exaggerations which the 1960s and 1970s discourse is so famous for. The interrogation of the notion of the subject in which we're still involved has changed the language-forms of culture irreversibly, and brought about a kind of Copernican revolution in which the practice of representation has been revolutionized. Representational art, like mine, which rests upon a notion of the unbroken continuity of certain aspects of modern culture, must be looked at and experienced through a dialectical understanding of the suspicions that have been brought against the unification of the dramatic space of the picture. My view is that those suspicions have transformed the atmosphere within which representations have meaning in culture, but that they have not withdrawn the legitimacy of the process or technique of the need for representation. No alternative has been created; however, all representation, mine included, has been augmented with a kind of critical iconophobia, an inner antagonism which compels representa-

Ambrogio Lorenzetti. *Allegory of the Good Government: Effects of the Good Government in the City.* 1338–39. Fresco, Palazzo Pubblico, Siena

tions to rebuild themselves with a different legitimacy. The arrogant, domineering identity which Western figuration had been loaded with, in the kind of language which had defined it for a long time, has itself been cracked, and different identities have been able to emerge. Some of those, which were animated by a very radical idea of themselves and culture, have opened up what you might call iconophobic representations, types of work in which the denunciation of the metaphysics, the laws, the power mechanisms inherent in the earlier identification process of representation is the main concern. I think there is some exaggeration in that denunciation, but I think that that exaggeration is a necessary form of thinking now. What is maybe not so clearly seen is that iconophobic critique simultaneously legitimates itself and the tradition of representation in the process of helping to break up the solidified identity of the idea of representation as it had come down through a kind of worn-out and corrupt humanist tradition. Ironically, it makes representation more visible now, more useful, more open to the aspirations of different people.

SG: So for you the opening up of the idea of the unified viewer, the unified subject, isn't just possible in the form of collage?

TJC: What I was trying to say before was that I think it isn't exclusive to collage, no. Let me, for a moment, go back to my point about the possible viewer who doesn't really see himself or herself as fundamentally monadological. If you look at a work like Lorenzetti's *Good and Bad Government*, I don't think it confirms the monadological unity of the viewer. It opens itself for a kind of construction of understanding by persons who, because of the conventions of the picture, are almost forced to pluralize themselves. It is only at a certain point in history that one-point perspective became part of the whole protocol, ideology, regime of individualism, personhood, and representation. And it is the case that art objects, particularly pictures, seem to confirm a unified subject position. They may confirm it by trying to work against it. The alternative I'm positing is one which existed for much of the history of artmaking. This is a relationship in which literally there is a single body, a single person, viewing the artwork. But the singularity is remade and contradicted by the artwork. The work powerfully takes up the individual and confirms and remakes the individual as part of a collectivity.

JW: Don't you think it is rather unsatisfying to suggest that, because there is an ideological concept of the legal person who is a legal possessor of property and derives personhood from that concept of property, we should totalize that to the point where we can no longer accept any form of individuation as legitimate? Things are, of course, more complicated. For example, the discussion can move in another stage where we see the biological individual who is, indeed, a social being totalized as a monadological person in the constitutional rhetoric of capitalism. Is capitalism, then, the horizon under which cultural critique is worked out? Critique suggests alternatives, and without the composition of alternatives, even speculative ones, critique loses its reason for existing. It continues as a kind of moral aura, without direction, endless and formal, critiquing and critiquing, as we've seen in the past decade or so. This is a cipher for the position that feels that any contestation over forms of property, which ground this notion of the unified person, has been resolved in favor of the existing order, the existing economy and state. I don't think this is true, and I agree with you that there are alternatives which can be recognized in the experience of the artwork.

The concept of the unified subject, the unified person, or the monadic person, is a historical condition which we move through in a historical process which can't be jumped over. The new situation in which representation exists is a kind of transitional one, maybe. Through it, we've been able to see the inner suturings, inner twists, self-denials, and so on. That has always been my experience of older art. The paradigmatic image of, say, realism, which was worked out in the 1970s, the one that suggested that realism was naive in that it unreflectively configured a reality too complex for it, that probably had to be expressed in order to break the spell that such realism had on many people, even after decades of avant-gardist fragmentations. The fact I feel that that critique itself moved too linearly to a polar opposite position, and became somewhat sterile in the process, doesn't mean that I could deny the necessity of the process of critique. I feel absolutely the opposite, and don't think that my pictures have any point of contact with the neoconservative return to tradition, which counterposes figuration and representation against modernism and experimentalism. My work comes out of the process of experimental critique, but is itself an experimental critique of aspects of that process.

THE STATUS OF THE CONCEPTUAL/CONTEXTUAL ARTWORK

CG: When we talked of the critique of the art object and of the unified subject, there is something that we missed. The critique of the art object shifted in the '70s to the critique of the context, so in a sense the conceptualization of art shifted to the contextualization of art. This is something I would like you to take a position on, vis-à-vis, how do you relate to works of people like Hans Haacke, Louise Lawler, or even John Knight? Would you say that the premises of your work invalidate the work of Knight or Lawler? Because in a sense I think that the premises are completely differ-

ent. In a sense, people like Knight or Lawler start from Adornian premises where the totalization of the world is such that nothing can be done except to mirror or document the totalization, but the premises of your work are, as was referred to previously, more a critique in the sense of Lukacs's critique of Adorno. So in a sense there is a contradiction in my view between the two kinds of work.

JW: There is a contradiction, I agree, but I don't think that because there is a contradiction there is an invalidation of one or the other, because I've learned too much from those artists ever to suggest what I'm doing could possibly invalidate what they are doing. None of the ideas of Asher or Buren or others who have been primarily concerned with the art context as a framing structure and a discourse structure, within which meanings are constructed, could possibly be dispensed with for me. I think that the only way we can now construct the kind of continuity that I am claiming would be, at least in part, through this discourse.

But on the other hand, this discourse should be no more privileged than any other. For example, in Buchloh's writings he established a kind of Buren/Asher position as a canon against which other work has to be measured. I don't think that that work can be legitimated that way, or needs to be. I think it is clear that, on its own merits, it has intervened in a decisive way in the way we look at any artwork's status as a sociological phenomenon.

CG: But those canons were established in the mid-'70s; I don't think that Buren's work would be defended by Buchloh now. In the tradition of Buren, I would rather include Hans Haacke, John Knight, or even Louise Lawler.

JW: I think there are two problems. They become obvious in the case of Buren. Buren is, to my mind, fundamentally an abstract artist. Therefore, there remains the problem of abstract art. At its most radical, abstraction tended toward the reductive, even the monochrome work, in which painting moved to the threshold where it seemed to be about to pass out of its own old form and become something utopian and different. I think that abstract art was arrested at that threshold, at the monochrome, historically, and that out of that arrest there emerged certain important discourses. Because of the impossibility or the social and historical failure of a utopian renovation of the world, we couldn't leap out of the realm of the art object, out of modern, bourgeois culture. And what has evolved out of that is a complex discussion about the arrested state itself, the delay or the cancellation of the idea that we might pass beyond bourgeois art. My view here is partly derived from my reading of Peter Bürger, who emphasizes the notion of the avant-garde as a movement expressing and reflecting this desire to pass beyond the bounds of bourgeois art forms into a new cultural world but becomes fetishically attached to its own arrested state. Those terms are ones that could be applied to Buren, and doing so wouldn't necessarily imply an invalidation of Buren's positions.

CG: Do you agree that Buren's gesture of "passing beyond bourgeois art" was heavily historicized to a precise moment in the late '6os?

JW: That is the way I interpreted it at the time. I saw it as a reprise of the problem of the monochrome and a turning of that problem, that phenomenon, toward linguistic form, in the Conceptual art way.

But the limitation of that problem is that Buren's approach is entirely tied up with the orthodox idea of the primacy of abstract art over representational art in the notion of the avant-garde. The idea that, of course, avant-garde art is fundamentally abstract art, is a really very, very classical way of thinking about art history, you know from Cézanne through Picasso to abstract art to the New York School. I don't think there is anything wrong with that, as far as it goes. But it is a very specific way of looking at the issue, a specific way which claims universality, but has not established the grounds for that claim. But from within that orthodoxy, you could easily say Buren has reached a point, an almost terminal point, beyond which no one can pass, and which therefore sets itself in a canonical relationship to other things, to any other practice. This is a very gratifying position for an artist to find himself in, and for a critic to be able to establish for an artist.

My reading of the avant-garde and of modernism does not establish an unqualified primacy to abstract art. Non-abstract art, or representation, figuration, always remains as an internal problem inside abstract art. One pertinent historical example is the situation in the mid-'2os in the Soviet Russian scene, where a figurative countermovement to the Constructivists emerged, one that was not just a Stalinist thing, one made in part by Constructivists themselves, often in relation to photography. You can see this easily in Rodchenko's and Lissitzky's middle-later work; Rodchenko is trying to get the figure back into Constructivist compositions.

AW AND CG: Malevich.

JW: Buchloh has looked at this development as a total regression and I could never accept that.

TJC: He's completely wrong there.

JW: Another important example from the same context is Eisenstein. Eisenstein's work was so heavily pictorialized and reattached to the body, but his compositions retain that classically dynamic Constructivist sense. It was a great experience to see the body in a film like *Strike* (1924), filmed with carnivalesque bodily action inside of constructivistic frameworks. I'm sure this was part of a response to a situation in which the limitations in abstract art become apparent in new ways.

TJC: Aren't you saying that abstract art, which has always been kind of crossed with the critique of representation and critique of the art institution, is reduced to the

Sergei Eisenstein. *Strike.*
1924. Still from a black and
white film, 82 min.

notion of reconstruction of the art situation? But putting it crudely, hasn't that always been in practice proved to be reductivist, repetitive, stifling, and felt increasingly as a dead-end practice?

AW: You could also put it another way, in a sense, in a specific context where there is actually discursive work to be done on the adequacy of abstract art.

TJC: I agree with you that this field of critique and this field of practice we call abstract art, and call the questioning of the art context and the art institution, will always reproduce itself. That is almost a general situation of art practice in late capitalism, and you know it continues. It will always reproduce itself as oscillation. Buren seems like a perfect example. Once a practice is launched, of course it reproduces itself very nimbly and very amiably, but it is extremely boring.

JW: But I wouldn't put it quite so crudely, in the sense that I think that it has had an immense pedagogic function. I think that in some ways everything does still oscillate around the problem of the monochrome. But, at the same time, the primacy of abstract art within that dialectic was something presumed and never proven, never really thought through. Buren's work remains within that problematic presumption of the primacy of abstract art, its ability to sit in judgment on art as a whole. That canonical position is only an assumption, something that came out of a moment when abstract art was being invented. At that moment, it did seem to be a revolutionary beacon, outside of our culture, pointing into the future, the better future. Now we tend to see it as a cipher for a revolutionary beacon, but as not actually constituting that beacon. I like that about "monochromistic" art, and I think that it is very important that it still does represent a cipher for something that we haven't managed yet to create in the real world. And that gives it an importance that won't vanish, even if it becomes boring. Buren has been right to accept the idea that his work is what can be called "boring," but to insist that, even if it is boring, and maybe even insofar as it is boring, it is a cipher for that which we haven't been able to live. Whether Buren's work has changed in the interim, that's another story.

I would say there is a logical relation between the boundaries of abstract art's discursivity and its concentration on the art context or the art institution. In my view, there are other institutions in the world besides the art institution, and the interesting thing is the relationship between these institutions and art. Therefore, on that level you can argue right along with Greenberg that the art institution establishes its own legitimacy by concentrating on what is proper to itself. But what is proper to itself is discursivity, its own reflection on its modes of relation with other institutions, and itself. It would be therefore perfectly legitimate to say art investigates itself as an institution in its investigation of other institutions. There are several, even many modes of investigation, representation or figuration being one possibility, an important one if only because it has been so permanent historically. That gets us back to the idea of the "painting of modern life," of a specific practice of figuration, seen as a practice which actually does participate in that project. It participates along with other practices, like abstraction, but it does not accept their canonical primacy. So I do think that Buren's position has important limitations. One of the most important is the idea that the art institution is so much more significant than the complex of institutions that make up the social world, which are both subject to representation, and makers of representations. Overemphasis on the art institution retains an almost secessionist attitude. And that secessionism, that withdrawal from the engagement with the complex of institutionalizations that constitutes modernity, is something that expresses a guilty conscience of abstract art. But the guilt remains important.

CG: At the same time I think that position is a critique of the place of the artist within the institution. So when the artist as a political force critiques from his/her position as a producer within the system, his/her production is a tool for legitimation one way or another. So that idea was a shift. I think Broodthaers did it in a sense, and now, probably in a debased way, people like Philippe Thomas are pushing the consequences probably to a fiction. He delegates his position as artist to a patron of some kind, a public or private collector. One could see this as pushing the critique of the artist position to an extreme point, a kind of putting the key into the lock, and passing on to something else. In this context, Jeff's work seems to represent a kind of alternative, and an alternative that may be thought of as a polar opposite to that of Thomas or Knight. Thomas pushes things toward what I might call a sort of "Warholian fiction"; Knight stiffens himself into an attitude of resistance which is maybe revealed to be false, but which is Adornian, in a sense, as against which might be, in Clark's terms, your Lukacsian position.

JW: I have difficulty seeing Philippe Thomas's kind of abnegation as criticism anymore. It seems to me, oddly, to be a kind of unresolved religious attitude, almost a kind of penance, not necessarily a rational, critical position. It contains elements of a humiliation of the artist, and its cynicism seems connected with humiliation. The

perversity of it is striking and comic, it has an element of transvestism in it which is amusing. But critical?

CG: I must mention that one of his pieces said "saying yes is enough to change the face of things," so in a sense it made sense. . . .

JW: Nancy Reagan said "just say no." [Laughter.] It's easy for Thomas in that it is post-Warholian, but Warhol too had this kind of problem, in which his self-abnegation was really the critical act and we are uncertain about what that act could mean in the traditions we are talking about. It is another way one appears to get out of being an old type of artist, and tries to return to the threshold.

THE PRESENTATION AND CONSUMPTION OF ART

AW: You sound like you have solved for yourself the problem of the consumption of your art. You seem to be laying aside these questions of the problematic nature of the referent, and of the contextualist critique of art. In doing so you make me wonder how you imagine the viewer: if an art is solely produced for a particular environment, that is the gallery or the museum, you make certain choices about who your viewer is and how he or she might be imagined. Obviously there are people practicing today, late Conceptualists, really, like Jenny Holzer or Barbara Kruger, who have found other ways of dealing with that, or not dealing with it or making their sort of peace with it, but this problem is contained in the choices you have made. I don't believe you have to make an art which analyzes the context of the production of art, yet by not doing so you nonetheless define a space in which your work will be seen.

JW: I think my work does reflect upon its own conditions, but in different ways. When I wrote of Conceptual art, in my essay "Dan Graham's Kammerspiel" (1982), one of the things outlined is that Conceptual art did not really proceed to a political economy of art. It petered out at a kind of ideological incrimination of art as an institution, but its fantasy of the noncommodity, nonobject of art really was just that, a fantasy. The notion was that by not making a physical object one could transcend, avoid, or defeat art's commodity status. That is clearly a phantasmagorical solution (and when you think of it as a phantasmagoria it becomes even more interesting), but it was not really an economic analysis of the art object.

CG: But for you, does the status of art as commodity have to be acknowledged within the work itself, as a kind of resistance?

JW: It's hard to specify what such acknowledgment will look like. I sometimes have the feeling that in a picture of mine where certain relationships are fictionalized and played out, and the spectator is involved in a kind of social phenomenology in experiencing the dramatization, the pictorialization, if you like that it is not so much the

immediate commodity status of the artwork, taken as a separate problem, but the commodity status of the people represented in the picture which emerges as a source of meaning, which affects the status of the picture as art. Traditionally, the artist defended the status of his work in terms of the meanings that were dramatized within the image. These could be narrative, literary, poetic, formal, musical in fact, all of these. A work always recognized that it was an object produced within an economy in some way. But really its value and meaning were not pitched in those terms, suggesting that art is not primarily an object.

TJC: Another line of thought in what you've written about your works is that at least some aspects of their own commodity status are symbolized or signified by transparency itself, by the illumination, and its relation to signage and the language of advertising.

CG: So the fact of producing this type of object in a discourse of popular culture through advertising the transparency, the backlight: is the object itself a critical element?

JW: I don't accept that position. I don't think the technical aspects, the illuminated transparency, is inherently critical at all. I think it's a supreme way of making a dramatic photographic image. The relation to advertising is really very secondary to me, and if you look at my work over a long period, you'll see I've never really exploited it as far as themes and styles are concerned. I know it underlies the conditions of spectatorship, but it doesn't determine my pictorial choices.

SG: Yes, but you have these connections with advertising and you can't avoid it.

JW: Sure, the spectator, subliminally at least, has a suspicion that these things are used for lying. That's interesting.

SG: But even that can be put in question, because if you live in Paris, one of the capitals, that kind of suspicion is just totally out of the window. . . .

JW: That's where I disagree with you, because you seem to think that everyone has become happily adjusted and that fear of technology and of the economy no longer exists; and I don't think that that's true.

SG: The way you present it is that suspicions lead to criticism and to alternatives. I'm saying it's not automatic; it is more difficult than that.

JW: I agree. That suspicion is subliminal and unconscious. The hypothetical spectator is an alienated person, "happy" or not, who has a great deal of the repressed anxiety over his, our, relation to technology, and of course, to nature and to other people. So, on that level, the technological product as an artwork can have a trace element of disturbance in it, an element that can work against repression. But it can also be just a happy gadget that makes art brighter, warmer, bigger, and flashier, and doesn't necessarily mean anything. I don't think technology guarantees anything, so that's why I

don't want to depend on it. The harder position for me to take is that the poetics of the drama in the picture legitimates it as art.

TJC: Which does not rule out aspects of the actual technological process which are important to you. I mean, you would say, wouldn't you, that the capacity this technology gives you to play with the guarantee of truth in order to subvert the offer of truth which that kind of technology usually makes by implication in its ordinary uses in society, that's important to you, isn't it? You're almost for a hypertrophy of this technology's offer of the visible?

JW: Yes, but what I don't want to do is fall back on some kind of pseudoradical argument that suggests that our relation to technology is fundamentally disruptive of those kinds of constructions. Even though technological effects are important, I don't think they are a sufficient criterion. A more significant approach is that it is the overall value of the content of the image, not to mention the sensuous experience of beauty, that validates anything critical in art, anything in art which dissents from the established form of things and their appearances.

REWORKING THE FIELD OF ART HISTORY

SG: In a sense, I see your project as an important one because you try to redefine what a picture should be, could do, in a way—excuse the loaded reference—Diderot or Pollock tried to reinvent the notion of tableau in a period of cultural and political crisis. This is such a bleak moment in our cultural life that this type of study, this type of critical reassessment and analysis of what representation can be is, by recalling a long historical past, crucial. But this redefinition of the parameters of a renewed critical type of art after the implosion of Conceptual and post-Conceptual attempts is in my mind, if not impossible, certainly difficult at least.

JW: Difficult, but possible. To shift this discussion, which has been between some art historians and critics and an artist, in a different direction, I think it's important to see that Conceptual and post-Conceptual attitudes and approaches have played an important part in what we could see as a radical reworking of the field of art history in the same period in which the kind of artistic experimentation we've been talking about was elaborated. Since my pictures and my work as a teacher have a connection with the fact that, as a young artist, I went to university and studied art history rather than going to art school, this topic is of particular interest to me. For example, when the concept of a painting of modern life emerged with particular crystal clarity in the nineteenth century, it changed the way the history of art could be seen. It was possible to rethink the modernity of the works of earlier artists. The way Manet worked with seventeenth-century Spanish painting is a central example. At this point, I think a certain very important evolution in the history of Western art was taking place.

Manet's art could be seen as the last of the long tradition of Western figuration, and of course at the same time, as the beginning of avant-gardism. The avant-garde countermovement against the idea of the painting of modern life, of course, built itself entirely upon it. Whether you look at Rodchenko, Arp, or Pollock, you will see that the attitudes toward tradition, and the antagonistic acceptance of the logos of tradition, derive from the idea of building monumental forms which express and explain what exists in modernity, so they are actually countermonumental. So it seems to me that the general program of the painting of modern life (which doesn't have to be painting, but could be) is somehow the most significant evolutionary development in Western modern art, and the avant-garde's assault on it oscillates around it as a counterproblematic, which cannot found a new overall program. This thinking both transformed art history and came out of its developing relationship with the whole discourse of modernity, out of the rearticulation of art history on the basis of the new critical theories of the 1960s and 1970s. This new situation provides the means for rebuilding that neglected field, aesthetics, as well. For me, none of my work could have been done without the turmoil within art history. Serge, you and I once had a discussion in a class in which I accused you art historians of being more avant-garde than the artists, because art historians were trying to keep thinking about what avant-garde meant, and by implication, what it means, or where it went. They were more interested in it than many artists, who seem to have gone on to other things, like expressing themselves. You cringed at my point, but I think you appreciated it at the same time, maybe because you also feel that has been and still can be a fusion of discursive work between art historians, writers along with artists, something which the generation of the 1960s and 1970s did experience in things like Conceptual art, where writing and making artworks were not considered such unrelated things.

The Interiorized Academy:
An Interview with Jeff Wall by Jean-François Chevrier

JEAN-FRANÇOIS CHEVRIER: It might be a good idea to start by clearing up certain ambiguities about your work, which is sometimes rather hastily categorized as an art of social critique. A lot of critical art is little more than the illustration of a sociological point.

JEFF WALL: First of all, I do have a relation with the things you are talking about. I respect the work of people like Hans Haacke and Mary Kelly. These artists have carried on something during the last fifteen years which is important and which has been discredited by current opinion. The thinking about images and culture in their work—which comes from Marxism and certain traditions of psychoanalysis—to my mind remains valid. The way you use the term "sociology" implies a formalized and even bureaucratic discipline that poses only the questions it can answer, and then credits itself with knowing something definitive about society. I think there has been a lot of art made in the 1970s and 1980s that conforms to this kind of thinking. This sense of presenting conventional militant answers to real problems is identified with what is called critical art. But to a certain extent the objections to critical art are just prejudices. You can't criticize critical art without confronting your own conformism.

J-FC: I do not mean to contest the value of sociology or the relevance of a critical stance in art. What I do contest is the transformation of art into a minor branch of sociology.

JW: There are internal problems with what critical art means by "critique." To me, a critique is a philosophical practice which does not just separate good from bad—that is, give answers and make judgments. Rather, it dramatizes the relations between what we want and what we are. When I look back over the last fifteen years, I see a lack of development in the idea of critical art and a failure by artists to appreciate how uncompleted an image has to be, how dramatic it really is. There has to be a dramatic mediation of the conceptual element in art. Without this mediation you have only concepts on the one hand and pictures on the other. Images become a decorative completion of an already fully evolved thought. They are just illustrations. So they are boring, there is no drama. But what makes dramatization possible? I think it is a

Conducted in Paris in 1990. First published in French as Jean-François Chevrier, "L'Académie Intérieure," in *Galeries* (Paris) no. 35 (February–March 1990): 96–103, 138, 140. First published in English as "The Interiorized Academy: Interview with Jean-François Chevrier," in Thierry de Duve, Arielle Pelenc, Boris Groys, and Chevrier, *Jeff Wall* (London: Phaidon Press, 1996), pp. 104–10.

program or a project that was once called *la peinture de la vie moderne*. I always think of the etchings of Goya underneath which he wrote: "I saw this."

J-FC: Isn't there a difference between a program and a project? It seems to me that it is very difficult to base realism, which is anchored in experience, on a program.

JW: Can't you have a project which is precisely to develop a program? Today I think that each artist has become his own academy. He has internalized commands that used to come from a real social institution to which he was directly subjected without the mediation of the market. It is a kind of spiritualization of the premodern situation where society—the court, for example—had a direct use for art. Since then, the utility of art has been ambiguous and indirect. Now, you have to build a kind of institution inside your own psyche, something like a superego. It is a kind of comedy, in the way that the dialectic of master and slave in Hegel can be read as comedy. The Freudian concept of superego is also related to this. Therefore any programmatic aspect in art has the character of an individual desire or, if you want to put it in "existential" terms, of a project.

J-FC: You mentioned a lack of development in the idea of critical art. At the same time, you define artistic praxis in terms that might be qualified as traditional. If I understand you correctly, the internalized academy that an artist constructs for himself provides him with the programmatic and even moral constraints that are no longer imposed by institutions. Isn't there a contradiction between "critical" art and the necessity of an "academic" structure?

JW: Yes, there is a contradiction. That's normal. The contradiction is that "critical art" has regressed and fallen apart into two polar, opposed, unrelated elements, lacking mediation. The old academies trained artists to practice art—that is, to make things with their hands, to work sensually. It also taught them to think and inculcated them with a theoretical attitude. Even though it trained them to conform, this type of teaching itself created new movements and a new type of artist who was able not to conform. Today, it is always something related to what we remember as the academy that provides the type of mediation I'm talking about, between the necessity for modern art to have a cognitive dimension and the equal necessity for pleasure. After 1793 it became possible not to conform, to be revolutionary. At that point the notion of the academy became a place for critical and self-critical approaches in which any struggle with conformity could be dramatized. The internalization of academic methods provided the ground for anti-academic, radical, and critical art.

J-FC: Does that mean critical art is essentially a critique of art?

JW: No, but under these conditions art approaches its subject matter with a sense of its own complicity with the formation of the very thing it wants to criticize. How

could you criticize others and leave yourself outside the picture? Once the bourgeois revolution had swept away the academy of the *ancien régime,* and the counterrevolution reconstructed it, art had to become self-critical. In this light, avant-garde art is a phenomenon which has revolutionary as well as counterrevolutionary origins. The internalized academy is the form in which this dialectic moves. In order to create a philosophically adequate image of a society whose relationships are based on domination, art must constantly reflect on the tendency toward domination in which it is itself implicated. To answer your question, critical art is not essentially about itself and cannot be about itself. But in order to be about something else, it has to call itself into question.

J-FC: It seems to me that your distinction between cognition and pleasure harks back to the era of the academies. But it also has a very puritanical ring to it.

JW: The prerevolutionary academy was an ethical mirror of the state, and remained such in the postrevolutionary, counterrevolutionary situation. Puritanism has its other side in libertinage. We know that libertinage provided the energy for revolution, which was made by modern, puritanical types of people. Regicide is a form of libertinage. The academy could see pleasure and learning as two separate poles, and in this static form of thinking it remained premodern. Modern art emerged in the fusion of the two poles. Today, our type of artist is involved in negotiating these interrelationships in new, maybe more neurotic, ways, because the pattern isn't laid down as clearly as it was in the good old days, when such things were imposed, not proposed.

J-FC: In the French cultural tradition there is a form of moral judgment that is at once a serious game and a source of pleasure. I'm referring to the very sophisticated tradition of the moralists that began in the seventeenth century. In some respects the moralists could be said to have subverted puritanism from within.

JW: One of my favorite novelists, Stendhal, is a part of that tradition. The internalized academic dialectics I am talking about developed in the discovery of that kind of play. The Surrealist idea of *humour noir* is also a fundamental part of this outlook.

J-FC: Where is the *humour noir* in your work?

JW: It is everywhere. Black humor, diabolic humor, and the grotesque are very close to each other. Bakhtin talked about the "suppressed laughter" in modern culture. Things can be laughed about, but not openly. The fact that the laughter is not open gives it a sinister, neurotic, bitter, and ironic quality. It's a kind of mannerist laughter that is similar to Jewish humor, *Schadenfreude,* and gallows humor. I feel that there is a kind of "suppressed laughter" running through my work, even though I am not sure when things are funny. *Humour noir* is not the same as the comic, although it includes the comic; it can be present when nobody seems to be laughing. It is one of

the forms of the serious moral game that you mentioned. In my opinion the Hegelian analysis of the relation between master and slave is one of the most important expressions of *humour noir*. I am interested in slaves.

J-FC: Is that a perverse way for a master to become a critical artist?

JW: That's a very diabolical question. Were you educated by the Jesuits? Nietzsche said that the most instructive epochs were the ones in which masters and servants slept with each other. Pleasure is a means by which antagonists in a social struggle gain precise knowledge of each other.

J-FC: Coming from you, that remark doesn't surprise me. In your pictures most of the relationships between men and women are relations of force.

JW: Maybe. But the relationships between men are also relations of force. The relations between women, on the other hand, are not. Society is antagonistic. People are compelled into their lives; we are unfree. The slaves must develop a "slaves' science." This science is the only legitimate thing to be contributed to the world by what you call "critical art."

J-FC: Is that science a kind of sociology?

JW: Yes, but it is a speculative sociology, to use a phrase of Gillian Rose's. If you are a slave, you must always at some level wonder what it would be like to be free. In *The Storyteller*, for example, I attempted to create an image of a way subjected people might try to build a space for themselves. I imagined the picture as a speculative project. All my pictures about talking, about verbal communication, are in fact about the ways people work on creating something in common, about how they work to find a way to live together.

J-FC: The ancient Greeks thought that action began and ended in language. Every action worthy of remembrance formed a story. History painting is also a type of storytelling.

JW: History painting is storytelling in the sense that Walter Benjamin gave that term. And storytelling is a way of building ethical worlds based, as Benjamin taught, on memory and dialogue. Bakhtin emphasizes the fact that an utterance derives not from one isolated individual but is already a response to the words of others. Thus the storyteller is not a hero separated from others by a special relation to language. I like your reference to antiquity because I feel that my work is in fact both classical and grotesque. Ancient art imagined the good society but was also open to the concept of the deformed. That is, it was able to recognize that it was not the society it could imagine. Now we are living at a moment when we have already imagined, and even in great and excessive detail, better ways of life than the one we are actually living. As a result, we often feel humiliated when we observe soberly the way we do live.

Jeff Wall in Conversation with Martin Schwander

MARTIN SCHWANDER: In an interview published in 1990 you said, "The process of experience of a work, while it must be open to the associations brought to it by different people, is still structured and regulated and contains determinations. I think it is controlled, above all, by genre, by the generic character of the picture-types and the types of subject. Bakhtin said that genre was the collective, accumulated meaning of things that has come through time and the mutations of social orders. It is the foundation of the guarantee of objectivity, the basis of the 'truth content' of representations."[1] With these comments in mind, I'd like to know what genre tradition you are connecting *Restoration* with.

JEFF WALL: I'm not so sure what the genre of the panorama picture is. The curious thing about the phenomenon of genre is that it operates whether the artist is very much conscious of it or not. That is what Bakhtin was referring to when he spoke about it as an aspect of what he called "collective memory."[2] You do not really have to be conscious of the generic structure of the work you're doing to do it, even to do it well. The work you do will have such a structure in any case. Genre is a fluid construct that operates regardless of the consciousness of the artist. It is fluid in that it isn't so clear whether its "constructs" can be very strictly defined, its borders easily located.

I think my panorama picture is something like one of those eighteenth century pictures that depict activity going on in a public building, like a church, where people are carrying on their normal business, as for example in a painting by Hubert Robert. The fact that it is the restoration of a picture that is going on in my picture may be secondary. The immediate theme of the picture, its subject, may be secondary.

MS: Even though you refer with the title of the work to the clearly visible, skilled process of restoration?

JW: Yes, I think it is possible for the dramatic theme of the picture to be dominated by the overall pictorial character of the work. To take again the example of Robert, you can imagine two pictures by him, both of typical public scenes. And in the two pictures, two completely different kinds of things may be happening, and yet if the pictures were structured similarly, they may be more similar than different in terms of their generic identity, regardless of the subject.

Conducted in Lucerne on August 12, 1993. First published in German and English as Martin Schwander, "Jeff Wall im Gespräch mit Martin Schwander"/"Jeff Wall Interviewed by Martin Schwander," in *Jeff Wall: Restoration*, exh. cat. (Lucerne: Kunstmuseum Luzern, 1994), pp. 10–19 (German) and 22–30 (English).

Jeff Wall. *Restoration.*
1993. 46⅞" x 16' ⅞"
(119 x 489.5 cm)

Hubert Robert. *Restoring
the Grande Galerie of the
Louvre.* 1796. Oil on canvas,
45¼ x 57⁷⁄₁₆" (115 x 145 cm).
Musée du Louvre, Paris

MS: The right-hand side of the picture with the two restorers at work can also be seen as a portrait of two young women. With *Adrian Walker* you made a portrait of a young man who is concentrating so intensely on his work that he seems to be removed to another sphere of life.

JW: But I don't think it is necessarily clear that *Adrian Walker* is a portrait. I think there is a fusion of a couple of possible ways of looking at the picture generically. One is that it is a picture of someone engaged in his occupation and not paying any attention to, or responding to the fact that he is being observed by, the spectator. In Michael Fried's interesting book about absorption and theatricality in late-eighteenth-century painting,[3] he talks about the different relationships between figures in pictures and their spectators. He identified an "absorptive mode," exemplified by painters like Chardin, in which figures are immersed in their own world and activities and display no awareness of the construct of the picture and the necessary presence of the viewer. Obviously, the "theatrical mode" was just the opposite. In absorptive pictures, we are looking at figures who appear not to be "acting out" their world, only "being in" it. Both, of course, are modes of performance. I think *Adrian Walker* is "absorptive." The fact of it being or not being a "portrait" of a specific real person, again, may be secondary in the structure. The title, because it names him, makes it appear that he is such a specific, real person. But it's easily possible that *Adrian Walker* is simply a fictional name that I decided to make up to create a certain illusion, like "Emma Bovary." Even though that's not true and there is such a person, and that is him, I don't think there is necessarily any resonance of that in the structure of the work,

Jean-Baptiste-Siméon Chardin.
Young Student Drawing. c. 1738.
Oil on panel, 8¼ x 6¾" (21 x
17.1 cm). Kimbell Art Museum,
Fort Worth

Jeff Wall. *Adrian Walker, artist,
drawing from a specimen in a
laboratory in the Dept. of
Anatomy at the University of
British Columbia, Vancouver.*
1992. 46⅞ x 64⅝" (119 x 164 cm)

generically speaking. The nature of the picture gives no guarantees that that identifi-
cation matters at all. So, like a lot of pictures, it is a bit of a hybrid. Portraiture seems
to be a social relationship, sustained by empirical and historical evidence, corroborat-
ing the identity of someone who appears in a particular picture; it doesn't seem to be
a pictorial relationship or a pictorial phenomenon, as such.

But when you have a picture of a figure absorbed in some activity you begin to
move outside of the boundaries of portraiture, strictly speaking, into a kind of picture
in which people are identified, and identified with, primarily by their physiognomy
and their actions and less by their names, less by their personal, empirical, historical,
social identity and more by their generic identity as controlled by the type of picture
they're in.

MS: Isn't there a difference, though, between works like *Restoration* and *Adrian Walker*
and many of your other works, because in the two just mentioned the "principal
actors" are not actors but rather persons who "are playing themselves," presenting and
impersonating themselves?

JW: They are performing, they are, as you say, "performing themselves." In the
Restoration picture I was working with people who are actually professional restorers, so
they give an authenticity to the scene. But if it were necessary, we could have used actors,
performers who are not restorers but who could have gone to an atelier and studied,
and would have been able to imitate restorers. So, again, I have to say that the fact that
someone really is what they appear to be in a picture is not a pictorial matter. Here's

Jeff Wall. *The Guitarist.*
1987. 46⅞ x 6' 2¹⁵⁄₁₆"
(119 x 190 cm)

another example of how fluid this aspect is. Some years ago I made a picture called *The Guitarist*, which I think is generically very similar to *Adrian Walker*. In it you see a young girl playing the guitar, and a young boy listening to her. They are both about fifteen. The girl who was performing couldn't actually play the guitar. I had to teach her a couple of basic chords and have her place her fingers properly on the neck and so on, so it would appear that she was playing a chord. But because she was inexperienced and unskilled, her hands weren't really "natural," not correct. I showed a test shot to a friend of mind, a very good guitarist, and he immediately commented on the position of the hands, saying it's obvious she knows next to nothing about playing the guitar. We discussed the idea of him coming and giving her a few lessons so she could make her hands look like she was more competent. But finally I didn't do that, because it seemed to me just as interesting, no, more interesting, that she was really a complete beginner, trying to make the kinds of sounds she was interested in from her favorite records. I wanted it to be about young people just beginning to learn a language, a new language. So in that picture the girl was really "herself," someone who couldn't play guitar but who was very interested in imitating someone who could—that is, interested in learning to play. But at the same time, in terms of my pictorial subject, she was a character of that type, exhibiting that desire, that character. For example, if the performer by chance knew how to play the guitar better, maybe I would have had to ask her to imitate someone who couldn't play it as well.

MS: In *Restoration*, the restorers simulate—and hopefully anticipate—the preservation of a large-scale panorama picture, the Bourbaki panorama in Lucerne, which really is in alarmingly poor condition.

JW: I was interested in the massiveness of the task the figures are undertaking. That for me was an important part of the theme. There might be associations of that massiveness with the futility of ever bringing the past into the "now."

MS: Another futile venture was probably the attempt to render a 360-degree panorama picture in a two-dimensional medium.

JW: A panorama can never really be experienced in representation, in any other medium. I made a 180-degree panorama photograph of a 360-degree picture, and so had to show only half of it. The geometry of that struck me as appropriate, harmonic, one to two. It itself expresses the fact that the panorama is unrepresentable. Maybe this unrepresentability was one of its great historical flaws. The fact that panoramas emerged so strikingly, and then died out so quickly, suggests that they were an experimental response to a deeply felt need, a need for a medium that could surround the spectators and plunge them into a spectacular illusion. The panorama turned out to be entirely inadequate to the challenge. The cinema and the amusement park more or less accomplished what the panorama only indicated. The panorama has pretty much always been understood as a proto-cinematic phenomenon, a precursor also of other forms of mass culture. Lately, with "virtual reality" devices, we've come back in a way to a "panoramic aesthetic" which doesn't want to have any boundaries. The interesting tension in the picture for me is that between the flatness of the photograph I'm making and the curved nature of the panorama's space. Because you can see it curve away from you and disappear, I see it as a kind of making explicit of the situation that exists with every picture which renders the illusion of volume and curved space on a flat plane. The fact that the panorama can be seen escaping from view is one of the things which most interested me in making the work—the idea that there is something in every picture, no matter how well structured the picture is, that escapes being shown. I've always been interested in this. In a few pictures I've done I've concentrated on showing people talking. Speech is something which by definition cannot be adequately depicted in a photograph or a picture, and so to me it always seemed fascinating as that thing which was forever escaping, a sort of will-o'-the-wisp, something that can never be located in the picture, but it is what the picture is about, what it is showing somehow. In fact, in the Bourbaki picture, there is a pair of restorers on the farthest scaffold who can be seen having a conversation, one which cannot be heard because they are so far away. I thought about those round buildings where you can hear a conversation way on the other side if you stand in one special spot. These things are subtle elements of mobility, of restlessness, of the fugitive. The stillness and stable composition of the picture, in general, intensifies this fugitive sense.

MS: But at the same time the picture depends, too, on the contrast between the drama of the vast space of the picture and the almost intimate depiction of the two restorers in the foreground.

JW: I find that very poetic and very political. One can make gestures that are very intimate and personal in a public scene, and they become sort of models of behavior. I think that in the arts, crafts, and professions people develop patterns of behavior which function as social models. These women, as restorers, are acting out a kind of conceptual model of what their idea of civilization is like, their idea of a certain valid

way of life. I think one of the historical roles of pictorial art was to make images which in a way are models of behavior, too. First, they are conceptual models of what a picture should be, because every picture can be thought of as a proposal of a model of what a valid picture is. But, also, the behavior of the figures in the picture may be models, or at least proposals of models, of social behavior, of whatever kind. So, in the panorama picture, the characters are developing, and enacting, an intimate, meditative relation to a work of art through their practice, their work. This is a kind of statement.

MS: The title you gave the work has itself a political dimension.

JW: *Restoration* has a postrevolutionary, even counterrevolutionary implication. I was interested in the double entente in the title, the idea that the panorama and the "regime" of representation in which it is involved could be identified with an *ancien régime*, which ironically we are preserving, and even resuscitating, bringing back to life.

MS: In many of your works you integrate pictorial concepts handed down through art history. This unambiguous handling of tradition, which is reflected in the works themselves, distinguishes you from the representatives of a "purist" and modernist conception of the avant-garde which held true up into the 1960s.

JW: I think that modernism as it is commonly construed overemphasizes the rupture, the break with the past. The emphasis on discontinuity has become so orthodox and routine that I prefer to concentrate on the opposite phenomenon. It's just as significant historically. Another aspect is that the photographic image by its physical nature is figurative, and so it is linked objectively to all figurative traditions, traditions which necessarily preceded both photography itself, and modern art. So it seems we are in a permanent relationship with a figurative form of art, a figurative mode of depiction of things. This mode is bigger, more extensive, than our concept of art, and certainly more extensive than our idea of modern art or modernism in art. Figuration rests on something spontaneous, which is the recognition of appearances by the human eye. So it has a kind of phenomenological base, even a physiological base, which is not so directly available to other forms of art, to experimental and conceptual forms. This is probably why the critique of a phenomenological basis to representation has been an important part of the traditions of experimental art in the twentieth century—for example, Duchamp's attack on the "retinal."

MS: *Restoration* can also be considered a homage to the traditional forms of skilled work—painting and restoration. But on the other hand this picture was produced with advanced computer technology.

JW: I like the fact that these different technologies collide in the picture. The layering of technologies is part of the nineteenth-century "spirit of the panorama," and we are still involved with that spirit in our own fascination with technological spectacle.

One paradox I have found is that the more you use computers in picture-making, the more "handmade" the picture becomes. Oddly, then, digital technology is leading, in my work at least, toward a greater reliance on handmaking, because the assembly and montage of the various parts of the picture are done very carefully by hand by my collaborator and operator, Stephen Waddell, who is a painter.

MS: This complicated and complex method of production gives you for the first time the possibility to continuously control and change all the elements that are important for the composition of the picture while it is being developed. Paradoxically these accumulative work-methods based on the most advanced visual technology recall the evolution of large narrative and dramatic paintings of the past which painters constructed in their ateliers, step by step, from a number of models and studies.

JW: It has curious resemblances to the older way of painting in the way you can separate the parts of your work and treat them independently. A painter might be working on a large canvas and, one afternoon, might concentrate on a figure or object, or small area. Part of the poetry of traditional painting is the way it created the illusion that the painting depicted a single moment. In photography, there is always an actual moment—the moment the shutter is released. Photography is based in that sense of instantaneousness. Painting, on the other hand, created a beautiful and complex illusion of instantaneousness. So past, present, and future were simultaneous in it, and play with each other or clash. Things which could never coexist in the world could easily do so in a painting. That is something photography was never suited for, although cinema is. The early "composite photographs"[4] were unconvincing, and it's no mystery why serious photography went in the opposite direction for a hundred years. Computer montage has destroyed that barrier. In my computer pictures I can conjure something up by an assemblage of elements created with their pictorial unification in mind.

MS: How do you assess the artistic quality and the significance of the Bourbaki panorama in art history?

JW: The Bourbaki panorama is worth preserving for two main reasons. First, it is a beautiful pictorial construction. For its size, it is a very good painting. I have had the opportunity to examine it carefully every day for three weeks. Most of it is very nicely painted in its rather conventional, naturalistic style. There are a few bad areas, but I have the impression those are things added later, in botched restorations. Some of the horses in the foreground are not so good. But the atmospheric treatment of the landscape is excellent; there are many good figures and figure groups, very well handled. The composition is remarkable, and, as a pictorial conception it is, in my opinion, one of the most interesting pictures of the nineteenth century. It should be much better known and appreciated than it is. The second reason is the originality of the subject.

Castres was not a great artist but he did have one great inspiration. I guess being in the Bourbaki army was the great experience of his life, something like Stendhal's experience of Napoleon's campaigns. The subject of the defeated army receiving asylum and assistance from the army of another country and from its citizens is very unusual, particularly in a work on this scale. Usually huge war pictures deal with victory, spectacle, or defeat, and not with assistance, sanctuary, and healing, as Castres's does.

MS: When you first saw the Bourbaki panorama you were working on *Dead Troops Talk*, a picture which depicts circumstances from the war in Afghanistan. Is there any connection between these two pictures? Is it an "antiwar" statement?

JW: Not necessarily. An "antiwar" statement would be one which insists that war has no validity, and therefore we should not engage in it, for any reason. Castres does not say that. To me, he expresses a sensitivity to the somber grandeur of a great defeat. His image of the long lines of suffering soldiers moving through the landscape like specters is very moving, but it says very little about the validity of war as such. In a sense, war pictures cannot really be "antiwar." They can, however, repudiate military glamour, the glamorization of combat and strategy, and focus on suffering.

MS: In Castres's picture, women—mostly peasants—rush toward the soldiers to bring them food and give them assistance. In your picture, young women are trying to save Castres's picture from deterioration.

JW: To be a restorer you must be in a very complex relationship with the past. Why would young people want to undertake this immense and tedious labor of preservation and repair, to work for such a long time in such a dusty place, so patiently, to preserve a monument which they themselves realize is part of a tradition—a patriarchal tradition—that they are probably battling with in the other aspects of their lives? To place a young woman in such a position is in my view something very pictorial.

MS: Accordingly, women have another kind of relationship to the past than men. . . .

JW: Maybe, because it seems that so many restorers are women. In any case, I think there is something striking in the confrontation of a young woman (or a group of young women) with a monumental painting; that something is evocative, dramatic, what I called "pictorial." It is almost as if as soon as you think of the two elements, "young woman/big painting," your mind's eye grasps it as a pictorial situation, as something charged. There is a certain irony in it, obviously.

MS: Could you elaborate on this ironic aspect?

JW: Well, the most obvious aspect is the relation to the men who made the picture, and the tradition in which it was made. The restorers have to have a special relationship with those men. They also have a special relationship with previous generations, in

general, a special interest in the things left behind by past generations. I would see it as a special relationship with the male ancestral line. It's a kind of "family romance."

MS: Perhaps it also has to do with a sublimated form of erotic relationship. . . .

JW: In a way. But I also think that, in pictures, everything has an erotic aspect. Everything pictorial has an erotic aspect—you could even say that everything erotic is pictorial and everything pictorial is erotic. I mean erotic here in the sense that there is pleasure to be gained from the picture, and that pleasure has a relation to the whole being of the person experiencing that pleasure, to their sexuality, too. The pleasure is physical. And when there are figures, images of beings, in the picture which give pleasure, then there is a process of fantasizing that takes place, often unconsciously. The spectator will fantasize according to his or her desire, fantasize relationships between figures in the picture, and between him- or herself and such figures. In old-fashioned pictures, which were illustrations of well-known stories, the spectators usually knew the story, and the relationships involved, and so their own fantasizing was shaped by that. So they knew something concrete about links between characters. In modern-type pictures we don't have the story, so the fantasizing is more free-form, and maybe more intense. There are obviously works of art in which an erotic relationship between the figures is an explicit theme, like Picasso's "artist and model" extravaganzas. I see that as a kind of narrativization of something that already exists in the structure of every picture, and so, in a way, as no more erotic than any other picture.

MS: Unlike in the case of Picasso, the erotic as such is not an explicit subject in your work. On the contrary, a lot of your works are about the obstacles or even the impossibility of human relations; they deal with aggression and alienation among people.

JW: I don't think that's true of all of my work. I've made pictures about contact and communication, friendship and closeness, too. I admit they're mostly about indirect contact, verbal communication. Up to now, the indirect eroticism of the pictorial as such has interested me more than any specifically erotic themes. But, in principle, I don't draw too sharp a line between the two approaches. An image of an erotic subject which could not provide the pleasure given by a beautiful pictorial construct would maybe not be something aesthetically interesting.

MS: In *Restoration*, human relations play a subordinate role. They make up a kind of "subtext" lacking plot or drama.

JW: I think this brings us back to the question of genre. When I was doing dramatic pictures, like *Mimic*, for example, I was interested in a certain type of picture, one I identified with painters like Caravaggio, Velázquez, or Manet. In that type of thing, the figures are in the foreground, they are life-size, they are close to the picture surface, and the tension between them is what is central. Behind them, there is a space,

a background. That is a very traditional kind of picture, I think. But I have gotten interested in other types of picture, and other types of pictorial space. I have made quite a few pictures which are very differently structured, in which the figures are further away from the picture plane, smaller, and more absorbed in the environment. You could say it's a move from Caravaggio to Vermeer or Brueghel. I am not necessarily interested in different subject matter, but rather in different types of picture. A different kind of picture is a different way of experiencing the world, it is a different world almost. *Restoration* is more this latter type of picture, which does not require the kind of dramatic intensity of the earlier pieces. Nevertheless, the next picture I'm doing is more in the line of *Mimic*. It is not a question of doing one or the other, but of opening different paths, and following them simultaneously.

NOTES

1. "Representation, Suspicions and Critical Transparency: An Interview with Jeff Wall by T. J. Clark, Serge Guilbaut and Anne Wagner," *Parachute* no. 59 (July–September 1990): 8. P. 214 in the present volume.

2. Michail M. Bakhtin (1885–1975), Russian semiologist and scholar of the humanities, contemporary of the Russian formalists. Investigating the concept of early structuralist linguistics, he was interested in issues concerning aesthetic form, especially the interaction of content, material, and form in language. Wall refers here to Bakhtin's comments in *Problemy tvorcestva Dostoevskogo* (Moscow, 1963), Eng.

trans. R. W. Rotsel as *Problems of Dostoevsky's Poetics* (Ann Arbor: Ardis, 1973).

3. Michael Fried, *Absorption & Theatricality: Painting and Beholder in the Age of Diderot* (Chicago: at the University Press, 1980).

4. "Composite photography" is a photographic technique especially used for taking pictures of large groups of people. The picture was composed in a kind of "collage" from separately made paper contacts. The technique was first described in 1854 by Wilhelm Horn in *Photographisches Journal* 1, p. 87. Principal representatives were Henry Peach Robinson (1830–1901) and the Swedish painter Oscar Gustav Rejlander (1813–1875).

Mark Lewis: An Interview with Jeff Wall

MARK LEWIS: Art has always been concerned with articulating a position with regard to the question of rights. To understand aesthetic rights simply in terms of combating interdiction, however, would be to risk abnegating art's own identity in favor of putative contents that may or may not be censored according to the myopic interests of petty state officials. The intimate bond that once tied interdiction to art's modus operandi (its historical and delicate attempts to circumvent the laws and protocols that forbade its invasion into certain areas of the territorial subject matters of the state, the church, or the privileged) has long since expired. Today in the West, art is free to represent what it likes with regard to subject matter.

JEFF WALL: I think that the critique of art has been approximately accomplished. That is, the interrogation of the foundations of its validity has reached a point at which the experience of art is now primarily an experience of the problem of its own validity. I do not think that this problem is related directly to the problem of rights. I don't know what "aesthetic rights" are. Art is covered by the democratic rights to free speech, freedom of expression. I have never been concerned with interdiction on the level of subject matter because it barely exists in our society. Look at Joel-Peter Witkin, for example. The provocations, like Robert Mapplethorpe's, are too much a mirror game of publicity to be *artistically* interesting.

ML: To think of aesthetic rights it may be necessary to return to and rethink the theory of disinterestedness articulated by Kant in his *Critique of Judgement*. A long line of commentators have tried to keep some form of this articulation alive (Schiller, Adorno, Greenberg, Focillon, etc.), and they in turn have been subjected to critical work that has undeniably pointed to some of the impossible engagements that these thinkers have entertained with the world. But to acknowledge these critiques is not at all to dispose of the underlying drama in these, for want of a better word, formalist texts. I wonder how that inquiry, that formalist inquiry, might be revitalized and understood now? And can we be sure that this inquiry will not get reduced to a kind of caricature of aesthetic connoisseurship—the name of Walter Pater comes to mind.

JW: I am not interested in formalism. I think that the existence of an attitude such as formalism is a symptom of the decay of aesthetic language among the intelligentsia and the elites who support art. There are obviously many reasons for this, but it's a sore point since Clement Greenberg wrote "Avant-Garde and Kitsch," where he located its

Conducted by correspondence in October 1993. First published as Mark Lewis, "An Interview with Jeff Wall," in *Public* (Toronto) 9 (1994): 55–62.

causes in the decay of the bourgeoisie and the proletariat in the imperialist epoch. The philosophical reflection of the inner contradictoriness of art demands an acceptance of the dialectical relation of "form" and "content." The collapse of these dialectics, or of the sense of dialectical reflection, could be seen as Greenberg sees it, as a symptom of capitalist crisis. To an extent, I think it *is* that, but I do not want to participate in a "progressive consensus" which has been so uncouth about "unprogressive" phenomena, like Matisse, Mallarmé, Proust, or Huysmans, and many more over the years up to now. The progressive consensus is itself a symptom of a decline of the left, a decline of the social-democratic elite. Formalism is their bête noire, the taboo that holds them together. There is no formalism in art, really. Your question about how we ensure that this does not evolve into a new Walter Paterism is itself part of the consensus idea of aesthetic thought. If a new Paterism evolves, let it—maybe that will create something marvellous. "We" should desist in imagining that "we" are called upon to determine developments in this way. A critique of a neo-aestheticism would be a challenge to the stultified analytical capacities of many members of the critical elite.

ML: With regard to the "progressive consensus," I am less sure of its hegemony and the strength of the consensual bond that would hold its opinions together. What I would say is that the dialectical relation between form and content, the "inner contradictoriness" of the work of art, is really a formal concern. What may be at stake here is a general misunderstanding of mimesis. Certainly Kant's articulation of this fundamental relation between art and nature implies a critique of imitation, and this rigorous and formal thinking of the question of representation is, I suspect, what you find so lacking in what you have called the progressive consensus. Formal concerns are central to the question of the work of art's engagement with the world. At the same time, we are aware that a certain conservative connoisseurship would like nothing better than to return art to a sort of pre-Copernican antitheoretical universe.

JW: I would put it a little differently. I'd say that artistic content is realized in the experience of the form of a work. A work does make a "formal proposition," but maybe not in the form of a proposition. It's like when Hegel says that a dialectical concept of identity, which insists on the "identity of identity and nonidentity," must nevertheless be articulated using the word *is*: the propositional form of identity.

In a way, you could say that there isn't any subject matter in a work of art. Subject matter is like a pre-text. It determines nothing directly artistic about a work, but, as pre-text, it determines the generic character of the work that is about to be made. This is another inner contradiction, I think. You begin with a subject, but the content of the subject is only made visible ("appears" in the Hegelian sense of necessary appearance) in the way the work actually looks—which comes from the ways it is made, formed, realized.

I am not as negative as you are about what you call conservative connoisseurship.

I think connoisseurship is an extremely theoretical approach to art, in principle, since it aims at making the subtlest distinctions between (and within) works. I feel that this terminology has just become frozen over the years and has lost the sense that critical philosophy and ideological critique are aspects of connoisseurship. A "serious" work of ideological critique *begins from* a concept of the "valid" and the "serious" work (or its opposite—counterfeit or kitsch). Connoisseurship and a canon of taste are already present in it. The academic radicals and conservatives have allowed themselves to tear apart a discourse which is more expansive than either of their positions can recognize. I'm not interested in connoisseurship in its auction-house sense and the snobbism of reactionary elites, except where fine empirical distinctions are concerned. There, the critical elite would probably have a lot to learn from a connoisseurlike study of the granular or molecular nature of individual, physical artworks, or objects—which is what we artists make.

ML: Because you use photography and because you use some of the technologies of advertising and public imaging in general, and, above all else, because the subject matter of your pictures has tended to include particular aspects of "public life," your work can be understood as reengaging the fundamental connection between the museum and the public life that ought to make the experience of the former a critical and aesthetic one. How might your work be understood as attempting—if indeed it is—to prolong this right for the aesthetic to be taken seriously, its refusal to be subsumed to a more generalized economy?

JW: I have always thought that public museums were at least as good a place as anywhere else to look at works of art, and think about them. But I have to approach the question a little differently than you are doing, because the concept of aesthetic rights does not work for me. The seriousness of the aesthetic experience, or its being taken seriously, is more a question of public literacy and values, of the ethical world created by education, urbanism, and the interlinkage of various institutions, including religious institutions as well as the museum world, or the art market. Just as you have noted that legislation and censorship have not deterred the process of completely opening (and ending) the question of the subject matter of art, no mass of "rights," however conceptualized, can substitute for the practical construction and preservation of what could be called "worlds of seriousness," established and evolving sites of praxis and reflection which are valued and protected by society, by institutions and social capital, and by individuals, by citizens and their property, or private capital. Society already has the legal means to do this. Art can be subsumed in a more general economy and still be taken seriously—that is, art can be a commodity (which it really has to be in capitalism) and still be taken seriously. The idea that the commodity status of art prevents people from taking it seriously and developing profound relations with it is another sacred cow of the progressive consensus. We take land seriously and it is a

commodity, and this could be said of any other object people are seriously involved with.

ML: There can be no argument about whether or not art enjoys commodity status. As your remarks suggest, a work that is not a commodity is a work that must remain completely invisible. However, the commodity form is not the sum total of our relations to objects and things, and this might explain some of the shortcomings of much recent art that has attached its critique single-mindedly to this aspect of the work's value. I think Adorno is useful here.

JW: Like Adorno recognized, the orientation here is in terms of the dialectical character of use-value and exchange-value, the "identity of their identity and nonidentity." The commodity status exhausts no object's whole existence, and art makes that visible as its beauty.

ML: Identity is something which is forcefully raised as a question in your work. All of your characters seem to emerge in your photographs in a state of tension with regard to identity. They are in effect on the cusp of an interpolation that would grant them a definitive identity (from bullies, from the police, from employers, from the CIA, from landlords, from rituals, from prescribed moralities, etc.); yet being on the cusp they have *not yet* received that identity. The tension that surrounds them so theatrically is, I think, this sense of having not taken the final step, of a resistance—often silent, often no more than a barely visible gesture—that is a utopian and perhaps impossible attempt to imagine oneself as producing an identity outside of any demand to identify oneself, and therefore to be something that is ultimately unknowable (to bullies, to police, to landlords, to bosses, to the state). To be unknowable, of course, is to be useless, a condition which the aesthetic has a close interest in.

JW: This question of the uselessness of art I understand in its more classical sense of a negation of the instrumental relation to things, people, and images. The validity of art is involved with this negation, in the name of reflection, and of the dialectical relation of *vita activa* and *vita contemplativa*, as Hannah Arendt, for example, describes it in *The Human Condition*. I like your account of the formation of identity in my pictures—it does correspond to my way of thinking about them. Photography has the problem of being a very definitive and static mode of representation—it "fixes" things. So I have been interested in using the static qualities of the image to focus on something fugitive and intangible. This is an aesthetic value which for me often determines the viability of this or that subject for a picture.

ML: Photography is now a classical medium. Your work suggests this significantly because it seems to point to the probability that photography has approached the condition of painting. I would like to ask you about how the two mediums of cinema and

painting, the mediums that technologically and historically antedate and follow photography, meet in your images.

JW: I agree that photography has now become an art, or a medium with status equal to that of the older ones. Many of the critical problems have not been resolved (like the status of the print in relation to the negative), but in general the debate about whether photography is an art of high ambition and status is over. I think that the debate about whether art will be anything else than photography is also finished. It is clear that the older forms, like painting, are not dead—they will obviously continue. We have just been fascinated with the glamour of the "end" of things. I hope that's over too! I always thought that photography attained its artistic status by means of the cinema, that before the cinema evolved to the point where it had obviously become a major art form, nobody was in a position to comprehend the problems posed by photography in relation to the pictorial traditions. When cinema permitted photography to become conscious of itself as art, photography also became conscious of itself as nonpainting. The new imaging technologies are warping this though, and so now we have not-photography.

ML: Earlier you mentioned Huysmans and I began to think about how in the novel *Against the Grain*, Des Esseintes leaves the realm of "social utility" and his life becomes determined by aesthetic concerns. Hence his obsessive interest in smell and taste, which are peculiarly productive of the *mémoire involontaire*. The gesture of resistance (to identity) in your work is also like the madeleine in Proust, or for that matter the punctum in Barthes. It takes the moment out of its mise-en-scène. The whiff of its presence allows the picture to yield certain truths that are primarily sensed by aesthetic, formal apprehensions (and this is why Proust is very close to Freud). So the decadence that Huysmans stands charged with could be another way of describing how he is able to understand this close relationship between knowledge and form. I wonder, though, if Huysmans's romanticism—and I introduce this new "ism" cautiously—runs the risk of displacing the concerns of, for want of a better word, political action into a wholly private, and ultimately unknowable, realm of taste.

JW: Maybe there is no real risk of the displacement you are concerned about. I do not think a concern with the formativity of art threatens the possibility of making political statements in art. Artistically, there is no other way of making them. Works like Dostoevsky's *The Possessed*, or Goya's *Disasters of War*, or Ibsen's *Hedda Gabler*, Manet's *Olympia*, or Rodin's *Burghers of Calais*, certain of Munch's pictures or Grosz's earlier works, Duchamp's *Urinal*—all have political content formulated as a philosophical problem and experience of a work, an image, or story, etc. Or, referring to the figures you mention, think of Huysmans's analysis of anticlerical extremism in *Là-bas*, or Proust's discussions of the Dreyfus case in his novel. The shadings of these

works, the fact that they open onto different and even conflicting horizons of implied political behavior, is to me *not a problem*. It's a phenomenological condition of art. Certainty fleeting along a curve of continually evolving experience is a model of reflexivity, and of a critical attitude. All these works were and are politically effective enough. In art I do not think that there ever has been the kind of polarity between inwardness and activism that you suggest. The relation is elsewhere—maybe it's in terms of the use-value of the beautiful?

A Democratic, a Bourgeois Tradition of Art:
A Conversation with Jeff Wall by Anne-Marie Bonnet
and Rainer Metzger

ANNE-MARIE BONNET/RAINER METZGER: In the book you wrote about Dan Graham's work, *Dan Graham's Kammerspiel*, you state that taking architecture into consideration was a way to solve some of the problems that Conceptual art had raised. Could we say the same about your work?

JEFF WALL: I don't think it has solved any problems for me; I was writing about him. Conceptual art was mostly interested in exploring social relationships; my work, on the contrary, is about photography. I make photography, not Conceptual art.

A-MB/RM: Yet in Lucy Lippard's book *The Dematerialization of the Art Object* you are presented as a Conceptual artist. When did you redirect your strategy toward photography?

JW: I painted until about 1967. From then until around 1973 was a time of a totally different experience of art, through the example of Duchamp, the increasing influence of theory and philosophy, of Conceptual art and, through that, of photography. Everything got much more experimental. The question for me was, what was it possible to do with these transformed mediums and conditions? By around 1973, I turned toward the visual again, toward the image.

A-MB/RM: At that time, you also studied art history?

JW: Yes, starting from 1964. Many young artists from Vancouver went to the university. The art school there was not attractive for us.

A-MB/RM: Do you think that your work in the '80s has been more influenced by art history than your work from the '70s?

JW: Well, there is hardly any earlier work, work from the '70s. My turn to the picture and the figurative tradition obviously implied a stronger relationship to the art of the past and recent past.

A-MB/RM: *The Destroyed Room* is the first example of this conversion of your work toward photography. As you describe it, as a work strongly influenced by art history,

Conducted in Munich in 1993. First published in German as Anne-Marie Bonnet and Rainer Metzger, "Eine demokratische, eine bourgeoise Tradition der Kunst: eine Gespräch mit Jeff Wall," in *Artis* (Bern/Stuttgart) 47, no. 2 (February–March 1995): 46–51. First published in English here.

and more specifically *The Death of Sardanapalus* by Delacroix. It seems that you tried then to reduce the influence of art history.

JW: Perhaps in the sense that I tried to make it less obvious. One of my most recent pictures makes a direct reference to a woodcut by Hokusai, so in this regard I haven't changed. In *The Destroyed Room*, I was interested in a "remaking" of an existing image, a sort of mannerist attitude toward it. The Delacroix painting seemed very modern to me. I see a lot of so-called "old" art that way. Why shouldn't we be able to relate to it as contemporary?

A-MB/RM: What is the importance of the notion of destruction in *The Destroyed Room*, the transformation of order into a radical disorder?

JW: It is less disorder than violence. I was particularly interested in violence at that time, for whatever reason. I was teaching at the university, concentrating on the earlier part of the nineteenth century, and got intrigued by the way that monumental paintings—Delacroix's preeminent among them—wove together themes of war and military glory, on the one hand, and the conflicts of private life on the other. The intertwining of these two spheres is almost emblematic of that whole period.

A-MB/RM: Especially Manet.

JW: No, Delacroix is much more important in this regard. He understood the notion of "military glamour" in the post-Napoleonic period.

A-MB/RM: What interested you most in these models—the representation of violence, or their involvement in modernity as Baudelaire described it in *The Painter of Modern Life*? You already mentioned Delacroix's modernity.

JW: Violence is only a theme in this kind of art; the art itself isn't violent. That makes it very different from, even opposed to, the art of the avant-garde, which expresses aggression against the idea of art itself. This aggression is no longer very viable. I don't think its necessary or possible to go beyond the idea of bourgeois art—that is, of autonomous art—toward a fusion of art and its context. Or, if it's possible, it isn't very desirable. We have learned how the aggression against autonomous art was consistent with aspects of totalitarianism, from the Stalinist period for example, and how state violence could benefit from that kind of aesthetic. The concept of art as autonomous, and therefore less amenable to this kind of instrumentalization, is a central idea of the modern, and I'm most sympathetic to that.

A-MB/RM: Modernity and avant-garde, to you, are then two separate things?

JW: We can't confuse them anymore. The notion of "avant-garde" art has some very clear boundaries. I have always conceived my work as autonomous art, and therefore as distinct from the experimental and polemic forms that want to intervene in the art

context. I took a different path, away from this totalized "experimentality." I was searching for a way to express my admiration for the pictorial tradition, but one that didn't deny the impact of modern art and modernism, but rather emerged from it, and at the same time that stayed with the picture, the image. This sense of tradition was very much in the air in the beginning of the 1980s, too, but it was expressed mainly in painting then.

A-MB/RM: You often make reference to Walter Benjamin's conception of historical memory. What is the relationship between tradition and historical memory?

JW: It's illusory to think that we can simply link ourselves to tradition. History—particularly modern history—is the account of the interruption of traditions. The new traditionalism of the '80s seemed to want to resume the history of modern art, and at the same time to say something about the catastrophic nature of modern history. This sense of threat and catastrophe, the attending to what was damaged and left at the side of the "path of progress," is something very close to Benjamin. Being in relation to something means that one is not identical with it. That's how it is with our relation to tradition; we can establish a relation to it, to the past, in the sense that we know that there is no identity, no continuity, between it and us.

A-MB/RM: How would you qualify the distance that you are taking toward the idea of the avant-garde? Is it postmodern?

JW: I'm not very interested in the notion of the "postmodern"; it suggests the modern era is over. Rather, the ideas of the avant-garde have changed, or weakened— what's primarily weakened is the idea that one had to be against the bourgeois conception of art.

A-MB/RM: I asked you about the notion of "postmodern" because I believe that your conception of historical memory implies a kind of further interpretation that's already a potential part of the work, exactly similar to the interpretation Charles Jencks developed about architecture with his "visual reading." Is the historical memory just a transcription for a new way to read art?

JW: I'm not so interested in that. I have never had the feeling that the models I am referring myself to are located in the past. What interests me interests me now. Even though the model could be five hundred years old, I see it now, in the present time.

A-MB/RM: The works of the past may have an unconscious presence? A presence similar to what Aby Warburg sketched in his reflection on Mnemosyne. A presence that's less about a memory that would be historical by decision than a collective memory.

JW: Yes, maybe. I was talking recently with a friend about *Dead Troops Talk*, and he said the work reminded him of *The School of Athens* by Raphaël, the conversation

among philosophers, the dialogue of the dead. *Diatribe*, too, revolves around a philosophical conversation. But the reservoir of types represented by genres is only brought to life by individual artists, working here and now, in terms of their own experiences.

A-MB/RM: In an interview you held with Els Barents many years ago, to the question of how your images conveyed the idea of freedom, you answered: "I always try to make beautiful pictures." Do you think that there is a political dimension to your answer?

JW: More ethical than political. It refers back to the Enlightenment, to the movement to liberate art from dogma. The experience of beauty is always associated with hope, and art, as Stendhal said, is "a promise of happiness." Things don't have to stay as they are, change for the better is possible. This is the basis of the democratic, and the bourgeois, tradition. Although these ideas are problematic, I don't see a good alternative to them. And the aesthetic pendant to this—also problematic—is the idea of autonomous art, and the tradition of the picture.

A-MB/RM: This faculty to transform things through beauty, do you see it as a pure intellectual construct, as a historical justification, or do you think this sort of catharsis effect has an actual reality?

JW: The artist always imagines an ideal spectator, and I guess that is the person transformed by his or her relationship with art. I can speak from my own experience and say that my involvement with art has helped me as a person. My life, without my experience of art, would be very different than it is. Aesthetic pleasure changes you. It may not change the world, but it changes you and the way you relate to the world.

A-MB/RM: However, there are numerous references in your work, aesthetic but also historical, political, etc. What is the relationship between this semantic complexity and your idea of beauty? Considering the fact that during the '90s, there seems to be a tendency to reduce this complexity.

JW: Nature is the example of the unity of beauty and complexity, and the primary reference for art has always been nature. The semantic complexity you're talking about is analogous to this original, material complexity. I know this is a very traditional way of looking at it.

A-MB/RM: Do you think that the complexity that is at the basis of your work has something to do with the fact that you are a historian and art critic? Is this thinking process in a motion that leads you to more complexity, precisely because you have been dealing with the phenomenon of art for a long time?

JW: Or to greater confusion! I don't know the answer to that. In my critical writing I've tried to concentrate on the relationship between form and content in art: in what

sense can one talk about the meaning of a work of art? But the question of the medium is just as important to me.

A-MB/RM: Do you count on an immediate feeling of beauty in your work?

JW: A spontaneous feeling, not an immediate one. All the great theories of art attempt to understand mediation, the necessity of a movement beyond immediacy.

A-MB/RM: I am wondering, when I think of the Documenta of 1987 and of your work *The Storyteller*, in relationship with Gerhard Richter, if a work of art doesn't require a certain amount of time to be looked at, and how long it requires to be looked at.

JW: The first encounter with a work of art always happens in the present moment, it is spontaneous. And I believe that if this first encounter, this spontaneous enthusiasm is not there, nothing else much is there, either. At best, there will be some sort of academicism. But I guess we shouldn't oppose efforts to mediate between the work and an audience that might not be very familiar with it, or with art in general, the kind of efforts made by the various institutions concerned with art and its public. But that's not my main interest, my interest is in that spontaneous reaction.

A-MB/RM: Since we've been talking about spontaneity and the way a work of art instantly produces its effect, couldn't we oppose to your idea of beauty the concept of the sublime dating back from the eighteenth century? Isn't your work aiming at the sublime rather than beauty?

JW: I think my work has more to do with the grotesque than with either what was called "beauty" or "sublimity." The grotesque refers more to a state of incompletion, a state in which things and beings suffer disfiguration through social, political, or psychological circumstances. The grotesque might be the principal form of the modern, of modern or modernist art. In that sense my work is grotesque.

Arielle Pelenc in Correspondence with Jeff Wall

ARIELLE PELENC: I thought we could start with the idea of conversation and talk. A lot of your pictures involve verbal communication: *Diatribe, The Storyteller, Pleading, Dead Troops Talk*. You once told me that the film *The Mother and the Whore* (*La Maman et La Putain*) by Jean Eustache was very influential, and this film is mostly based on talking. How does talking, or voice, participate in the construction of your pictures?

JEFF WALL: One of the problems I have with my pictures is that, since they are constructed, since they are what I call "cinematographic," you can get the feeling that the construction contains everything, that there is no "outside" to it, the way there is with photography in general. In the aesthetic of art photography as it was inspired by photojournalism, the image is clearly a fragment of a greater whole which itself can never be experienced directly. The fragment then, somehow, makes that whole visible or comprehensible, maybe through a complex typology of gestures, objects, moods, and so on. But, there is an "outside" to the picture, and that outside weighs down on the picture, demanding significance from it. The rest of the world remains unseen, but present, with its demand to be expressed or signified in, or as, a fragment of itself. With cinematography or construction, we have the illusion that the picture is complete in itself, a symbolic microcosm which does not depict the world in the photographic way, but more in the way of symbolic images, or allegories. For example, Giotto's paintings, although often part of narrative cycles, seem to evoke a whole universe just by the nature of the depiction and composition. Italian Catholic art as a whole has this totalizing quality, in which the design of the picture implies a complete and profound statement about the subject, and we do not have the feeling that there is anything left outside the frame. This condition is always at odds with the nature of pictorial construction based on perspective and the rectangle, which necessarily implies a boundary to the picture and not to the subject. This conflict is one of the essential sources of energy for Western pictorial art. It reached its first absolutely decisive formulation in the "naturalistic Baroque" of Caravaggio and Velázquez, in which meanings seem to be totalized while the pictorial form is recognized as being inherently bounded. In their work, there is simultaneously no outside and an outside, and I think we've been in this borderland ever since.

Making pictures of people talking was for me a way to recognize this condition. I have always been interested in the nature of the pictorial, its indwelling structure,

Conducted by correspondence in 1996. First published as "Arielle Pelenc in Correspondence with Jeff Wall," in Thierry de Duve, Arielle Pelenc, Boris Groys, and Jean-François Chevrier, *Jeff Wall* (London: Phaidon Press, 1996), pp. 8–22.

Jean Eustache. *The Mother and the Whore.* 1973. Still from a black and white film, 210 min.

its transcendental conditions, if you like. Journalistic photography developed by emphasizing the fragmentary nature of the image, and in doing so reflected on the special new conditions created by the advent of the camera. So this kind of photography emphasized and even exaggerated the sense of the "outside" through its insistence on itself as fragment. I accept the fact that a photographic image must be a fragment in a way that a painting by Raphael never is, but at the same time I don't think that therefore photography's aesthetic identity is simply rooted in this fragmentary quality. In the history of photography itself there has obviously been a continuous treatment of the picture as a whole construction. This has often been criticized as the influence of painting on photography, an influence that photography has to throw off in order to realize its own unique properties. But in my view, photography's unique properties are contradictory. Imitation of the problematic completeness of the "naturalistic Baroque" is one of them.

A picture of someone talking is to me an elemental example of the problem of the outside and the threshold. I can construct the gestures and appearance of the speaker and listener, and so can suggest that I also control the words being spoken and heard. But, at the same time, it is obvious that I cannot, and that every viewer of the picture can "hear" something different. Talking escapes, and so it is itself an image of what is both included and never included in a picture, especially in a picture which seems to wish to imitate the "naturalistic Baroque" invented by painting.

AP: The child in *In the Public Garden* looks like an automaton—in the garden but cut off from the outside world. There is a lot of automatic gesturing in your pictures, maybe because of their "cinematographic" character. This automatism of the image is different from the distancing produced by theater or painting. In classical cinema, the *hors-champs*, the outside, is open and endless. But with modern cinema the *hors-champs* is transformed by the jump cut (*faux raccord*). It becomes like an irrational number not belonging to one or the other class or group it is separating. Your work presents these irrational cuts where the rupture with the outside world is visible inside the image, like in *Dead Troops Talk*, for example.

Robert Bresson. *Mouchette.*
1967. Still from a black and
white film, 90 min.

JW: My work has been criticized for lacking interruption, for not displaying the fragmentation and "suturing" which had become de rigueur for serious art, critical art, since the 1960s. In your terms, it didn't seem to have any jump cuts which let in the outside and break up the seamlessness of the illusionism. But, already by the middle of the 1970s, I felt that the "Godardian" look of this art had become so formulaic and institutionalized that it had completed its revolution, the plus was becoming a minus, and something new was emerging. I preferred Bresson's *Mouchette* to Godard's *Weekend*, and was interested in the preservation of the classical codes of cinema as was being done by Buñuel, Rohmer, Pasolini, Bergman, Fassbinder, and Eustache, all of whom achieved very new things in what I would call a non-Godardian or even counter-Godardian way. Eustache's *Mother and the Whore* had a tremendous effect on me. I wish he hadn't died.

What I think these people were doing was transferring the energy of radical thinking away from any direct interrogation of the medium and toward increasing the pressure or intensity they could bring to bear on the more or less normative, existing forms which seemed to epitomize the medium. They accepted, but in a radical way, what the art form had become during its history. They accepted technique, generic structure, narrative codes, problematics of performance, and so on, but they broke away from the decorum of the dominant institutions, like the production companies or, in Europe, the state filming agencies. In that process, they brought new stories and therefore new characters into the picture. Think of the couple in Fassbinder's *Ali: Fear Eats the Soul*, or Mouchette herself, or the people in Bergman's *Persona* or *Winter Light*.

There's a lot that could be said about a kind of internalized radicalism in the work of these filmmakers and others working between, say, 1955 and about 1980, an almost "invisibilized" intensity as far as any disruption of the classical codes is concerned. What happened was that the "outside," as you call it, did get inside, but in doing so it refused to appear directly as an outside, disruptive element. It dissembled. It appeared to be conventional, appeared to be the same as (or almost) the conventionalized "signs for the real" that make up ordinary cinema. Buñuel was of course a master at this. So

Rainer Werner Fassbinder.
Ali: Fear Eats the Soul.
1974. Still from a color
film, 94 min.

the new form of the threshold was not a drastically broken-up surface like in Godard, but a self-consciously, even ironically, even manneristically normalized surface. This is—or seems to be—a more ambivalent approach to the idea of critique and autocritique than an openly contestatory one. This apparent ambivalence, this technique of mimesis and dissembling, this "inhabitation" didn't satisfy anyone who demanded avant-gardist criteria of overt, antagonistic confrontation. I agree that there are these "jump cuts" or irrational cuts in my work. But they appear as their opposites, as adherence to a norm, the unity of the image or picture. I accept the picture in that sense, and want it to make visible the discontinuities and continuities—the contradictions—of my subject matter. The picture is a relation of unlike things, montage is hidden, masked, but present, essentially. I feel that my digital montages make this explicit, but that they're not essentially different from my "integral" photographs.

AP: Representation of the human body, depending on the construction of micro-gestures, is kind of programmatic in your work. Recently some unrealistic, improbable bodies have appeared, such as those in *The Vampires' Picnic, The Stumbling Block, The Giant*, and the zombies in *Dead Troops Talk*. What are these bodies?

JW: I feel that there has always been a grain of the "improbable" in my pictures and in my characters. For example, I thought of the woman in *Woman and Her Doctor* as a sort of porcelain figurine, and tried to make her look a bit like one, very glossy, so that the "clinical gaze" of the doctor would have something to work on. I made a "double" in 1979 (*Double Self-Portrait*). The man in *No* seems to have only one leg—how is he moving along the street? The woman in *Abundance* always seemed sort of hallucinatory to me. *The Thinker* is an impossible being, too. I have always thought of my "realistic" work as populated with spectral characters whose state of being was not that fixed. That, too, is an inherent aspect, or effect, of what I call "cinematography": things don't have to really exist, or to have existed, to appear in the picture. So, I see my more recent "fantasy" pictures as just extensions of elements that have always been present. Being able to use computer technology released certain possibilities,

certain energies, and made new approaches viable. But a recent work like *Restoration*, for example, used the computer and the process of digital montage to create a very realistic, very everyday, very "probable" scene; so this technique does not just imply overtly fantastic images. It makes a spectrum of things possible, and helps to soften the boundary line between the probable and the improbable. But it did not create that threshold—that was already there, both in my own proclivities, and in the nature of cinematography. "What are these bodies?"—that question requires an interpretation of the picture in which they appear, and I'm not the best person to do that.

AP: In an interview with T. J. Clark you emphasized the notion of the representative generic constructions of your pictures. By using generic constructions, figures, stories, or gestures, your work seems to underline the inadequacy of representation to its referent. Would your "spectral characters" be an indication that the world and its representation do not match?

JW: The claim that there is a necessary relationship (a relationship of "adequacy") between a depiction and its referent implies that the referent has precedence over the depiction. This "adequacy" is what is presumed in any imputed legitimation of what you're referring to as representation. A critique of representation claims that representation happens when someone believes that a depiction is adequate to its referent, but is deceived in that belief, or deceives others about it, or both. Representation occurs in that process of self-deception, and so it becomes the object of a deconstruction. I don't think depictions, or images, can be judged that way, and I don't think they're made in those terms, or at least not primarily. Depiction is an act of construction; it brings the referent into being. All the fine arts share this characteristic, regardless of their other differences. Depictions are generic because, over time, themes, motifs, and forms bear repetition and reworking, and new aspects of them emerge in that process. Genres are forms of practice molded slowly over time, like boulders shaped by water, except that these formations are partially deliberate, reflexive, and self-conscious. "Generic" constructions are old by nature, maybe that is why they play such an important part in the expression of the "new" and the "modern," as Baudelaire observed.

In that sense, there is always something spectral—ghostly—in the generic, since any new version or variant has in it all the past variants, somehow. This quality is a sort of resonance, or shimmering feeling, which to me is an essential aspect of beauty and aesthetic pleasure. But none of this is concerned with the adequacy of the depiction to its referent. This notion of such a relation is not artistic; it seems to have more to do with other ways of thinking, other images, other depictions. The "match" between the world and depictions is organized or regulated differently in different practices. Art might refer to, borrow from, or even imitate other things, the way many artist-photographers have imitated photojournalists, for example. But it does not accept the totality of regulations covering or defining that from which it borrows—

the principle or condition of the autonomy of art ensures that. I think our awareness of this is the outcome of the years—or even decades—of deconstruction.

AP: In his essay "Analytic Iconology," the art historian Hubert Damisch looks into the question of beauty in relation to the Freudian theory of desire, revisiting the myth of Paris through European painting from Raphael to Seurat. It is clear that the female nude from the Renaissance to Manet and Picasso has been the site for aesthetic and libidinal gaming with tradition, a site of transgression of its rules and laws. *The Destroyed Room* is a kind of allegory of the nude, and you have made male nudes— *Stereo* and *The Vampires' Picnic*. *The Giant* is your first female nude. What importance do you give to this subject?

JW: I'm not convinced that the nude is such a "site" on which such transgression is acted out. That's not to deny the historical and even psychological truth of this acting out, but only to place oneself in relation to it. Being "in relation to it" is not to be outside it or free of it, but not to be simply subjected to it as an inevitable and necessary condition. I don't think it is any longer necessary to make nudes, which might be a way of saying it is no longer necessary to enact transgressions in order to make significant works of art, even modernist art. This is, again, not to suggest that the cultural and social antagonisms which provoke the whole process of art as transgression, from Romanticism on, have been cured or calmed. But the "culture of transgressions" involves a sort of romantic binarism. Law exists, and the soul is crushed by it. To obey the law is to live in bad faith. Transgression is the beginning of authentic existence, the origin of art's truth and freedom. But modern societies are constitutional; they have written, deliberately, their own foundations, and are continually rewriting them. Maybe it is a sense that it is the writing of laws, and not the breaking of them, that is the most significant and characteristic artistic act in modernity. Avant-garde art certainly operated this way, writing new laws as quickly as it broke any old ones, thereby imitating the constitutional state. The maturation and aging of modernist art maybe brings this aspect more into focus. In any case, the gesture, or act, of transgression seems far more ambiguous in form and content than it has seemed in concepts of art simply based upon it. I feel that art develops through experimentally positing possible laws or lawlike forms of behavior, and then attempting to obey them. I admit this is a completely reversed view, but it interests me more than any other. So I guess the nudes I've done are not intended to be sites for any such gaming with authority. I see them as "mild" statements, marking a distance from any philosophy of desire. Except for the vampires, of course.

AP: I think you're dismissing the idea too easily. I was thinking about transgression in a more symbolic sense, not simply in terms of "shocking the bourgeoisie." If you say that modern society is constitutional, are you saying that it is like *all* societies in the sense that they are constructed in terms of the main law—the interdiction against

incest, which allows language as the symbolic function? Any significant work of art touches on or crosses that interdiction, that borderline, which is also the border between nature and culture. When that border is not approached, you have academic art, art made by the application of laws. The production of meaning in poetic language, because it reactivates what Julia Kristeva called the "archaic body," is equivalent to incest. That is, by means of rhythm, intonation, everything that introduces the heterogeneous law is challenged. It seems to me that the economy of meaning in your work acknowledges this territory.

JW: OK, I agree that in that sense, my work must involve what you want to call transgression. When I talk about law-making, I see that in the light of the origins of constitutional states, that is, regicide. So there is no question of the application of laws, of academic conformism, except in the sense that we can never simply oppose conformism without in some way internalizing it, participating in it, becoming part of it. The image of pure lawbreaking activity, pure violation, pure incestuousness (if you want to call it that), seems to me to be a rhetorical construction, a kind of romantic fiction of the radical avant-garde.

To my mind the violator is hypothesizing a new or antithetical code, to which he or she conforms often very strictly. I recognize what Kristeva is referring to—the heterogeneity and productivity of the poetic. I identify that with the pleasure created over and over again by the picture itself. But I don't think of it as essential, or as more productive than the "linear" or impulses toward institutionalization, reiteration, enforcement, and mimesis. This is part of not accepting that art is primarily or directly a gesture of liberation, as all avant-garde concepts insist it is.

They are still quarreling with their own "Ancients." In my opinion, the triumph of the avant-garde is so complete that it has liberated what previously had to be seen as the antiliberating elements in art, or in the process of making art. There are transgressions against the institution of transgression. I think the pictorial has come to occupy this position to a certain extent.

AP: I can follow you on that, but to be a little more specific, your pictures are full of "micro-transgressions," many of which are involved with themes of violence, particularly male violence. I think of *No*, *Milk*, *Dead Troops Talk*, or *The Vampires' Picnic*. If we think of representation in terms of a symbolic function equivalent to the Name of the Father, it seems your work has something to say about it but not in terms of "deconstruction" or "seduction."

JW: The problem is that the rhetorics of critique have had to make an "other" out of the pictorial. This is the form the history of art has taken, from the beginning of modernism. This is our "Quarrel of the Ancients and Moderns." The pictorial itself is identified with the Name of the Father, with control and domination, and, finally with violence. I think I understand why this has happened, but, as I said, I see that as

Jeff Wall. *No.* 1983. 10' 5⅜"
x 7' 5" (318 x 226 cm)

a necessity imposed by the polemical character of artistic discourse, by the "quarrel." So there is truth in the identification. But, rhetorically, this truth has been totalized, and transformed into what Adorno called "identity." I'm struggling with this identity.

The violence you see in my pictures is social violence. *Milk* or *No* derived from things I had seen on the street. My practice has been to reject the role of witness or journalist, of "photographer," which in my view objectifies the subject of the picture by masking the impulses and feelings of the picture-maker. The poetics or the "productivity" of my work has been in the stagecraft and pictorial composition—what I call the "cinematography." This I hope makes it evident that the theme has been subjectivized, has been depicted, reconfigured according to my feelings and my literacy. That is why I think there is no "referent" for these images, as such. They do not refer to a condition or moment that needs to have existed historically or socially; they make visible something peculiar to me. That is why I refer to my pictures as prose poems.

AP: *The Vampires' Picnic* is certainly a prose poem. I saw it as a kind of reversed and dark version of the Paris myth, a kind of disintegration of the aesthetic judgment, and this interiorized violence, this emotional and pictorial discord seems to have something to do with the symbolic function.

JW: The feelings of violence in my pictures should be identified with me personally, not with the pictorial form. These images seem necessary to me; the violence is not idiosyncratic but systemic. It is repetitive and institutionalized. For that reason I feel it can become the subject of something so stable and enduring as a picture. The symbolic function we call the Name of the Father appears in a process of masking and unmasking, and perhaps of remasking. The work of art is a site for this process, and so the work potentially is involved in masking. But from that it is difficult to move to an

Jeff Wall. *The Vampires' Picnic*. 1991. 7' 6 ⅜" x 10' 11⅞" (229 x 335 cm)

essential identification of any artistic form with masking alone. This would be to single out that form as so different that it would have to have a category all of its own. Any image of a male has to include in some way the identity with the father, and so all the problems involved with that are evoked just in the process of depiction. Rather than dominating and organizing that experience, the picture sets it in motion in an experimental universe, in a "play," including a play with tropes of depiction, a play of styles. For example, I think that the nude in *The Vampires' Picnic* signifies the father function. I wanted to make a complicated, intricate composition, full of sharp details, highlights, and shadows in the style of German or Flemish Mannerist painting. This style, with its hard lighting and dissonant color, is also typical of horror films. I thought of the picture as a depiction of a large, troubled family. Vampires don't procreate sexually; they create new vampires by a peculiar act of vampirism. It's a process of pure selection, rather like adoption; it's based in desire alone. A vampire creates another vampire directly, in a moment of intense emotion, a combination of attraction and repulsion, or of rivalry. Pure eroticism. So a "family" of vampires is a phantasmagoric construction of various and intersecting, competing desires. It's a mimesis of a family, an enactment of one. I thought of my vampire family as a grotesque parody of the group photos of the creepy and glamorous families on TV shows like *Dynasty*. The patriarch of this family is the nude who is behaving oddly. In this behavior he occupies the position of father, and the discordancy implies something about the vacancy of the symbolic position itself, which can be occupied adequately by a figure who does not perform in a conventional or law-governed way. I wanted to get a lawless feeling, a feeling that things are amiss and at the same time normal—that "father feeling."

AP: In your *Galeries* interview with Jean-François Chevrier you discussed the "black humor" and suppressed laughter you thought were in your work. But I see, or hear, another laughter, softer, gentler, and maybe more humanistic. This is maybe most

Jeff Wall. *The Stumbling Block*. 1991. 7' 6⁵⁄₁₆" x 11' ⅞" (229 x 337.5 cm)

evident in *The Stumbling Block*, maybe in *The Giant*, where I sense it to be a nourishing, maternal feeling.

JW: When I started to work with the computer, I had the idea that I could use the otherworldly "special effects" to develop a kind of philosophical comedy. *The Giant*, *The Stumbling Block*, as well as *The Vampires' Picnic* and *Dead Troops Talk* are in this genre, as are older pictures like *The Thinker* or *Abundance*. This makes me think of Diderot, of the idea that a certain light shone on behavior, costume, and discourse creates an amusement which helps to detach you from the immediate surroundings and projects you into a field of reflection in which humanity appears as infinitely imperfectible. This imperfection implies gentleness and forgiveness, and the artistic challenge is to express that without sentimentality. I guess the key metaphor in these works is "learning." We learn; we never complete the process of learning, and so learning is a kind of image of incompletion and limitation, but a hopeful image as well. I've tried to express this feeling, and this love of learning, in pictures on the subject of discourse and talk, like *The Storyteller* or *A Ventriloquist at a Birthday Party in October, 1947*. In *The Stumbling Block* I thought I could imagine a further extrapolation of society in which therapy had evolved to a new, maybe higher stage than it has up to now. In my fantasy, *The Stumbling Block* helps people change. He is there so that ambivalent people can express their ambivalence by interrupting themselves in their habitual activities. He is an employee of the city, as you can tell from the badges on his uniform. Maybe there are many stumbling blocks deployed on the streets of the city, wherever surveys have shown the need for one. He is passive, gentle, and indifferent: that was my image of the perfect "bureaucrat of therapy." He does not give lessons or make demands; he is simply available for anyone who somehow feels the need to demonstrate—either to themselves or to the public at large—the fact that they are not sure they want to go where they seem to be headed. The interruption is a curative, maybe cathartic gesture, the beginning, the inauguration of change, healing, improvement, resolution, wholeness, or wellness. It's my version of New Age; it's

Jeff Wall. *Abundance*. 1985.
7' 3⅜" x 48" (222.5 x 122 cm)

homeopathic. The ills of bureaucratic society are cured by the installation of a new bureaucracy, one which recognizes itself as the problem, the obstacle. I think there's a sort of comedy there. It's not really black comedy, though; there's still a little black in it. It's a sort of "green comedy," maybe—dark green.

I had a phone call from a critic yesterday; she was preparing a talk involving *The Giant* and had connected it to the figure of the "alma mater," a monumental symbol of learning which personifies the university. I hadn't thought of that, although I had heard the term "alma mater" ever since I had been a student. *The Giant* is a sort of imaginary monument, and that genre itself is connected with various branches of humor or comedy, for example, the Surrealists' proposals for reconfiguring some of the familiar monuments of Paris. Theirs were usually done in a spirit of *humour noir*. Mine is maybe post-*humour noir*. I associate *The Giant* with two other pictures: *Abundance*, in which the older women personify something intangible—freedom; and *The Thinker*, which was also a sort of hypothesis for a monument after the model of Dürer's *Peasant's Column*. I think both of those works involve some *humour noir*, but *The Giant* is different.

AP: Earlier, when you were discussing the role of "talk," of "voice," in your pictures, you concentrated on speech in terms of the characters in the picture, that is, in terms of the narrative. There is another kind of voice in your pictures that signifies but not in terms of the narrative. There is something "ventriloquial" in the pictures.

JW: That sounds like what I would call "style," keeping to the old-fashioned way of describing things. Maybe it has something to do with the elemental illusion of photography; the illusion that something was there in the world and the photograph is a trace of it. In photography, the unattributed, anonymous poetry of the world itself

appears, probably for the first time. The beauty of photography is rooted in the great collage which everyday life is, a combination of absolutely concrete and specific things created by no one and everyone, all of which becomes available once it is unified into a picture. There is a "voice" there, but it cannot be attributed to an author or a speaker, not even to the photographer. Cinematography takes this over from photography, but makes it a question of authorship again. Someone is now responsible for the mise-en-scène, and that someone is pretending to be everyone, or to be anonymous, in so far as the scene is "lifelike," and in so far as the picture resembles a photograph. Cinematography is something very like ventriloquism.

Dirk Snauwaert: Written Interview with Jeff Wall

DIRK SNAUWAERT: In the beginning I thought your work related primarily to Vancouver as a "site," and to the activities and social relations of people there—that is, in the early '80s I saw your work as a kind of documentary project. Was this in fact part of your way of thinking then? This aspect seems to have become less important, though you still continue it from time to time.

JEFF WALL: I never really saw my work as documenting Vancouver as such. I'm not very interested in Vancouver in that sense; to me, its interest lies more in the ways in which it is a kind of representative place rather than a unique place, though of course it's a unique place, like any place. My "Vancouver" pictures were about relationships, as you say, but relationships that could be taking place in a lot of cities. I would even say, any city. What interested me more was to make pictures that had specific relationships with certain kinds of painting, like Manet's, certain kinds of cinema, like Bresson's or Buñuel's, and certain kinds of photography, "street photography," and to find a way of hybridizing all that I admired about those things. In doing that I thought I could create a figurative practice that could be formally interesting and be able to say something about conditions and relationships in the real world, whether that world was identified with Vancouver or not. I thought, for my purposes, that painting needed to be more psychologically intense, cinema needed to be "arrested" (according to the concepts from Barthes and Benjamin), and photography needed to be made viable at the scale of the human body, the scale of natural vision, a scale painting had mastered.

DS: Although you say you reject the instantaneous "objective" acceptance of reality of art-photojournalism, you've made two works that are in fact snapshots, or real, ordinary photographs, *Pleading* and *In the Public Garden*. Isn't this a contradiction? Also, why have you made only two of these in the past twenty years or so? Are they an anti-aestheticist element in your work?

JW: I guess it is a contradiction, but . . . I do, or maybe it's more accurate to say I did, reject the idea of "direct photography," as practiced by art-photojournalists, like Cartier-Bresson, or later, Winogrand, and so many others. But "rejecting" something is a way of coming into relation with it, getting involved with it, keeping it in play somehow, at least I think that's what it is for me. Maybe I never reject anything,

Conducted by correspondence in 1996. First published in German and English as Dirk Snauwaert, "Schriftliches Interview mit Jeff Wall/Written Interview with Jeff Wall," in Ingvild Goetz, ed., *Matthew Barney, Tony Oursler, Jeff Wall* (Munich: Sammlung Goetz, and Hamburg: Kunstverlag Ingvild Goetz, 1996), pp. 89–93.

Jeff Wall. *Pleading*. 1984. 46⅞ x 66⅛" (119 x 168 cm)

Jeff Wall. *In the Public Garden*. 1993. 46⅞ x 6' 2" (119 x 188 cm)

finally . . . Anyway, over the past ten or fifteen years I've struggled to contravene aspects of the aesthetics of photography, the canonical aesthetics that made documentary, straight photography into the norm. This wasn't because of any particular dislike of that photography, at least as it has been practiced by artists I admire, like Evans, Wols, or Sander. It was more experimental. I was interested in other ways of making photography without having to "be a photographer." Great canonical photography was made by imitation photojournalists; I felt there were other, equally legitimate imitations to explore. I made *Pleading* and *In the Public Garden* out of actual circumstances, the ones that led to those particular moments and those pictures. I thought it would be interesting and consistent to act against my way of working, and open up something that might someday develop into something, something like "photography." It's not anti-aestheticist, it's an extension of the overall thinking about the medium and institution of photography.

DS: Can you specify those circumstances and moments? The pictures also have a completely different texture. Because of the grain of the film you used and the blowup, they have a pointillist or divisionist aspect, which is again different from the detailed precision of your other pictures.

JW: They were just lived moments, one in London, one in Venice. They were pictures of real events; I made the photos spontaneously, like any one of thousands I've made.

These had pictorial values, and thematic values, that made me consider them in the light of the way I look at my other pictures, so they became pictures, too. They were enlarged from 35 mm negatives, so they show the kinds of grain and sharpness you'd expect from that material. It's different from the norm in my work, which is usually made with larger format film, but I like that difference; I see it as another possible dimension, and another aspect of photography. I don't usually go out hunting for pictures with the standard hunting equipment, the 35 mm camera, but if, without hunting, I catch something, then I can be a "photographer," too. My other work does not interfere with that; quite the contrary.

DS: The relation of your work to painting has been described extensively. Most authors seem to be able to see your pictures only in a historical perspective (e.g., Thierry de Duve points this out in Thomas Crow's article and then projects connections between your work and that of Cézanne). Doesn't this history-related reading, which talks basically about formal qualities and the meta-level reading as art, bother you? Apart from the reference to the lightbox and publicity, one can hardly find concise critiques of the relationship of your work with mass culture, youth culture, suburbia, cinema, or peripheral emanations of the "culture of spectacle" like in *Restoration*. You have chosen this double reading level since your installation of *The Destroyed Room* in a shop window. Was this the aim, to confuse or destroy the high and low readings for a redefined reading of aesthetics through the everyday by identification, or misidentification, with the subject matter?

JW: That reading doesn't bother me, because it's valid enough, as far as it goes. Maybe the problem is that this emphasis on my relation to painting, to high art, and to the modern tradition is often made without reconnecting that relation to other things, like the ones you're talking about. When I talk about the "painting of modern life," people often think I'm referring to the nineteenth century, but I'm not, I'm talking about now. It's just that the phrase comes from the past, so it gets associated with it, naturally enough, I guess. The idea of the painting of modern life is always about the now, and about the interrelation of mediums in the image of "now." I bridge the divide between "high" and "low" art, old and new art, etc., with this assumed identity. But it's an identity that conceals many others—that of journalist for example. Baudelaire was very explicit about that.

DS: The scripts/scenarios for your pictures become more and more fictionalized. Their relation to cinema seems to have become stronger. You operate like an art director, choosing your locations and requisites, making your settings and framings. You made the life-size, monumental painting into a "still photo" where enchantment is replaced by reenactment, truth by psychological depth. The synthetic contraction of the fiction in one static image, in the frozen time of "still" photography, seems to allow you to develop a reflexive reintroduction of narration into experimental art. Do

the allegories, instead of the more straightforward scenes you have been making in the last seven or so years, seem more appropriate to you as a response to the actual cultural situation, and what is the different functioning you expect from the allegories?

JW: I guess you mean the overt allegories like *The Giant* or *The Vampires' Picnic* . . . I got interested in these kinds of pictures for various reasons. One was that I wanted to work with larger groups of performers, and not remain tied to one-, two-, or three-figure compositions. It's the inner movements of the structure, or order, of the medium or the art form that really makes things happen. I started doing that around ten years ago, with pictures like *The Storyteller*. The larger groups created new subjects, new situations, and new ways of handling them—at least they were new for me. I don't see these pictures as any more narrative than others . . . I see all pictures as containing an arc of narrative . . . but I felt that the mimesis of cinema I was interested in—cinematography—might become more and more overt and more extreme, more experimental, through these subjects and the treatment they suggested. As you say, "stillness" became a more complex issue, and I wanted for some reason to make experiments with stillness. Partly, this was because photography is about both movement and actual things happening, events. I guess I reasoned that there were alternatives; if there was no "real event," maybe there was no movement, or no movement in the commonly accepted "photographic" sense.

DS: In his interview with you T. J. Clark refers to the imaginary inclusion of the viewer in the scene, when talking about Lorenzetti's *Good and Bad Government*. His argument is that your works do not create that inclusion and therefore fail in their aim to somehow redeem the viewer as a part of a community. He suggests that your characters remain ciphers, and reflections of your own highly individuated state, as artist-impresario.

In your more recent works you include phantasmagoric elements that are both seductive and alienating at the same time. They interrupt the "normal" continuous reading of the motif. They're not collage, and they're not "straight" photographic representation; nor do they pastiche historical images. Is it your intention to overcome conceptually this polarization between the unified and the "splintered" subject by inducing a subjective historical reading of the allegories you create? Is this a new proposition within your ideas about the "concept of the picture"?

JW: I think my pictures are similar to other pictures, or at least to other pictures that interest me, and there are a lot of those. I think Clark and others are, or were, interested in developing a critique of representation, and therefore representational characteristics in a work of art are problematic for him, and them. My feeling is that all critiques of representation require representation, and, maybe despite themselves, exhibit deep affection for it, and dependence on it. The phenomenon, or the concept of "representation" is a sort of sacrificial body, to which one has an intensely ambiva-

lent relationship. Maybe my pictures fail to achieve ideological objectives which something in them leads critics to expect, and that failure is identified with the power relationships imputed to the practice of representation itself. I, as artist, get identified as the ideological operator, and my work as an expression of my own will-to-power. I've rejected this on the grounds that pictorial art, or representation if you want to call it that, cannot be circumscribed by these kinds of ideological critiques; there are too many other ways of experiencing and understanding it. The pictorial is such a rich, sophisticated form that it can't be invalidated by such critiques, no matter how innovative the critiques may be. The pictorial is the ground which creates the space between any polarized positions, like the ones you mention, between different concepts of the subject. The positions appear essentially polarized when the nature of the ground is forgotten. Representation, or the picture, includes antithetical elements within itself as the normal condition of its existence. Polarization of identities is a phenomenon of the picture.

DS: Michael Newman has referred to the Jewish character and meaning of the object "Odradek" in your work *Odradek, Taboritskà 8, Prague, 18 July 1994*. Frédéric Migayrou has talked about the Golem in relation to *The Stumbling Block*. Is the Judaic tradition, which you've identified with the black humor in your work, present in other aspects?

JW: Is there anything like a "Judaic character" in modern or modernist art? This is the same as asking if there's a Protestant character in it, a Catholic character, a Zen Buddhist character in it. The interesting thing about modernist art is that it has assimilated relevant aspects from all these traditions, and others. Not eclectically, but syncretically. Nobody can do "Catholic" art now the way they could in the seventeenth century, partly because of the effects of the Reformation and the reflection of that in the "Quarrel of the Ancients and Moderns." Modernism began in the contestation about the essence of things which was fought out as religious dogma, but it did not actually take sides. It hesitated, like Hamlet. That hesitation created an opening. We stay in the open as long as we hesitate.

DS: But, for example, there is an anti-iconic element in the Judaic culture, an opposition to the figurative depiction of the sacred, and an orientation toward the word, the text, and its interpretation. Your work is intensely imagistic; what do you think about the anti-iconic?

JW: All modernist art is comprised of conflicting impulses. We don't accept the picture, the image, now without experiencing a moment of rejection of it. This is in part what the critiques of representation are trying to express. Iconophobia emerges from our tribal religious traditions. It's particularly evident in Judaism, Islam, and in important strains of Protestantism. This is being worked out in a media culture that depends radically on the image. The energy of the pictorial, of pictures, is derived from those

Jeff Wall. *Eviction Struggle.*
1988. 7' 6" x 13' 7" (229 x
414 cm)

Jeff Wall. *Eviction Struggle.*
1988–89. 35 mm color film
transferred to video loops

antagonistic but inseparable dependencies. In this light, we could speculate that pictures present deep, unfathomable dependencies as experiences of pleasure.

DS: Over the years your work seems to have been read as the return of figuration in art, as opposed to abstraction. You have yourself insisted on the presence and the ability of the human body to address specific complex meanings which would be failing in neo-Conceptual art (e.g., the Stephan Balkenhol essay), although you have insisted on your being a part, and continuation, of the aims of Conceptual art.

Your work seems to be the possible negotiation "site," where formalist modernist and multiple-reading postmodernists, social historicists, and aesthetic intemporalists confront and polemicize about the correct interpretation, and thereby about the relevance of narrative figuration. Do you see it as part of your project to relink both antagonistic directions, as you have said previously, or do you consider these academical quarrels as superfluous and unproductive?

JW: I think the quarrels are superficial, unproductive, tedious, academic hairsplitting—just like the "Quarrel between the Ancients and the Moderns." We need this torment for discussion, for finding out what we think.

DS: You have made one version of *Eviction Struggle* accompanied by nine video monitors that show the scene from the viewpoint of every character involved in the scene, in a doubling or even tripling of viewpoints and time relations. Was it a way to break

Jeff Wall. *An Eviction.*
1988/2004. 7' 6" x 13' 7"
(229 x 414 cm)

out of the unity of space and time of the perspectival frame, and investigate "death of the author" scenarios where all characters tell their own individual version of the same story? A logical consequence would be that you also turn to 35 or 70 mm feature film. Have you seen what other artists have produced (Matthew Barney, Robert Longo, Larry Clark . . .), and what do you think about the relationship of film to their work? Do you have any projects with film?

JW: That's not how I saw my video experiment. I'd done a book, *Transparencies*, in which each of the pictures reproduced was accompanied by a detail reproduced at the actual size it appears in the work in question. Later, when I was invited to be in an exhibition, *Passages de l'Image*, which dealt with the interrelation between still and motion pictures, I thought I could make another version of the relation between the picture and the detail from the book. *Eviction Struggle* was shot from a very specific distance: it was the furthest back I could get from the characters and still see the expressions on their faces. That was the threshold of the representation as a whole. So an emphasis on the face was implied already. The invitation stimulated me to make the experiment, which I guess has something to do with a comparative way of seeing an event. I didn't want to break out of the picture in the sense of seeing it as a constraint, because I don't see it that way; I just wanted to actualize something already implied in the nature of that particular picture. It isn't something that I've wanted to take any further, though.

I saw Clark's *Kids*, Salle's *Search and Destroy*, and Barney's *Cremaster 4*, I didn't see Longo's *Johnny Mnemonic*. *Kids* was a real film, a photographer's film, but with true movement. Matthew Barney's film reminded me a lot of Fellini's *Juliet of the Spirits*. I know a lot of artists want to make films, for different reasons, but I'm not one of them. I don't see any necessary connection between photography and cinema, but I do see one between cinema and photography, since films are comprised of a large number of photographs looked at in a certain way. For me, the term "cinematography" refers to motion pictures among other things, not exclusively.

At Home and Elsewhere: A Dialogue in Brussels between Jeff Wall and Jean-François Chevrier

JEAN-FRANÇOIS CHEVRIER: You were born and indeed still live with your family in Vancouver, the major city of the west coast of Canada. At the very beginning of the 1970s you lived in London, and you travel a lot, but you remain very attached to the city in which you were born. For a long time, the settings of your pictures were drawn exclusively from Vancouver. I always wondered whether this was the result of a deliberate choice or a necessity. More recently you've been making images in other cities in Europe and in the United States. You are especially interested in Los Angeles, where you photographed a synagogue.

JEFF WALL: Actually the title of the picture, *8056 Beverly Blvd., Los Angeles, 9 A.M., 24 September 1996*, doesn't specify that it's a synagogue.

J-FC: Yes, maybe some time ago you would have called it *The Synagogue*, but now, you note the place and date of the shot, as you would in a caption to a documentary photograph. Anyway, you don't any longer make your pictures only in Vancouver, and we'll come back to this new diversity in choice of cityscape later. But, first of all, I wanted to ask what the idea of "native city" means to you, something that in your case applies to Vancouver. In French, the expression *ville natale* designates precisely the city where one is born. It's very concrete. The expression doesn't refer to your origin in the abstract but to a real place of birth. In English, the equivalent for this is "birthplace"—a word that doesn't contain the idea of "city." To capture that idea, you have to use another expression, hometown. It seems that this terms shrinks the sense of the city to the scale of domesticity, to the intimacy of the family, and moreover "town" applies to an urban area rather more modest than a "city." Vancouver itself is no town, but a real city. In any case, to what degree do you feel that Vancouver is your "hometown"? I notice you've often photographed members of your family: your wife and father in *Woman and Her Doctor*, dated 1980–81. . . .

JW: Yes, and he was in fact a doctor.

J-FC: You also used one of your sons in a 1981–82 work called *Backpack*, and then, five years later, in 1986, for *The Smoker*. You also photographed your other son in 1987 in

Conducted in Brussels in September 1998. First published in French as Jean-François Chevrier, "At Home and Elsewhere: dialogue à Bruxelles entre Jeff Wall et Jean François Chevrier," in Wall, *Essais et Entretiens 1984–2001* (Paris: Ecole nationale supérieure des Beaux-Arts, 2001), pp. 342–74. First published in English as "A Painter of Modern Life," in *Jeff Wall: Figures and Places—Selected works from 1978–2000*, ed. Rolf Lauter, exh. cat. (Frankfurt: Museum für Moderne Kunst, and Munich: Prestel Verlag, 2001), pp. 168–85.

Jeff Wall. *8056 Beverly Blvd., Los Angeles, 9 A.M., 24 September 1996.* Gelatin silver print, 6' 8⅛" x 8' 4¹⁵⁄₁₆" (203.5 x 256 cm)

The Guitarist. These images are domestic genre scenes or portraits in an interior. I notice that the city, the urban landscape, does not appear in them.

JW: I'll try to answer about the *ville natale.* I've always tried to avoid this idea in some way or other. In English, the term "hometown," or even "birthplace," tends to have a kind of pastoral quality, a kind of idealized sense of "where one comes from." You get that feeling from all those films where the hometown is a happy, harmonious sort of utopia. I'm not very interested in giving my pictures that pastoral feel. I think there are philosophical, aesthetic problems with that kind of affection for one's own birthplace. I've always had the feeling that if you pay great attention to your origins you begin to fall into something that's not good for picture-making—which is think-ing of your place and the people in that place as a kind of "chosen people," special and different from all others. For example, in Vancouver (like in many places) there is a strong regional tradition in all the arts. I've always been uneasy with that and resisted it. Every place can make the claim that it has a special spirit, special quali-ties, and so on, often ad nauseam. I'm not interested in "chosen people." I'm more intrigued by the sense of the common which was made significant by the rise of the everyday, the concept of the everyday that was part of the origin of modern art. With that notion of the everyday came the idea of the unspecial people, the unchosen people. The unchosen is the more profound condition.

So, Vancouver is my hometown, the place I was born in. But I've tried to see it and experience it as if it was not. I've used members of my family in my pictures— mostly in the early days—but I didn't want to photograph them "as themselves," exactly. I wanted to work with them in terms where I could replace that specialness with something else, something that doesn't deny the uniqueness of the person in the picture, but doesn't accept the factual uniqueness of a person as an absolute. I would say I'm trying to reduce the familiarity I have with my own place and people and make it appear to be like other places, other people, and doing so as a statement about what is important in pictorial art.

Jeff Wall. *Steves Farm, Steveston.* 1980. 22'³⁄₁₆" x 7' 5'⁵⁄₁₆" (58 x 228.5 cm)

Jeff Wall. *A Hunting Scene.* 1994. 65¼" x 7' 9³⁄₁₆" (167 x 237 cm)

J-FC: In parallel with these interior scenes that are, as you've just said, generalized—not hemmed in by the feelings you might have for the particular people who appear in the photographs—you've also been working since 1980 on numerous landscapes which often do have something urban about them. From the same year date three panoramic landscapes that also have an autobiographical content—in particular the view of the Jewish cemetery, a subject to which one imagines you aren't indifferent.

JW: I'm trying to escape from the idea that it could have any autobiographical character, as I said. Obviously it's impossible to make a photograph that doesn't have any autobiographical character, since the taking of the photo is part of your biography. I want to avoid, or reduce, this aspect.

J-FC: You've often said that you start out composing your images from things you've seen, and that you choose the composition settings very carefully. I'm thinking especially of *A Sudden Gust of Wind* from 1993, which takes place in a half-rural zone on the outskirts of Vancouver; and *A Hunting Scene* of 1994. In both these cases, as in many others, the landscape is generic: the place was chosen to be representative, for its value as a type. The setting for *Hunting Scene* is a typical suburb. Like your friend Dan Graham, you've always been interested in this kind of place. We'll probably come back to the frequency in your work of the suburban landscape, which is typical not just of Vancouver but of the whole of North America, indeed of every advanced industrial nation even. Could you give us a rough idea of the specific features of

Vancouver—specific as against generic—as they appear in your work? When I say, "specific features," I might just as well have said "places," or "sites," or again "figures." I might even have said, "enigmas." In the end, the specific is perhaps an enigma burrowing away within the generic. And, in *A Hunting Scene*, the enigmatic character of the image derives from its ambiguity. Who are these huntsmen in the suburbs? What can they be hunting? For me, and perhaps for any European, it is strange to see a hunting scene in such a landscape.

JW: As you know, most of my pictures have been made collaborating with performers. During the past twenty years, that has begun to be respected as a way of making photographs. Before the middle of the '70s no one took the idea seriously. I never accepted that, for many reasons. But when we talk about enigma, the enigmatic, I can say that in many ways it derives from the performer. Although I used people I knew in my pictures, particularly at the beginning when I was trying to find my way, I preferred to work with strangers. Once in a while I've worked with professional actors, but mostly I like to work with amateurs. I think that the stranger, someone I don't know—or, to generalize, someone we don't know—is himself or herself a source, a figure, of the enigmatic.

When I'm working on a picture, I rehearse the performers and spend time with them, sometimes a long time. I try not to get to know them very well. With Canadians, this is easy, since we're sort of reserved anyway. Sometimes I barely get to know them at all. One of the aspects of performance that interests me most is that you can collaborate with someone in a fairly intimate way and yet not learn much about them as a person. We remain separate, even though we've created something together. I have my ideas, my plans, my projects, but I do not have a way to take possession of the entirety of the other person in the process of making the picture. I like that very much—the amateur and the stranger are a kind of emblem of all the people we do not know, do not understand, but with whom we nevertheless have some kind of relationship.

That sense of not knowing, not concluding, not making a decision, can extend from the people to the objects as well. In making a picture, you're studying the subject somehow, but you cannot feel you have concluded your studies in the picture, that you know something about the subject. Say the subject is the suburbs—you don't know the subject the way a sociologist, an urbanist, an anthropologist might claim to know it.

The suburbs in any North American city are as familiar a landscape as we can imagine by now, having been scoured by generations of photographers. Most cities are being transformed again now in that the suburban areas are growing independent of the cities to which they were originally attached and becoming new, peripheral cities. But the peripheral cities are often more dynamic than the old centers, so there's a doubt where the periphery is, where the frontier is. This is happening more and more quickly, and the transformation of countryside into city is occurring very

Jeff Wall. *Coastal Motifs.*
1989. 46⅞" x 57⅞" (119 x
147 cm)

Jeff Wall. *The Bridge.* 1980.
23¹³⁄₁₆" x 7' 5¹⁵⁄₁₆" (60.5 x
228.5 cm)

quickly, too. In *A Hunting Scene* I was interested in how people who may have been living in some way for a long time, like these two men, would persist in their habits even during the drastic change in the environment that is happening. Old behaviors flow across a new landscape. Why? Why not?

J-FC: The idea of enigma associated with ambiguity we've just been talking about seems to me equally noticeable in the more purely descriptive, unstaged images—for example, the Vancouver landscape, *Coastal Motifs* (1989). The viewer wonders why you chose this viewpoint. I can see that the landscape is very open, vertically at any rate, with the vast sky above letting one really feel the elevation, accentuated by the bluish effect from the mountains. It forms part of the romantic topos of nature transfigured by distance. At the same time, the "motifs"—the idea of the motif is in the work's title—of an industrial plant bordering a stretch of water are rigorously circumscribed. It's as if the water were sitting in a washbasin at the foot of a second-rate scenic overlook. I have the sense that even with a landscape such as this you have systematically undercut, or rather reduced, the connotation of the sublime that is associated with nature on this grand scale. I say "reduced" in the sense that Mikhail Bakhtin, who has been a touchstone for you, writes of the "reduction" of laughter, that is, the way that laughter, in the wake of the medieval period, was subjected to the rational principles of what we call in French *la pensée classique*—to the constricting logic of Renaissance thought first of all, but then of the classical mentality that followed. The

1980 panoramas, *The Bridge* or *Steves Farm*, are elongated, extruded views that evoke a narrow mindset—a constricted, rigorously confined outlook.

JW: The way I understand Bakhtin is that at some earlier moment, a premodern moment, there were different behaviors from ours, different morals, a different ethos even. His sense is that they were less inhibited than ours are. Under the influence of the processes of modernization and rationalization, new inhibitions on expression, and even on being, arose. What Max Weber talked about in his study of Protestantism must have a lot to do with this. Everything that was once a lot more open has been closed down somewhat, not completely but somewhat, even quite a bit. Everything becomes more regulated, more efficient, more repressed, without ever disappearing. Laughter was once loud and frank and hearty, now it's thin, nervous, and self-conscious. It is "reduced." But we still laugh, and in laughing stir up a memory of what laughter was in Rabelais's time. The concept of reduced laughter is a very suggestive one, it suggests other reductions, too, like your "reduced sublime," which I've never thought about before.

The sublime suggests incomprehensible magnitudes that expose the limits of our ability to know and to imagine. The modern world is built by people who are prepared to work, wait, save, be cautious, plan and calculate, and make fortunes. They do not want to imagine infinite magnitudes, they want to acquire real quantities. So the impulse to rationalize and prosper conflicts with the natural world and the impulses that surge out of it spontaneously. That's a romantic condition that is addressed by the idea of the "reduced sublime," the way I understand it. I like the idea that pictures, in their form and structure as much as in their subjects, could express the tension between both impulses. Both of them are central to what modernity is. It's cliché romanticism to "side" with the sublime as such against the rational and calculated, to be always just the rebel, just the imaginer. One is always both the builder, the writer of laws (and the enforcer of laws), and the one who breaks the laws and yearns toward the infinite. In a landscape we can always see the remains of the primordial earth and at the same time the legitimate use people have made of the environment, the permanent ordinariness we create all around us. Although sometimes I think humans are of no use to nature, I also accept that we are permitted to mine ore, eat animals, and cut trees, by our nature. It might not be legitimate, metaphysically, but it's what we are, actually. Maybe we as a species are not legitimate, metaphysically.

Coastal Motifs shows a segment of the working coastline in Vancouver. Once, during an exhibition in New York, a woman told me the picture exposed the way we were ruining the world. I didn't feel that way about it. I was impressed with the way we had come to terms with the coastline, using it but not obliterating it. I thought the area was very gentle, really. The fact that we turn nature into a workday environment is something we have to do—but it isn't something we are obliged to feel positive about. We're always in the state of being satisfied with what we've done and then

Jeff Wall. *The Thinker.*
1986. 6' 11⅛" x 7' 6¾"
(211 x 229 cm)

Albrecht Dürer. *Bauernsäule*
(Peasant's Column). 1525. From
Dürer's *Unterweysung der
Messung* (*A Course on the Art of
Measurement*, Nuremberg, 1525),
book 3, plate 16

being humiliated by it. The ordinary is a sort of mark scratched on an infinite, curved surface, a mark that lasts.

J-FC: Yes, it's a mark that lasts forever. Reduction is a way of making what had been repressed endure. There's a work from 1986 in which the theme of the stranger, or of strangeness, that you'd already mentioned discussing *A Hunting Scene*, is especially powerful: it's *The Thinker*. I confess that it was this picture that first got me deeply interested in your work. The landscape in the background behind the figure of the thinker is broad and deep. But, leaving aside the details, I noticed that this depth, which stretches back all the way to the towers of downtown Vancouver, resonates with what I would call at the very least an odd, even grotesque reincarnation of the sublime figure of Rodin's metaphysical "Thinker." In many ways, your protagonist is a stranger to the city from which he "stands out" (as we say that a figure "stands out," "shows up against," a background). Does this mean that the landscape of your home-town is strange, foreign, to you, as well as familiar? Obviously I'm thinking of Freud's *Unheimliche* (the "uncanny"), which François Roustang proposed translating into French as "*l'étrange familier*" (the "strange familiar") rather than the accepted trans-lation "*l'inquiétante étrangeté*" ("disquieting strangeness").

Should the large-scale panorama of 1987, *The Old Prison*, be interpreted allegor-ically? Is every representation of a landscape, be it natural or urban, destined to be closed off in the picture, as signified here by the prison? To what ancient, far-off confinement is *The Old Prison* meant to serve as a derisory monument? To judge by two other pictures—*The Pine on the Corner* from 1990 and *Park Drive* from 1994— it anyway seems as if the photographic image can only capture fetishes, remains,

simulacra of nature: the pine, standing alone on the corner of the street, is a remnant (or else the exorcism) of a felled forest, the tree-lined road indicating its absence. As it does so, the image betrays the process of "reduction" with which it unavoidably colludes.

JW: Let me talk about *The Thinker*, briefly, to respond to your construction. My picture was made, as you know, not so much in reference to Rodin, but to Dürer, who made this striking and important proposal for a monument. I didn't know it until 1984 or '85. The column of farm implements on top of which sits this remarkable figure of the "mourning peasant" seemed very modern to me. He's mourning for the fate of his and his class's hopes for emancipation. Their defeat is symbolized by the great sword in his back. It sometimes strikes me that an image from the past becomes spontaneously open and possible again the moment I see it. This happened with the Hokusai print which inspired the *Sudden Gust of Wind*, too. By the way, that's why I don't believe there is "old art" as opposed to "new art"; if I'm experiencing something now, really experiencing it, it is "now" for me, it's new art again, for me. That's an opening in history, an opening in time, brought about just by experience.

What was important for *The Thinker* in the Dürer print was the sense that serious thought emerges somehow from a kind of betrayal, a betrayal that's a revelation, in the sense of *trahir* as you define it. The stab in the back—it's a universal image of treachery anywhere knives are made. Betrayal reveals in a shocking way the real conditions under which we are living, so it has to do with disillusionment and disenchantment. I suppose that with *The Thinker* I wanted to propose an imaginary monument to disenchantment.

I put the figure on a reduced, shrunken version of *Peasants' Column*, a tree stump, a piece of curbstone, and a cinder block. There's the forest which was there to begin with, the roads which are bordered with curbs, and the blocks out of which the buildings are made—I thought that was a reasonable analogy for our time to the column of farm labor implements that Dürer made.

My thinker is not a peasant but an aging worker, not like the "young workers" I'd made some years before. An aging worker who can't work so hard anymore is someone who is going to be feeling pretty valueless and probably be treated as valueless. He's going to be seeing the world and society through what Sartre called "the eyes of the least favored." People like that have a special relation to disillusionment, and I think that relation is important, full of meaning, and most important, full of vast feeling. I think Dürer's project is filled with fascination at the emotional life of the disfavored person; it has an aspect of political protest but it goes toward touching the points where protest emerges from both thought and feeling. The emotional content is complex, unlike ordinary "protest images," and that attracted me.

I guess the figure of the stranger is important to me and to what I'm trying to do. I guess I have always felt a little estranged at home, for all kinds of reasons, per-

sonal reasons, cultural reasons. So, maybe the city behind the thinker plays the part of another city, not "mine," the object of his thought, the picture in his mind. Does he want to burn it down? Does he want to find his own corner, his own "*heimlich*" little spot and settle down contentedly? Probably a bit of both. To me, the city doesn't need to be Vancouver, yet it is. To put it another way, there are two contradictory necessities—one that it is not Vancouver, one that it is.

J-FC: Your first photographic pictures date from the end of the 1970s. We agreed not to talk about your earlier career within the Conceptual trends of the late 1960s, but, if we think back to the very beginning of what we might call your "second" art career—one which can be seen as part of an ongoing pictorial tradition—everything actually began in 1978, the year you first exhibited a photographic "tableau." That was *The Destroyed Room*: a work that was devised with reference to Delacroix's *Death of Sardanapalus*, and which incorporates, I note in passing, a brutal dramatic and stylistic "reduction" of its own. At first glance, the image has nothing whatever to do with the urban environment, except in the form—a light box similar to those used in advertising displays you find in cities (in fact, that's quite a lot already!). As you've often pointed out, you were inspired by the punk aesthetic of store windows. We shouldn't forget, too, that this light-box picture was first shown in the display window of a Vancouver gallery in 1978. Such a presentation situates itself within a commercial tradition that assimilates art object and luxury item, as against the avant-garde gallery's exhibition space conceived of as a hermetic white cube. You positioned yourself somewhere between the fine arts and the media, but also between the history of art and the present-day urban environment, between the realm of objects and the theater of the street. Very soon, as early as 1982, with *Mimic*, this was joined by the legacy of "painted theater," which, from the eighteenth century, has been associated with "bourgeois drama" (as can clearly be seen in an image such as *Woman and Her Doctor*).

JW: I did begin photography again in the '70s, in different terms than I had engaged with it in the '60s. When I started again, I did so in a spirit of contestation with what I thought photography as art had become. I saw "art photography" as being very constricted, aesthetically, by its own discourse. The terms had been set in the '20s and '30s, everything was based on the fine print and the documentary idea. Everyone my age encountered photography more or less this way around 1966. For many reasons this idea seemed profoundly inadequate to what I thought the medium could do. The possibilities of the medium were not interestingly defined by the discourse of photography at that moment. They were suggested more by other things, like the cinema, the popular media, and the history of painting. So at the beginning of my second attempt at photography in the '70s, I tried to work against "art photography" by means of the energy flowing from these other practices. It seemed necessary to work against the

concept of "art photography," and in doing so to bring in pictorial qualities, subject matter, and techniques that were excluded by that concept.

It was then that I began thinking of my work as "cinematography." I was impressed by the photographic quality of the best films—of the work of Sven Nykvist with Bergman, of Nestor Almendros, of Raoul Coutard with Godard, Michael Ballhaus with Fassbinder, and so on. I realized that the work of cinematographers wasn't considered photography, but that's essentially what it was. They made photographs using a somewhat different kind of camera, photographs that were viewed in a different way, but nonetheless photographs. Therefore all the problems of photography are present in cinematography. But in the cinema the acceptance of performance, the acceptance that there can be blending of the documentary aspect of photography with artifice and performance, leads to a breakaway from the limitations of art photography as I had encountered it. The new space that opened up for me seemed related to the kinds of things that painting had accomplished—a fusion of reportage and the imaginary. These similarities seemed very rich, very promising. For me, it was because they seemed to come together to create a new field of possibility that I was led to make experiments like *The Destroyed Room*.

This was also connected to an acceptance of the ways photography was being deployed in the real world, the world of work and consumption. That's why I was sensitive to the possibilities of the illuminated transparency—it was doing something interesting and rich that had not been comprehended as legitimate for serious photography.

J-FC: You've recalled all the elements that come together in your reinvention of the photographic tableau at the end of the 1970s. I would like to emphasize as well the theatrical dimension that is already present in the pictorial tradition that's been an essential reference for you, and which you've reconstituted in a critical mode. Theater is already within painting. It's also in the street, and I think you play on that two-sided theatrical dimension, both pictorial and urban at the same time. A work such as *Mimic* from 1982 is very relevant here. It clearly refers to the movies, and transforms street photography by way of a theatrical logic that harks back to the tradition of "painted theater."

JW: Well, once I understood that there was a means to introduce a form of theater, or artifice, into photography, it also opened the door to understanding that this theatricality was compatible with the "documentary style" of street photography. That led me back to street photography pretty quickly, by 1981 or '82. I was interested to go back out into the street after having worked in the studio quite a bit from 1977 on. To go into the street with a new approach and with some equipment that hadn't been used very much in that way—I mean large-format cameras and lighting equipment. I felt I could do something that resembled street photography, or at least had an interesting relationship with what street photography was attempting. *Mimic* was my

move to try to bring street photography and "cinematography" together. I wanted it to have the look I liked in films like John Huston's *Fat City*, shot by Conrad Hall in 1972, or Ulu Grosbard's *Straight Time*, with cinematography by Owen Roizman, which came out in 1978—a very hard-lit, documentary look. Any number of still street photographs have that, too—Winogrand and the others. But I wanted very fine grain, not the gritty, grainy '70s film look, because I wanted finer detail. If I'd shot *Mimic* on smaller film, which would have been easier technically, it would have had a grainy surface that would have gotten in the way of your ability to see the bodies in space. It was shot on 8 x 10. So there had to be some hybridization of that kind of photography, an adaptation from film projection to looking at a large still picture hanging on the wall.

J-FC: You completed *The Destroyed Room* in 1978. At the same time, a show summarizing the conceptual limits of institutionalized art photography was being held at The Museum of Modern Art, New York. The exhibition was called *Mirrors and Windows*, and it was indeed this alternative between mirror and window, subjectivity and objectivity, that you were trying to displace. . . . At the beginning of this dialogue I invited you to go on a somewhat Freudian stroll, now I'd like to go and look up Karl Marx. For you, who has read Baudelaire partially through Marx, as Walter Benjamin did, the imagery of the "Painter of Modern Life" (which is your declared program) is conditioned by the "fetishism" and "phantasmagoria" of consumer products. I'd like to set that determination next to a remark of Benjamin's that seems to apply to your work: "His renouncing the charm of the faraway marks a crucial moment in Baudelaire's lyric poetry." I'm of the opinion that the lyricism in your work also presupposes having renounced the charm of the faraway. Benjamin's acute comment on Baudelaire chimes in with what we were saying about the Vancouver landscapes. But the echo is still more perceptible, I feel, in the urban scenes, in all those images where the decor is nothing more than a street, where the horizon is bordered by the frontage of some apartment block, a row of houses (*A Hunting Scene*), where the sight lines are rigorously directed, even channeled (*Mimic*), as if the viewer's eye had to submit to the same constraints that have seized the figures caught up in the mechanics of the drama. In 1984, in *Milk*, the closed-off effect exemplifies the predicament of a character "with his back to the wall" (and whose inner anger bursts out in a great spurt of milk). Variants of this approach can be seen in *Trân Dúc Ván* (1988), and in *A Fight on the Sidewalk* (1994). There, the viewer is projected into the scene like a phantasm, represented by the figure of the witness standing in front of a wall covered in graffiti that has been painted over—one could just as well say it has been "repressed" in the psychoanalytical sense. With an image like that, we are back with Freud. The man observing the street fight is projected into the scene in accordance with the dynamics of the phantasm as described by Freud. The path we've been following here

Jeff Wall. *The Crooked Path*. 1991. 46⅞ x 58⁷⁄₁₆"
(119 x 149 cm)

is pretty typical, I think: we started with Freud, then on to Marx, then back to Freud again. Finally I'd like to ask whether, in your view, the "urban condition"—in Henri Lefebvre's sense of that term—inescapably leads to alienation? Your work in the 1980s seemed to be primarily concerned with urban alienation. Today can you see an opening, a way out? Because, now that nature has been reduced to a simulacrum of itself, or so it seems, there's no possibility of escape there—or could there be? You've repeatedly suggested that the answer may lie within the structure of the drama itself—that that's where we might glimpse a possibility or a promise of freedom. It's as if freedom itself had to beat a path through all the constraints and conflicts, but can only do so if they can be seen clearly, in other words can be "played through" and dramatized. I'm thinking now of *The Crooked Path*, from 1991. This tortuous track through a patch of wasteland represents the narrow winding route, marked out by repeated use, which enables the modern city dweller to clear a way through the maze of life, through the labyrinth of urban experience. But according to Benjamin, Baudelaire didn't share that perspective and could only postpone the fatal outcome: "The labyrinth serves as the right path for those who can reach their goal quickly enough. And this goal is the market." In fact, in your image, beyond the scruffy field (at the end of the path?) we are, of course, presented with a suburban commercial environment, as we can make out a supermarket, or rather a warehouse. If a way through is indeed feasible, it can only be glimpsed within the unyielding constrictions that form the logic of consumer economics.

JW: That is a very difficult question! I don't think it's possible to answer directly the point about whether I see a way out of alienation, but I'll try to answer it in some way. Some critic said that *A Fight on the Sidewalk* looks like a picture of a man standing in front of a modern painting looking at a piece of modern sculpture. That responds to the contemplative sense I wanted to create. Baudelaire said something else about the "painting of modern life" that I think is important for photography; he said that

it was necessary for this art to combine an element of the instantaneous, the fleeting, with an element of the eternal, and out of the combination of those two elements would be created what he called "philosophical art." Baudelaire managed to project a possible form of art far into the future. The "painting of modern life" can be painting, photography, cinema, anything; it may be the most open model for art ever formulated. But open in a demanding, structured way.

Baudelaire recognized that, with the rise of the everyday, of the actual lived life of individuals, everything of significance would have to be expressed in terms of that actual moment-to-moment lived experience, and that that experience would be capable of absorbing and reinventing all the previous forms in which significant art had been imagined—religious, mythic, rationalistic, and so on. Everything would be found somewhere "in the street," where the angel's halo had fallen.

I think it is necessary, to a certain extent, to extricate Baudelaire's poetry and aesthetic thought from the dominant interpretation it has gotten from Walter Benjamin, and even more, from the followers of Walter Benjamin. It's important to recognize the presence of a rhetorical tough talk in Benjamin's writings that comes from the situation and attitude of the German left of the 1930s. That aspect is important, but it is limited in appreciating Baudelaire. It overemphasizes the fact that Baudelaire's writing is centered on the fetish, the phantasmagoria of capitalism, and on the phenomenon of the market. I don't think that the idea of the painting of modern life is bound by those considerations, although they are obviously important. It's important to recognize the presence of nature, of contemplation, of the new everyday, of the inner world in Baudelaire—aspects of his model that can't be excluded, even though they are more or less ignored in the typical "militant" Benjaminian interpretation.

J-FC: But Baudelaire hates nature; he made it utterly artificial in his work.

JW: OK, that's true, but it doesn't really mean anything. An important concept of nature exists by virtue of the fundamental idea of the "painting of modern life." Baudelaire expressed more than just his point of view in that essay, in creating that idea, so he created openings that he himself maybe wasn't interested in and didn't follow up on.

I don't want to accept the sense of the totality or finality of alienation, but you're right that the idea or theme of escape is elementally connected with it. You're right that one of the ways we escape from the weight of shame, amnesia, and failure is to observe it in a detached, artificial, artistic way. Seeing it that way can change our relation to it. We change our relation to those afflictions in contemplating them, making them objects of contemplation or dramatization, turning them into pictures. This is a kind of therapeutic aspect in art. No matter what Baudelaire said or how he acted, the painting of modern life contains a sense of this healing quality. Changing the way we see, witness, or experience some disaster or humiliation opens up the possibility

Jeff Wall. *A Fight on the Sidewalk*. 1994. 6' 2⅞" x 9' 11¼" (189 x 303.5 cm)

of new types of behavior, maybe new artistic behaviors, maybe new everyday social behavior. So, in connection with this thought, I should say I'm not interested in escaping from alienation, in an exit from alienation. I'm not interested in exits. I'm more interested in open and closed spaces and the relationship between them. For example, *A Fight on the Sidewalk* (which also derived from something I saw in the street) represented one of those closed spaces, small spaces. The two men have been fighting and have ended up snarled together on the ground, each one locked in the other's grip. For a moment they can't move, and find themselves face to face, very close, very intimate. Suddenly the situation has been transformed, maybe just for a second. This transformation doesn't take these guys out of the fight, it doesn't change anything directly, but it does create a new angle of access, of vision, in which the event can be experienced, by the participants (imaginary as they may be) and us, the viewers, the strangers to the event.

J-FC: Now let's spend some time considering a picture you made in 1986, *The Storyteller*, whose title is a reference to Walter Benjamin's particular notion of storytelling, and which seems to me to recapitulate the dramatization of an urban condition in which, despite the extremely precarious circumstance, positive intimations of communication and interaction nevertheless arise. In this picture you reconstruct the figure of the narrator-storyteller, the narrator being for Benjamin the literary, hence modern, equivalent of the storyteller. A woman, evidently a descendant of Canada's first peoples, is seated on a grassy bank while two other people sit opposite listening, gathered round a fire that's almost gone out, the three of them making a rough circle. Higher up on the bank, and below right, beneath the concrete mass of a highway overpass, three other figures, one on his own, punctuate this "mini-territory" that is conceived like a theatrical backdrop. These three (two plus one) scattered figures form a counterpoint to the group around the narrator. They stand for the breakup of the already open, fragile, circle of listeners; unless, reading it contrariwise, the circle of listeners instead represents the unstable resolution of the dispersion. The solitary figure in the foreground conveys the isolation of an individual excluded from the community, trapped in his derelict state, whereas the forward thrust of the prowlike form of the

overpass embodies the mobility and speed of society's first-class passengers as they cruise by on the highway above. The setting is pregnant with allegorical signification. It shows what urban planners call a "residual space": a space without "amenities," a space which in French we would say survives *en souffrance*, that is, those with the power to transform it suffer its very existence. But this residual space is also a space of refuge, a place for the excluded, for people on the margins of society who suffer because of their situation. As you've stressed in your brief text about the picture, it's a "refuge space" for what is a "residual" culture. And I quote: "The *figura* of the storyteller is an archaism, a social type which has lost its function as a result of the technological transformations of literacy. It has been relegated to the margins of modernity, and survives there as a relic of the imagination, a nostalgic archetype, an anthropological specimen, apparently dead. However, as Walter Benjamin has shown, such ruined figures embody essential elements of historical memory, the memory of values excluded by capitalist progress and seemingly forgotten by everyone. This memory recovers its potential in moments of crisis. The crisis is the present. This recovery parallels the process in which marginalized and oppressed groups reappropriate and relearn their own history. This process is in full swing and its impact is transforming standard criteria of literacy, creating openings for a newer concept of modernist culture, one not so unilaterally futuristic as the one still reigning in Europe and North America." You made these comments back in 1987. What's your position today? Are you still working as explicitly as you were then on the idea of the archaic—distinct from tradition—as a historical storehouse and as a counterculture? Does the trope of the excluded "native," one who has become a stranger in his own land, like the Native Americans of North America, provide you with a counterimage to the consumer-citizen of the modern metropolis?

JW: I think that this figure remains at least different from what you call the "consumer-citizen," if not all the way to a counter-image. To a great extent I must say I still subscribe to what I wrote then—that other modes of cognition and representation, and other modes of being in the world, other ways of doing things—remain indispensable. I think that societies with huge conformist majorities need to work on a dialogue with those people in the minority in one way or another. The minority surely doesn't rule, but it remains significant anyway, maybe because it so obviously doesn't rule. By "dialogue" I don't mean total agreement with every minority viewpoint like we have in North America now. Dialogue itself means the relation of two unlike positions, so it implies disagreement, or at least absence of utter concord. It also means that each of the discordant voices possesses equivalent legitimacy. I had a chance to study *The Storyteller* a bit last year because I saw it in a traveling exhibition. One thing struck me more strongly than it had before. When I made the picture I thought what was important was to express the apparent significance of what the storyteller had to say. The two guys sitting near her are taking her seriously, or seem

to be. But the couple further away, up the hill, have what seems to be a very different response. Now, I know I wanted this response to be there, this sense of skepticism and detachment, because I rehearsed it with the performers, and positioned it in the composition like that. Nevertheless, I have to say that the performers give you things you don't know to ask for, or don't know you are asking for. The interesting thing about the "cinematographic model" is what happens during the process of performance, which is at the same time the process of the picture-making. As I said, I often have it so that I do not know the performers too well, personally. I try to communicate some things about what I want to do with them, but some things I don't concern myself with communicating. Sometimes it's good to be improperly understood, it creates some openings. So performers don't, can't, know exactly what you want. Still, you get things, things you don't know you want, things they don't know you want, things they don't know they are going to do. But they happen somehow, and subsist inside the structure of the image. With the woman in the couple, I was immediately attracted by her Mona Lisa–like smile, this enigmatic, detached expression on her face. I must say I didn't even think very much about why, not for a long time. But gradually I realized that the couple must not really be very convinced about what the storyteller is saying. That is, I always realized that, but I never really paid attention to it. Later, I recognized more clearly that their somewhat skeptical attitude meant that, although the storyteller is saying something important, or at least serious, the picture as a whole was leaving open the possibility that her story could be ungrounded, incredible, untrue. The storyteller might be mistaken, or failing, or confused, or disingenuous. That is, the picture says to me that it is also necessary to be skeptical of storytelling and not necessarily accept the storyteller's word as a word telling a truth. That's not to say it must not be a truth; but it means it is not necessarily. In 1986, I thought it was important to emphasize the serious nature of the story being articulated, and to express that in terms of the attitudes both of the speaker and of the listeners. But I see more clearly now that there is a countercurrent to that, and that it was built into the picture's structure instinctively. I deliberately asked this guy to wear the red jacket, because, you know, it's often nice to have a little point of red in a composition, it draws the eye to a sort of salient point. But the salient point is this figure with a dubious, doubting expression on his face.

So my own view of the picture is changing, maybe because I'm changing, and my relationship to the critical discourses of the '70s and '80s is changing in some way. But I don't think the picture itself is changing. At the time, I thought the dissident view was mostly expressed by the figure at the far right, who is sitting alone. He's excluded himself or has somehow been excluded. I wanted to express the idea that every group should be judged by the way it treats those it excludes or those who choose not to be included. Exclusion is a right. In our society we have the right to withdraw from almost any institutional structure, to not participate. That is our right,

Jeff Wall. *Citizen*. 1996. Gelatin silver print, 71¼" x 7' 8⅛" (181 x 234 cm).

just as it is our right to be ignorant, antisocial, uneducated, and prejudiced. We can do those stupid things freely because, as citizens, we are not the property of the state or of any group or tribe.

J-FC: Exactly. One of the big black-and-white pictures that you showed at the last Documenta was called *Citizen*. The modern citizen is this: a young man stretched out on a lawn, alone, motionless, clearly relaxed and confident. I personally find it difficult not to see this image as ironic. To my mind, the citizen is an active entity, or at least a person who speaks, following the definition given by Hannah Arendt, a definition moreover that seems to fit well with your work, as you attach such importance to the representation of speech in the image. Why this touch of irony amid the group of figures you presented at the Documenta? Is the citizen a person who is so much at ease that he can fall asleep on the grass, as if he were in his own home? Isn't this vision of the citizen a bit loose?

JW: But you know, it may also be true that only citizens can really relax. Because if you don't have the rights guaranteed by a constitution of some kind, it may not be possible to relax, especially in a public place.

I think it's important—and I can't really explain this—but for me, when people are sitting or lying on the ground, that seems to be an important moment, an important gesture. I don't know what it is. Furniture is maybe a sort of insulation against a certain way of being in the world. When one sits on furniture, one is institutionalized in some way. In *The Storyteller* they are sitting on the ground, and the citizen is lying on the grass.

Arendt and others say that the citizen is the one who is active, who participates, who speaks, who learns, who teaches, and helps to write constitutions. A busy person, a very busy person! But if you have these rights you have them from birth, if you are born into a constitutional, democratic society. You don't have to do anything to acquire them, and you don't have to be any particular sort of a person, either. If you have therefore inherited those rights, from others who have worked so hard to give them

to you, to us, I suppose we have a responsibility to maintain that work, to contribute to the democratic inheritance. But since we already have the rights, we do not actually have to contribute to the democratic inheritance in the way the classical theorists of democracy supposed—just because we already have them! So those who are inactive also have rights, among which is the right to be inactive. This is also another way of saying that those with rights are nobody's property, and so don't have to do everything expected of them, they are not society's property, they are not the state's property. The great thing about these rights is that they apply to everyone, anyone and everyone, including completely undeserving people. That is a very great, very calming, very pacifying thing. The citizen has a responsibility to be active and work at citizenship only if he or she recognizes that responsibility, that opportunity. If they don't, they are still citizens, exercising their rights as citizens in a different way, maybe an inferior way. Anyway, I think it is very beautiful and gentle to be able to sleep in the public park without fear. Sleeping in public without fear of your fellow citizens is a gesture about those fellows, and your relationship with them.

I went to Los Angeles to make a picture of a man sleeping in a park. I didn't exactly know why. And at the beginning the picture was not of a "citizen." But at a certain moment in the process of making the picture, I had the feeling that it was a picture of a citizen. I spent about two weeks shooting the picture, and had to spend pretty much the whole day, from about 8:30 in the morning to around 4:00 in the afternoon, in the park. So I could study what actually happens in a city park during the day. Parks really are what they were originally planned to be—open spaces available for the use and enjoyment of members of society, citizens, refugees, applicants for citizenship, visitors, and undiscovered illegal aliens. People often stop in the park for a quiet rest on the grass, a cigarette, a conversation, a nap. My pictures, especially my "realistic" ones, or my "neorealist" ones, all derive from these actual experiences, and from watching and observing, while daydreaming and thinking. Slowly, while working, I understood something about what I was doing, and why the picture wasn't titled in a spirit of irony.

I just want to draw your attention to the background, where there is another figure sitting at a picnic table, far off, out of focus. You can just make out that this person is reading something. Let's put it this way: one person is studying the constitution, the other is snoozing away, enjoying the benefits of the probity and alertness of the first.

J-FC: In ten years' time, when you look at the picture again, perhaps you'll pick up on the irony you can't see today! You'll read it differently, just like you did with *The Storyteller*.

JW: Maybe that will depend on how high my taxes are then!

J-FC: In any case, your images do show violent situations, actual or latent. From *Mimic* on, as I've noted, you've been portraying the public spaces of the multicultural

Jeff Wall. *Outburst.* 1989.
7' 6⅟₁₆" x 11' 6¾" (229 x
352.5 cm)

cities of North America as territories for communities that remain alien, even hostile to one another. Only the notion of work in *Young Workers* of 1978 and of childhood in the series of eight tondi (*Little Children*, 1988) seem to be able to bridge the ethnocultural divide. But in both cases the faces shown are free of any context, on a neutral backdrop or against the background of the sky, and so quite removed from the urban situation.

JW: I don't think my pictures show people who are always hostile. Some are, some aren't. The guys in *Mimic* are, the women in *Diatribe* aren't, the two men in *Passerby* aren't, and so on, and if they are antagonistic, it's not usually because of ethnic differences.

But, in any case, American societies, that is, Canada and the United States, are almost by definition multicultural, multiethnic societies, that is immigrant/aboriginal societies. To me, that's normal. I find it weird to go to monocultural places, not that there are too many of them left. I find it normal that in constitutional, democratic states, people of different backgrounds come together, coexist, and even become close to each other, to be friends, get married and have children of mixed race—like the majority of Americans now. At the same time, it is normal under the same constitution to live together and have aversion to each other, not to want to mix together, to dislike each other and to fight. Multiculti society is no utopia, and it is not free of all ethnic antagonisms. But the framework for the antagonisms is different. The antagonisms are legitimated, even respected, within the context of universal citizenship. As I said, the citizen has the right to be prejudiced and have bad attitudes. But America is about the process of living together with others and with our bad attitudes toward those others, and their maybe equally bad attitudes toward us, and to some other others as well. America experimented with this early and to an extent still pretty much untried elsewhere, so American people have the experience of relating to many different kinds of people. I find that continually fresh and unpredictable, and I like living in America, Canada, for that reason, that open social feeling. The rhetorical multiculti propaganda is way less interesting than the creole of bad and not-bad

attitudes reflecting off each other in actual American-type life. I'm interested in these ideas, but I don't choose between good and bad attitudes. Both are good for making pictures, which is my first and almost only interest.

My picture *Outburst* says something about all this. It was made in 1989 and shows an ordinary sportswear clothing factory where everyone is Asian. And the Chinese boss or foreman, or whatever he is, is in the process of getting very angry at one of the ladies working there, for some reason. Well, for many reasons I wanted to make a picture about work, like factory work. It's a fact that in Vancouver, but also in a lot of other places, the majority of the people are Asian. Here, the Asians are not getting along too well, at least not these two. To me, it shows that there are conflicts which are very probably not ethnic conflicts, and they take place in a multiethnic society as a matter of routine. The bad attitudes aren't clearly marked by ethnicity, gender, class, and so on, they slide through all those things, creating complex situations—normal, complicated, messed-up situations.

Some people, and some critics, shook their fingers at me for making such an unsmiling picture of people of another race. And in Vancouver, where the picture has been in a public collection for ten years, nobody has ever said a word about it, at least not one I've ever heard or heard about. That's probably because art or the art world deals mostly with rhetorical multiculturalist ideas, not with the actuality of the way different people relate or fail to relate to each other. That kind of phony cultural piety is a big part of the actual social construct of bad attitudes in America-Canada. I like to think that my pictures are free of that rhetoric. One of the ways they are is that I accept the existence of bad attitudes, including my own, and I think attitude is shown, is disclosed, in pictures, in photographs. Gesture is a form of disclosure.

J-FC: To finish, I'd like you to look at connections between your recent black-and-white pieces and the motif of the house, and more particularly of the "haunted house." One might even say, the haunting image of the house. Firstly, I observe that your shift to black-and-white accentuates the enigmatic character of your images. It's as if, putting aside speculative considerations, putting aside allegorical considerations, you're exploiting both the "uncanny" and the archaic documentary tradition associated with black and white. One of the images that you exhibited at Documenta, *Housekeeping*, seems to my eyes to make the image of the haunted house relevant in an astonishing way. In fact it is not a house, but nothing more than a standard-issue hotel room, and the living dead, or the specter, is nothing but a cleaning woman viewed from the rear as she leaves the room. Presented like a snapshot, the moment shown is when the bedroom, newly spick-and-span, is about to be frozen into an image of vacant space, an empty, lifeless interior. All traces of its having been lived in, been used, have been carefully rubbed out, effaced. After the maid closes the door, only a nameless, neutral decor will remain behind. I think this elimination of all potential drama offers a contrast with *The Destroyed Room* of twenty years earlier.

Jeff Wall. *Housekeeping.*
1996. 6' 3⅜" x 8' 5⅜" (192 x
258 cm)

JW: Yes, you could say it took twenty years to clean up.

J-FC: *Housekeeping* represents the degree zero of drama; the drama in *The Destroyed Room* has all been smothered. It suggests to me the "neutral" or "blank" writing style that Roland Barthes detected in Camus's *Outsider*: "A style of absence that is almost an absence of style." You were surely experiencing this extreme reduction of a familiar world contaminated by strangeness. But we also encountered the motif of the haunted house that Freud characterized as the tipping point where the *Unheimliche* becomes horror. You went on following this tack unhesitatingly, right up to the great grotesque composition of 1991, *The Vampires' Picnic*. You described the characters in this phantasmagoria as "suburban vampires," that is to say, as "vulgar" vampires, vulgar in the sense that Latin gave way to the "vulgate" of modern tongues. Now, you'd already introduced the motif of the modern suburban vampire into your comments on Dan Graham's speculation on the suburban residence, in particular on *Alteration to a Suburban House*—a work that also dates, by the way, from 1978, like *The Destroyed Room*. In your essay, you developed the idea of altering the suburban dwelling until it partakes of the fantastic. Toward the end, you reinterpreted Philip Johnson's Glass House, which had also served as a model for Dan Graham, as the dwelling of a vampire—a bit of a contradiction in terms as a vampire is neither living nor dead and so doesn't need to "dwell" anywhere. My feeling is that, after reconfiguring Philip Johnson's house into *Vampires' Picnic*, all your images showing domestic interiors have been shot through with the fantastic.

JW: Just to begin with, I'd like to say that I wanted *Housekeeping*, and some of the other black-and-white pictures I've made recently, to resemble snapshots. Part of my interest in taking up black-and-white photography was, as you say, to rethink my relation to the documentary tradition. Or, maybe more precisely, to the assumption that uncolored photographs signify something we call "documentary."

It would be interesting to exhibit *Housekeeping* along with *The Vampires' Picnic*. The thematic, literary connections you're making draw attention to something else:

the fact that what I have called "cinematography" opens the possibility of these two apparently very different approaches to be seen as the result of a single way of working, as having an inner relationship with each other, as photographs.

The joke about cleaning up *The Destroyed Room* points to literary connections between works which are stylistically or generically very different from each other, and I'm aware of those to some extent. I agree that apparently actual, everyday figures, like the hotel maid, might also have a sort of spectral other identity. Baudelaire also suggested that we experience the presence of mythical figures from all times each day in the street, in the modern city. Remnants of them appear as fellow citizens. This is more obvious with the more dramatic characters, like the prostitute or the ragpicker, but he would also claim that in everyone's unconscious there are present traces which can be connected with phantom, symbolic images and figures from all times, cultures, and myths. That shows up in ordinary language, say, when you call someone a "devil" or a "martyr." This process of identification, and maybe mistaken identity, which we're always involved with, is central to the literary or thematic aspect of pictorial art. Through these phantom identifications, we react to our experience of other people, other beings, and this is always present when we're witnessing occurrences, things apparently happening right in front of our eyes. I'd claim they're also happening elsewhere at the same time, maybe behind the eyes. So I can't draw a sharp distinction between the prosaic and the spectral, between the factual and the fantastic, and by extension between the documentary and the imaginary. "Cinematography" is my way of working on this.

J-FC: Everything you've said about how near the spectral is to the literal, and how one is always toppling over into the other, corresponds exactly to the logic of the fantastic as an intrusion into reality. The fantastic disrupts the everyday world. Roger Caillois put it well: the fantastic is not a creation of another world, a world other, as is the case with the marvelous—it is the world as it exists itself breaking down, "the irruption of the untoward in the banal," as he wrote in his *Anthology of the Fantastic*. In your pictures, the urban space seems to be edging ever closer to a hallucinatory kind of domestic space, of which *Insomnia* (1994) is the most extreme example. The *Cyclist* (1996), too, echoes *Odradek* (1994). The male figure slumps over the handlebars, his bike propped against a solid gray concrete wall. The situation, like the decor, provides no way out, it's blocked. Last March, at the end of an interview with the architect Charles Vandenhove, with whom you've been collaborating recently, we mentioned La Maison Heureuse, a charity institution in Liège. I was wondering, and I'd like to ask you, what exactly a "happy house" is to your mind?

JW: As I said before, I think that the idea of the painting of modern life has a therapeutic aspect. I know that a lot of people think, as you do sometimes, that I show miserable spaces occupied by alienated people. That's partly true. But I don't like to

Jeff Wall. *Odradek, Táboritská 8, Prague, 18 July 1994.* 1994.
7' 6⅜" x 9' 5¾" (229 x 289 cm)

Jeff Wall. *Insomnia,* 1994.
7' 6⅜" x 9' 5¾" (229 x 289 cm)

separate the spectral from the prosaic, alienation from its alternatives. Odradek is a being invented by Kafka, in one of his most remarkable stories, about a little wooden object that is somehow alive, also a creature, and who lurks around the staircase of an apartment house. In 1994 I went to Prague to hunt for Odradek. I was fortunate to be able to get a shot of him in an old building there. Odradek provides a kind of therapy in being able to have some reflective effect on our afflictions and troubles. The *Cyclist* is resting; he's gaining strength, however little it may be, to move on.

J-FC: I think it's rather difficult to present *Insomnia* as an image of rest. The house isn't a refuge offering protection from urban (i.e., social) violence anymore when it becomes a haunted place, a place of sleeplessness. When I look at *Insomnia*, a phrase of the poet Pierre Reverdy comes to mind: "If once you've opened your eyes, it's hard to sleep soundly again"—and Maurice Blanchot's definition of insomnia in Lautréamont's *Les Chants de Maldoror*: "The hallucinatory heaviness of a sleepless night."

JW: The state of wakefulness, even of sleeplessness, isn't necessarily negative, or violent. Think of the language of the Enlightenment. Benjamin worked with the trope of awakening in an extremely positive, emancipatory way.

J-FC: Yes, but in the fantastic, the inverse is true: hyperlucidity becomes hallucination, insomnia, horror, and the surfacing of hallucinatory and alienating dreams.

JW: The man in *Insomnia* is at home, and he has a home. He is comfortable enough in the house to wind up on the kitchen floor, and maybe he'll fall asleep there.

J-FC: Now you've convinced me that it really is ambiguous.

JW: But I think we should remember, too, that the beauty of an image derives in part from the fact that we never know exactly what we are feeling when we look at it. In phenomenological terms, the modern sense of beauty is characterized by energy, mobility, an energy we cannot avoid experiencing. What I mean is that the experience of beauty is unstable, or an experience of instability; so ambiguity is part of the structure of that experience, and part of the structure of an image.

J-FC: I now recall that the fantastic dimension appeared in *Ventriloquist,* an image of a "happy house," but with the added fantastical touch—the wooden figurine that prefigures *Odradek.*

JW: This idea of the "happy house," or "happy home," is just one of the possible chimeras in the normal polyphony. It pleases us by being able to be a little *unheimlich,* a little frightening. That pleasure marks both the ventriloquist herself, and the kids watching the show.

I'd like to say something about your idea of a therapeutic, positive, interior space, in relation to the picture *Volunteer.* That picture shows a young man working late at night in what we call a drop-in center. Those places are established sometimes by a church, sometimes by civic organizations, sometimes just by philanthropists, to provide a place where people with nowhere else to go can come and find some shelter, get information or maybe advice, can maybe get something to eat or drink, or simply to find a little company and get away from the dangers of the streets. Often, the places are run by unpaid volunteers. Volunteer work has something enigmatic about it, in relation to a world dominated by the principle of exchange and paid employment. This man cleaning up after others, strangers, is for me maybe the most explicit image of the "happy house" that I could make. I know that these places are maybe far from happy, but they are what is actually possible, under the circumstances.

John Huston made a beautiful film, *Fat City,* at the beginning of the '70s. At the end of it, an aging, washed-up boxer sits at the counter of a bleak cafeteria late at night, talking to a younger friend, also a fighter. An old man brings them their coffee; he's really old, and moves very slowly, almost painfully. The two guys watch him go back away from them, back into the kitchen. The old boxer says, "Look at him. How'd you like to be him?" The younger one, who still has some hope left, says, "Maybe he's happy." The older one replies, "Maybe we're all happy." That kind of metaphysics should be set alongside whatever you might mean by the idea of the "happy house."

John Huston. *Fat City*. 1972.
Still from a color film, 100 min.

J-FC: Listening to you, I've been reminded that the mere possibility of being in a house is already highly significant to you. The "happiness" a house brings derives first and foremost from the fact that it's accessible. The counterproof is given in *Door-pusher*, or *Eviction Struggle*. In *Eviction Struggle*, a protagonist wants to get in but something keeps him out. It's clear just how precarious, just how threatening the uncanny is within our "urban condition," encapsulated by the simple possibility of being thrown out of one's house and home.

JW: Yes, to be deprived of being indoors is a fundamental condition of being exposed without protection. But at the same time, as I tried to say in regard to *Citizen*, there are other ways to imagine that condition, that being out-of-doors.

J-FC: But lying down outside is to behave as though "outside" were a place to live. The vault of heaven becomes the roof of the house.

JW: Well, there's something utopian about the "luncheon on the grass."

J-FC: Needless to say. . . . I'd like us to end with a really beautiful image that you made recently. It was not shot in Vancouver. In fact, the landscape is that of Istanbul, and there's a crooked path. The picture shows an emigrant, alone, before a vast stretch of the industrial zone on the outskirts of the city. It's an image of migration, of a person searching for a new house. This is an image of the stranger—or of strangeness—trying to find a place in a city, in an urban space.

JW: All over the world now, rural areas are being depopulated under the pressure of economic developments; people are being forced into cities, which begin to resemble vast villages rather than glittering cosmopolitan constructs. People who study the global economy are talking about the megalopolis of the future, which will be different from the great cities of the nineteenth and twentieth centuries. It is maybe not what Balzac and Stendhal described: the new arrival comes to the capital and, through a process of disillusionment, becomes cosmopolitan. Istanbul has been called a "giant Anatolian village," and there are many other mega-villages now around the

Jeff Wall. *A Villager from
Aricaköyü arriving in
Mahmutbey-Istanbul,
September, 1997.* 1997. 15¼ x
18⅞" (39 x 48 cm)

world. They're a new combination of the old urban experience with the new instant
postmodern village. Cairo, Buenos Aires, Seoul—I could probably have made *A
Villager* in any of those places, too, I find that fascinating. Even if emigrants tend to
arrive in groups and gather alongside their families or people from their home vil-
lage, I wanted to emphasize the experience of one person, one young person, arriving
in a new place, so I set him by himself, coming in along the road.

One morning, while I was working on another picture in a neighborhood in
Tijuana, Mexico, I saw a lot of little schoolkids, each one perfectly dressed in immac-
ulately clean clothes, with their school bags all in order, emerging from houses built
by hand by their parents from extremely poor materials. They headed off along a dirt
road toward the school, which was built in the same way. They lived in a kind of
poverty, but they expressed something other than their poverty, something much
more interesting to me. Those who work and struggle, and save money, and who plan
to make a success of things in these situations, have a very complex and significant
experience of city and country. In a way, they are the new Protestants. In *A Villager*,
I didn't want to show the arrival of a defiant, angry, suspicious, and anxious young
man. Though there are, of course, any number of those.

J-FC: You've shown this arrival in a way that is once again very ambivalent, because
we could just as well imagine that the person is about to leave. But the title tells us
he's arriving. We'll end then on that one last note of ambiguity—enough to remind
us that strangeness is consistent with an instability of interpretation.

Boris Groys in Conversation with Jeff Wall

BORIS GROYS: I first saw your black-and-white photographs at the last Documenta in Kassel. You'd mounted a small light box in the same room. It was as if you were quoting yourself in order to draw attention to the change of direction in your work. What are the reasons for this change?

JEFF WALL: There are two or three reasons for it, I guess. When I began working in color more than twenty years ago, I was afraid it might lead to monochrome being excluded entirely. This thought was constantly at the back of my mind. As I see it, photography has so many possibilities, and there's no reason why any one of them should be more central than any other. So, while I worked exclusively in color for a pretty long time, I knew all along that in order to stay involved with photography as I understood it, I'd have to resolve this exclusion.

Another aspect was that monochrome photography has always struck me as being about luminosity, in much the same way that my transparencies are. Monochrome photographs seem to contain this intense luminosity, perhaps because everything depends on grays and tonal gradations. It's as if pure light were present in them, and that seems to have to do with the absence of color. The third point was that in some way or other, there's this idea that monochrome photography belongs to the past, to the history of photography. I both agree and disagree with that, because while monochrome photography does indeed point to a time before color photography was perfected, it nevertheless still exists today, and it continues to develop. So monochrome photographs can have just as much to do with the present as with the past. Photographers of my generation began by fighting against what photography had become as a medium or art form, against how photography saw itself, and for years photographic work consisted chiefly in responses to the question of how to dissociate oneself from orthodox attitudes that had come to be equated with the aesthetics of photography. This process of dissociation, in my opinion, led to many significant innovations and to a general broadening of the discourse—altogether, it had a very positive effect, on both the form and handling of the medium. But after a while, I began to see more and more clearly that the struggle against received attitudes was taking place on photography's home ground, as it were, and that photographers could instead consider themselves as artists in other significant ways. I began to be able to see myself as a photographer in ways that ten or fifteen years earlier had not really interested me.

Conducted by correspondence in 1998. First published in German as "Die Photographie und die Strategien der Avantgarde: Jeff Wall in Gespräch mit Boris Groys," in *Paradex* (Cologne), November 1998, pp. 4–8. Reprinted here is the revised English version published as "Boris Groys in Conversation with Jeff Wall," in Thierry de Duve, Arielle Pelenc, Boris Groys, and Jean-François Chevrier, *Jeff Wall* (2nd rev. ed., London: Phaidon Press, 2002), pp. 148–57.

All these things played a role in my decision to expand my work to include monochrome photography, without my intending to replace anything by it. Of course, I still work in color.

BG: Your color work employs transparencies and light boxes, your monochrome work, paper. At the exhibition, I had the feeling that you somehow managed to introduce luminosity into the monochrome picture itself. However, at the same time I had the impression—maybe you see it differently—that there is always some kind of tension between picture and narrative content, and that in your color work the light box "relativizes" the narrative content. To use a word from Buddhism, it is as if the color works showed everything as maya, an illusion, whereas the monochrome works are more interested in narrative content. The light box functions almost as quotation marks, signaling to the viewer that this is an illusion, an appearance, a quotation—a quality that is not present in the monochrome works. Do you see your monochrome works as turning more to narrative content?

JW: No. But I agree that the illuminated transparencies can be seen as creating a kind of alienation effect.

BG: I wouldn't say alienation so much as *epoché*. The picture is an appearance. What takes place is not alienation but a sort of philosophical *epoché*—a kind of neutralizing of the picture.

JW: Well, I think the two are related. An alienation effect can also open up a rift between the documentary aspect of photography and its more pictorial aspect, and narrative occurs in that rift, in that space. I don't think transparency and light box are in any sense privileged in this respect, as opposed to opacity and paper. I believe that it is the pictorial result, the individual photograph, which is the appearance you spoke of, and not this or that surface or technical aspect of photography. The picture itself has the character of an appearance, and to the extent that its narrative or factual content becomes pictorial, it will tend to take on the status of an appearance. So it doesn't matter if it is opaque and monochrome, as long as it has that status, which is the important thing.

BG: At a purely formal level, the light box functioned for the viewer as a reference to avant-garde traditions—emptiness, pure light, zero point. All these things seemed to indicate that what one was dealing with here was pure appearance, and not a picture claiming to depict reality. Is it that you consider it no longer necessary—for the viewer, for yourself—to mark such differences?

JW: What you say is interesting. But I think I *do* still need that. I believe that the nature of our struggle with photography is changing, at least for me, and maybe for others as well. As already mentioned, for a long time the chief struggle in photography was

against photography's documentary, factual claim. Now, while I don't reject the legitimacy of that claim, I nevertheless don't believe it alone gives a sufficient definition of photography and what photography can be. It seemed to me that the only way to work through this was to make photographs that somehow suspended the factual claim while simultaneously continuing to create certain illusions of factuality. One of the ways I tried doing this was by a kind of mimesis, or simultaneous imitation of other art forms, painting and film in particular, each of which had a history of querying and subverting documentary claims. What I began to realize only later was that photography itself provided the basis for this mimesis. I was able then slowly to turn my attention to photography itself as a self-sufficient participant in the mimetic game. It seems possible now to develop a photographic mimesis of photography.

BG: I see. Perhaps we could talk about photography's changing position. As I see it, there have been marked changes in recent years. In particular, much large-format photography seems to have taken on the role of nineteenth-century painting, because contemporary painting is no longer in a position to do what nineteenth-century painting did, namely, to make statements about the world. All the self-reflexive and self-destructive avant-garde movements have resulted in painting being obsessed with its own "thingness," materiality, and structures, to the extent that it can no longer depict the world. So now what we see in exhibitions, for instance at the last Art Fair in Berlin, are huge paintinglike photographs. As pictures, they say something about the world, and, interestingly enough, critics have started talking again about intentions, narrative content, sociocritical aspects and, of course, about the artist's position in society. What worries me is that the avant-garde aspects are being forgotten. We are beginning to forget that every picture is a quotation, an appearance, a suspension of factuality. It seems there's a tendency to greet these large-format photographs with relief, because they offer a chance to escape from avant-garde ideas or from what is experienced as a dictatorship of the avant-garde. The art-viewing public is beginning to respond to these pictures as if they were nineteenth-century paintings. The entire history of pictorial criticism is being lost sight of. Do you see it this way, too? Is there a danger for you of an uncritical reception of art coming back—picture without suspension, without *epoché*?

JW: I don't know if I would call it a danger. It's certainly true that the so-called avant-garde erected barriers to a more spontaneous—what you refer to as uncritical—reception of pictures, or tried to. Yet I don't really believe that previous audiences had such a direct and spontaneous relationship to pictures, or that people really thought pictures were a direct representation of reality or the world. They experienced pictures as appearances as well. So I don't see such a rigid historical break between pre-avant-garde modern art and avant-garde art itself, although of course there is a break. No, the idea of an avant-garde, while growing older and developing, is losing none of

its strength. On the contrary, it is becoming more complex and more interesting. I think previous discussions of the avant-garde overvalued the epistemological break, because that was how two or three generations saw it and how they defined themselves historically. As I say, it is not that there was no break, only that many of the elements we associate directly with the avant-garde and its critique of art were already to be found in earlier art—both in its production and its reception. Perhaps they were not directly articulated, partly because the requisite institutions—press, critics, and so on—were not in existence, and yet these elements were nevertheless there. So the belief, for instance, that previous viewers could not see paintings as appearances is demonstrably false. One need look no further than Mannerism for an example of an extremely intellectual current containing all these elements in a highly sophisticated form, perhaps even more highly developed than today.

Conversely, the avant-garde never unequivocally renounced all thought and hope of being able to say something about the world beyond the work of art. Self-reflexive tendencies went hand in hand with projects concerned with nature, society, and so on. What I object to is the polarizing assumption that by accepting the representational status of pictures, one automatically excludes investigation into the nature of pictures in favor of some kind of restoration. There never was, in my view, any overriding disempowerment, and to that extent there can be no restoration, either. An acceptance of the representational nature of pictures has always accompanied experimentation as well as destruction, and is itself part of the destruction.

BG: So do you believe that your photographs are able to make factually true statements about the world? For one might summarize the avant-garde epistemological break in this form: "Make your picture, but any claim it makes to utter truths about the world outside of itself is an illusion." It is at precisely this point that avant-garde and nineteenth-century realism part company.

JW: I think there are different ways of saying something about the world. I have illustrated the point with reference to the relation between prose and poetry. On the one hand, there is prose, by which we understand a kind of institutionalized writing, in which certain regulators see to it that something is being spoken about. In journalism, for instance—the most important type of prose in the eyes of the avant-garde—we find institutionalized elements that vouch for the relationship between a particular text and the events it describes. Such a text raises a form of controlled truth-claim, and on the whole we tend to accept it, even if in democratic states details are invariably hotly debated. In this sense, we accept that journalism, in contrast to art, really does say something about the world outside the text.

Then there is something we call poetry, which doesn't make the same sort of truth-claims as journalism, yet it does claim to express or articulate something—about nature, say, or about emotions, time, an event, and so on. The truth-claim that

poetry makes isn't easy to define, yet generally speaking we accept it. Most artists—at least most good ones—would probably concede that at some point or other their work raises a poetic kind of claim to relate to something outside itself. I am content to stake such a claim.

This enables us to bridge the gap between the nineteenth and the twentieth century. For serious art in the nineteenth century also raised precisely the sort of claim we have been talking about. But at the same time, unless I am mistaken, artists have been raising similar claims ever since art began. One misunderstands nineteenth-century realism seriously—those parts of it at least that, as in Manet, Cézanne, or Seurat, also happen to be good art—if one believes they raise the same sort of truth-claim as prose. I think it's pretty clear that these works are firmly rooted in a tradition that fully recognizes the quality of pictures as appearances, which the avant-garde adopted and made its own by stressing it—and which, incidentally, emerged at least partly out of the movement toward abstract and constructivist art.

BG: Yet the artists you mention all belong to early modernism, and their art is a direct precursor of the avant-garde. By introducing new and unusual forms, the artists of the avant-garde made it impossible for the viewer to respond to their works in the usual ways. They drew a sharp demarcation line between themselves and their cultural context. Of course, what we are witnessing here is an aggressive strategy that forces the viewer to respond to the work of art in a particular way. This aggressiveness displeases many artists of our generation—nor do they wish to be classified according to purely formal criteria. I can understand this, and yet I have to confess I have a certain residual yearning for those clear exclusions. There is a certain danger that the postmodern striving for openness and for inclusiveness may turn into a commercial strategy of trying to please every conceivable public. And I wonder how an artist today can dissociate himself from his cultural context if he no longer does this at the level of form.

JW: I think it's normal for any artist trying to produce good art, and therefore trying to situate himself in a lengthy tradition of good art, to dissociate himself from his "context." "Context" is usually the term applied to the bulk of mediocre productions by those who are more interested in this sphere than they are in better artworks. And this interest today goes by the name of "cultural criticism." Naturally, any good work of art rises in some sense out of its milieu—which is characterized by less good works, by the average cultural production prevailing—and many people have concluded that somehow a direct and immediate connection must obtain between the milieu and the good, important work of art. They overlook the conflict, the process of dissociation that necessarily takes place between the good work and the milieu it arises in. A good work of art is not just the product of its context; it is something the context does not require, something that may not even be welcomed by it. But yes, as you say, every

distinction must be achieved at the level of artistic form—there is no other effective way of drawing the demarcation line.

BG: Your introduction of the notion of mediocrity makes it sound as if we were viewing everything under the aspect of "quality." Of course, quality is important. But the fact that what you refer to as the mediocre demands, in a certain sense, to be taken seriously is an insight we owe to the avant-garde, no less than the insight that we should be clear about the distinction between thought and thoughtlessness. I don't believe in being polemical, yet I like to be explicit—and your light boxes were, in their self-reflexiveness, very explicit. Are your monochrome works meant to be equally explicit—are they meant to adopt a certain standpoint vis-à-vis their context?

JW: The aggressiveness of the avant-garde that you spoke of is an expression of this act of separation or dissociation. It is considered unacceptable nowadays to discuss this problem in terms of quality, and yet to exclude the notion of quality is tantamount to siding with the "context," with art's cultural milieu, in other words with mediocre or bad art rather than with the exacting and exciting character and openness of good art. The avant-garde wanted to go *beyond* art, because for the artists that was the only chance they saw, within a culture that in their eyes was irretrievably corrupt and impotent, to do anything worthwhile.

We've seen hundreds of years of routine production in painting, sculpture, and graphics, in which not a glimmer of the thought or reflection you mention could ever be found. It should not surprise us then if we find a similar explosion of mediocrity in photography. Photography has finally achieved a status pretty much parallel to all the other art forms, both in the institutions and on the market. In fact, the explosion in photography should be even greater than in the traditional mediums, because as far as the simple creation of images is concerned, the process is easier in photography than it has ever been before.

In my opinion, there's only one way artists can really take up a position here, and that's in the actual creative process of their work. Whatever sets itself off against mediocrity as being in some way better does it precisely in the way it is made. And the distinguishing marks, as it were, have to be all over the surface of the work, they have to be everywhere. I hope that in this respect there is no difference between my monochrome works and my works in color.

BG: Generally speaking, do you consider this uncritical response to what you and other artists of your generation are doing as a failure?

JW: I don't think one can actually say at the moment that it's a failure. For one thing, criteria only prove themselves by being contested and by the process then being worked through. And there does seem to be a tendency, a spontaneous need people have, to respond to pictures in such a way that we believe that what happens on the

picture's surface actually happens in the world. As we have seen, the avant-garde wanted to make the satisfying of this need more difficult, and this movement has modified how people interested in art respond to pictures. But I don't think even the avant-garde could ever finally eliminate that spontaneous instant where one sees *through* the picture, prosaically or poetically, to the world beyond. One may take this as evidence for the avant-garde's project having failed, and for the advent of consumer-oriented art, art that obeys the criteria dictated by popular culture and the entertainment industry. Of course, the whole problem has been and continues to be discussed at length, and there are plenty of artists and critics who have nothing whatsoever against the idea of criteria from the entertainment and fashion industries migrating into art. One constantly comes across such views in the art periodicals. One might be forgiven for occasionally thinking an article in *Artforum* or *Frieze* ought rather to be in *The Face* or *Details*.

I am against these developments in art. But I would distinguish between this problem and the question of the spontaneous, uncritical response. As I see it, this spontaneous, "uncritical" response is part of the process of being critical. One might describe it as the indispensable moment of aesthetic pleasure, without which no deeper contact with a work of art is possible. There's nothing to stop us doing an immanent critique of this aesthetic pleasure, but first we have to experience the pleasure. The pleasure that works of art can give, serious ones at any rate, is a significant part of art's seriousness. The avant-garde experimented by placing obstacles in the path of this pleasure, and succeeded in making the whole process more complex and interesting than it was previously considered to be, but without entirely transcending it.

David Shapiro: A Conversation with Jeff Wall

DAVID SHAPIRO: I have admired your work for a long time, and particularly because you work both as an art theorist and as an artist. I'd like to start out by asking how that happened—how you came to be doing both.

JEFF WALL: First of all, I don't really see myself as really an art theorist or anything like that; more as a kind of occasional writer. My writing partly emerged from problems or occasions in teaching. I've taught for many years, my main subject being a sort of combination of contemporary or modern art history and some reflections on aesthetics. Writing things like lectures becomes a way of putting something on paper; so that's been one of the frameworks. The other is having been invited to write essays, mostly for catalogues. I've never really had a plan to do any serious writing, in fact.

DS: So it grew out of working as an artist?

JW: Yes, and out of teaching, and so, it turned out, I had some ideas that I thought were interesting, and maybe even original, and they had to be expressed in writing, since there's no other really viable form for them. So I had to accept the fact that I have to try to write sometimes. But as I said, I don't consider myself a writer; I don't think I'm a very good writer, but I felt that the ideas were interesting enough to me that they would probably be interesting to other people, and I sort of forced myself to find a way to write. So it's all been, in a way, circumstantial and accidental, although by now I kind of feel like it's a part of what I like to do; if I get time, and if I had more time, I would probably write a little bit more.

DS: So you're saying that there are certain things that can't be expressed visually—in the form of art—that need to be expressed only through writing?

JW: I think that there's an intellectual element, an intellectual content to art, or an intellectual content to the way we relate to art. There's also what we call aesthetics, which is a philosophical attempt to understand the experience of art; that's something I've always been somewhat interested in, if not necessarily in an academic way, but just in a reader's way.

DS: In the aesthetic movement of the nineteenth century, Charles Baudelaire talked about being a painter of modern life. You've [often said] that you see [Baudelairean modern life painting] as a project in which you're engaged. So is that how you got to

Conducted by correspondence in 2000. First published as David Shapiro, "A Conversation with Jeff Wall," *Museo* (Columbia University, New York) no. 3 (Spring 2000): 9–19.

the medium in which you work? Do you see [photography] as the most appropriate medium for today?

JW: No, I don't. I don't think that there's any "most appropriate medium." Photography has been an important phenomenon since it was invented, in both social and artistic ways. And it was inevitable that it would become central to art, simply because it's a picture-making process, and art, Western art at least, is in a very major way about making pictures, or images. But that doesn't make photography a more appropriate medium for our times, in my view. All media are interesting, depending on what's being done with them at the time; sometimes their field is a bit less energetic for one reason or another, but [they] usually come back.

The idea of the "painting of modern life," which I've liked very much for many years, seemed to me just the most open, flexible, and rich notion of what artistic aims might be like, meaning that Baudelaire was asking or calling for artists to pay close attention to the everyday and the now. This was still somewhat new in his time because the predominant idea about art was still that [it] was about treating time-honored themes in terms of the decorum of the established aesthetic ideas. The painting of modern life would be experimental, a clash between the very ancient standards of art and the immediate experiences that people were having in the modern world. I feel that that was the most durable, rich orientation, but the great thing about it is that it doesn't exclude any other view. It doesn't stand in contradiction to abstraction or any other experimental forms. It is part of them, and is always in some kind of dialogue with them, and also with other things that are happening, inside and outside of art.

DS: And you take "painter" to be [figurative]—that is, you don't paint, and haven't, right?

JW: I don't paint, but I began as a painter. I take the term "painter" as figurative. "Painter" can mean "maker" in that sense. It's not limited to being an actual painter on canvas with paint, although it doesn't exclude that in any way either.

DS: Why essentially did you move from painting to photography?

JW: I can't answer that. If I could answer that question, I'd know a lot.

DS: Do you have any ideas on where painting is going, with the changing mediums today?

JW: I think that painting is a permanent part of art, just like drawing is, because we have the kind of hands that we [have], because we have the kind of eyes that we have. We're always going to have drawing, and by extrapolation, painting. It's a consequence of what we are as organisms. Painting and drawing cannot disappear from serious art, cannot "die," as they say. [They] can go through all of the complex

changes and developments [that they have] gone through, because they are perma-
nent. And therefore, [drawing is] a kind of touchstone for all pictorial art, regardless,
because it won't and can't be replaced with anything else. Painting as a medium and
a form can't change very much. So that makes it very interesting, and very open, too.
If it was not so simple and flexible and beautiful, it would be changing technologi-
cally, but it's too right just as it is to change, and so it's going to stay there. I'm very
involved with painting, always have been and always will be, not particularly because
I want to paint, but because it is the most sophisticated, ancient practice.

DS: And you look more toward painting than any other visual medium?

JW: No. I think painting is important but I think they're all important: painting, pho-
tography, cinema, literature, sculpture. The idea that I relate somehow very especially
to painting is a kind of cliche that has come to be attached to my work.

DS: That you look toward particularly nineteenth-century painting models?

JW: I know that I'm somewhat responsible for that because of some of the things that
I've said. So I can't complain about it too much, but [the claim has] gotten exagger-
ated. In the nineteenth century, with Manet and the others, there was such a high
level of pictorial invention, such an interesting take on the now. They created some-
thing that is still very important to anyone concerned with pictures, and so I'm keep-
ing in touch with that, but not in an exclusive way, not as a model for my own work.
My work derives from photography also, that is, photography as photography, and
from other art forms. But it also comes from things that I'm experiencing directly. So
I'm trying to use the nineteenth century, in a way, as one of the frames of reference
for a pictorial practice. We could say that, in many ways, we are still experiencing the
nineteenth century in art.

DS: About being a "painter of modern life," I see that in many of your works. But
does that hold true for a work like *The Giant*, with its digital manipulation?

JW: I like the term "painting of modern life," but I don't use it as a formula, as total
identity. It's a very interesting way to think about what you're doing. Basically it
means using the standards that have emerged over a long time, very high standards
one hopes, and the memory that recognizes the existence and importance of those
standards, and applying it to the now. That doesn't mean that "painting of modern
life" means just "scenes off the street." It means phenomena of the now that are
configured as pictures by means of this accumulation of standards and skills and style
and so on. That means that there are no single themes, genres, or anything else that
[could] be called "painting of modern life." "Painting of modern life" is an attitude
of looking, reflecting, and making. So I think that *The Giant*, which is an imaginary
scene, is a painting of modern life. It originated in my imagination, and my imagination

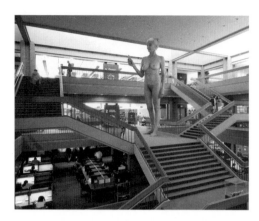

Jeff Wall. *The Giant.* 1992.
15¾ x 18⅞" (39 x 48 cm)

is in the here and now, in the same way that something I might see in the street is here and now. Baudelaire's art ideal was a kind of fusion of reportage with what he thought of as the "high philosophical imagination" of older art.

DS: So plausible and implausible imagery would be equally appropriate to you in terms of image-making?

JW: Yes.

DS: Alright, I guess we'll switch gears a little. I was reading your interview with Arielle Pelenc, who said that your work has been criticized for lacking interruption, that is, for lacking fragmentation. Do you agree with that criticism? I wasn't sure that I did. Do you take gesture and interruption to be different phenomena? And I guess I don't really see that as a criticism if [your work] does lack a fragmentation, insofar as that I feel like there has for a long time been a sort of regime of the fragment, and I don't know if you see your work as coming out of that.

JW: I think that the demand that works of art appear immediately as fragmented, out of some kind of avant-garde and collage aesthetic background, is just an orthodoxy of the times. It's not that such a viewpoint has no validity, but that it cannot be complete, cannot define what good art is, as such, even for a moment. So, obviously, my work didn't really look like the kind of work that was being approved of in that orthodox way. My reaction to that is that my relation to the idea of fragmentation is, in a way, dialectical in that I'm not oblivious to the whole phenomenon of what's being talked about, but I have my own take on it.

DS: Which is?

JW: The aesthetic norm of fragmentation implies that the avant-garde movements made a fundamental and irreversible break with the past. The art of the past is defined as "organically unified," art that does not want to recognize its own contingent character, its own fragile illusionism. It wants to revel in the illusionism, for its own sake

and for the sake of its audience, and it wants to seem to be inevitable and complete, the creation of magicians. This is what is called the "genius ideology." Tearing apart the organic work of art was the accomplishment of the avant-garde, which revealed the inner mechanics of traditional illusionistic art, the stagecraft of the masterpiece. To a great extent, I agree with that process, and I like a lot of avant-garde art very much; it's very important to me. But I feel that it's an unfree way of relating to it, to erect it as an absolute standard against the aspects of the unified work which I like. I like the idea of the unified work because I like pictures, and there is always a sense in which a picture exists as [such] through its unification, [through] its precisely pictorial unification. I think the art of the past is not as unified as the avant-garde polemic needed for it to be, or [made it] appear to be. There are always acknowledgments of contingency and a sense of alternatives in good work from earlier times, probably very far back in time. So, firstly, there probably is no completely unified work, outside some very specific limits—at least, none in the tradition that we've been talking about. But there is the phenomenon of unity in a work, the way it might be experienced as a unity, even if, when you look closer at it, it displays or at least indicates, or hints at, its own contingency. That phenomenon, that moment of appearance, that moment of the experience of the work's unity, remains important. That moment, that instant, will always be there when we experience good art, even if we are experiencing a work which rejects the whole idea of unity, like in radical avant-garde or neo-avant-garde art. So I see the unity of the work of art as an unavoidable moment of the making and of the experiencing of any work. There is a dialectic in all of this, not two antithetical forms, each complete in themselves, one coming after the other in time and rendering the first one "obsolete"—a favorite polemical term of the proponents of the new orthodoxy. And, just an aside, I would say that it was always my experience that the criticisms aimed against so-called premodern art were not terribly accurate, and they were tendentious, in that by trying so hard to break away from the past, a lot of avant-garde artists and writers—critics, let's say—exaggerated the flaws or weaknesses of the art of the past so that they could get away from it. That's just a rhetoric of the avant-garde, and the times made it necessary; OK, but let's not live under that as some kind of law now. You look at so-called premodern art—I say "so-called" because I don't really think it's unmodern—whether it's Caravaggio or Botticelli or Dürer, it's not as unified as those writers made it out to be. The antithesis between avant-garde art and "museum art" is less pronounced than the avant-garde wanted it to be. Older art is much richer and more nuanced than a lot of the arguments give it credit for being. It's kind of obvious by now, how adolescent a lot of avant-gardist attitudes were—the "burn the museum" attitude from the '20s, from Dada, through the '60s.

DS: It's still there though. It's still around.

JW: It's still here, but it's maybe not as dominant. Anyway, for these kinds of reasons, I could begin, in the '70s, to distance myself from that kind of avant-gardism, to try to find other qualities that would go somewhere, without in any way opposing the idea that all contemporary art has to experiment, and has not to follow formulas, no matter how correct the formulas might be. I don't think that that was accepted, at the beginning anyway, and my pictures were often looked at as a simple recovery of the Old Master artists, an unproblematic "return to tradition."

DS: Rather than growing out of their reaction; a reaction to their reaction?

JW: Only slightly a reaction to their reaction.

DS: That in a good way, that is, not just as a reneging of their reaction.

JW: I think that the critics, when they are triumphant, when their cause is dominant, are very unobservant. And that's probably the case with some of the reception of what I was doing and still am doing.

DS: But now there's a lot of what I call "monumental photography." Surely there wasn't when you were starting. Do you see yourself as part of a Zeitgeist?

JW: I hope not.

DS: Andreas Gursky and Wolfgang Tillmans are also making a sort of "monumental photography."

JW: I think that there's a lot of big photography. Photography's gotten a lot bigger in the last ten or twelve years, because it's become a kind of known thing that a photograph can look great at that scale. So that now it's become something that everybody can do. The scale of the photograph has been experimented with, for decades, but it's now become a known and popular artistic phenomenon. I worked on it; lots of people worked on it. But I think it was inherent in the nature of photography for that to happen. It was inherent in the fact that once photography got taken more seriously, and was practiced in a more experimental way, a way that was more like the way people practiced other art forms, that newer elements of its nature would appear.

Classic art photography, which was very much the predominant language until about the 1970s was based upon the documentary model. And it seemed to be satisfied with a small image, related to the world of book publications. There was no interest in larger scale photography, and there were no grounds for it. Only when people came from outside the classic domain of photography and started practicing photography, did some of these things that had been neglected get [reconsidered]. What I think is positive about that is that photography can function in the world very interestingly as art and can be experienced as art at a larger scale. But now anyone—all the art students do it, because it's just . . . done. It doesn't mean anything anymore as experimen-

tation, but it is now freely available as one of the actual capacities of the medium. The experimental work done since the '70s has unlocked a lot of aspects of photography that weren't really available, or were blocked in a way by the sort of perfected aesthetic of documentary-type photography.

DS: So you don't see yourself as a documentary photographer in any way?

JW: Sure I do. I think that all photography contains an element of reportage, just by nature, and so everybody who practices it comes into relation with that aspect in one way or another. What's interesting is that there's no one way, anymore, to come into that relationship. I think in 1945 or 1955, it was clear that if you wanted to come into relation with reportage, you had to go out in the field and function like a photojournalist or documentary photographer in some way; that was expected and everyone expected it of themselves, and there was no very clear alternative. No other aspect of photography was really taken seriously, and that was great nevertheless, because classic documentary photography really is photography; it really does connect to the nature of the medium. But, still, it does not cover the horizon. There are other practices that are equally deeply connected to what photography is, and as well, there is no single way to satisfy the documentary demand. There's no one way to come into this relationship with reportage. I think that's what people in the '70s and '80s really worked on; not to deny the validity of documentary photography, but to investigate potentials that were blocked before, blocked by a kind of orthodoxy about what photography really was.

DS: Do you have ideas about further experimentation in photography, or do you feel set in a medium for expression?

JW: Well, I've been doing black-and-white now for four or five years.

DS: Why?

JW: I started doing black and white because when I first started working in color, which was in the '70s, I knew that, while color was important, it was also only one aspect of the medium. Black and white is a peculiar kind of image. Drawings, for example, with a pen and pencil, are black and white. The idea of noncolor images is very old, and it really derives from the medium of drawing, because if you have a piece of chalk, it's only one color. You make the drawing, and it's all in one color, but the world isn't [in one color]. That anomaly really goes right back to the beginning of art—just having one substance to depict all the other substances. So photography also has that in its black and white. So, it seemed to me that if you're going to work in the medium of photography, you couldn't just work in color; just like in the '70s and in the '60s, a lot of people trying to do new things said that you can't just work in black and white, you've got to work in color. That's true, but it's the other way around as well. So I very much wanted to work in black and white, for a long time. Then in

around 1988 I saw the work of a few other photographers who were working in large scale in black and white; Craigie Horsfield was the most important one, and I thought, God, that's interesting—I haven't seen such interesting black-and-white work on the scale that I've been working on, and it gave me more of a stimulus to get involved with what I wanted to do. It took me a while to resolve some of the technical problems of working in black and white at the scale I wanted, and so I didn't actually make any large prints until 1996. Now I consider black and white to be an integral part of what I'm doing. It seems to me just a completion or expansion of what photography is. I like to see myself as a modernist, in that I'm responding to what the medium really is.

Interview between Jeff Wall and Jean-François Chevrier

WRITING ON ART

JEAN-FRANÇOIS CHEVRIER: As is indicated by the very title of the text—"Partially Reflective Mirror Writing"—your latest essay on Dan Graham partially reflects your own position as an artist-cum-writer (critic, theoretician). And this isn't the first time that you talk about yourself while writing about Dan, who, in his piece on *The Destroyed Room*, had himself tried to appropriate your work. Through Graham's work you have been forever questioning your own debt to Conceptualism—a Conceptualism deriving from Pop art. In the late 1970s you stayed aloof from Conceptualism by once again starting from the picture, informed by the cinematographic narrative. But your praxis of Conceptual art, in particular in *Cine-Text*, produced in 1971, was very literary. Since this dialogue is intended to introduce a collection of your essays and interviews, I should like you to specify the place that criticism and theory have taken up in your activities since the 1970s, and how, today, you situate your practice of writing, as well as your use of literature.

JEFF WALL: Let me be paradoxical and say that writing is a part of what I do by being "to the side." I guess that is another way of saying I cannot define the relationship. Maybe I don't wish to define it. When I began to feel I was getting serious about my work, back around 1966 or '67, I was impressed by the young artists who were involved in a dialogue with art criticism. The most important one was Robert Smithson, who I got to know here in Vancouver around then. My first interest wasn't in the fact that this was being done in writing, as writing, but that there was an open and public discussion going on between a group of people who intrigued me.

Smithson was to a certain extent responding to what Don Judd was writing, and Judd was reacting to what Clement Greenberg and Michael Fried were writing, and so on. Greenberg, Fried, Judd, and Smithson all seemed to me to be engaged in a complex of disagreements that made up many of the important ideas of the time—and I think this conversation is still significant.

What I liked was art criticism, when it was practiced at such a high level, when it became a kind of literature through the force of the argumentation and the style of the writing. I admired Greenberg as soon as I first encountered his work, Fried as well. I read a lot as a young kid, and knew about art criticism and the fact that it was

Conducted in Paris in 2001. First published in French as "Entretien entre Jeff Wall et Jean-François Chevrier," in Jeff Wall, *Essais et entretiens 1984–2001*, ed. Jean-François Chevrier (Paris: École nationale supérieure des Beaux-Arts, 2001), pp. 7–36. First published in English as "Conversation between Jeff Wall and Jean-François Chevrier," in *Jeff Wall: Tableaux* (Oslo: Astruup Fearnley Museet for Moderne Kunst, 2004), pp. 107–19.

done best by poets like Baudelaire, and I saw that Greenberg was someone in that tradition, probably the most significant writer in that tradition. I reacted very strongly to Michael Fried's writings then, too, and understood that he was doing something important. I liked art criticism because I learned about art from it, I learned to test my own reactions to art (which I had mostly seen in photographs in books) against what these writers said. Art criticism for me in the 1960s was a way to have a dialogue about what I was desperately concerned with, and couldn't always talk about in everyday life. For me, it was *the* important form of writing, it was what writing was all about.

At that time I never really thought of participating in art criticism, just of following it closely and reacting to it, talking to it myself, and talking about it with other people. Even though I was studying art history and writing essays and theses and so on, I didn't really think of any of that as "my writing"; it was just "school."

When I got interested in what was happening in Conceptual art, I thought there may have been a way to have a writing practice inside my work, as such. But that was something separate again from art criticism. I knew the work of Art & Language, Victor Burgin, Kosuth, and the others at that time, but didn't want to go in that direction. I saw that as a kind of late consequence of reductivism, of Minimalism. I didn't want to be a reductivist, and I didn't want to have to write only about art itself, and about why the text in front of me could be considered an artwork or an art object. One of the reasons for that was that I thought that there was a difference between art criticism (as I've tried to characterize it here) and art as such, and that that difference was essential, and needed to be preserved. I wrote about this in my most recent essay, "Partially Reflective Mirror Writing."

I also thought that being a really good art critic was something special, it was the result of having a special talent or ability, and it wasn't necessarily the same thing as having artistic talent directly, even though as I said the great critics of the nineteenth century were usually artists, too, but poets, not painters or photographers. I didn't think I had that kind of talent.

J-FC: For some years now you've been questioning the place and uses of photography in Conceptual art. Before the invention of film, photography was situated between painting—or, more generally, the pictorial—and literature, or all forms of chronicle. By choosing to deal with the photographic image by way of the picture, you are tipping the scales toward painting, whereas Conceptual art had likened artistic praxis to literary writing. Dan Graham once told me that in the 1960s he had been affected by the *nouveau roman*, the "New Novel." He liked Butor and Pinget, when other people in the United States—most of the art world, in fact—preferred Robbe-Grillet. To my knowledge, you have never mentioned any reference of this type in relation to your own work, and even today you make no mention of that backdrop of essay-writing in Graham, which is, true enough, more perceptible in Robert Smithson. Where do you stand in relation to literature? You've illustrated, or pictorialized, one of Kafka's works,

Odradek, and today you're currently working on other projects involving illustration and interpretation. Could you also go back over your teaching experience, which, I think I'm right in saying, was very important for you, after your art history studies?

JW: I had always been interested in literature, and had read a lot of novels and some poetry. I saw that older art had its connections to literature, if only because artists had to make paintings or sculptures on subjects derived from texts. I could see how that had changed in modernist art, but reckoned that, despite the transformations, there was still some form of relationship. I felt that the exclusion of literature from painting was an act of painting but at the same time it was an act on, or toward, literature. When I began to read Roland Barthes, around 1968, I sensed that he was developing concepts related to that thought, especially in *Writing Degree Zero*. So it seemed to me that, within the rejection of literature in modernist art, a new relation to literature was being hypothesized. Maybe it's more precise to say that a new relation to the sense that there was a relation, even if it was denied, was being hypothesized. Anyway, that had something to do with me making textual experiments around 1969. What I did wasn't Conceptual art and it wasn't an overtly literary activity, it was just some kind of experiment, using a kind of novelistic but reflexive writing in connection with photographs. It was influenced by Burroughs, by Smithson, and by André Breton's *Nadja*, which includes the documentary-style photographs by Boiffard. I saw *Nadja* as a kind of model for a possible writing practice, as art. But I gave that up almost immediately because the results were mediocre.

I realized that the linguistic Conceptual artists were much more rigorous, and less sentimental, in their thinking through of the hypothesis of a "writing practice" as art than I was being, just as were the people actually practicing art criticism. What I was doing was half-assed and I quit it immediately. That was about 1970.

At that point I decided to study both Conceptual art and art criticism more closely, and that was what I spent a lot of my time as a Ph.D. student doing. Both Conceptual art and criticism led me toward aesthetics, because the reflection on the concept "art" was at the center of all three. At that moment aesthetics was being deconstructed, of course, so it was a very good time to get involved with it, and with all the associated problems.

So there was a long period when I didn't actually make any works of art, but tried to work through a lot of things theoretically, in a kind of "theoretical practice." We'll come back to that idea of "theoretical practice." That theoretical practice had to become a writing practice, obviously, because theory is done in writing. So I had to confront the problem of writing again, but this time more seriously than before, because I no longer believed it was possible to "write out" a work of art, even in the sense of linguistic Conceptual art. I thought maybe I'd have to be a sort of theorist, someone with a full-out writing practice.

There was a political aspect to this, because at that time any notion of "practice"

was a notion of "praxis." That is, it was defined in terms of the Marxism of the day—
or at least, in relationship to the intellectual movements of the late '60s and early '70s,
which were so deeply indebted to the Marxisms then being rediscovered and
rethought.

Being involved in theoretical writing was uninteresting if the writing was not
radical in some way, socially radical by being formally or structurally radical. I was
trying to do that, trying to rethink art theory and art criticism and aesthetics in those
kinds of terms. At some point I had the idea that I would have to write a sort of crit-
ical history of modernism or maybe a kind of modernist aesthetics. I had heard of
Adorno's *Aesthetic Theory* but couldn't read it in German, and it didn't appear in
English until the middle of the '80s, more than ten years later. But I studied him, and
Walter Benjamin and many of the other important figures, during the time I was in
London. I read Kant, Hegel, Schelling, and tried to understand the idea of aesthetics
in the German tradition. I thought there was an echo of Hegel's notion of the "end
of art," and what was happening at that moment, in post-Conceptual, post-studio art.
I studied the French reception of Hegel, and the French turn to Heidegger and
Nietzsche, too. I was interested in seeing if there was a sort of mainstream of what
we might call avant-garde thought or theory that crossed the barriers of national lan-
guages and traditions in Europe, something that responded to modernity overall,
something that could be the object of what I thought of as a real theoretical discourse
about art or aesthetics.

Some of this took written form in pages I wrote that were ostensibly part of the
Ph.D. thesis I was supposed to be composing at the Courtauld Institute. But I was
never really composing a Ph.D. thesis, I was just writing pages in order to begin to
carry out this thinking, this kind of practice. So finally there was no concrete, finished
written form for any of this. The work was more or less broken off when I left
London with my family in 1973.

It continued in another form back in Canada. By 1974 I was teaching, and my
classes were on subjects drawn from my studies. For about six or seven years I put a
lot of effort into this teaching work, and managed to organize many of my thoughts
through the activity of giving lectures and seminars. That was in fact very exciting
and gratifying, and I worked harder on that than I did on anything else, even after
1976 or '77, when I finally found a studio practice again. Until about 1984, my picture-
making was done in the time left over from teaching.

The lectures and seminars were written down, often in very finished textual
form. Sometimes I just read my text to the class, not pretending to improvise, but
instead concentrating entirely on the shape of the ideas and the nature of the lan-
guage. This work was close to a writing practice, but not a writing that I thought
about publishing. Maybe in fact it was a practice of speaking, or of reading aloud.

The critical writing I started to do for publication around 1981 came out of this

work. "Dan Graham's Kammerspiel" was done because Tom Lawson, who had started *Real Life* magazine in New York around that time, asked Dan Graham to write a text on one of my pictures, and me to do the same with one of his. Dan wrote a piece on *The Destroyed Room*, and then I tried to do something similar on his *Alteration to a Suburban House*. Dan's essay was two or three pages long and mine was the essay you know, fifty or sixty pages! Tom did publish it in *Real Life*, in fact, though slightly abridged and edited.

The response to that essay was very positive, and I guess it made me think once again about the idea of a writing practice, the idea that I might be able to develop something like that in a way that was consistent both with my earlier approach and with what I was now doing, my photographs.

I see it now as a delayed result of my longtime interest in art criticism. Maybe it is a sort of Duchampian delay.

I'm sorry, but I haven't really answered your question. As far as literary references are concerned, however, I can't be any more precise, I can't single out works or even a trend that would provide a real explanation of what I do. The references are in the pictures, they are absorbed.

PHOTOGRAPHY

J-FC: For the past ten years or so, you're much more interested by photography itself and its history than you were at the end of the 1970s, when you produced your first photographic pictures. At the end of the 1960s, you were involved in Conceptual-type works, but we've decided not to talk about that today. You were combining image-documents with a kind of writing akin to the screenplay. Then you radically stopped that vein to study art history, and you took up your artistic activity again in the late 1970s. Between 1978 and the end of the 1980s, the conception of your photographic pictures was evidently determined by a cinematographic model, as well as by an idea of painting and of pictorial presentation, to a point where people at that time muddled your work with what was then called "staged photography" and the "fabricated image." For a keen observer, it was nevertheless already obvious that your work did not have a whole lot to do with those trends: in your work there was a methodical consideration of the possibilities of the medium, associated with a very speculative approach, at a time when you were challenging the modernist tradition in its definition as laid down by Clement Greenberg. I can remember in particular your statements against Cartier-Bresson, who had set down the canons of direct and spontaneous photography, as a pure way of seeing things. At the time, you seemed to be overlooking the history of photography—you even seemed to be avoiding it. These days, not only do you call yourself a photographer, but you also even lay claim to a documentary dimension in your work, which you connect with a "neorealist" vein. Why this new interest in

"photography" and its history? How does this interest alter your position from the 1980s? How has this change come about?

JW: It's not new. I would say rather that I've shifted the emphasis. It's always been clear to me that I was involved in photography. The so-called "staged photo," which I called "cinematography," was something that appeared to be distinct from what you're calling live, or straight, photography. At the time one talked about artists "using photography," to distinguish them from "photographers." I began working with photography in the experimental context of Conceptual art. In the late '70s–early '80s I changed direction; I felt I had to break with what you're calling a modernist tradition. I was interested in a contestation with that notion of photography. Looking back, I can see that I wasn't really aware that that contestation was taking place on a field essentially defined by photography. After about ten years of that contestation, I realized that my position had changed. In that latter part of the '80s I came to see that I had lost my battle with photography. That feeling was very strong by 1986 or 1987. I realized then that I was happy to have lost; the contestation was over and I was in fact a photographer. But photography had changed too—its character, aesthetics, presuppositions, its discourse weren't the same. I was one of a group of artists who enriched that by revealing some new possibilities. When I made my first color pictures I was trying to preserve a relationship with traditional photography, and I saw my landscapes, or cityscapes, as part of that tradition, despite their use of color and their large scale. I wanted to keep a connection with straight photography.

Once I realized I'd lost that battle, the landscapes became important in a new way. They helped me make pictures like *The Storyteller*, where the performances are set further away from the camera. The landscapes were the way documentary or straight photography became a stronger element in what I call "cinematography." I'd been very concerned with that earlier, when I made *Mimic*, in 1982. But there I was trying to rework street photography in new terms: I wanted to be able to deal with that essential encounter that happens in the street—the encounter with a stranger— but to do it on a larger scale, reconstructing it with performers, and being able to compose the picture. All that meant working with very different equipment, not the little Leica but a larger-format camera; I think I learned how to make that kind of equipment work for me in the street, how to make it seem to capture events as they occurred. You could say it was a monumentalization of street photography. I could work in relation to the genres of classical documentary photography; I wouldn't have to renounce it, critique it, or follow it, but could maybe open some new directions, like working at life scale, as painting had been able to do for centuries. The picture could be large enough to respond to the criteria I'd admired in painting while still being connected to the tradition of reportage.

I've always been interested in "neorealism." Even though I started emphasizing

the term a bit later, you can see it in pictures like *No*, *Milk*, and *Bad Goods*, or, a bit later, *Eviction Struggle*; they all deal with aspects of documentary photography. In neorealist cinema you find the same documentary or cinema verité camera style, the nonprofessional performers, the use of real places, and a staging that you could call "near documentary." In these pictures I moved some distance away from the Mannerist aspect of my earlier work. I like to be able to work in a way that can move between that mannerist, artificial style, which resembles certain kinds of painting, and a more fluid kind of reportage that is closer to the history of photography.

In the past ten years I've tried to follow both directions without favoring either one, since I'm interested in both. I've come to understand how open a medium photography is, and how we still don't really understand it, understand how it permits, or even demands, contradictory approaches.

J-FC: In fact you've waged two fights against photography: first of all in the Conceptual movement, in the late 1960s, then ten years later, in your first photographic pictures. At that particular time, painting was said to be rediscovering its vigor, and this revival of the pictorial was having echoes among artist-photographers. We were witnessing the advent of a kind of neo-Pop, picto-photographic Conceptualism, with a semiological content. This more or less critical neo-Pop semiology was especially perceptible in the appropriation strategies of media-related imagery. The Metro Pictures gallery, in New York, was one of the seminal places where this tendency was concentrated. The pictorial reference could be applied to media models and to agitprop models, or models of social criticism (I'm thinking of Barbara Kruger, among others). Your work was seen within this ambience, but you were actually somewhere else. It would be interesting to specify how and why, coming back to your interpretation of photomontage, and of Heartfield in particular. It seems to me that at that time you were already trying to reposition yourself in a longer history, by being aloof from the model of the historical avant-gardes and going back to Baudelaire's program of the "Painter of Modern Life." You were staying away from the possibly rhetorical content in the neo-Pop criticism of the media.

JW: I was interested in these questions already in the '60s. I got involved in art history through thinking about the problems I was facing in my studio. I studied this stuff not to become an art historian, as people seem to think, but as a way to get some distance and clarity on it for my own purposes. I got interested in Heartfield in the atmosphere of the counterculture and politics of the 1960s. He was one of the major models for the critiques of the time, and different energies were circulating in the reception of his work then. I went to London to study him further, but, by around 1971, I'd become pretty disappointed, and realized that he just wasn't as significant an artist as I'd previously thought he was, and that I wasn't getting much pleasure from his work. Since I wasn't interested in being an art historian, I had no reason to waste

my time on someone who wasn't inspiring me. So I dropped Heartfield and decided to study Duchamp.

Then images started coming back to me, almost like childhood memories, images from the period in which Duchamp's work emerged: late Symbolism, Post-Impressionism, and so on. I had thought that Duchamp was important mainly for the way he participated in the destruction of that great pictorial culture. But the closer I looked, the more I saw him as a part of it. And through looking at his work I looked in a new way at everything around him, a way that reminded me of the enjoyment I'd experienced as a child in looking at books of reproductions of Seurat, Manet, or Brueghel. I thought I understood something of the real critical dimension of contemporary art: it wasn't a matter of attacking or destroying, not a question of violence; rather it was about a militant exploration of the legitimacy of tradition. That's how I began to define my own position, and how I still do now.

The artists who were involved in the critical art of the 1960s and 1970s were really serious, really trying to think about their practice. I respected that, and still respect it, but at the same time I realized there was a difference between them and me because I had started to doubt that the new forms could be as significant as the older ones. I had always been interested in painting, since I began as a painter, but it started to come back to me at the beginning of the '70s. I'd been able to see quite a bit of modern and contemporary art after about 1966. I was at the opening of the 1972 Documenta, where most of the new forms were presented in a very large, intense context. Seeing this work and thinking hard about it led me to feel that the new forms—Conceptual art, performance, and so on—were subject to certain limitations that did not affect the older forms. This was still mainly an intuition at the time, but a strong one.

My response was to look more intensively at the pictorial forms that were then subject to so much critique. It was clear that the very idea of representation was the focus of every deconstructive energy after about 1966, and this is still basically the case. The critical orthodoxy that emerged in 1973 or 1974, in response to the politics of the time, is still the dominant discourse. In the early '70s I saw myself as part of that neo-avant-garde and I didn't think I'd have to distance myself from any orthodoxy; I thought I'd be one of the people who'd challenge tradition and create something new. I was rather surprised it didn't work out that way. That led me to make what I think were new connections with so-called "traditional" art. But in fact I don't believe in "traditional" art; art has always been contemporary.

J-FC: Tradition is a backward-looking construct, worked out on the basis of the present.

JW: At the end of the 1960s I got interested in German philosophy and aesthetics. I was confronted with Kant's idea, in the *Critique of Judgment*, that an aesthetic judgment is at once noncognitive, or nonconceptual, subjective, and universal. I was inter-

ested in Thierry de Duve's writing on Kantian aesthetics, his notion that tradition is an accumulation of aesthetic judgments made by individuals in their time. Any consensus on these judgments is dynamic—each person puts the consensus to the test in their own experience of a work of art. It's difficult to oppose the consensus on Picasso's *Demoiselles d'Avignon*; it's a masterwork. But for the consensus really to exist, there still has to be doubt about the work, and each person has to experience the picture and judge it again; the agreement isn't automatic. An automatic consensus is just dogma and academicism. Individual judgments progressively create the criteria of quality. These judgments, which are constantly being reworked, can take the form of art criticism. At that time I imagined a kind of criticism that would go back and connect Baudelaire's views with those of Clement Greenberg and Michael Fried. I've never thought of "tradition" as an institution to be simply respected; it's something dynamic in which things are perpetually renewed for each person involved, each person who takes pleasure in works of art. It's through that pleasure that the tradition is renewed.

J-FC: In the 1960s and 1970s, as you've reminded us, photography was often regarded as antipictorial. A lot of artists used photography as a document, against painting. Can you tell us precisely how you situate your idea of photography within this debate and its developments?

JW: The elements for a critique of classical photographic aesthetics were in the air in the late '60s, but they didn't coalesce until maybe ten years later. In the '60s I was involved in that without being able to understand what was at stake. I stopped making the work I was doing, mostly texts with small black and white photographs, around 1971. I went through a long period, six or seven years, without producing anything. And when I did resume working with photography, when I found my way, it was in terms of the tableau. At that moment, around 1976 or '77, I felt that certain possibilities for photography could now surface, possibilities that had been invisible for some time because of the institutionalized definition of the medium that had been dominant since the 1920s. Part of the pleasure I took from painting was in the glimpses painting gave me of qualities I sensed were present within photography itself. I wondered why photographs couldn't be somewhat larger so that they could engage the onlooker more emphatically and physically, and why they should not be in color. My pictures, right from the beginning, were my answers to these questions. I realized, for example, that painting had no exclusive right to the depiction of things at life scale. Photographers might not have looked at it this way because it was sort of taken for granted that the surface of photographs is not interesting, the way the surface of paintings is. But I've always liked looking at photographs from close up, especially when they are quite large. There's a cloud of granular energy that physically makes the image, and it can be enjoyed for itself, independent from the image, like a cellular structure.

I thought a lot about these things in the years I wasn't able to make anything, from 1972 to 1977. I was impatient with what I thought of as the documentary dogma that excluded any collaboration between the photographer and the subject of the picture. In these terms the photographer had to be unobserved, and the subject too preoccupied with their own affairs to notice his presence. I felt that implied a lack of intimacy, that the subject was too much at a distance from the maker of the picture. Photography seemed trapped in its own apparent uniqueness; the older arts, like theater or painting, had always been able to create the illusion that the viewer was sharing a very private space with someone else. At the beginning, photography seemed very different from pictorial art, since it alone was able to record the immediate appearance of things, apparently with the minimum possible illusion. But this becomes an artistic limitation in that photographers are by nature more distanced from many situations than would be someone working in one of the other arts.

The cinema seemed to be a response to this problem, since it makes use of the techniques and resources of the older illusionistic arts. It therefore is more like those arts in producing that sphere of intimacy and privacy I'm interested in. I felt that the cinema created a model of photographic practice that could itself be detached from the cinema; that's what I called "cinematography."

J-FC: Could you describe the relationship that you are establishing between the cinematographic dimension of photography and the history of photographic images themselves?

JW: I was interested in the way cinema affected the criteria for judging photography. Cinematography permits, and validates, the collaboration between photographer and subject that was largely excluded in classic documentary terms. That exclusion limits photography, and so my first moves were against it—working in a studio with all the technical questions that implies. I had to learn some of that technique as I went along; that process was part of transforming my relationship to photography. At the beginning it was done in the spirit of contestation, but as I've said, it was not so long before I realized I'd lost that contest and realized that nothing I was doing was "outside of photography." At that point—in the mid 1980s—I felt I'd worked myself into a position where I needed to come into a new relationship with the kind of photography I'd been questioning. As I saw more of the "new" photography in exhibitions through the '80s, I began to realize that I preferred Walker Evans or Wols to most of the newer work, and I preferred them to my own work, too. Classical photography might have been displaced from the center of attention by the newer forms, but it was not diminished in the process. It became stronger through having been confronted with alternatives, as far as I was concerned.

The generation of the 1960s and '70s carried out this confrontation, dismantled the classical version, reworked it, and found ways to see it differently. They—we—

might not have been able to make works that equal Evans or Wols in quality, but the confrontation was essential. It showed that there were other potentials within the medium, things that were blocked by the overstated legitimacy of classic aesthetics. So once again you see that traditions stay alive by being confronted, not simply respected. Those who spent the '60s and '70s emphasizing their respect for the classic tradition didn't play much part in preserving it and making it new again.

J-FC: To have this critical eye on an art, I think you have to know how to move and shift, how to have the viewpoint of another art. This is why I don't agree with the modernist logic. My own experience has shown me that in order to look at photography with some remove, you had to have come from painting or literature, and not regard photography for its own possibilities, for itself, in a fanatical way. This is why the modernist discourse is dangerous. In fact it is important to consider an art for its possibilities and its difficulties, but you cannot get to know these things without also looking elsewhere; whereas modernism thinks that it is not possible to know about the possibilities of an art except from within, by isolating it and purifying it. When you refer to Greenberg and Fried, you're rationalizing your attitude, but it seems to me that this doesn't go with your work, in the facts. Nor mine. When I started to take a close interest in photography, and when I started to be able to criticize the orthodoxy of it, as I did with regard to Cartier-Bresson and his epigones in the field of auteur reportage, or in relation to so-called "creative" photography, I was staring out from the viewpoint of painting and literature. You yourself have included film and literature in your photographic work, and the fact is that Walker Evans, whom you admire as a classical photographer, had already done that. A photograph, for him, was an element, a "piece" in a sequential montage, in a narrative. Each element was like a prose poem, which wasn't a mere fragment, or a fetish, or even a picture. Everything that sets you apart from Evans has to do precisely with the picture. Walker Evans, for his part, tended rather to be oriented toward the narrative, or toward a narrative poetry. This narrative in his work might take the form of a book, an exhibition, or, more modestly, a few pages in a magazine. You yourself certainly started out from there, what's more, in your earliest Conceptual-type works, just like your friend Dan Graham, and Robert Smithson. Except that, for all the reasons you've expressed, you've needed to reinvent and redefine the picture.

CRITICISM AND ENIGMA

J-FC: We might try to remember what the critical thinking of the neo-avant-gardes consisted of between 1968 and 1975, and what its presuppositions, conventions, and rhetoric were. I should then like to know to what extent and on what bases, for you, this rhetoric—as it was established at that time and as it continues to function today in an institutional, commercial, and academic mode—can be questioned and challenged

in order, if I've understood things properly, to refind the critical force that initially informed it.

JW: Questioning the pictorial tradition implies questioning the institutions for which it has been a sort of symbol. The pictorial tradition used to signify a whole institutional world; painting was a symbol of authority. Any critique of authority is going to involve those symbols one way or another. The critique of authority, the questioning of the legitimacy of authority and institutions, is at the origin of modernity and is one of its most striking characteristics.

But as far as art is concerned, this kind of critique has become rather routinized, rather institutionalized, since the 1960s. We have to make a distinction between art and other domains, like economics, politics, science, and even religion; all those fields operate in terms of cognitive standards and discursive knowledge. I agreed with the whole direction of the neo-avant-garde in treating art in this cognitive, discursive, critical way. But I've come more and more to see that pictorial art is not primarily about this kind of knowledge-creation and that the image, as such, is not a very powerful means for that kind of work. Brecht and Benjamin stressed that images should always be accompanied by texts; the texts, or the combination of picture and text, put the pictures to work in a discursive way, with the aim of changing the world. That's perfectly legitimate. It's the principle of radical, militant photojournalism, the idea that photographs, properly combined with written information can really tell us something about the world and thereby help us act in the world. Again, perfectly correct. Photojournalism is an aspect of journalism, and what you could call "progressive" journalism has as its task to expose problems in order to aid in their resolution, or remedy.

But its very difficult for the autonomous image of pictorial art to take part in this kind of activity because the pictorial, in itself, is more nonconceptual, noncognitive. It's based on experience, and the experience has no direct or apparent purpose or immediate context of use. The experience shapes us somehow, it affects our feelings and changes us; this is why Kant claims we need art, because it affects us in ways that can't be defined socially and institutionally. If you see it this way, then critique as such can't be the central artistic issue.

I thought a lot about this, precisely between 1968 and 1975 or 1980, and realized that this point of view was very powerful, very suggestive. This version of classical aesthetics has been criticized continually by all the anti-Kantians, the Marxists, and the others, but it has not been invalidated or made irrelevant. Its version of the aesthetic experience remains very significant. But, since it is entirely dependent on experience, it means that, if you don't have such experiences, you can't believe it matters. But if you have the experience, and feel it matters, then you can also have a sense of how you are being changed by the experience and your relation to it, as you go back away from art to your other obligations. These obligations are those that are addressed

more directly by things like journalism, by the demand to improve the world. The experience of art changes and shapes your relation to those obligations. It could make you better equipped for meeting them, because you have become a different person, at least in part, through your encounter with autonomous art.

J-FC: What you're talking about comes, first and foremost, I think, in Western culture since German Romanticism, from a definition of poetry as an autonomous practice of language. You talk about Kant, who was obviously decisive for this Romantic theory. Well, at the hub of Kantian aesthetics there is the sublime, which is a speculative notion, a limit-concept within a rational system. But since Kant, this idea has been terribly simplified, and popularized, to adjust the aporias of critical thinking applied to the aesthetic experience. A lot of contemporary artists have taken it up again to avoid the issues and emphasize an obscurantist, anti-intellectual definition of art. In your work, there is no sublimity, or, if there is, it is systematically reduced. You avoid the behind-the-scenes comeback, in aesthetics, of a religious dimension which critical thinking, since the Enlightenment, has far-reachingly challenged.

JW: I'm not a Kantian. I simply don't like the instrumentalization of art that's characterized parts of the avant-garde since the beginning and that was very prominent in the 1960s and '70s. You don't have to be very philosophical to be averse to that. I've always loved pictures and nothing has been able to change that for me.

In 1977, I traveled with my family to Spain and visited the Prado for the first time. I saw Goya, Velázquez, and the other masters in that collection. It was a tremendous experience, and it strengthened my intuition that this kind of art was not a thing of the past. It was contemporary art, there was nothing essentially "historical" about it. *Las Meninas* was there, a picture still speaking to us, in the world at that moment, that Now.

That connected for me with the apparently Kantian idea of aesthetic experience. It showed me that an intense aesthetic experience is always also a moment of intense contemporaneity, a moment of the Now, regardless of whether it occurs in front of a picture 300 years old.

I did not learn anything new at that point, but I had an experience that confirmed some of my attitudes toward art. It reconfirmed the value of autonomous art, an art that depicts but recognizes that it does not speak directly, and therefore that does not criticize directly. For example, a picture showing a violent, reprehensible event: it will affect you immediately and you might be able to disapprove of the perpetrators. But if the work is good, you will notice that the artist can barely frame an accusation. He can't point a finger at the guilty party. That party is there, identifiable as one or some of the figures in the composition, but he is treated with the same attentiveness, with the same care, as is the victim. Depiction has an empathy for everything depicted.

J-FC: On this point Varlam Shalamov is must reading. In the *Tales of Kolyma*, he describes the behavior of crooks deported to the gulag like him. He criticizes them harshly for all the advantages they derived from the system, and the oppression they wielded over the other prisoners. But he describes them with the same care and attention as any other character, as any real gulag victim. He refuses any indulgence in their regard by radically condemning the romanticism of the dregs of society, but he is also very attentive, very precise, very "fair" in his description. He doesn't express any compassion, quite the opposite, but he doesn't let denunciation get the better of description. We might talk of a removed empathy. Nothing to do with a rhetoric trying to reconcile denunciation and compassion.

JW: Yes, Shalamov is great. You can say the same thing about Goya. He paints murderers with the same empathy as he does their victims. This has nothing to do with any kind of amorality of art. Nietzsche talked of "beyond good and evil" in philosophical terms. But in painting, or the image, it is just a matter of depiction, of figuration. It is far more difficult to make an artistically valid image of something evil than it is to exaggerate the features of a criminal to turn him into a monster.

J-FC: In the Western world we have never managed to describe the world of evil, crime, and violence, without making some reference to hell. Hell recurs every time we deal with situations where violence and cruelty appear as such. But you have to know that hell is never anything other than a model. It's important to avoid taking it for the actual reality of things, or else the image becomes a mystification, it shrouds the event. Hell is a historical representation. The problem is that a lot of thinkers, especially on the right, divide the world into heaven—paradise—and hell. Reality is thus reduced to two major poles, which are imaginary and phantasmatic. This is one of the procedures favored by contemporary reactionary thinking. But it has to be acknowledged that these two models have existed for a long time, and that they can be redefined outside of reactionary mythology.

JW: I guess you could model it, as you say, in the sense that you could show how a person, a murderer, say, feels about the world, and how he might live afflicted by a phantasm. Art can get at these things if it wants to. I'm more interested in the relation between the intensity of the inner life and the fact that it, too, is carried out in what we call the "everyday." This everyday is a sort of mediation between direct figuration, or reportage, and fantastic exaggeration, or fantasy.

This is another way to think about the "painting of modern life"—as a form in which we can monitor the fantastic or the inward and report on its nature and effects. The artist himself or herself might be subject to some kind of obsession and project that obsession on a depicted figure. The depiction might suffer because the projection involves a suppression of aspects of the imagined figure, simplifying it and making it compatible with the obsessive definition of the being in question. So you get some

kind of demonic presence. That could be still good art, but it might also lack completeness. An image that reduces a being to a demon will always find a practical application. It's a classical formulation of propaganda.

The model of the "painting of modern life" suggests that the artist reflect critically on his own fantastic projections in making depictions, and, in doing that, discover something ethical. So, for example, if one is to depict a criminal or evildoer, one has to show him as a human being in a particular situation, not as a monster. The ethic emerges from the artistic quality of the work done.

J-FC: What you're saying there redefines the potential of a critical art. Rather than a denunciation, a division between good and evil, heaven and hell, critical art works in ambiguity, without necessarily being a form of opportunism, or culminating in a relativization of all values. What your images have their sights set on is not an image of good; perhaps, rather, it's peace, a peace that is expressed in confidence and abandonment. The problem is that you can have trust in others, or you can trust to circumstances, to the point of dropping your guard and putting yourself in danger of being attacked! The person who falls asleep, like the character of *Citizen*, is trusting, you don't know what he's dreaming about, and he will possibly have horrible nightmares. You would then topple into *Insomnia*. You can't see *Citizen* without *Insomnia*. This is how your work is a redefinition of critical art. We aim at peace, you say, but in peace there is war. Your idea of peace is quite the opposite of quietism. You don't present the image of a stable, ideal world, a world miraculously pacified.

JW: I like to think that what you are seeing in *Citizen* is something inherently photographic. It's an instant, a condition that could vanish very quickly, even though, at the same time, it's arrested and seems now to be able to last forever. The peace you see is fragile and might be very short-lived. It's not so much the composition that tells you this, it's the fact that it is a photograph. The same subject in a painting would feel very different.

The process of depiction, of picture-making, is so rich and expansive. Almost by nature, it suggests, or encourages you to fuse opposite, contradictory qualities in anything you work on. It's never static unless it's done badly.

J-FC: Very few people need art. A lot of people need culture, but as soon as you talk with any kind of precision about art, there's nobody there anymore. It's important not to lose sight of the fact that what you're talking about concerns very few people, and that misunderstandings arise very fast. In your pictures, the viewer will in most cases look for an answer to questions that you haven't asked yourself, and that don't exist in them.

JW: Misunderstanding is inevitable and interesting, and possibly it's one of the essential elements, or moments, of artistic experience. I'm not aware of the meaning of

most of what I'm doing, and I don't think I need to be. I can't predict or control what others make of my pictures, and I think that's also significant. Pictorial art is radically open to the world. We can't know who is going to respond to it, there are no demographics, no sociological studies, that can tell you much about that. Because it is rooted in experience, it is addressed to the individual, and to the complexity and spontaneity of individuals. Certain associations made between works are made only because a certain person suddenly recognizes them. If that person didn't exist, the connection would probably never have been noticed.

J-FC: I agree with you and I think this is real progressivism: art is not accessible to one and all, even if it may address everyone willy-nilly. It's a bottle tossed into the sea, which will reach someone, somewhere, who knows where. Those "few" can't be counted, they don't form a population, it isn't a demographic reality. Nor do they form a people, for we are no longer in the age of Dante or Victor Hugo. They are a certain number, unknown, somewhere.

JW: If you happen to be standing in a group of strangers in front of a work in a museum or gallery—or anywhere—you will never be able to predict who is going to have a powerful, creative response to that work. And the person or persons who do have it won't know in advance that they are going to have it. Clement Greenberg said that aesthetic experience is involuntary. You don't decide to respond to a work, you're just hit by it somehow. You don't really understand your own response at that moment. That reflects back to us that we don't really know ourselves. So misunderstanding, perplexity, and even frustration are part of the experience, since we might not like the fact that we suddenly like something, something we thought we didn't or shouldn't like.

The photograph of the man sleeping in the park tells us almost nothing about him, who he is, why he is there, and so on. The more intensely he's depicted, the less knowable he appears to be, the more enigmatic. One of art's greatest qualities is its presentation of the mystery of identity, of what people "are." Shakespeare's characters don't know one another, they misunderstand one another, and they make poetry in the process.

J-FC: Enigma is connected with the ghostly or spectral. The two notions are almost synonymous. Enigma comes from the fact that you can't be contemporary with yourself. "Ill-informed," noted Mallarmé, "is the person who would proclaim himself his own contemporary." You mentioned Shakespeare. It's undoubtedly the character of Hamlet who represents for Mallarmé the impossibility of clinging to a presentness in a self-presence. Any relation to self, especially if it is simple and everyday, if it is not mediatized by an ideological construct, by a belief; any relation to self which tries to pass on this side of the ideological armor that provides a belief, any relation to self, in

these conditions, is spectral. Through this spectral relation to self, genealogical ghosts return, which means that one is oneself. Father, mother, ancestors, and more broadly everything that introduces misunderstanding as much as affiliation.

JW: Yes, each individual is an antiquity; he, she, emerges from a deep past. Buddhists believe in reincarnation, in a spectral identity that drifts though time. Baudelaire talked about the ghosts that the imagination meets on every street corner in Paris. I think the picture, the depiction, is by nature one of the places where this is most compellingly made evident. It's apparent in the sense we have of the beauty of pictures.

Post-'60s Photography and Its Modernist Context:
A Conversation between Jeff Wall and John Roberts

JOHN ROBERTS: Since Conceptual art you have been part of a generation that has placed a significant emphasis on your status as writer and intellectual. This connects your practice, via Conceptual art, to a previous history of avant-garde writerliness. That is, what distinguishes the Soviet and Weimar avant-garde artist is the way the artist repositions himself or herself within the intellectual division of labor as someone who makes no distinction between artistic knowledge and nonartistic knowledge. This produces a qualitative transformation in how and what the artist writes. The artist no longer produces writing as an occasional support to studio work, but as a constitutive part of his or her social identity as an artist; writing and studio practice become interchangeable, in turn, transforming studio work (and extra-studio work) into a writerly (theoretically driven) practice. How do you see your own intellectual and writerly commitments in relation to this legacy?

JEFF WALL: I was involved with Conceptual art for about five years, from 1966 to 1970. By 1970 or '71 I had begun to turn in a different direction entirely. I wasn't alone in that; a number of artists in my generation worked their way through the claims made by the most radical forms of the period, recognized at least some of the limitations of those claims, and moved away from those forms. I had an intense encounter with the antiaesthetic, or anaesthetic, art of the '60s, and with its precursors in the avant-gardes of the '20s and '30s, partly because I was a student and partly because of my own studio practice. When I came to London in 1970, I was in the process of reevaluating my work of the previous few years and, in doing that, of evaluating the claims made by the avant-gardes of the earlier decades and the neo-avant-gardes of the moment. I found a lot to be dissatisfied with in many of the claims to artistic revolution being made or revived. My dissatisfactions were, of course, first of all with my own recent work. I saw it as simply inadequate, as a feeble alternative to the art I had admired since childhood—Picasso, Pollock, and so on. I began to wonder why I had diverged from my earlier interests and gone in the direction I did after 1965. I think I was capable of differentiating between my own artistic failures and my critical response to other art of the time. I believe I was able to avoid projecting my own sense of disappointment with my own work onto the art of the moment, but instead to learn something from my failures. That learning helped me to be able to make some critical assessments of the claims being made in the early '70s, and the establishment of an orthodoxy based on those claims in the next five to ten years.

Conducted by correspondence between February and August 2006. Scheduled for publication in *Oxford Art Journal* 30, no. 1 (February 2007).

When I started teaching, in 1975 or so, I was obliged to continue the sort of studying—and therefore, the writing—I had done as a student. I wrote many lectures in longhand, prose, and delivered them as they were written. At the time, I felt that teaching work to be a significant part of whatever contribution I might be able to make to art, and I put a lot of energy into it. I think I was a good teacher, for a while at least. Some of my earliest pictures, like *The Destroyed Room* or *Picture for Women,* had a fairly intricate relationship to the content of my teaching (and lecture-writing). I see that now as a sort of transitional phase. The main written results of that activity were "Dan Graham's Kammerspiel," which I wrote between 1980 and 1982, and "Unity and Fragmentation in Manet," written in 1984. By 1985, I had pretty much given up that kind of teaching and the writing that went along with it, and wanted to put most of my energy into my pictures. But just about at that moment, I started getting requests from other artists to write essays for their exhibition catalogues. Because most of them were my friends, I agreed to do the essays. I wrote for Ian Wallace, Rodney Graham, Roy Arden, and a few others. After that, the requests stopped, and I stopped writing that kind of text. The last thing I wrote seriously was "Marks of Indifference" in 1994–95, at the request of Ann Goldstein (also a friend) for her show on Conceptual art in Los Angeles. I retired from teaching altogether in 1999.

I think I was quite aware of the tradition of writing by artists you're talking about. For that period of transition, from 1975 to 1985, my writing was caused by my teaching, and I did think about the teaching in an avant-gardist way, as if it was an integral part of my practice, and I think the content of the teaching and writing shows that, especially "Kammerspiel."

So I feel I've had an experience of the kind of vanguardism you're talking about, and that I've participated in it. But I do not think that my writing is either a support for my studio work or a constitutive part of my identity or practice as an artist. I don't think the avant-garde notion of the fusion of intellectual-theoretical activity with studio practice is any better or more liberating than the more conventional sense of an artist who doesn't have much interest in writing anything.

I sort of fell into writing. "Kammerspiel" came about because of discussions with friends, Dan Graham and Tom Lawson; my Manet essay because of my relationship with Thierry de Duve, who invited me to participate on a panel discussion in Seattle. If no one had asked me, I would probably have never written a thing after "Landscape Manual." I never put my notes together for a thesis at the Courtauld Institute. I did the lectures because that was my job. But when I sat down to write, I guess many of the impulses you are talking about were present, even though I pretty much disagree with your whole definition of the situation. I might have thought that I was challenging the artistic division of labor, as you call it, for a while in the '70s, but I realized soon enough that my writing was just essay writing, a critical, analytical activity related to my work in some ways but not a part of it. I realized I had no

overt or pressing interest in challenging or redefining the artistic division of labor. I was just interested in the subjects and so I talked about them in print.

I make a distinction between artistic and nonartistic knowledge, as you put it; I am not sure art is something we turn to for knowledge, like we would to science, history, or journalism. Art is more to do with experience.

So in general, I think writing and that sort of intellectual work has no inherent relation to the significance or quality of any artistic practice. Most good artists have a lot to say about art, but they don't have to write it down to make it valid for themselves and for whoever they are talking to. That model of the artist-intellectual has a certain history; it's become a standard, even though there are few such artist-writers. But it is just one proposition and has no special status. I think it is irrelevant to questions of artistic creation and to the abilities and qualities of an artist.

I don't think I've broken with modernism.

JR: Isn't the importance of writing in the 1960s and 1970s for artists, though, more generally historical? It is easy to forget now, but artists' knowledge of the original avant-garde, and alternative models to nonwriterly modernism, were very sketchy indeed. There were very few historical sources—in English, at least—that artists could call on as critical guides. The "turn to writing" by this generation, therefore, was very much about reentering modernist history before modernism, as a way of reasserting their artistic autonomy. That is, artists had necessarily to become their own art historians if they were to recover a workable, nonhistoricist tradition of the modern, because art historians at the time were certainly not in a position to do this kind work for them. Today, of course, things are very different, with the increasing convergence between the critical interests of artists and the critical interests of art historians.

JW: It's important in terms of the formation or education of artists, but it has nothing to do with the quality or even the nature of the work they make. Being able to see and become familiar with works that were previously out of reach is, and was, important, and some artists were very active in researching, studying, even curating in the field of the avant-garde and related things. Again, all very good, but also a little overstated. It is not as if before the '60s artists didn't probe about out of interest in good works, and find what they were looking for. They might not have done it in an orderly way, the way a critic or historian would do it, but they did it. In New York in the '30s and '40s, for example, the artists were desperate for information about what was happening in Paris, so they got hold of any publication or reproduction they could, they went to every exhibition, and so on. But they didn't do any writing to speak of, no real "research," didn't take on any intellectual or academic roles.

JR: In putting some distance between yourself and a writerly post-conceptualism, you appear to have drawn closer to Greenberg's and Fried's exceedingly unwriterly reading of modernism.

JW: I am not putting the distance; you are bringing something closer than it ought to be. I'm reacting to that. You have to recognize that I was interested in Conceptual art for only a brief period, as I said. By 1970 or 1971 I was through with it, and going elsewhere. So you could say I drew away from that whole thing (and the "writerliness") thirty-five years ago. I wrote—later—about some aspects of Conceptual art because people more involved in it than I was asked me to. I've explained the Dan Graham thing and the Museum of Contemporary Art catalogue essay; Lynne Cooke invited me to lecture on On Kawara for the Dia Foundation, and I did my text on his work for her. I was startled she asked me, since I'd never expressed any interest in Kawara, to her or anyone else, as I can remember. But I just did it, just to do it. I usually thought, "why not" with those things. I guess my critical writing reflects on some of the associations I made in the '70s and '80s, some of the friends I had (and many of them are still friends). Even if I rejected the whole idea of "Conceptual art," I didn't stop liking some of the people I knew who were doing it, and I didn't stop liking their work, or some of it, or some aspects of it. Plus, I think those people knew that, even if I had turned away from that sort of art, I had done so after an authentic encounter with it, and so I was very familiar with, knowledgeable about, it. They knew I was not antagonistic and could consider it pretty clearly and with some insight. Maybe that's why they invited me to write about it. But—I repeat—my writing never had anything to do with the idea that an artist ought to institute writing into the work itself. It is quite opposite; my critical essays are just that—critical essays that happen to have been written by an artist, who wrote them for specific occasions. They don't enter into the field of my artwork as such. They are a separate activity, like that of other artists who have written about this and that.

In 1968, I was interested in the interaction between Don Judd, Robert Smithson, Clement Greenberg, and Michael Fried. I think that stretch of writing was one of the high points of art criticism in the twentieth century. I didn't really take sides; I admired Fried's "Art and Objecthood" enormously (and still do), but I also admired Smithson's "Monuments of Passaic." My own photography was probably shaped in some ways by the tension involved in these rather contradictory affections. I still feel just as involved with Greenberg and Fried as I did then; a bit less so with Smithson, but I can reread his work still, with pleasure and admiration. Only Judd seems to have faded out, not lasted well.

So I have not drawn any closer to Greenberg and Fried; I was always close to them and still prefer their criticism to just about anyone else's then and since then. But I did not think then that accepting them meant having to flat out reject some contradictory elements, like Smithson. That would be ideological, not artistic, thinking.

You know all about how Greenberg said that the new Conceptual and Pop forms were not likely to lead to ambitious or major art. He's been dismissed for that, and considered to have been just completely off the mark. But—and this is often not

remembered, or at least not admitted—he also said that, even if he would argue that Conceptual type art was less likely to lead to art of quality than, say, abstract painting, he emphatically added that nevertheless he could not rule out the possibility that just that unlikely form of art would defy his expectations and do just what he claimed it was not likely to do.

I tend to agree with him. I enjoy work that in principle I have no faith in; that's always contradictory. But the enjoyments are real enough to convince me to let them be.

JR: In the '60s Greenberg and Fried, however, didn't really know what to do with photography, and pretty much steered clear of it—although reputedly Greenberg spent some years sketching out a book on photography. Their big stumbling block about the photograph was that it couldn't guarantee the kind of quality they expected from modernist painting, given photography's technical objectivity and "rigid" pictorialism. Your own turn to photography clearly rejects this high modernist judgment, insofar as you make pictorialism the key site of modernist reflection and sensuous intervention. Clearly this openly challenges conventional modernist history. As you have remarked on Manet, the decoupling of realism and modernism in '60s modernist history abandons the pictorial to the forces of reification. Yet, interestingly, Fried has made a career as an art historian in the 1980s and 1990s first and foremost as a modernist critic and advocate of nineteenth-century realism, and is now writing a book on photography! How, then, do you see this issue of quality and photography from the perspective of those modernist debates in the '60s?

JW: I don't know anywhere that Greenberg or Fried says anything negative about photography in the terms you're using here. Greenberg's few articles on photography are well known and his view is quite the opposite—he clearly thinks photography is a major art form and Walker Evans a major artist. They maybe did not engage photography more than they did in the '60s because, first, they were more interested in painting and sculpture, and, second, photography was just at a turning point in its evolution. Evans and his generation had brought the original version of art photography to a sort of conclusion, and what was new was just in embryo around 1964. But that doesn't imply any objection to photography on the level of quality; it just suggests that Fried and Greenberg didn't see any challenges coming from photography at that point, regardless of how good they thought Evans, or other, earlier figures, like Atget or O'Sullivan, might be.

I did not reject anything from them by taking up photography. "Conventional modernist history" is not something to which I make reference; it's pretty much all ass-backwards, being so conventional. Fried's evolution is radically unconventional. He turned toward Manet and the nineteenth century in order to say more about the notion of modernism he'd developed in relation to abstract painting first off, not to repudiate it. Fried wanted to extend and develop his ideas, and saw that to do so he

had to engage with the painting that could be said to initiate high abstraction—French modern painting from Manet on. That always seemed evident to me. If you read his books you get the sense that the question of photography is always just around the corner, and that at some point or other he would have to address it directly. Its only a little surprising that, instead of writing about the photography contemporary with Manet or Courbet, he's writing about photography now. It's also then not totally surprising to me that he was partly encouraged to write about contemporary photography through appreciating my work and seeing in it many echoes and resonances with his own thought over almost forty years. I think those affinities are there, since I've always found Fried's work the most interesting and closest to my way of thinking, along with one or two others, like Thierry de Duve and Jean-François Chevrier.

JR: I agree that Greenberg and Fried had no general antipathy to photography, particularly when they could slot an avowedly modernist photographer such as Evans into their schemas. But, nevertheless, they felt slightly unnerved by photography's resolute pictorialism and its evacuation of the authorial mark. Hence, without Greenberg's and Fried's suppression of the pictorial, Conceptual art's appropriation of the photo-document makes no sense. Consequently, by allowing Greenberg and Fried this "slack" retrospectively, the very struggles in your work around the value-status of photography as against painting seem to slip their ideological moorings. We now no longer need to fight in photography's corner, yet in 1967–68 there was an important issue at stake for artist-photographers trying to escape Greenbergian notions of "quality": how might I resist the increasing conflation in modernism between the cognitive particulars of abstraction and "tastefulness." Evans was no help in this matter, his work tended to conspire with this "tastefulness." So my point is this: Greenberg and Fried may have been "friends" of (some) photography, but this doesn't explain why artist-photographers in the late '6os made the moves they did against their notions of "quality."

JW: I really do not agree with the way you see Evans—his work was never seen by anyone as "tasteful," more as cold, remote, and depressing. He didn't have much of a reception before 1970. And I don't think you're right in your characterization of Fried's and Greenberg's relation to photography. Neither of them ever really denied its potential within modernism; as I said, they simply were not primarily concerned with it, but not from antipathy. Many things that Conceptual artists did might have stemmed from some aspect of their reaction to Fried; but that has nothing to do with Fried, or Fried's views on photography. There was no law stating they had to react as they did and take things the way they did, no law demanding the majority get in an uproar over "Art and Objecthood" and resolutely go in the opposite direction. But that's more or less what happened. There are a lot of reasons why the anti-aesthetic trend has been dominant since 1970. The majority reaction to Fried was not caused by Fried but by a lot of elements put together. The opposition to the notion of "qual-

ity" has been too widespread not to make me feel suspicious about it. I was not part of the majority reaction.

JR: I did say "conspire" in this perceived Greenbergian tastefulness, for what was absolutely central to the moment of Conceptual art and beyond was the notion of using photography to get art to an unmarked place—that is, a place not circumscribed by the inflationary aesthetic value-judgments of modernist painting and modernist photography. Some aspects of Evans's turn to the American vernacular may have held the attention of some artists (Ruscha in particular), but overall artists using photography didn't want to be seen as fine art photographers, or be beholden to any notion of the "good" or normative picture, as enshrined in Szarkowski's writing on photographic modernism. Thus some distance had to be established between photography's anti-aesthetic potential (its scope for negation) and the modernist drive to incorporate photography into a model of painterly quality—the very thing prewar avant-garde photography had reacted so powerfully against. Maybe this position could not be sustained without allying photography unambiguously with its anti-aesthetic and functional modes, but its force still has to be acknowledged in an assessment of the period. Anyway, I think this is a good point to move the exchange forward into a more detailed discussion of how your work both converges with and diverges from this moment of rupture. As you have stressed, earlier, by the late 1970s your frustration with and antipathy to post-conceptualism led you to reassess your relationship to the critique of modernism. Crucially this involved establishing a very different working relationship to montage. Montage, in all its forms, of course, was the very ground of prewar avant-garde photography and post-conceptualism, insofar as it linked the dissolution of the idealized unity of the artwork to claims for the radical transformation of the function and experience of the artwork (a shift from the understanding of the artwork as a bounded "thing," so to speak, to the notion of it as a diffuse process). But instead of extending this logic into the realms of the *informel* and nonlinear installation, as many of your peers did, you pull sharply in the opposite direction. By subjecting the asymmetries and discontinuities of montage to the "integrity" of pictorial composition, the traditional picture space and nonlinearity are forced into a productive, disjunctive dialogue. The formal balance and continuity of the picture, then, are a provisional one, a space fraught with internal inconsistencies and anomalies. Yet the implication is clear: for modern art not to dissolve into a theodicy of the fragment, it must re-embed itself within the centripetal force of a "classicizing" tendency. And of course the major classicizing tendency of the twentieth century is realism. This turn to realism, under the auspices of a critique of the fragment, played a key part in your early work as a way out of post-conceptualism. In this it is not so far away from Lukacs's critique of modernist literary form in the 1930s. Did these debates on realism and the defence of a classicizing art mean anything to you in the late '70s?

JW: I just can't agree with the way you are presenting this. It's all based on the assumption that the Soviet version of the avant-garde, as interpreted by the '70s and '80s left, is the central frame of reference. But that view doesn't hold up. There were other tendencies, other directions affecting photography and the other arts all through that time, and many of them are more relevant to what has happened since. It was not so difficult for me to move in a different direction because my assessment of the various precedents did not give so much weight to the Rodchenko-Lissitzky-Klutsis version. I was more interested in other things, what I considered then, and still consider now, better things. Just for example—and once again—it is just not feasible to restrict the example Walker Evans gave us in the way you're doing. His work is far more significant than Rodchenko's or Lissitzky's.

Of course I developed another way of looking at montage. I was not impressed by the hectoring graphic arts way that the Soviets did it, and even less impressed by the '70s and '80s versions. Champions of the Soviet avant-garde always point to the same few Lissitzkys, the same few Rodchenkos, a few posters by Klutsis, the same impoverished little canon as if nothing else of value was made between 1920 and 1945. I had enough of that when I dropped my research on Heartfield in 1972.

The "moment of rupture" affected other artists differently than it did me. If some of them wanted to go on with the anti-aesthetic, productivist thing, that did not mean much to me. I don't agree that montage as you have it was the ground of pre-war photography. There are any number of examples from the period that show otherwise. But that is going back over the same argument again.

It's not such an anomaly for me not to have wanted to dissolve the artwork as "thing" into "process"; again, that was not as dominant a way of working as you claim. Not everyone wanted to dispense with the unity of the work, or, not everyone responded to that in the same way. If there are internal tensions and anomalies in my pictures, they are there in the way they have been in (good) pictures for centuries. The idea that pictorial art and pictorial space were too simple to deal with modern reality is another of those unexamined assumptions of avant-garde rhetoric, just as is the accusatory notion of the "organic" as opposed to the "inorganic" work.

But I don't think you can just define what I'm doing, and was doing, as a version of some sort of dialectic between radical open form and realism. That, again, assumes that the Soviet-type terms are the essential ones. We don't have to go through the Stalinist/anti-Stalinist frame of reference. It is hardly unusual to find both open form or deconstructed elements and "realist" elements coexisting in the same work, the same picture. So, to answer the last question, the realist debates were interesting enough, but their frame of reference had long before been transgressed by good work in photography, cinema, painting, etc., so that they were just too limited to be obligatory. Lukacs is erudite but just not very compelling in this area. If there's realism in my work, it's not that kind of realism.

JR: So what kind of realism is, or remains, in your work?

JW: I don't think I can define it, or maybe I don't think it needs to be defined. Realism tends to mean an interest in the everyday, an appreciation of how things and beings in the world really look when you are not looking at them in pictures, and a sense that both those things are central to the making of pictures (or depictions) at their highest level in our tradition (such as it is, or remains). That picture making requires that these interests are put into play by an individual. Nothing can be codified. There can't be a programmatic way of doing it.

JR: Would you include "world-historical" and "world-disclosing" in this nonprogrammatic definition of realism? Certainly one of the criteria for admission into the canon of classical realism (David, Goya and Courbet, Cervantes, Balzac, Dickens, and Mann) by many theorists of realism, such as Lukacs and even early T. J. Clark, is that the ambitious realist work produced a historicizing and synoptic account of the "everyday" and social and class conflict. Thus, despite the illusion of social totality in the classical realist work, the classical realist work nonetheless offers an imaginary relationship to the concept of totality based on an image of social inclusiveness and heterogeneity. I've always been struck by these kinds of ambition in your work; each image, or sequence of images, produces one more element, in a relational, fictive, whole. Do you see your understanding of the "everyday" as touching on this?

JW: I think those terms are still relevant, even though they carry a lot of the old programmatic baggage. The totality is inaccessible as such, but it can be intuited, fleetingly, in the experience of some specific depiction. The picture stills the fleeting quality but doesn't negate it by stilling it. It suspends it. Aesthetic experience is an experience of that suspension, in which, as Kant described, we take pleasure in the intensified feeling of cognitive awareness without that actually having any directly cognitive content. That "feeling of knowing something important" while still recognizing that that is an illusion is a form in which what has been called "world disclosure" occurs. The everyday has a central part to play because any disclosure takes place by means of a specific depiction made by a person amongst persons, on an ordinary day. The singularity of the making is also itself a disclosure of something—a disclosure of what an individual is. Or something like that.

JR: The suspension of "fleeting quality" as an aesthetic experience, for realism though, is never a disembodied experience. Indeed, perhaps, the crucial determinate of looking at realist pictures (those which contain figures, that is) is that they offer up an empathetic space for the spectator. The viewer's cognition of a scene is not just optical—in the conventional modernist sense—but embodied via their imaginary movement through the internal details of the picture space. Interestingly, Fried builds on this principle in his recent book on Alphonse Menzel, in order to draw up a

critical account with French modernism and his own previous modernist, "optical" commitments. For Fried, Menzel is the empathetic artist par excellence, insofar as his realism encourages the corporeal and "ambulatory" involvement of the spectator, inculcating, in turn, a "projective seeing" and multisensory sensitivity. Accordingly, Fried attests that nothing in the development of modernist painting in France and in modernist art after 1940 in the United States "has trained us for this sort of close-range effortful . . . [and] empathetic looking." Indeed, he argues further that the downplaying or denigration of this approach has meant that some realist works have been "slighted as objects of concentrated looking." Well, yes, one might say. I'm intrigued, therefore, about how important this notion of empathetic looking has played in your understanding of realism and "world disclosure." Because Fried is certainly clear—as you yourself are from your unambiguous commitment to the "multisensory picture"—about how French modernism in the end rendered the empathetic gaze opaque.

JW: Depiction, as we are talking about it, can be empathetic in the sense that just wanting to depict expresses an attachment to the "what" that is getting depicted—the "what" being the world, the real, whatever you want to call it, the visible. And even the not visible. I have said that our Western form of depiction is one of the most striking expressions of affection for the world, for nature, for being, for there being a world. So, in that light, the experience of gazing at a depiction of something is an experience of empathy. It might be that the liking for depiction is itself one of the signs of there being empathy, of its conditions of possibility. This is not far from Kant's sense of natural beauty. (I've been criticized for thinking this way, been told I was "sounding like a museum trustee deflecting awkward questions by invoking eternal values." I guess I can appreciate what an affront it must be to suggest that depicting something expresses any affection for the existence of that thing, and things as a whole!)

I have freely interpreted Fried's notion of opticality to at least connect with the perception of photographs. The notion originated with his experience of the paintings of Louis, Stella, and the others, but I don't think it is limited to that kind of art. Seeing Louis in Fried's frame of reference also made it possible to see pictures, call them traditional depictions if you like, differently—to see them as open to the same opticality. It turns out not to matter whether it is a painting or a photograph, a depiction or an abstraction. Opticality suggests that one does not need to imagine oneself walking into or through the space depicted, one can experience the work authentically without that having to happen—even without it having to happen when it could happen, as in a picture. I notice that when I am looking at pictures, including my own pictures, I don't "take a walk" through the space, imaginatively touching things and so on. I probably could, but I normally don't. My way of seeing might be to recognize the possibility of doing that, since it is built into the nature of the picture, but to

decline the invitation. I find it more enjoyable not to see the picture that way but just insistently to see it as a picture. That means to see the elements depicted as resolved on the surface of the depiction (no matter how invisible that surface is in photography) and to experience their placement in depth as a thoroughly pictorial or optical effect of the nature of the rendering process. It might also be that the picture itself, as a form, makes the "opaque" looking elaborated in French painting possible or available along with the "pure opticality" of American modernism, and the empathetic looking you're talking about. They are simultaneously present, none invalidating the other, each creating a suspension either of itself or of the others, in a mobile and unpredictable—and almost indescribable—process. Seeing the picture is going into this process, maybe?

JR: Fried makes a big play for the "ambulatory" in his book on Menzel for a good reason, I believe. He notices that the empathetic passage/navigation through many of Menzel's pictures has a modernity that is particular to painting. The naturalistic photograph can certainly echo this, but it cannot bring the component parts of a scene into conversational and interactive focus in the way painting can. Consequently, there is a sense in which a number of your photographs are painterly in precisely this fashion. Take *An Eviction* (1988), for example. Readings of the picture focus on the violent altercation outside the house. Nobody picks up on the surrounding observers: the two adults and child in the distance, the man with his child outside the picket fence, the man crossing the road, the woman pushing a trolley. Each is easily missed or taken to be incidental, but, in fact, all are crucial to the form of the work. In their direct observation of the incident, collectively, they establish a conversational space through which the event is made socially tangible. Now, this is not strictly cinema. No cinematic scene-setting is capable of, or interested in, producing this conversational space-at-a-distance. It's just too ambiguous. Neither is it "literary," insofar as the dialogic form of the modernist novel (as in Joyce or early John Dos Passos) cannot replicate the "instaneousness" of the photographic form here. Hence, it can be said that this conversational exchange is specific to this kind of panoramic photography. This, in turn, makes this kind of painterly photograph unprecedented in postwar art. So, my point is this: the empathetic, as a corollary of this conversational form, offers an autonomous viewing space obviously indebted to cinema and the novel, but is actually distinct from them. And this, finally, is where the empathetic gets interesting. Because, it's not just a matter of whether we take a "walk through the space" or not, but how meaning is spatialized. In works such as *An Eviction* or *The Holocaust Memorial in the Jewish Cemetery* (1987), we are being asked to compose the picture through a kind of "purposeful scanning," in which the interiority of depicted figures becomes the imaginative focus of the work's legibility. Looking is indivisible from empathetic reconstruction, projection, "vocalization."

Jeff Wall. *The Holocaust Memorial in the Jewish Cemetery*. 1987. 47⅟₁₆" x 7' 1⅟₁₆" (119.5 x 216 cm)

JW: I guess so. But I prefer to enjoy seeing things at different distances all disposed on the same surface, the same rectangle. Empathy with the depiction is enough, more may be "literature" again.

JR: The reception of your early work tended to focus on the novelty of your use of the lightbox. No photographers had adopted its qualities in quite the same way you had: that is, by backlighting the photograph, the photographic object took on a quasi-architectural mode of display. But if these works echo the lighting used in the "architectural furniture" of the urban street, corporate interior, and mall, etc., and, as such, determine the general critical tone of the work, at the same time they don't exhaust the social function and meaning of light in your photographs. This is something that struck me forcefully about your Tate retrospective, as one moved from the early street scenes and landscapes to the black-and-white pictures, with their crepuscular subtraction of light, to the interiors with their harsh illumination, different bodies of work represented different engagements with, and different registers of, luminosity. In this sense the absence or presence of light, the possibilities of its artificiality or naturalism, its simulated naturalism, or heightened artificiality, harsh punctuality, or soft diffusion, appear to subject the conditions of "photographic light" to generalized scrutiny. Is this a fair way of presenting your interests here?

JW: Fair enough. Each picture has its own light, its own color, its own space, angles, etc. It is always based on the illumination, though, and I think this in itself has nothing to do with whether I am using a transparency or an opaque print.

JR: Sure, each work has its own specific light source. But no artist using photography has focused quite as methodologically as yourself on the materiality of light via the "illuminated image." Dan Flavin once said of his own work, "The lamp lighting should be recognized and used simply, straightforwardly, speedily or, not. This is a contemporary, a sensible, artistic sense. No time for contemplation, psychology, symbolism, or mystery." In these terms Flavin was renowned for desymbolizing light. I was wondering whether Flavin's sense of fluorescent, artificial light as being democratic in its reach and diffusion played a part in your choice of the "illuminated image"?

JW: Yes, Flavin was important. I was interested in him earlier on, in the '60s and '70s, partly through my friendship with Dan Graham, which began just after I moved to England in 1970. Dan was very involved with Flavin. I'd liked his—Flavin's—work since I'd first seen it a few years before, in reproduction only. I really liked his first show of pure lamps, at the Green Gallery, I think. I saw photos of that maybe in *Artforum*. Flavin had visited Vancouver sometime around 1968 in connection with an exhibition of recent New York art, and I actually saw his work and heard him talk then. I liked how he drew attention to the nature of the fluorescent light and the meanings it suggested. That stayed with me and had something to do with my accepting to work in transparency about ten years later. I got interested in how the fluorescent light hovered within the transparency and added its own partially perceptible shimmer, or energy to the depicted light, in the picture. That shimmer added a layer of complexity and meaning, I thought then. Later I drew away from that militant New York hard-nosed '60s way of reductivism, taking away this and taking away that. I began to become more and more aware of the limitations of reductivism and didn't see the limiting of art as very promising. I no longer feel that the fluorescent light adds more to the image than any ambient light in a room adds to a picture in that room. Every picture is seen by some light or other. That is just as interesting as having the fluorescent system operating behind the image, just as much attuned to the materiality of light, as you put it. So I am not as interested in that aspect of my own work anymore. I'm more interested in the pictures. But its all still there.

JR: I've just been looking at photos of that early New York show, and the work really stands up. As you say, you weren't prepared to follow Flavin (and Judd) down the reductive route. But your work certainly inherits that "cleanness" and clarity, which touches on more than the subtractions of Minimalism. I like Flavin's description of his light works as "keenly realized decoration." There is a whole conceptual universe in that "keenly realized" (that is more Tatlin than William Morris). So, with your interest in the illuminating power of the light box dropping away, is there any accord now between the picture and that whole post-Constructivist legacy that both Flavin and Judd drew on? Or to put it another way: what qualities do the pictures now carry for you?

JW: I don't think I can just break away from the things that interested me in the past, and anyway, I still like Flavin's work. Judd, I'm not so convinced about anymore. I like that Flavin took a "readymade" element—the lamp fixture—and did not just present it as an "instance of a work of art" but made another move with it, toward that decorative form. Carl Andre did something comparable, with bricks and metal squares and other things. That enriched the notion of the readymade, it didn't just depend on it and repeat it. It wove it back into the making aspect of art, in a way against the other way of looking at it, which is to invalidate the making and hand that over to the "economy," or the "culture."

Jeff Wall. *After 'Invisible Man' by Ralph Ellison, the Prologue.* 1999–2000. 5' 8¼" x 8' 2¾" (174 x 250.5 cm)

I'm sure there is some accord with Constructivism and post-Constructivism, but it is a background element, since other things are more important to me. The picture itself is something—you could even say it is *the* thing—against which the Constructivists defined themselves. But these oppositions are fluid things, they are not like other forms of opposition, like political or ideological opposition. I can be opposed to Constructivism and still love Lissitzky or Flavin, and take from that affection something unexplained and unpredictable. And anyway, I'm not opposed to Constructivism, I'm not opposed to any good art. I want my pictures to have the same qualities that good works of art of any kind have. And if they will have those qualities, they will be akin to other good works, even if the other works are very different—in the way that my work is different from Flavin's or Andre's. I think Greenberg had it right in saying that, after time passes, the good art of an era begins more and more to look similar, and as more time passes the good art of all eras begins to do the same.

JR: Finally, I'd like to talk about *After Invisible Man by Ralph Ellison, the Preface* (1999–2001). As you clarify in your notes for the work, at the end of the novel the narrator—the "underground" man—is holed up in his basement flat, with 1,369 light bulbs hanging from the ceiling. "Without light I am not only invisible, but formless as well," he says. This is an extraordinary image (close in spirit to obsessive-compulsive installations of self-taught artists, so beloved by the Surrealists) whose implausible mixture of claustrophobia and intense light you stage with a certain élan. Too much light, too many of the bulbs on, and we wouldn't have much of an interior to look at. In this, the work's rendering of Ellison's play on racism as a reification of light seems to offer a vivid allegory of photography: photography is always fighting against its own overexposure to its would-be unadorned powers of illumination. This is also reflected in the self-conscious intertextuality of the picture. That is, the photograph is the result of the building of a set/artwork whose details are derived from another artwork (a scene from a novel), which in turn, depicts an artwork in the making. The point, then, seems to be that the claims for meaning, realism, affect, empa-

thy in photography are not diminished by this chain of displacement, by darkness, opacity, the absence of light, so to speak.

JW: That's an interesting interpretation. Your readings are always interesting. I don't have much to add to it; I am not so concerned to comment on interpretations of my work, or anyone's, these days.

NOTES

1. Michael Fried, *Menzel's Realism: Art and Embodiment in Nineteenth-Century Berlin* (New Haven and London: Yale University Press, 2002).

2. Ibid., pp. 26, 256.

3. Ibid., p. 256.

4. Ibid., p. 257.

5. Dan Flavin, "Writings," in *Dan Flavin: The Architecture of Light* (Berlin: Deutsche Guggenheim, 1999), p. 87.

6. Ibid., p. 71.

Index

PHOTOGRAPH CREDITS

In reproducing the images in this publication, the Museum obtained the permission of the rights holders whenever possible. In those instances where the Museum could not locate the rights holders, notwitstanding good-faith efforts, it requests that any contact information concerning such rights holders be forwarded, so that they may be contacted for future editions.

Courtesy Roy Arden: 112, 117.

Photo: Argonne National Laboratory: 73.

Artists Rights Society (ARS), New York. Photo: digital image © 2006, The Museum of Modern Art, New York: 145 left.

© 2006 Artists Rights Society (ARS), New York/VG Bild-Kunst, Bonn. Photo: Heinrich-Blessing: 51, 57 top.

Courtesy Stephan Balkenhol and Gladstone Gallery, New York: 104, 106.

Photo: Martin Bühler, Kunstmuseum Basel: 135.

© Columbia Pictures. Photo: Columbia Pictures/Photofest: 295.

Courtesy Paula Cooper Gallery, New York: 177 top.

Courtesy the Samuel Courtauld Trust, Courtauld Institute of Art Gallery, London: 187 bottom.

© Esto, New York. Photo: Bill Marris: 61 bottom.

© Esto, New York. Photo: Ezra Stoller: 57 bottom, 59, 61 top, 64.

© Walker Evans Archive, The Metropolitan Museum of Art, New York. Courtesy Paula Cooper Gallery, New York: 175 right.

Photo: Foto Marburg: 277 right.

Photo: Foto Marburg/Art Resource, New York: 79.

Leonard Frank courtesy Vancouver Public Library VPL 6126: 92.

© Editions Gallimard: 137.

Courtesy Marian Goodman Gallery: 32, 44, 47, 48.

Courtesy Itzehoe Hablik-Archiv, Wenzel Hablik Museum–Stiftung Wenzel-Hablik-Museum: 49.

Courtesy Douglas Huebler/Artists Rights Society (ARS), New York: 156.

© 1996 Jasper Johns/licensed by VAGA. Photo: digital image © 2006,

The Museum of Modern Art, New York: 134.

© 2006 On Kawara. Photo: digital image © 2006, The Museum of Modern Art, New York: 126.

© Kertész Estate. Photo: digital image © 2006, The Museum of Modern Art, New York: 145 right.

Photo: Kimbell Art Museum, Fort Worth, Texas: 231 right.

© 2006 The Franz Kline Estate/Artists Rights Society (ARS), New York: 132 bottom.

© 2006 Joseph Kosuth/Artists Rights Society (ARS), New York. Photo: digital image © 2006, The Museum of Modern Art, New York: 35.

Photo: Erich Lessing/Art Resource, New York: 78, 127, 177 bottom, 190 top, 230 bottom.

Photo: digital image © 2006, The Museum of Modern Art, New York: 71 top, 93.

© Bruce Nauman/Artists Rights Society (ARS), New York. Courtesy Sperone Westwater, New York: 152.

© New Yorker Films. Photo: New Yorker Films/Photofest: 180, 251, 254.

© 2006 Barnett Newman/Artists Rights Society (ARS), New York. Photo: digital image © 2006, The Museum of Modern Art, New York: 132 top.

Photo: Photofest: 179, 181, 219, 253.

© 2006 The Picasso Estate/Artists Rights Society (ARS), New York/ADAGP, Spain. Photo: John Bigelow Taylor/Art Resource, New York: 128.

Courtesy Pioneer Entertainment/Photofest: 161.

© 2006 Pollock-Krasner Foundation/Artists Rights Society (ARS), New York. Photo: digital image © 2006, The Museum of Modern Art, New York: 131, 176.

Photo: Réunion des Musées Nationaux (RMN)/Art Resource, New York: 133 bottom.

© 2006 Gerhard Richter. Photo: digital image © 2006, The Museum of Modern Art, New York: 141.

© 1998 Kate Rothko Prizel & Christopher Rothko/Artists Rights Society (ARS), New York. Photo: digital image © 2006, The Museum of Modern Art, New York: 133 top.

© 2006 Edward Ruscha. Photo: digital image © 2006, The Museum of Modern Art, New York: 165, 166, 174 left.

Photo: Scala/Art Resource, New York: 186 bottom, 215.

Photo: Roberto Schezen: 71 bottom.

Courtesy Stephen Shore. Photo: digital image © 2006, The Museum of Modern Art, New York: 174 right.

Photo: Seth Siegelaub. Courtesy The Siegelaub Collection and Archives, The Stichting Egress Foundation, Amsterdam: 41, 155.

© Estate of Robert Smithson. Reproduced courtesy *Artforum*. Image courtesy James Cohan Gallery: 153.

© 2006 Frank Stella/Artists Rights Society (ARS), New York. Photo: digital image © 2006, The Museum of Modern Art, New York: 130.

Tate, London/Art Resource, New York: 151.

Courtesy 303 Gallery, New York: 90, 94–97.

All works by Jeff Wall courtesy and © Jeff Wall

© the Andy Warhol Foundation for the Visual Arts. Courtesy the Estate of Andy Warhol and the Andy Warhol Foundation for the Visual Arts: 162.

© 1984 The Estate of Garry Winogrand. Courtesy Fraenkel Gallery, San Francisco. Photo: digital image © 2006, The Museum of Modern Art, New York: 175 left.

This publication is made possible by Carol and David Appel.

Produced by the Department of Publications, The Museum of Modern Art, New York

Designed by Katy Homans
Production by Marc Sapir
Printed and bound by Oceanic Graphic Printing, Inc., China

This book is typeset in Walbaum. The paper is 120 gsm NPI Woodfree

Published by The Museum of Modern Art, 11 West 53 Street, New York, New York 10019

Distributed in the United States and Canada by D.A.P./Distributed Art Publishers, Inc., New York
Distributed outside the United States and Canada by Thames & Hudson Ltd, London

Library of Congress Control Number: 2006938731
ISBN: 978-0-87070-708-7

Cover: Jeff Wall. *A Sudden Gust of Wind (after Hokusai)* (detail; see back cover). 1993.
7' 6¾₆" x 12' 4⅞₆" (229 x 377 cm). Tate, London. Purchased with assistance from the Patrons of
New Art through the Tate Gallery Foundation and from the National Art Collections Fund

Printed in China